PRAISE FOR THE ART OF FAITH

"Prompted by the conviction that attention to images can enrich the life of the spirit, Couchman has produced an enormously useful and beautifully written resource for beginners and experts alike. This work is permeated with the love of art that has been enlivened by a deep faith."

—ROBIN MARGARET JENSEN

Professor of the History of Christian Art and Worship, Vanderbilt University; Author, *Understanding Early Christian Art* and *The Substance of Things Seen: Art, Faith and the Christian Community*

"In recent years, we have witnessed renewed interest in the visual arts, across a broad range of denominations. There is a palpable longing for art to once again enrich the teaching and worship of local church communities. With this encouraging opportunity comes a considerable challenge: the need for a renewed understanding of the rich heritage of Christian art and symbols that, in our secular age, has been mostly lost. Judith Couchman's well-researched and thoughtfully conceived book meets that need and offers practical help to those who are about the work of returning the gift of art to the Church."

—CAMERON J. ANDERSON

Executive Director, CIVA | Christians in the Visual Arts

"Packed full of information, lucidly written, and clearly laid out. If you have a question about the meaning of something in a work of Christian art, this book probably has an answer. A must-have reference on Christian art for teachers and students alike."

—AIDAN HART

Iconographer, Author of *Techniques of Icon and Wall Painting*, and Assistant Illustrator for *The Saint John's Bible*

"Judith Couchman's *The Art of Faith* is an invaluable reference tool and museum companion for anyone with an interest in Christian art. Old and New Testament biblical characters and other personages from the world of faith are sorted out. Symbols and the use of colors are explicated and the church year is made clear. But this only touches the surface, for the heart of the book as a reference tool is found in the great art that is cited. Each person, symbol, color, and sacrament is paired with an example from art history and where it can be found. These examples are drawn from the rich storehouses of Christian art in museums, both great and small, churches, libraries, and even the catacombs—anywhere one might find the very best that Christian art, from its beginnings through the seventeenth century, has to offer. These examples number into the hundreds. And yet the book is accessible for those with only a cursory question as well as for those with more scholarly concerns. For those of us who work professionally with Christian iconography in the twenty-first century, *The Art of Faith* is a book to be kept close at hand."

—EDWARD KNIPPERS
Visual Artist

"Where was this book when I was an art student in college? In great detail, Judith Couchman gives the reader an opportunity to trace sacred art from the third century forward. She explains the figures and their contribution to beauty. Judith also teaches us what questions to ask as we view Christian art today, making what we're seeing more personal. In other words, the study of art as it relates to faith becomes accessible because we understand what we're looking at and that understanding makes us want to share it with everyone we know."

—LUCI SWINDOLL
Author of *Simple Secrets to a Happy Life*

The ART of FAITH

A GUIDE TO UNDERSTANDING CHRISTIAN IMAGES

JUDITH COUCHMAN

PARACLETE PRESS
BREWSTER, MASSACHUSETTS

The Art of Faith: A Guide to Understanding Christian Images

2017 Second Printing
2012 First Printing

Text copyright © 2012 by Judy C. Couchman (Judith).

Illustrations by Anne Elhajoui and Khaleelah Elhajoui; illustrations copyright © 2012 by Judy C. Couchman (Judith), Anne Elhajoui, and Khaleelah Elhajoui.

ISBN 978-1-55725-630-0

The Paraclete Press name and logo (dove on cross) is a trademark of Paraclete Press, Inc.

Unless otherwise noted all scriptural references are taken from *The Holy Bible, New International Version®*, *NIV®* Copyright © 1973, 1978, 1984, 2011 by Biblica, Inc.™ Used by permission. All rights reserved worldwide.

Scripture references marked NKJV are taken from the New King James Version. Copyright 1979, 1980, 1982 by Thomas Nelson, Inc. Used by permission. All rights reserved.

Scripture references marked KJV are taken from the King James Version of the Holy Bible.

Scripture references marked DRA are taken from the Douay-Rheims Version of the Holy Bible.

LIBRARY OF CONGRESS CATALOGING-IN-PUBLICATION DATA
Couchman, Judith, 1953-
 The art of faith : a guide to understanding Christian images / Judith Couchman.
 pages cm
 Includes index.
 Summary: "Judith Couchman, art history instructor at the University of Colorado at Colorado Springs, unfolds the fascinating (and sometimes mysterious) world of Christian imagery through the ages. This comprehensive guidebook is practical and easy to read, and includes illustrations"—Provided by publisher.
 ISBN 978-1-55725-630-0 (pbk.)
 1. Christian art and symbolism. I. Title.
 N8010.C68 2012
 704.9'482—dc23 2012005604

10 9 8 7 6 5 4 3 2

Published by Paraclete Press
Brewster, Massachusetts
www.paracletepress.com

Printed in the United States of America

CONTENTS

PART FIVE
Sacred Symbols

PART SIX
Liturgical Art

FOR
Laurel,
MY ARTISTIC FRIEND.

ACKNOWLEDGMENTS

Hardly anyone writes a book alone. Authors devote many solitary hours to researching and writing texts, but usually informal support teams back them up. For this book supporters encouraged and prayed for me; helped research and compose the first draft; reviewed the ever-changing manuscript; listened to my doubts and difficulties; and offered gentle advice and realistic perspectives. I'm grateful beyond words for their input.

A small group of women—some I haven't met in person—prayed me through the tedious research and revisions. Beth, Kathe, Nichole, Rosalie, Shirley, and Wendy, thanks for the immeasurable value of your intercession.

When I felt pressed for time, Mona and Nicole researched and wrote rough drafts for selected parts of the book. Thanks to both of you for bringing talent, diligence, and humility to these tasks. You each deserve a byline. Laurel also enhanced the manuscript by critiquing definitions and bolstering limited knowledge in some areas. Anne, I'm honored that once again you contributed your abundant artistic gifts to one of my books, and included Khaleelah in the process. Jan and Mary, thanks for your careful help with the index.

Beth, Mary, Melinda, and Nancy, thanks for listening to my process and offering advice. Kathe, our weekly phone conversations about purpose and writing inspired and strengthened me. Jeanette, your faith and insights comforted me when I had to cut the original manuscript in half. And many thanks to Lil for believing in this project from the beginning, plus the Paraclete team of Anna, Jon, Maura, and Robert.

Finally, I thank my art-history students and the congregation at Grace and Saint Stephen's Episcopal Church. Both groups inspire me to keep learning and researching. In turn, I hope this resource enhances their appreciation of Christian art.

INTRODUCTION

But what does this image mean?

Long before I studied art history, I gazed at ancient Christian art and asked this question. Although an editor and writer by profession, I migrated toward art, visiting museums while traveling and taking advantage of exhibits in my hometown. I bounded up the steps at the Art Institute of Chicago and the Metropolitan Museum of Art, looked at every painting and sculpture possible, and eventually wound up stumped.

As I shifted back and forth on throbbing feet, pondering a famous medieval triptych or Renaissance tapestry, I identified a few biblical figures or something as obvious as a unicorn. Flowers, animals, symbols, liturgical objects, and odd people crammed backgrounds and spilled into borders. But if the curator hadn't posted their meanings, these images seemed as good as invisible.

Still, I didn't lose interest in Christian art. I considered it my religious heritage—something that could enrich me spiritually—and I wanted to decipher it. Over the years I began studying art history, one class at a time, and when I reached early Christian and medieval art, my soul shifted. As the professor's slide show illumined a dark classroom, I envisioned God's creative hand hovering above history, imprinting the world through artists and their works. With a sprinkling of symbology, Christian art finally blossomed for me. I longed to learn more. I also wanted to infiltrate aspects of Christian art into my writing, helping the curious to better understand this faith's visual metaphors. Perhaps as it did for me, deciphering sacred art would sharpen their spiritual outlook and deepen their understanding of church history.

Over time I earned a master's degree in art history and began teaching the subject part-time at a local university, focusing mainly on early Christian and medieval art. In these classes students learned the forms of Christian art, along with how to identify its eras, themes, and stories; to interpret its symbolism; and to analyze specific works. I needed an easy-to-read reference book that would guide students through these processes. But even more, I wanted a book that travelers, art enthusiasts, museum visitors, church parishioners, and others could easily carry and consult. Besides unraveling symbolism, it could enhance faith, heighten worship, and perhaps cultivate a few armchair art historians.

After much thought and a few excuses, I decided to combine my roles of seasoned professional writer and modest art historian and create *The Art of Faith*. I grew passionate about developing a guidebook with an accessible writing style and length that most anyone could use to learn the basics—or supplement formal studies— about the wonders of Christian art from its inception through the Baroque era.

Even if you're not an art fan, *The Art of Faith* can help you better understand the Christian heritage. Early Christians were called People of the Book. But they also were People of the Image. Art played an important role in spreading, communicating, and commemorating their faith. Exploring Christian art can influence your life, too.—*Judith Couchman*

Note: I kept this book as reader-friendly as possible, especially for students and those new to the study of art history. Consequently, you won't find the usual style conventions for scholarly art books and textbooks. For example, I fully cited the locations for works of art, including cities, states, regions, and countries, as needed. As much as possible, I also presented the common and English names of churches, galleries, libraries, museums, and other exhibitors.

The ART *of* FAITH

The Art of Faith

The purpose of Christian art is to deepen our encounter with God. From the tiny to the monumental, from a piece of personal jewellery used for private meditation, to a massive stained-glass window in a great cathedral, the function is the same: to catch the imagination, to open the heart and the mind, so that we may better hear the divine promptings.

—ROWENA LOVERANCE

1
Defining Christian Art

Pictorial art, like poetry, began early in the church's history.
Because of the Incarnation, Christianity points to an intimate
relation between material things and the living God.

—ROBERT LOUIS WILKEN

According to some Christian traditions, the first-century King Abgar of Edessa in Mesopotamia suffered from a disease and sent a messenger to Palestine in search of Jesus. The king instructed his servant to return with the famous Miracle Worker or at least a painting of him. Elbowed out by crowds around Jesus, the messenger scrambled up a tree and began drawing the Healer's face on a cloth. Soon Jesus noticed him and reached up for the linen handkerchief (*mandylion*). Jesus pressed the cloth against his face and handed it back to the astonished messenger. Miraculously, the Lord's face had superimposed on the fabric. The messenger hurried the mandylion back to his king, and Abgar recovered.

Like most word-of-mouth stories, details about the Abgar-Jesus connection varied through the ages. The fourth-century historian Eusebius recorded that the king and the Healer communicated through letters, and after the Resurrection, the apostle Thaddeus visited Abgar and laid healing hands on him. Yet most versions of the tale focused on the Savior's face, believing in the miraculous so generations could gaze upon his countenance.

In another story about a mystical cloth, Jesus imprinted his face on a woman's veil. During the Lord's excruciating struggle toward Golgotha, a resident of Jerusalem, Israel, named Veronica offered him a cloth to wipe sweat from his brow. When Christ handed the fabric back to her, it reflected his face. Veronica took the cloth to Rome, Italy, where Christians long venerated its image. A pier in Saint Peter's Basilica honors the veil, and some scholars think the Mandylion of Edessa and the Veil of Veronica form versions of the same story.

Perhaps this was a catalyst for Christian art: wanting to see Christ's face.

Whether we believe these ancient "face stories" as actual or legendary, they highlight the desire to visually witness the sacred. Consequently, early Christian artists began creating images of Jesus to help people accept, follow, and celebrate their newfound beliefs. They also illustrated signs, symbols, saints, biblical stories, liturgical objects, and church furnishings to pass along their spiritual perspective and heritage.

As Christianity spread across centuries and continents, artists and patrons utilized the styles, resources, and techniques of their cultures to propagate the religion. From simple beginnings in catacombs and private homes, Christian art swelled into an industry supported by popes, emperors, and the wealthy. For many centuries Christianity dominated the subjects and themes of the creative Western world. Before the Age of Enlightenment, the world clearly defined Christian art, despite its variations in style, form, and location. From the early third century through the mid-eighteenth century, people identified this art by some or most of the following characteristics.

F I G U R E S It's almost too obvious to mention, but Christian art focused on the deity and people of Christianity. These included God, Jesus Christ, and the Holy Spirit; Old Testament, Apocrypha, and New Testament people; real and legendary saints; angels, Satan, and evil spirits; religious leaders and pious Christians. Artists created portraits, visual narratives, or fictional and representational scenarios.

T H E M E S Christian art depicted the main themes of the faith, such as original sin; the divinity of Christ; the way to salvation; temptation and obedience; godly living and good works; eternal life in heaven or hell; and others. Artists memorialized events that exemplified these concepts: the Creation and Fall; the virgin birth; Christ's baptism; his miracles; Passion Week; the Ascension; Pentecost; the Last Judgment; and more. In addition, art recorded sacred rituals and sacraments related to major themes, for example, anointing with oil, baptism, confession, confirmation, the Eucharist (Communion), marriage, and ordination.

M E S S A G E S Sacred art of the past guided, inspired, comforted, chastised, terrified, and occasionally entertained its observers. It prompted conversion, gratitude, worship, questions, and debate. But overwhelmingly, this art grew didactic, teaching the spiritually "saved" and "lost" what to believe, how to

live, and what to expect in the afterlife. It supported Christianity as the one true religion; Christ as the only way to salvation; the Bible as literal; and the church as Christ's delegated authority on earth. People felt encouraged or distraught by these messages, depending on their personal persuasions.

C O N T E X T S The location of art could earn the label "Christian." For example, the decoration on an altar or liturgical vessel, a foyer or a gravestone, classified as Christian art if it contributed to worship or merely inhabited church property. Even if the images or symbols didn't look overtly Christian, their locations defined them. However, the earliest art often practiced syncretism, combining sacred and secular, Christian and pagan, images. A few centuries passed before the images decidedly and thoroughly looked "Christian."

In addition, people who delved into the creative process determined whether a work of art would be "Christian." Usually three types of participants influenced art.

A R T I S T S Depending on the era, an artist who created Christian work often worked on commission and followed a patron's wishes for content. To a degree, an artist determined the style and embellished on the client's instructions. In the Middle Ages, a seasoned master influenced the outcome more than an apprentice. During the late Renaissance, artists like Leonardo da Vinci and Michelangelo Buonarroti received more latitude than an unknown, untried artist.

P A T R O N S The people who commissioned and paid for art significantly influenced its outcome. A patron for a grand, important, or expensive work—a painting, sculpture, mosaic, tapestry, or jewelry—was usually a wealthy emperor, king, royal, pope, clergyman, or layperson. Some modestly funded individuals or families afforded simple funerary paintings or carvings, but generally the lower classes didn't purchase formal art, or at least sacred works that survived into the twenty-first century.

V I E W E R S An observer could interpret images as the artists and patrons intended, or apply personal meaning to the work. However, a Christian viewer from the third century and beyond usually understood the intentional religious interpretation. In the eighth century John of Damascus, a Doctor of the Church, explained, "Things which have taken place are expressed by images for the

remembrance either of a wonder, or an honour, or dishonour, or good or evil, to help those who look upon it in after times that we may avoid evils and imitate goodness."

During the centuries since John of Damascus wrote this explanation, perceptions drastically changed about art in general and sacred images in particular. However, looking at Christian art today, it's helpful to remember these criteria from a bygone world. Using these guidelines as filters, we can better understand the meaning and influence of Christian works in their time and space.

2

The Missing Years

Christian art begins not as a great storm but rather as the tide turning,
in an undramatic way, and its beginnings are little noted
either by Christian or non-Christian contemporary observers.

—Lawrence Ness

One of the earliest forms of Christian art wasn't a painting, a sculpture, or even a catacomb fresco. It was a patch of graffiti on plaster, discovered in the Poedagogium on the Palatine Hill in Rome, Italy, and dated to around AD 200. Imperial teachers used the Poedagogium building to educate the emperor's staff, and perhaps an idle student etched the crude artwork. The drawing depicted a man with an ass's head, nailed to a cross. Viewed from behind, the crucified man turned to the left, looking down at a youth with a raised arm. An inscription underneath the cross figure claimed in Greek, "Alexamenos worships his god."

Art historians disagree whether the scrawled words should be interpreted as a Christian's profession of faith or a pagan's scorn. On the one hand, Jesus rode on an ass, so this animal became an important symbol for early Christians. From this perspective, some suggest drawing the crucified Christ with a donkey's head paid homage to a hailed Savior. On the other hand, most observers recognized the inscription as a taunt from someone who misunderstood the new religion. In early Christianity, a rumor circulated through Rome that Christians worshiped the head of an ass.

What was the true meaning? Only the graffiti artist knew for sure.

During the same era, pagans, Jews, and early Christians carved deep recesses in the soft tufa rock shaping the outskirts of Rome. From the third to fifth centuries, survivors often painted these catacomb walls with images that represented the deceased, and images of a person in prayer, the *orans* (Latin for "praying"), decorated several catacombs. The orans figure populated Late Antiquity, usually depicted as a standing, veiled woman with her hands outstretched and gazing toward heaven. It's not always clear, however, whether an orans figure represented a pagan, Jewish, or Christian worshiper. Each religious group used this stance as a prayer posture.

Old Testament Jews spread their hands in prayer. From the desert of Judah, David prayed, "I will praise you as long as I live, and in your name I will lift up my hands" (Ps. 63:4). When a pagan orans lifted up her hands, she expressed "the affectionate respect due to the state, to ruler, to family, or to God." Because early Christians were Jewish, they naturally practiced this stance. The apostle Paul advised the earliest Christians, "I want men everywhere to lift up holy hands in prayer, without anger or disputing" (1 Tim. 2:8 NIV1984), and early church literature recorded the widespread practice of this prayer position. Consequently, the famous orans in the Catacomb of Priscilla in Rome, doesn't own a clear interpretation of her origin or beliefs. As much as art historians argue one interpretation or the other, nobody knows for sure.

Like the Palatine graffiti and the catacomb orans, some of the earliest years of Christianity and its art linger in ambiguity. Even more mysterious, it doesn't appear early Christians produced art for the first two centuries of the faith. As far as we know, with a few exceptions of signs and symbols, Christian art didn't appear until the early third century. Nobody knows the exact reason for this omission, and at any moment a new archaeological discovery could prove this assumption wrong. In the meantime, art historians and church scholars suggest these theories for the missing years.

G O D ' S L A W Originally Jews, the first Christians traditionally obeyed God's command to worship no gods other than him and to create no graven images (Exod. 20:3-4). The strictest interpretation of this law meant creating no sacred art, and especially not depictions of God. In contrast, some scholars think Hellenistic (Greek) believers, from a creative culture, influenced the first stirrings among Christian artists.

C R I T I C A L C H U R C H F A T H E R S Some early church fathers attacked pagan art. Apologists delivered these criticisms verbally or in written treatises, warning Christians against pagan religious practices. This meant not worshiping the images of gods, goddesses, mythical humans, and the emperor, or supporting pagan temples such as the great Pantheon. Some church fathers mistrusted artists who embraced Christian beliefs. In the second century, Tertullian of Carthage advised them to become craftsmen instead.

RELIGIOUS PERSECUTION Until the Edict of Milan in the fourth century, when Emperor Constantine declared Christianity a legal religion, believers endured waves of persecution under varied Roman emperors. Although persecutions abated for years at a time, their unpredictability kept the faithful in suspense. It's possible Christ's followers didn't want to draw attention to themselves with conspicuous art. Distinctly Christian images endangered their lives.

TOO HEAVENLY MINDED Another theory suggests the earliest Christians grew too spiritually minded to create art. Caught up in the ecstasy of their faith, they didn't care about anything as common as images. The early church anticipated Christ's imminent return, so art didn't matter. At best, this described nascent Christians at Pentecost, when the Holy Spirit descended on believers. When a group worshiped together daily, shared all things in common, and spoke in other tongues, who carved out time for art?

NO LAND OR CAPITAL This theory claims early Christians overlooked art because they lacked a distinct identity. They blended into the Greco-Roman culture and produced no material artifacts. Without the surviving literature, it's hard to identify their existence in the first- and second-century Roman Empire. Christians lacked the land and capital to distinguish themselves and create art. When believers finally owned material resources, they produced a distinctly Christian art and symbolism.

Just as we can't precisely pinpoint why Christian art didn't exist in the earliest years of Christianity, we don't know exactly why it appeared around AD 200. But when paintings from this growing religion emerged from underground Roman catacombs, Christian art never turned up completely absent again.

3
The Eras of Christian Art

That contemplative wisdom by which we are impelled to the arts . . .
is the gift of God. If we have been created as rational creatures,
we have received this.

—METHODIUS, FOURTH CENTURY

When Princess Constantina passed only fourteen years after the death of her father, Emperor Constantine, Romans memorialized her with a royal mausoleum. Constantina (also called Costanza) professed faith in Christ, but the circular, domed building contained no overt symbols that signified her faith. The tomb's mosaics represented common Roman motifs: birds, cupids, foliage, grapevines, drinking vessels, and winemaking. Pagans claimed these themes to celebrate the god Bacchus, while Christians viewed the images as reminders of Christ's Last Supper.

Visitors to the mausoleum, later transformed into the Saint (Santa) Costanza Church, might puzzle over the images if they don't know about Constantina's two arranged marriages to pagan rulers and the religious syncretism in fourth-century Rome, Italy. Christianity and paganism coexisted and even mingled in art, culture, and religious practices. At one point scholars noted that amidst the *putti* (small angels) picking, transporting, and stomping grapes on the mausoleum's ceiling, the building's four niches suggested the form of a cross. Artists color coordinated the twelve pairs of columns in red and green marble to highlight the points of a cross. It's as if the cross quietly but securely superseded the pagan activity, occupying a revered place above it all.

As sacred art developed, artists and patrons erased doubt about its origin and meaning. For the most part, Christian art became thoroughly Christian. Toward the end of the tenth century, Gero, the archbishop of Cologne, Germany, commissioned a crucifix for his cathedral that demanded attention to Christ's death. Over six feet tall, the painted wood sculpture featured a lifeless Christ still hanging on the cross. Christ's skin sagged and his stomach bulged. His head hung down, with the hollow eyes and withered lips of prolonged suffering.

Later in the fourteenth century, the artist Giotto di Bondone painted a barrel-vaulted room built over Roman ruins in Padua, Italy. It functioned as a family chapel. When Roman Christians walked toward the altar, the life of Mary and the story of her Son lined the walls, divided into rectangular panels. Giotto successfully distilled each image into an emotionally complex yet unmistakable scene. Viewed vertically, each set of three images foreshadowed or related to the others. Wherever visitors carefully stepped into the Scrovegni Chapel, or however closely they scrutinized the Gero crucifix, they didn't doubt. This was Christian art.

Through many centuries and styles, from Late Antiquity through the Baroque, this creativity promoted the church's doctrines, morality, and history. This art celebrated Christianity.

A Simple Overview

The chart on the following pages briefly overviews the major eras of Christian art, along with a few well-loved but lesser-known groups. It provides a snapshot of the eras and their approximate dates, primary locations, general art styles, common formats in existence today, and well-known examples. This can help make sense of what you observe in art books and museums.

However, it's impossible to fully represent art eras through a simplified chart. For a more detailed view of these eras, consult the many books, journals, and websites devoted to them.

ART ERA	POPULAR STYLE	COMMON TYPES
Early Christian Third Through Fifth Centuries Western Roman Empire, the Holy Lands	Copied the classical style of balance, order, restraint, idealized figures, and columned architecture. Catacomb frescoes look less precise. Influenced by Emperor Constantine I and Greco-Roman art.	Basilica churches and monasteries with interior decoration; frescoes; grave markers; illuminated manuscripts; liturgical objects; metalwork; ossuaries; pottery; sculpture; sarcophagi; oil lamps; royal regalia.

NOTABLE EXAMPLES

- *Jonah*, sculpture by unknown artist, third century. Cleveland Museum of Art, Cleveland, Ohio.

- *Dome of Heaven*, fresco paintings by unknown artists, fourth century. Catacomb of Saints Peter and Marcellino, Rome, Italy.

- *Junius Bassus Sarcophagus*, relief sculpture by unknown artist, fourth century. Historical Museum of the Treasury, Saint Peter's Basilica, Vatican City, Italy.

ART ERA	POPULAR STYLE	COMMON TYPES
Coptic Fourth Through Tenth Centuries Egypt	Paintings with flat perspective. Rounded figures with large heads, eyes, and ears. Simplicity. Stylized and almost abstract. Vivid colors. Adopted ankh (ancient Egyptian sign for life) for crosses. Developed a distinctive Coptic script. Influenced by Egyptian, Greco-Roman, and Islamic art.	Basilica churches and monasteries with interior decoration; frescoes; grave markers; icons; illuminated manuscripts; ivory carvings; metalwork; pilgrimage artifacts; pottery; relief sculpture; shrines; tapestries; textiles; woodworking.

NOTABLE EXAMPLES

- *Angel Tapestry*, weaving by unknown artist, fourth century. Coptic Museum, Cairo, Egypt.

- *Christ and Saint Mena*s, icon by unknown artist, sixth century. Louvre, Paris, France.

- *Saint Apollo*, fresco painting by unknown artist, sixth or seventh century. From the Monastery of Saint Apollo. Coptic Museum, Cairo, Egypt.

ART ERA	POPULAR STYLE	COMMON TYPES
Celtic Fourth Through Twelfth Centuries Thirteenth Through Sixteenth Centuries Revival British Isles, Western Europe	Animal and bird figures. Spirals, scrolls, geometric, and interlacing forms. Abstract design and ornamentation. Some undeciphered symbolism. Influenced by migratory tribes in Europe and Greco-Roman art.	Gem and metalwork, especially brooches and crosses; illuminated manuscripts; liturgical objects; military armor; small shrines; stone sculpture, particularly outdoor high crosses. Portable objects for migratory people.

NOTABLE EXAMPLES

- *Ardagh Chalice*, gem and metalwork by unknown artists, eighth century. National Museum of Ireland, Dublin, Ireland.

- *Book of Kells*, illuminated manuscript by unknown artists, ninth century. Trinity College Library, Dublin, Ireland.

- *The Cross of Muiredach*, stonework by unknown artists, tenth century. Monasterboice, County Louth, Ireland.

Byzantine Sixth Through Mid-fifteenth Centuries Eastern Roman Empire	Paintings with flat perspective. Motionless figures with solemn, slim faces. Standardized themes and styles. Magnificent ornamentation. Detailed design and technique. Influenced by Emperor Justinian I, Empress Theodora, and Islamic art.	Circular, domed churches, baptisteries, and monasteries with interior decoration; frescoes; icons; illuminated manuscripts; ivory relief sculpture; liturgical objects; metalwork; mosaics; oil lamps; reliquaries; royal regalia; textiles.

NOTABLE EXAMPLES

- *Ivory Throne of Bishop Maximian*, relief sculpture by unknown artist, sixth century. Archepiscopal Museum, Ravenna, Italy.

- *Virgin and Child Enthroned Between Emperors Constantine I and Justinian I*, tympanum mosaic by unknown artists, tenth century. Hagia Sophia, Istanbul, Turkey.

- *Golden-Locked Angel*, icon by unknown artist, twelfth century. State Historical Museum, Moscow, Russia.

ART ERA	POPULAR STYLE	COMMON TYPES
Carolingian Eighth and Ninth Centuries Belgium, France, Germany, Holland, Italy	Return to the classical style: balance, order, restraint, idealized figures, and columned architecture. Narrative. Varied manuscript illumination styles. Carolingian script developed for the royal court. Influenced by Emperor Charlemagne and Greco-Roman art.	Westwerk (western entrances with towers) churches and monasteries with interior decoration; elaborate gem and metalwork; frescoes; illuminated manuscripts; liturgical objects; reliquaries; sculpture; royal regalia.

NOTABLE EXAMPLES

- *Lindau Gospels*, illuminated manuscript by unknown artists, eighth century. Morgan Library, New York, New York.

- *Equestrian Portrait of a Carolingian Emperor* (probably Charles the Bald), sculpture by unknown artist, ninth century. Louvre, Paris, France.

- *Plan of an Ideal Monastery*, drawing by unknown artist, ninth century. Saint Gallen Library, Saint Gallen, Switzerland.

ART ERA	POPULAR STYLE	COMMON TYPES
Ottonian Tenth and Eleventh Centuries Germany	Reestablished Carolingian approach. Honored the classical style: balance, order, restraint, and columned architecture. Idealized, tall figures with oval heads. Narrative. Emphasis on court, church, and military connection. Influenced by emperors Otto I, II, and III. Also by Greco-Roman, Byzantine, and Carolingian art.	Churches and monasteries with interior decoration; elaborate gem and metalwork; frescoes; illuminated manuscripts; liturgical objects; reliquaries; sculpture; royal regalia.

NOTABLE EXAMPLES

- *Codex Egberti*, illuminated manuscript by unknown artists, tenth century. Municipal Library, Trier, Germany.

- *Otto-Mathilda Cross*, gem and metalwork by unknown artists, tenth century. Essen Cathedral Treasury, Essen, Germany.

- Doors of Bishop Bernward, relief sculptures by unknown artist, eleventh century. Saint Michael's Church, Hildesheim, Germany.

ART ERA	POPULAR STYLE	COMMON TYPES
Romanesque Eleventh and Twelfth Centuries France, Germany, Great Britain, Italy, Scandinavia, Spain, Portugal, Central Europe	Intricate manuscript, painting, and relief sculpture composition. Didactic and narrative. Figurative and representational. Classical balance, order, restraint, idealized figures, and columned architecture. Massive, plain architecture. Influenced by Greco-Roman art..	Massive, cruciform churches and monasteries with modest interior decoration. Frescoes; gem, ivory, and metalwork; illuminated manuscripts; liturgical objects and vestments; memorials; paintings; pilgrimage artifacts; reliquaries; relief sculpture; shrines; tapestries; tombs; royal regalia.

NOTABLE EXAMPLES

- *Battló Crucifix*, sculpture by unknown artist, twelfth century. National Museum of Catalonia, Barcelona, Spain.

- *Last Judgment Tympanum*, relief sculpture by Gislebertus, twelfth century. Autun Cathedral, Autun, France.

- *Reliquary of Saint Foy,* gem and metalwork by unknown artists, eleventh and twelfth centuries. Saint Foy Abbey Church Treasury, Conques, France.

Gothic Twelfth Through Fifteenth Centuries England, France, Germany, Italy, Spain, Other Western European Countries	Figurative, more animated poses. Narrative. Ornate decoration. Occupied with light. Representational. Typological. Detailed architecture and sculpture. Influenced by Abbot Suger, Saint-Denis, France.	Towering, elaborate cruciform churches and monasteries with interior decoration. Frescoes; gem and metalwork; illuminated manuscripts; liturgical objects and vestments; memorials; paintings; relief sculpture; pilgrimage artifacts; reliquaries; sculpture; shrines; stained glass; tapestries; textiles; tombs; royal regalia.

NOTABLE EXAMPLES

- *Reliquary Cross of Floreffe*, metalwork by unknown artist, thirteenth century. Louvre, Paris, France.

- *West Façade Rose Window*, stained-glass by unknown artists, thirteenth century. Notre Dame Cathedral, Paris, France.

- Back of the *Chichester-Constable Chasuble*, textile work and embroidery by unknown artist, fourteenth century. Metropolitan Museum of Art, New York, New York.

ART ERA	POPULAR STYLE	COMMON TYPES
Renaissance Fourteenth to Sixteenth Centuries Italy, Western Europe, Northern Europe	Contrasting light and shadow. Glorification of figures and nature. Perspective adding depth to images. Realism. Architectural emphases on classical columns, arches, and open pavilions. Influenced by Italian artists and architects.	Cruciform churches and monasteries with interior decoration. Frescoes; gem, and metalwork; illuminated manuscripts; liturgical objects and vestments; memorials; paintings; pilgrimage artifacts; relief sculpture; reliquaries; sculpture; shrines; stained glass; tapestries; textiles; tombs; royal regalia.

NOTABLE EXAMPLES

- *Moses*, sculpture by Michelangelo Buonarroti, fifteenth century. Saint Peter in Chains Church, Rome, Italy.

- *The Ghent Altarpiece*, painting by Huber van Eck, fifteenth century. Saint Bavo Cathedral, Ghent, Belgium.

- *The Last Supper*, painting by Leonardo da Vinci, fifteenth century. Holy Mary of Grace Church, Milan, Italy.

ART ERA	POPULAR STYLE	COMMON TYPES
Baroque Seventeenth Century Europe	Direct, dynamic movement. Emotional and energetic. Detailed and realistic. Return to spirituality and obvious interpretation. Simpler. Influenced by the Protestant Reformation and the Roman Catholic Church.	Cruciform churches and monasteries with interior decoration. Frescoes; gem and metalwork; illuminated manuscripts; liturgical objects and vestments; memorials; paintings; relief sculpture; reliquaries; sculpture; shrines; stained glass; tapestries; textiles; tombs; royal regalia.

NOTABLE EXAMPLES

- *Christ in the House of Mary and Martha*, painting by Jan Vermeer, seventeenth century. National Gallery of Scotland, Edinburgh, Scotland.

- *The Ecstasy of Saint Teresa*, sculpture by Giovanni Lorenzo Bernini, seventeenth century. Our Lady of Victory Church, Rome, Italy.

- *The Fall of Man*, painting by Peter Paul Rubens, seventeenth century. Prado Museum, Madrid, Spain.

4

The Art of Survival

Our knowledge of Early Christian art and its development is limited by
the small number of surviving monuments. Each work is therefore
all the more precious, as visible testimony from the period that laid
the basis of Christian art and contributed vitally to European culture.

—IRMGARD HUTTER

During 1522, townspeople stormed the parish church in Wittenberg, Germany,
to tear down, smash, and burn sculptures and paintings. As the unofficial leader
of the Reformation, Martin Luther felt compelled to respond, and besides, the
destruction dismayed him. He disagreed with the rioters' scriptural reasons for
destroying images and preached against their actions. The conflict between Luther
and the rioters stemmed from Christianity's ongoing, uncomfortable relationship
with images. Uncertainty and hostility focused on the question, "Should Christians
create sacred images?"

This isn't a question we wrestle with much today, but at crucial junctures
in history, it fractured the church. The image question and its resulting conflict
emerged from the Old Testament. The second commandment addressed the issue
of idolatry and creating images to worship. It said, "Thou shalt not make unto thee
any graven image, or any likeness of any thing that is in heaven above, or that is in
the earth beneath, or that is in the water under the earth" (Exod. 20:4 KJV). Given
this instruction, the Israelites didn't create sacred images.

About fifteen hundred years later, the new Christians—Jews descended from the
Israelite desert wanderers, living in the first-century Roman Empire—considered the
Old Testament their spiritual heritage. So did Gentiles who adopted the new religion.
They honored the second commandment, and the image question entered the Christian
culture. But what, exactly, defined a graven image? What constituted worshiping it?
These questions riddled Christianity from its inception through the Reformation, rising
and falling according to which cleric or ruler led the church in any given century.

Obviously, Christian art flourished for long stretches of time, with popes and
emperors as major patrons, and their subjects following suit. The richly symbolic

architecture of cathedrals and parish churches brimmed with icons, sculpture, paintings, tapestries, liturgical vessels, illuminated manuscripts, and other art that created a sensory and mystical worship experience. But at certain junctures in Christian history, the image question burst to the forefront of church life. Christians verbally and physically battled one another about whether they should create sacred art.

In eighth- and ninth-century Byzantium, Christians clashed about images, especially the creation and use of icons. The Byzantine Emperor Leo III started the conflict by removing an image of Jesus on the Chalke gate, the ceremonial entrance to the Great Palace of Constantinople in the Eastern Roman Empire. He replaced it with a cross. The opposition murdered some of the men assigned to this task. As a result, two iconoclasm periods ensued that, combined, banned icons for nearly a century. Byzantines who revolted against the ban faced severe punishments, even death.

Christians against sacred art believed images of deity and other religious figures encouraged idolatry. They stood in favor of iconoclasm, a word originating from the ancient Greek words *eikon* ("icon or image") and *klao* ("break or destroy"), which meant the deliberate destruction of images. History named them the iconoclasts. In turn, Christians who defended images reminded their challengers how God instructed Moses to erect a pole with a carved bronze snake attached to it. Israelites who suffered from poisonous snake bites looked at the image and lived. God himself had commissioned sculpture to heal his people. These Christians became the iconodules, from the Greek for "those who serve images."

During the sixteenth-century Reformation, some zealous reformers also promoted the destruction of Christian images. Frenzied Christians smashed, burned, or ripped apart altars, crucifixes, paintings, sculpture, shrines, stained glass, and other art dedicated to Christian deities, saints, and the Virgin Mary. They marauded through communities, terrifying Christians who valued these objects and demolishing treasured art collections. The destroyers considered sacred art an extension of a corrupt papal reign and culture.

Despite these iconoclastic episodes, sacred art still expanded, transitioned, and prevailed in sometimes hospitable, sometimes hostile, environments. It could be dubbed "the art of survival." Consider these reasons why Christian art, although not always beloved by all Christians, survived and thrived.

PATRON CHURCH When Christian art prospered, it intertwined with the church's image and rituals. The pope and other high religious leaders

commissioned art for ceremonial, decorative, liturgical, and personal use. For centuries the church functioned as Christian art's largest and most influential patron, commissioning some of the world's most memorable works. For example, in the sixteenth century Pope Julius II commissioned the painted ceiling in the Sistine Chapel at the Vatican in Vatican City, Italy. Still today, the Vatican and its museums shelter an astounding collection of sacred art. Art commissions also supported the worship and life of churches throughout Christianity. Even small parish churches needed altarpieces, liturgical vessels, relics, and sacred images to inspire and educate their congregations.

IMPERIAL ART With the powerful rise of Emperor Constantine in the fourth century, Christian images and symbols began appearing in the Roman Empire's imperial art. Constantine employed the *Chi-Rho*, a representation of Christ's cross formed by superimposing the first two Greek letters of the word "Christ," as a predominant sign of his reign. After Emperor Theodosius declared Christianity the official religion of the Roman Empire in the fifth century, these images and symbols graced the art and regalia of emperors, kings, tsars, and dynasties for over a thousand years. The Crown of the Holy Roman Empire, created in the late tenth century, played a key role in coronations for hundreds of years. Bearing enameled biblical scenes and a bejeweled gold cross, the crown now resides at the Hofburg Palace in Vienna, Austria, "until there is again a Holy Roman Emperor of the German Nation." Like church leaders, monarchs also commissioned great works of Christian art and architecture. Because Christian states preserved the art, regalia, and architecture of their monarchs, sacred images survived.

HIDDEN TREASURES Thanks to a few forward-thinking Christians, some sacred art survived because it lay hidden for long periods of time. When enemies threatened to destroy communities or Christian zealots smashed and burned images, the devoted concealed, buried, or smuggled sacred art and artifacts. During periods of iconoclasm some icons, illuminated manuscripts, and other sacred art "went underground" until the crisis passed. Also, with enough notice clerics buried liturgical objects before foreign invaders ravaged church treasuries and destroyed buildings. If these art rescuers couldn't retrieve their buried treasures, sometimes archaeologists dug them up centuries later.

For example, when sixth-century Byzantine authorities decided to melt down liturgical silver to pay wages to the emperor's army, clergy from a monastery,

probably named Holy Sion, buried its valuables. During the 1960s excavators discovered these magnificent liturgical objects and church furnishings in southern Turkey. The Sion Treasure represented Byzantine silverworks, but also a congregation's appreciation for the sacred and beautiful.

For unknown reasons, other Christian art remained forgotten for centuries, covered by the debris of civilizations and discovered intentionally or accidentally by later generations. The Christian catacombs in Rome, Italy, and the first house church in Dura-Europos, Syria, belong to this category.

G O D ' S S T O R Y After Scripture formed into a sacred canon, many Christians believed the Bible survived because God inspired its content. Likewise, did Christian art endure because it illustrated God's story? Until the Reformation, sacred art often functioned as the Bible in pictures, especially for the illiterate. In the seventh century Pope Gregory the Great explained, "What writing presents to readers, a picture presents to the unlearned who view it, since in the image even the ignorant see what they ought to follow; in the picture the illiterate read."

If Christian art ushered from God's eternal Word, why wouldn't it endure?

The Holy Trinity

*God the Father is a deep root, the Son is the shoot
that breaks forth into the world,
and the Spirit is that which spreads beauty and fragrance.*
—TERTULLIAN, THIRD CENTURY

5

God the Father

The secret of the most High God, who created all things,
cannot be attained by our own ability and perception.
—LACTANTIUS, FOURTH CENTURY

In the second century the church apologist Clement of Alexandria emphasized worshiping God instead of representing him through art. He believed pictures degraded the divine, and he didn't want Christians to fall into idolatry like pagan worshipers. In fact, Clement ridiculed images of gods and goddesses honored by Roman citizens. He called them idols manipulated by demons who mocked God.

The third-century Cyprian, bishop of Carthage, explained God's illusiveness to humans, which created difficulties portraying him in art. Cyprian wrote, "He cannot be seen—he is too bright for vision. He cannot be comprehended, for he is too pure for our discernment. He cannot be estimated, for he is too great for our perceptions. Therefore, we are only worthily estimating him when we say he is inconceivable."

However, through the centuries the church grew more comfortable with envisioning God, and artists more freely created images of him, but still not widely. This art reflected a combination of biblical and imagined portraits of the Father's interaction with his people. For example:

A G E D M A N God as a bearded old man eventually became a clichéd image because some revered artists painted him as aged with gray or white hair. The prophet Daniel referred to God as the "Ancient of Days" (Dan. 7:9, 13, 22). E X A M P L E : *Creation of Adam*, painting by Michelangelo Buonarroti, sixteenth century. Sistine Chapel, Vatican City, Italy. In a creative twist, Michelangelo painted this segment of his Sistine Chapel fresco with a gray-haired yet muscular God reaching out to Adam. The painter depicted a wise and proactive deity with windswept hair, concentrating on his creative task with determined urgency.

A N G E L To explain the Trinity, Byzantine and Orthodox artists drew from the Old Testament story of three strangers visiting Abraham (Gen. 18:1–8). Artists

illustrated the Father, Son, and Holy Spirit as angels. These Christians considered three angels a metaphor for the Trinity, not a true replica of the godhead. **EXAMPLE**: *Trinity*, painting by Andrei Rublev, fifteenth century. State Tretyakov Gallery, Moscow, Russia. For this icon, Rublev drew delicately colored angels to represent two groups: the three men who visited Abraham in the plains of Marme and the Holy Trinity. Scholars debated which angel represented the Father, but many concluded the central figure embodied God because of its placement in the painting and his regal turn of head.

CLASSICAL CLOTHING In this representation, an artist dressed God in classical Roman garb, with a tunic and a toga. First-century Romans wore this clothing during Christ's time on earth. **EXAMPLE**: *God Surprises Adam and Eve in the Garden*, mosaic by unknown artists, thirteenth century. The Baptistery, Florence, Italy. In a section of the cupola's mosaics, artists depicted a fully clothed God offering the naked Adam and Eve a glass of wine. They probably intended God's clothing to emphasize the couple's nudity.

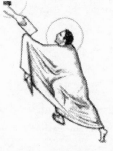

HAND(S) REACHING FROM HEAVEN Artists avoided illustrating the divine by showing God's hand(s) reaching from heaven, occupying only a small part of an entire picture. God sometimes revealed his hand(s) in images of Moses receiving the law (Exod. 24:12) and at the baptism of Jesus (Mt. 3:13–17). **EXAMPLE**: *Moses Receives the Law*, Paris Psalter, illuminated-manuscript page by unknown artist, tenth century. National Library of France, Paris, France. In this manuscript page, the artist featured a barely visible hand emerging from a dark, circular spot in the sky to give Moses a document.

■ God's hand, from *Moses Receives the Law,* Paris Psalter, tenth century.

HOVERING OVER THE WORLD
In these images God loomed larger than the world, a visual comment on his authority and relationship to humanity. **EXAMPLE**: *God the Father Measures the World*, Moralizing Bible (Bible Moralisée), illuminated-manuscript page by unknown artist, thirteenth century. Austrian National Library, Vienna, Austria. In a literal interpretation of God judging the world, this illuminator showed him bending down to measure the earth with a large compass.

(Commission)

A Soaring BALD Eagle

(Flying over the farm.)

1. They that wait upon the LORD shall renew their strength they shall mount up with wings like Eagles, They shall walk ans not grow weary, They shall run And not grow Faint." IS 40: 30-11

Pro 4:8 –
intimate Relationship w/ wisdom

He that honors

Will I me
honor

18 Samuel 2:30

Pro. 4:8
Cherish her, and she will exalt you
embrace her, and she will honor you.

SEATED IN HEAVEN For this representation, artists drew God sitting on a cloud or suspended in the sky, indicating his sovereignty over heaven and earth (Exod. 15:11; Deut. 33:26). **EXAMPLE:** *God the Father in Glory with Saint Mary Magdalene and Saint Catherine of Siena*, painting by Fra Bartolomeo, sixteenth century. Brera Art Gallery, Lucca, Italy. To emphasize God's glory and authority, Fra Bartolomeo painted him seated on a cloud, with his right hand raised in blessing and his left hand holding a book inscribed with the Greek letters *Alpha* and *Omega*, translated as "the beginning" and "the end." Although the artist honored Mary Magdalene and Catherine of Siena by placing them in the painting, he emphasized God's authority by standing the women on the ground with prayerful gestures.

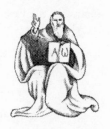

■ God seated in heaven, from *God the Father in Glory with Saint Mary Magdalene and Saint Catherine of Siena* painting by Fra Bartolomeo, sixteenth century.

6
Jesus Christ

It was because the Christian church believed the Christ
to be the Savior of all men that she used the universal
language of the sign and the symbol.

— GEORGE FERGUSON

How do you represent the unexplainable? Most likely, Christian artists pondered this question when creating images of Jesus. He proclaimed himself the God-man, unlike anyone who'd ever existed. The New Testament didn't describe Christ's features, and in the only Old Testament reference, Isaiah the prophet foretold, "He had no beauty or majesty to attract us to him, nothing in his appearance that we should desire him" (53:2).

Because Jesus breathed as God-in-the-flesh, images of him vastly outnumbered those of God or the Holy Spirit. The Lord visited earth in created skin, offering a visual concept that generations understood and communicated artistically. Paul the apostle explained, "For in Christ all the fullness of the Deity lives in bodily form" (Col. 2:9). In this physical manifestation, humanity witnessed the divine.

Many scholars think Jesus resembled most first-century Jews because Judas needed to identify the Teacher among some disciples before soldiers arrested him (Mt. 26:47–49). The Byzantines believed a sixth-century icon at Saint Catherine's Monastery near Mount Sinai, Egypt, replicated the Lord's appearance. Drawn from oral history, an iconographer painted the Sinai Christ with dark eyes and long hair, setting a prototype many artists emulated within their individual styles. However Jesus actually looked, the church developed a symbolic language to portray both his divine splendor and human traits. Through many centuries, the following attributes accompanied images of the adult Savior.

ARMS OUTSTRETCHED Even without a visible cross, when Christ stretched out his arms horizontally, this usually indicated the act of crucifixion, especially if two male figures flanked his sides with similar stances. Other times, the outstretched arms formed a welcoming gesture to the Lord's followers on earth or to heaven during his ascension. EXAMPLE: *Crucifixion*, relief sculpture

by unknown artist, fifth century. Doors of Saint Sabina Basilica, Rome, Italy. In one of the earliest surviving renderings of the Crucifixion, a sculptor carved a dominant Christ and two smaller thieves, all with outstretched arms. Instead of crosses, he stood the figures against an architectural shape resembling a basilica.

A U R E O L E Artists usually reserved the aureole—a symbol of divinity and supreme power—for the Father, Son, and Holy Spirit. However, sometimes they also presented the Virgin Mary or Christ and his mother in an aureole. The aureole encircled the body, sometimes with a fringe or rays of light, sometimes looking like pointed flames. Early Christian artists painted aureoles white, and Renaissance painters colored them gold to indicate light. Sometimes artists painted aureoles blue to represent heaven. **E X A M P L E :** *Transfiguration*, painting by Theophanes the Greek, fifteenth century. State Tretiakov Gallery, Moscow, Russia. To represent the sanctity and power of Christ's transfiguration, in this icon Theophanes painted the Lord in a light blue aureole with white flashes of lightning.

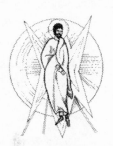

■ Aureole surrounding Jesus, from *Transfiguration* by Theophanes the Greek, fifteenth century.

B E A R D E D Jesus wearing a beard denoted his maturity and wisdom. However, the image of a bearded Jesus with long hair didn't standardize for several centuries. It appeared during sixth-century Byzantium and around the twelfth century in Western Christianity. Artists usually painted a bearded Christ when he appeared after the Resurrection. **E X A M P L E :** *Bust of Christ*, painting by unknown artist, fourth century. Catacomb of Commodilla, Rome, Italy. This funerary fresco of a bearded Christ probably initiated many artists portraying him with long hair and a full beard. First-century Romans usually didn't wear this style. Consequently, Christ's hairy demeanor identified him as a mature Jew.

B E A R D L E S S The earliest images of Jesus portrayed him as short-haired and clean-shaven, in the style of classical Roman portraits. A beardless Jesus indicated his youthfulness, or his precrucifixion persona. **E X A M P L E :** *Baptism of Christ*, painting by unknown artist, fourth century. Catacombs of Marcellinus and Peter, Rome, Italy. The fresco artist painted Jesus as a naked boy with cropped hair and a smooth face, with the Holy Spirit's rays of light cascading on him during baptism. The painter probably depicted youthfulness to emphasize Christ's "rite of passage" into ministry.

CARRYING A CROSS Early Christian artists established varied symbolism for Christ carrying his cross. The Lord hoisting a traditional Latin cross (upright post with a horizontal beam) referred to his crucifixion. When he shouldered a patriarchal cross (upright post with two horizontal beams), the image communicated his spiritual leadership or triumphant resurrection. EXAMPLE: *Anastasis*, mosaic by unknown artists, twelfth century. Holy Luke Church (Hosios Loukas), Phocis, Greece. These mosaicists designed a variation on Christ's triumphal *Anastasis* (Greek for "resurrection"). They depicted Christ carrying a patriarchal cross while standing on the ruins of hell, pulling Adam out of a sarcophagus (stone coffin).

CROWN OF THORNS In Scripture thorns often represented sin, and consequently Christ's crown recalled humanity's transgressions. In art a crown of thorns memorialized the suffering Jesus who wore this spiky headdress before his crucifixion (Mt. 27:29). EXAMPLE: *Christ Carrying the Cross*, painting by El Greco (Domenikos Theotokopoulos), sixteenth century. Metropolitan Museum of Art, New York, New York. Most images of Christ and his thorny crown emphasized pain and suffering. However, in this unusual painting El Greco filled the canvas with a gentle pathos, as though an upward-gazing Christ barely noticed the thorns on his head or the cross in his arms.

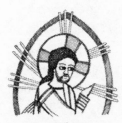

■ Christ with glory, from *Harrowing of Hell* mosaic, ninth century.

GLORY This symbolism combined a nimbus (halo) circling the head and an aureole surrounding the body. Artists reserved the glory for the most-exalted divinity: God the Father, Christ as Judge, and the Supreme Lord of Heaven. EXAMPLE: *Harrowing of Hell*, mosaic by unknown artists, ninth century. Saint Praxedes (Prassede) Basilica, Rome, Italy. In this version of Christ pulling Adam from hell, mosaicists honored Christ with a combination of sacred symbols: a nimbus circling his head, an aureole surrounding his body, and rays of light shooting from his head and torso.

HALO OR NIMBUS Early Christian artists developed a system for designating holiness. A golden circle, square, or triangle shone behind the head of the divine (God, Jesus, Holy Spirit) or a sacred person (saints, church doctors). A nimbus took many different forms, according to the person it highlighted. The

Virgin Mary wore a *circular nimbus*, sometimes elaborately decorated. A saint also wore a simple, circular nimbus. The *cruciform nimbus*, a cross within a circle, indicated Christ's redemptive role. Only he wore this nimbus. A *hexagonal nimbus* portrayed an allegorical figure. A *rayed nimbus* with three bursts of light circled the head of God, Jesus, or the Holy Spirit. A *square nimbus* indicated a living person. A *triangular nimbus* also appeared with a member of the Trinity, or sometimes as two interlaced triangles or a hexagon. **EXAMPLE:** *Baptism of Christ*, painting by Andrea Verrocchio and Leonardo da Vinci, fifteenth century. Uffizi Gallery, Florence, Italy. In this painting, the artists crowned Jesus, John the Baptist, and two angels with circular nimbuses. As an apprentice to Verrocchio, Da Vinci painted one angel holding Christ's robe. This caused a stir because Leonardo's work outshone his master and allegedly discouraged Verrocchio from painting.

COMMON NIMBUS SHAPES

Through the centuries, artists incorporated many nimbus or halo shapes into Christian art, but these rank among the most common.

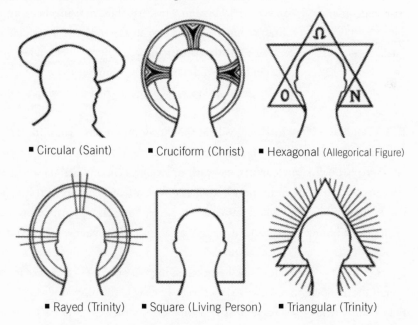

- Circular (Saint) - Cruciform (Christ) - Hexagonal (Allegorical Figure)

- Rayed (Trinity) - Square (Living Person) - Triangular (Trinity)

HOLDING A BOOK Beginning with early Christian art, when Jesus held a book, it symbolized Scripture or the Gospels. This image also referenced his role as the pre-existing Word (Jn. 1:1). **EXAMPLE**: *Sinai Christ*, painting by unknown artist, sixth century. Saint Catherine's Monastery, Mount Sinai, Egypt. One of the earliest icons of Christ, this work emphasized Christ as the *Pantokrator* (Greek for "powerful ruler") and the Word. The painter depicted Christ blessing the viewer with his right hand (as a ruler) and holding a bejeweled Gospels book in his left arm (as the Word). This pose served as a prototype for images of the Savior throughout Christian art, including today.

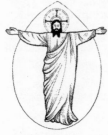

■ Christ in mandorla, from *Transfiguration* painting by Fra Angelico, fifteenth century.

MANDORLA OR ALMOND Italians named this aureole the "mandorla" because it looked like an almond. The mandorla enclosed a sacred person in an almond-shaped frame, around the entire body. Artists usually reserved the mandorla for Christ, but sometimes the Virgin Mary also sat or stood in this shape. **EXAMPLE**: *Transfiguration*, painting by Fra Angelico, fifteenth century. Saint Mark's Museum, Florence, Italy. Fra Angelico painted Christ's white mandorla into an almond shape that filled the composition. The painter allowed Christ's outstretched arms to extend beyond the fresco's mandorla, perhaps to indicate the glorified Lord still reaching out to humanity.

RAISED HAND When the Lord raised his hand in art, he bestowed a blessing or traced a sign of the cross. **EXAMPLE**: *Creation Tapestry*, embroidery by unknown artists, eleventh or twelfth century. Girona Cathedral Treasury, Girona, Spain. Embroidery artists wove a Christ image with his right hand raised in blessing, seated in the center of creation scenes. This arrangement distinguished him as the ultimate focus of creation and the benevolent Savior.

SEATED CHILD Jesus sat on his mother's lap or rested in her arms as a reminder of his virgin birth and Mary's crucial role in his life. Especially before the Reformation, Christians revered Mary as the holy mother. **EXAMPLE**: *Sistine Madonna*, painting by Raphael (Raffael Sanzio de Urbino), sixteenth century. Old Masters Picture Gallery, Dresden, Germany. Raphael painted Mary standing on billowing clouds, with Jesus clasped in her arms. The artist also framed them with

pulled-back curtains, appointing the mother and child the main characters in a heavenly drama.

SEATED ON OR HOLDING AN ORB In nations led by royals, an orb or an orb with a cross often belonged to the regalia of kings. An orb represented the earth. As a result, Christ seated on or holding a globe-like orb glorified him as enthroned in heaven and ruling over the world. This image indicated Christ's post-Ascension appearances. EXAMPLE: *Christ, Angels, Saint Vitalis, and Bishop Ecclesius*, mosaic by unknown artists, sixth century. Saint (San) Vitale Basilica, Ravenna, Italy. In this mosaic variation, the artist seated a young Jesus without a beard on a bluish orb, awarding a crown of martyrdom to Saint Vitalis, the church's namesake. In contrast, most artists created Christ-with-an-orb as a mature ruler with a beard.

WEARING PURPLE The color of ancient kings, purple denoted Christ's spiritual kingship, especially after his resurrection. At the Crucifixion, soldiers wrapped Jesus in a purple robe to mock his claim as King of the Jews (Jn. 19:2). EXAMPLE: *The Crucifixion and Iconoclasts Whitewashing an Icon of Christ*, Khuldov (Chuldov) Psalter, illuminated-manuscript page by unknown artist, ninth century. State Historical Museum, Moscow, Russia. The creator of this famous Byzantine painting garbed Jesus in a purple robe to emphasize his spiritual kingship. In some early illuminated manuscripts, Byzantine artists painted Jesus fully clothed on the cross.

WEARING WHITE Early on, Christian artists set the precedent for Christ wearing white after the Resurrection and particularly during the Ascension. The color symbolized his purity and holiness. EXAMPLE: *The Ascension*, Rabbula Gospels, illuminated-manuscript page by unknown artist, sixth century. Laurentian Library, Florence, Italy. In this unusual depiction of the Ascension, the illuminator placed Christ in an almond-shaped mandorla above his disciples, wearing white and lifting his right arm in a blessing. The artist also rested the Lord's right foot outside the mandorla, as if he needed to take the last step into heaven.

WOUNDED When Christ displayed his wounds, this reminded Christians of his sacrifice for humanity's sins. Some images displayed the five wounds of Christ as a reminder of his suffering: two hands, two feet, and one side. EXAMPLE:

THE UNCONVENTIONAL JESUS

Today when we envision Jesus, a standardized image meets the mind. He's a mid-life man clothed in a robe. However, even hundreds of years ago, some artists stepped beyond the expected "norm" when they portrayed Christ. Consider these examples:

■ *Young Christ* sculpture, fourth century.

Young Christ by an unknown early Christian artist. Art experts first identified this fourth-century statuette of a young, fleshy Christ with long curls as a pagan poetess. National Museum of Rome, Rome, Italy.

Christ and the Theotokos and Child with Saints and Angels by an unknown Byzantine artist. An ivory relief-sculpture diptych from the sixth century portrayed Christ as grandfatherly. A ragged hair and beard, wrinkled eyes and flesh, made the Savior look worn and weary. However, the most unusual feature imagined the Lord's pot belly. Positioned in the center of the left panel, his stomach protruded from his garment, suggesting a belly button. Berlin State Museum, Berlin, Germany.

■ Grandfatherly Christ, from *Christ and The Theotokos and Child with Saints and Angels* relief sculpture, sixth century.

The Arrest of Christ in the Book of Kells by an unknown Celtic artist. To represent Christ, the artist for this ninth-century Gospels illuminated manuscript emulated Celtic characteristics. He painted Jesus sporting a red-orange beard and hair; curls framing his large, worried eyes; and his arms and legs bowed outward, as if his compact body could lose its balance. Trinity College Library, Dublin, Ireland.

Pietà (Vesperbild) by an unknown German artist. In this wood sculpture from fourteenth-century Germany, the artist abandoned beauty and idealism for a raw, unsettling naturalism. He created an exhausted, despairing Mary mustering up just enough energy to hold her son's dead body. The rugged sculpture also brutally exposed how Christ's neck no longer supported itself. Archaeological Museum, Bonn, Germany.

■ Christ, from *The Arrest of Christ,* Book of Kells, ninth century.

The Last Judgment by Michelangelo Buonarroti. In the sixteenth century, when Michelangelo unveiled his fresco of *The Last Judgment* behind the Sistine Chapel's altar, he scandalized the papacy. In the center, a lighted Christ looked young, muscular, beardless, and not seated as described in Scripture. Only a swath of cloth covered his mid-section. This powerful Christ contradicted the conventional images the pope expected. Sistine Chapel, Vatican City, Italy.

Five Wounds of Christ, stained-glass window by unknown artists, fifteenth century. Great Malvern Priory, Worcestershire, England. Traditionally, artists illustrated Christ showing his five wounds, but some later images reduced them to an emblem. At the Malvern Priory, artists pieced together a stained-glass emblem with Christ's two hands at the top, his feet at the bottom, and a heart in the middle to represent his side.

7

Stories About Jesus

At times we see simple and unlearned people . . . touched by a picture
of the Passion of our Lord or other miracles, that they witness by tears . . .
the outward representations [of what has been] engraved
on their hearts like letters.

—WALAFRID STRABO, NINTH CENTURY

Toward the end of the fourth century, the monk Paulinus built a church in Nola, Italy, to honor Saint Felix. In an unusual move, he commissioned artists to paint colorful images of Jesus, saints, and biblical narratives on the building's exterior. The monk defended his decision as a means to direct simple folk away from pagan idols, enticing them to enter the church. As people stepped inside, the art "nurtured their . . . minds with representations by no means empty." In particular, the images of Jesus drew them to his divinity, character, and teachings.

As the central figure of Christianity, Jesus dominated Christian art from the beginning. Artists created portraits of the Lord and events from his life, in many mediums, in many styles. However, some images proved more popular than others, depending on the era and culture. In the Early Middle Ages, the Roman Emperor Theodosius declared Christianity the official state religion, and Christian images emphasized the Lord's kingship and rulership. Relief sculptures on Romanesque church tympanums focused on Christ in the afterlife, in sync with the belief he would return at the approaching millennium. Gothic artists produced many images of Jesus and Mary, a reflection of that era's Marian cult.

Artistic styles also varied. Byzantine artists copied the same figures and stories repeatedly, without altering features. Western artists changed the scenery, created varied perspectives, altered the traditional style, or garbed figures in the clothing of their era rather than from the first century. But whatever the emphasis, whatever the style, the Lord's role remained the same. For Christians, he was the Messiah, the Savior, the Deliverer of sinful humanity.

The following biblical-narrative images appeared most frequently through the centuries, with an emphasis on the Passion Week. They're listed, as best we know, in the order of occurrence.

GENEALOGY OF JESUS Mt. 1:1–16; Lk. 3:23–38. Gospel writers traced Jesus's ancestry to prove he fulfilled the prophecy that "a shoot will come up from the stump of Jesse" (Isa. 11:1). Artists frequently and elaborately portrayed this genealogy as a tree. EXAMPLE: *Tree of Jesse*, illuminated-manuscript page by Master of James IV of Scotland, sixteenth century. Getty Museum, Los Angeles, California. The master illuminator literally interpreted Isaiah's prophecy. At the bottom of the page, he painted a stump growing out of Jesse's chest, with Old Testament kings sitting on tree branches, looking up toward the Christ child seated on Mary's lap.

THE NATIVITY Lk. 2:1–7. Artists celebrated the birth of Jesus by usually showing him in a manger, adored by his parents. As a star shone overhead, often barn animals, sheep, and shepherds worshiped below it. A huge star in the night sky represented the Star of Bethlehem that guided shepherds and Magi. EXAMPLE: *The Nativity with Donors and Saints Jerome and Leonard*, painting by Gerard David, fifteenth century. Metropolitan Museum of Art, New York, New York. David focused on the Nativity with hovering angels and a sheath of grain near the manger, suggesting Christ as "the bread that came down from heaven" (Jn. 6:41). Netherlandish painters typically included grain in nativity scenes.

ADORATION OF THE SHEPHERDS Lk. 2:8–20. After hearing a startling announcement from a host of angels, shepherds found the newborn Jesus and worshiped him. EXAMPLE: *Adoration of the Shepherds*, painting by Giorgione (Giorgio Barbarelli da Castelfranco), sixteenth century. National Gallery of Art, Washington, DC. Usually the shepherds looked more prominent in an adoration image than in a scene called the Nativity, as evidenced in Giorgione's painting. He placed two shepherds in the foreground with the holy family farther back, in the entrance of a cave.

PRESENTATION IN THE TEMPLE Lk. 2:21–40. When Joseph and Mary presented the baby Jesus at the Temple for naming and circumcision, their child stirred the hearts of two elderly worshipers. A devout man named Simeon held the child and praised God for "a light for revelation to the Gentiles and for glory to your people Israel" (2:32 NIV 1984). The prophetess Anna "gave thanks to God and spoke about the child to all who were looking forward to the redemption of Jerusalem" (2:38 NIV 1984). EXAMPLE: *The Presentation in*

the Temple, painting by Ambrogio Lorenzetti, fourteenth century. Uffizi Gallery, Florence, Italy. Lorenzetti created a regal presentation for a future king, highlighting the temple's magnificent structure and painting figures in bright, royal colors.

ADORATION OF THE MAGI Mt. 2:1–12. Three Magi from the East spotted a star and journeyed to greet the new King of the Jews. Reaching Jerusalem in Israel, the foreigners asked the ruling king over the Jews, Herod the Great, about the child's location. Finding the holy family, the Magi presented gold, incense, and myrrh to Jesus. (These gifts became Christian symbols for the Magi.) Warned by a dream not to return to Herod, the men traveled home by another route. EXAMPLE: *Adoration of the Magi*, painting by Sandro Botticelli, fifteenth century. Uffizi Gallery, Florence, Italy. Botticelli painted one of the Magi emerging from a crowd of people dressed as fifteenth-century Florentines. The artist played down the wealthy visitors' importance as compared to the lowly, holy family seated on crumbling steps above the group.

FLIGHT INTO EGYPT Mt. 2:13–15. In a dream, God warned Joseph to escape with his family to Egypt because Herod plotted to kill Jesus, for fear the child would usurp the ruler's authority. EXAMPLE: *Rest on the Flight into Egypt*, painting by Federico Barocci, sixteenth century. Vatican Museums, Vatican City, Italy. Defusing the pressure of escaping Herod, Barocci painted Joseph, Mary, and Jesus enjoying a picnic setting on the journey to Egypt.

MASSACRE OF THE INNOCENTS Mt. 2:16–18. "When Herod realized that he had been outwitted by the Magi, he was furious, and he gave orders to kill all the boys in Bethlehem and its vicinity who were two years old and under, in accordance with the time he had learned from the Magi" (2:16). But Jesus and his family had already escaped to Egypt and settled there until Herod died. EXAMPLE: *Massacre of the Innocents*, painting by Peter Paul Rubens, seventeenth century. Art Gallery of Ontario, Toronto, Ontario, Canada. Rubens painted a jumbled pile of dead and writhing bodies, demonstrating how Jewish mothers tried defending their children against Herod's murderous soldiers.

RETURN FROM EGYPT Mt. 2:19–23. After Herod the Great's death, an angel instructed Joseph to pack up his family and leave Egypt. They settled in Nazareth in the district of Galilee. "So was fulfilled what was said through the

prophets, that he would be called a Nazarene" (2:23). **EXAMPLE**: *The Return from Egypt*, Saint Albans Psalter, illuminated-manuscript page by Geoffrey de Gorham, twelfth century. Saint Godehard's Church, Hildesheim, Germany. For this English manuscript, Gorham painted slender figures entering Nazareth quietly, without notice. The artist matched the simplicity of the composition with his clean, subdued style.

YOUNG JESUS WITH SCHOLARS Lk. 2:41–52. On the way home from an annual Passover visit to Jerusalem, Mary and Joseph searched for their missing twelve-year-old son. After three days they found Jesus in the temple courts, conversing with teachers. Mary asked Jesus, "Son, why have you treated us like this?" (2:48). He replied, "Didn't you know I had to be in my Father's house?" (2:49). **EXAMPLE**: *Christ Discovered in the Temple*, painting by Simone Martini, fourteenth century. Walker Art Gallery, Liverpool, England. Martini painted a frustrated holy family: a frowning Jesus with his arms crossed; a stern Joseph with an arm pointing toward his wife; and an imploring Mary with one hand lifted, as if asking her son a question.

BAPTISM OF JESUS Mt. 3:13–17; Mk. 1:9–11; Lk. 3:21–22. Jesus traveled from Galilee to the Jordan River so his cousin John could baptize him. "As soon as Jesus was baptized, he went up out of the water. At that moment heaven was opened, and he saw the Spirit of God descending like a dove and lighting on him. And a voice from heaven said, 'This is my Son, whom I love; with him I am well pleased'" (Mt. 3:16–17). The dove served as a symbol for the Holy Spirit in the earliest Christian art and worship. **EXAMPLE**: *The Baptism with Apostles*, mosaic by unknown artists, fifth century. Orthodox Baptistery, Ravenna, Italy. Looking up, believers baptized in the Orthodox Baptistery saw a mosaic of Christ's baptism in the building's dome. Church officials commissioned the dove, Christ's head, and John the Baptist's head as eighteenth-century restorations.

THE TEMPTATION Mt. 4:1–11; Mk. 1:12–13; Lk. 4:1–13. After Jesus fasted for forty days and nights in the desert, the devil tempted him with food, a miracle, and power. Jesus rebuked the devil with Scripture, and the tempter left. **EXAMPLE**: *The Temptation of Christ*, painting by Juan de Flandes, fifteenth century. National Gallery of Art, Washington, DC. Flandes donned a menacing Satan with horns and bread in his hands, tempting a serene Jesus.

CALLING THE DISCIPLES Jn.1:35–51.Jesusaskedtwelve men to follow him and participate in his ministry. Images depicted Jesus calling one man or a few at a time. The disciples were Andrew, Bartholomew, James the son of Alphaeus, James the son of Zebedee, John, Judas Iscariot, Matthew, Philip, Simon Peter, Simon the Zealot, Thaddaeus, and Thomas. **EXAMPLE:** *The Calling of the Apostles Peter and Andrew*, painting by Duccio (Duccio di Buoninsegna), fourteenth century. National Gallery of Art, Washington, DC. Duccio focused on three figures against a simple waterfront background, emphasizing Christ's call to Peter and Andrew.

MIRACLES *See* chapter 8, "Miracles of Jesus."

SERMON ON THE MOUNT Mt. 5:1–12. From a mountainside, Jesus taught the Beatitudes to a large crowd and his disciples. These admonitions contrasted the values of God's kingdom with the world's values. The nine statements began with "Blessed are," and later Christians considered them a code to live by. For example, "Blessed are the merciful, for they will be shown mercy" (5:7). **EXAMPLE:** *The Sermon on the Mount*, painting by Cosimo Rosselli and Piero di Cosimo, fifteenth century. Sistine Chapel, Vatican City, Italy. In scenes from Christ's life, the painters designed a crowded composition with two stories merging into each other: the Sermon on the Mount and healing the leper.

WOMAN OF SAMARIA Jn. 4:1–29. While visiting the town Sychar in Samaria, Jesus asked a Samaritan woman for a drink of water from a well. This surprised the woman because Jews and Samaritans didn't mingle. A conversation ensued. Jesus spoke about living water, the woman's past, and his messianic role. Leaving her water jar, the woman returned to town, spreading news about the remarkable man she'd met. **EXAMPLE:** *Jesus with the Samaritan Woman by the Well*, painting by unknown artist, fourth century. Catacomb on the Latin Road (Via Latina), Rome, Italy. In a lunette (arch) fresco the artist stiffly painted a clean-shaven Jesus and a young woman on each side of a cauldron-shaped well. In contrast to other images about this story, the painter depicted Jesus touching the well, ready to offer the woman both physical and spiritual water.

WOMAN TAKEN IN ADULTERY Jn. 7:53–8:11. In the Temple courts teachers of the law and some Pharisees brought an adulterous woman

to Jesus. "Now what do you say?" they asked, trying to find a way to accuse him (John 8:5). Jesus didn't speak, but instead bent down and wrote on the ground with his finger. When the men kept questioning Jesus, he answered, "Let any one of you who is without sin be the first to throw a stone at her" (8:7). One by one, the men left. Jesus told the woman, "Go now and leave your life of sin" (8:11). EXAMPLE: *Christ and the Woman Taken in Adultery*, painting by Nicolas Poussin, seventeenth century. Louvre, Paris, France. Poussin caught the action after Christ wrote on the ground, with accusers pointing to one another while walking away from him.

JESUS AND THE CHILDREN Mt. 19:13–15; Mk. 10:13–16; Lk. 18:15–17. When fathers and mothers brought their children to Jesus for a blessing, disciples rebuked the parents. Jesus replied with the famous words, "Let the little children come to me, and do not hinder them, for the kingdom of heaven belongs to such as these" (Mt. 19:14). Jesus placed his hands on the children and blessed them (Mk. 10:16). EXAMPLE: *Blessing the Children*, painting by Lucas Cranach the Elder, sixteenth century. Metropolitan Museum of Art, New York, New York. Cranach placed Jesus, cuddling and kissing a baby, in a crowded group of women, children, and disciples. At the top of the canvas, the artist also inscribed Mark 10:14: "Suffer the little children to come unto me, and forbid them not: for of such is the kingdom of God."

PARABLE OF THE GOOD SAMARITAN Lk. 10:25–37. Jesus told a story about the Good Samaritan to an expert in the law. He began, "A man was going down from Jerusalem to Jericho, when he was attacked by robbers. They stripped him of his clothes, beat him and went away, leaving him half dead" (10:30). A priest and later a Levite encountered the man, but crossed to the road's other side. When a Samaritan passed by, he bandaged the man's wounds and took him to an inn for care, paying the expenses. Jesus told the law expert to practice neighborliness and "Go and do likewise" (10:37). EXAMPLE: *The Good Samaritan*, painting by Jacopo Bassano, sixteenth century. National Gallery, London, England. Bassano painted pain into the Good Samaritan's struggle to lift the beaten stranger and pour oil on his wounds.

PARABLE OF THE PRODIGAL SON Lk. 15:11–32. Jesus told a parable about God's love for his wayward children. The younger of two sons asked their father for his inheritance and then "squandered his wealth

in wild living" (15:13). When the prodigal son "came to his senses" (15:17), he returned to his father and begged for forgiveness. The father warmly accepted his son and celebrated the return by slaying a fattened calf. The older brother, a faithful worker for years, complained that his father never honored him with a party. The father replied, "'You are always with me, and everything I have is yours. But we had to celebrate and be glad because this brother of yours was dead and is alive again; he was lost and is found'" (15:31–32). EXAMPLE: *Return of the Prodigal Son*, painting by Rembrandt van Rijn, seventeenth century. State Hermitage Museum, Saint Petersburg, Russia. Through a bent old man and his kneeling son, Rembrandt mastered complex emotions in this painting: belated regret, unconditional love, true repentance, and lavish forgiveness.

THE TRANSFIGURATION Mt. 17:1–9; Mk. 9:2–9; Lk. 9:28–36. "Jesus took with him Peter, James, and John the brother of James, and led them up a high mountain by themselves. There he was transfigured before them. His face shone like the sun, and his clothes became as white as the light. Just then there appeared before them Moses and Elijah, talking with Jesus" (Mt. 17:1–3). EXAMPLE: *The Transfiguration*, mosaic by unknown artists, sixth century. Saint Catherine's Monastery, Mount Sinai, Egypt. When planning a church for Saint Catherine's Monastery, designers deemed the Transfiguration a suitable apse image for a building nestled at the foot of Mount Sinai, where Moses met God in a burning bush.

ENTERING JERUSALEM Mt. 21:1–11; Mk. 11:1–11; Jn. 12:12–19. Not long before the Lord's death, he rode into Jerusalem on a donkey and the crowds cheered him with "Hosanna to the Son of David!" (Mt. 21:9). They hailed him as "Jesus, the prophet from Nazareth in Galilee" (21:11). EXAMPLE: *Entry of Christ into Jerusalem*, painting by Pietro Lorenzetti, fourteenth century. Saint Francis of Assisi Basilica, Assisi, Italy. For this unusual fresco, Lorenzetti painted bright colors and set Jesus and his lauding crowd against an architectural background of the city.

CLEANSING THE TEMPLE Mt. 21:12–13; Mk. 11:15–17; Lk. 19:45–48. In Jerusalem "Jesus entered the temple courts and drove out all who were buying and selling there. He overturned the tables of the money changers and the benches of those selling doves. 'It is written,' he said to them, '"My house

will be called a house of prayer," but you are making it a "den of robbers"'" (Mt. 21:12–13). **EXAMPLE**: *Christ Driving the Money Changers from the Temple*, painting by Rembrandt van Rijn, seventeenth century. Pushkin State Museum of Fine Arts, Moscow, Russia. Rembrandt painted a few versions of the event, but this up-close image most poignantly captured Christ's determination, along with the money changers' surprise and dismay.

WASHING THE DISCIPLES' FEET Jn. 13:1–20. At a meal before the Passover feast, Jesus washed his disciples' feet. When the apostle Peter protested, Jesus answered, "Unless I wash you, you have no part with me" (Jn. 13:8). Peter then asked the Master to wash his hands and head, too. Later Jesus explained, "I have set you an example that you should do as I have done for you. Very truly I tell you, no servant is greater than his master, nor is a messenger greater than the one who sent him. Now that you know these things, you will be blessed if you do them" (13:15–17). **EXAMPLE**: *Christ Washing the Feet of His Disciples*, painting by Tintoretto (Jacopo Comin), sixteenth century. Prado Museum, Madrid, Spain. Tintoretto created at least six versions of Christ washing the disciples' feet, but in this whimsical painting, he featured disciples pulling off sandals and stockings.

THE LAST SUPPER Mt. 26:20–30; Mk. 14:17–26; Lk. 22:14–30; Jn. 13:21–30. At the Last Supper Jesus said one of the twelve disciples would betray him. Then he served bread and wine to them. The bread represented his soon-to-be broken body, and the wine his spilled blood on the cross. Early Christians patterned the Eucharist (Communion) service after the Lord's words and actions at this meal. **EXAMPLE**: *The Last Supper*, stained-glass window by unknown artists, twelfth century. Chartres Cathedral, Chartres, France. For one of only four Chartres windows dated before 1120, the designer crammed several disciples around Jesus with John uncomfortably leaning on the Lord's chest.

AGONY IN THE GARDEN Mt. 26:36–46; Mk. 14:32–42; Lk. 22:39–46. Jesus walked to the Garden of Gethsemane with his disciples and told them, "Sit here while I go over there and pray" (Mt. 26:36). Taking Peter, James, and John along, the Lord grew troubled and asked the three disciples to "keep watch" with him (26:38). Jesus agonized in prayer, asking God the Father to take away the cup of suffering. He then added, "Yet not as I will, but as you will" (26:39). Three

times Jesus returned to the disciples and found them sleeping. The last time Jesus roused the sleeping men, he warned, "Rise! Let us go! Here comes my betrayer!" (26:46). **EXAMPLE**: *Agony in the Garden*, painting by Andrea Mantegna, fifteenth century. National Gallery, London, England. Painting beyond Scripture's description, Mantegna added six putti (small angels) standing on a cloud, watching Jesus earnestly pray toward heaven.

BETRAYAL BY JUDAS Mt. 26:47–56; Mk. 14:43–52; Lk. 22:47–53; Jn. 18:1–11. When Judas and a crowd with swords and clubs arrived at the Garden of Gethsemane, the disciple greeted Jesus and kissed him. Jesus replied, "Do what you came for, friend" (Mt. 26:50). Then the officials arrested Jesus. Angry, the disciple Peter pulled out his sword and lopped off an ear of the high priest's servant. Jesus healed the servant's ear and asked Peter, "Do you think I cannot call on my Father, and he will at once put at my disposal more than twelve legions of angels? But how then would the Scriptures be fulfilled that say it must happen in this way?" (26:53–54). Then the disciples deserted Jesus. Later Judas committed suicide. **EXAMPLE**: *Suicide of Judas*, relief sculpture by Gislebertus, twelfth century. Saint Lazarus (Lazare) Cathedral, Autun, France. Gislebertus sculpted the church's tympanum above the main portal, and also interior historiated capitals (decorated tops of columns) with scenes from Scripture and Romanesque Christianity. For one capital, the sculptor created ghastly demons pulling on the rope that killed the hanging Judas.

JESUS BEFORE CAIAPHAS Mt. 26:57–68; Mk. 14:53–65. After Jesus's arrest, he stood before Caiaphas, the high priest. When Jesus affirmed his identity as "the Messiah, the Son of God" (Mt. 26:63–64), the high priest charged him with blasphemy. The high priest asked the assembled elders and the teachers of the law, "Look, now you have heard the blasphemy. What do you think?" (26:65–66). They declared Jesus worthy of death. **EXAMPLE**: *Christ Before Caiaphas*, painting by Giotto di Bondone, fourteenth century. Scrovegni Chapel, Padua, Italy. For this fresco, Giotto painted Jesus looking away from Caiaphas, who tore open his robe because of the "blasphemy."

PETER DENIES CHRIST Mt. 26:69–75; Mk. 14:66–72; Lk. 22:54–65; Jn. 18:25–27. The disciple Peter sat outside the courtyard of the high priest while Caiaphas challenged Jesus and declared him blasphemous. Bystanders

asked Peter if he knew Jesus, and the disciple denied the Lord three times. "Immediately a rooster crowed. Then Peter remembered the word Jesus had spoken: 'Before the rooster crows, you will disown me three times.' And he went outside and wept bitterly" (Mt. 26:74–75). **E X A M P L E :** *Christ Before Annas and Peter's Denial*, painting by Duccio di Buoninsegna, fourteenth century. Siena Cathedral, Siena, Italy. Duccio's scene pushed a questioning girl aside and featured a protesting Peter already wearing a saintly halo and seated among a group of solemn men.

C H R I S T B E F O R E P I L A T E Mt. 27:11–26; Mk. 15:15; Lk. 23:1–5; Jn. 18:28–37. According to custom, the governor of Judaea released one prisoner during Passover. After a mostly silent Jesus stood trial before the governor Pontius Pilate, the ruler asked the accusing crowd, "Which of the two do you want me to release to you?" (Mt. 27:21). He offered them Jesus or Barabbas. The crowd cried, "Barabbas!" This sealed Jesus's fate, even though Pilate considered him innocent. Pilate ordered Jesus's crucifixion. **E X A M P L E :** *Christ Before Pilate*, painting by Tintoretto (Jacopo Comin), sixteenth century. Academy Gallery, Venice, Italy. Tintoretto focused on Christ's humility and Pilate's shame. He painted Christ embracing his white robe, casting his eyes down, and standing on steps before Pilate, who won't acknowledge him.

T H E F L A G E L L A T I O N Mk. 14:65; Jn. 19:1. "Pilate took Jesus and had him flogged" (Jn. 19:1). Flogging usually preceded a crucifixion, except for mass killings. The flogger swung a flagrum (whip) with a short handle and long, thick thongs weighted with lead balls or mutton bones. The flagrum cut deep contusions in the skin and caused hemorrhaging. **E X A M P L E :** *Christ at the Column*, painting by Donato Bramante, fifteenth century. Brera Art Gallery, Milan, Italy. In this flagellation image, Bramante avoided depicting brutality and highlighted Christ's lean torso, tense stance, and pained expression before the flogging began.

M O C K I N G C H R I S T Mt. 27:27–31; Mk. 15:16–20; Jn. 19:2–3. After Christ's flogging, the "soldiers twisted together a crown of thorns and put it on his head. They clothed him in a purple robe and went up to him again and again, saying, 'Hail, king of the Jews!' And they struck him in the face" (Jn. 19:2–3 NIV 1984). **E X A M P L E :** *The Mocking of Christ*, painting by Matthias Grünewald, sixteenth century. Old Masters Picture Gallery, Munich, Germany. Grünewald fully

clothed a red-haired, blindfolded Christ, with his mockers dressed in contemporary clothing for sixteenth-century Germans.

ROAD TO CALVARY Mt. 27:32–34; Mk. 15:21–24; Lk. 23:26–31; Jn. 19:17. As Jesus dragged his cross up the hill to Golgotha, the place of his crucifixion, he stumbled and couldn't walk farther. Soldiers forced Simon of Cyrene, a passerby who'd just strolled in from the country, to shoulder the cross for Jesus. EXAMPLE: *Christ on the Way to Calvary*, painting by Giovanni di Paolo, fifteenth century. Philadelphia Museum of Art, Philadelphia, Pennsylvania. On an altarpiece panel, Paolo illustrated a passage from The Meditations of Christ, a thirteenth-century devotional manuscript that described Christ turning to Mary as he carried the cross outside Jerusalem's gate.

THE CRUCIFIXION Mt. 27:35–56; Mk. 15:25–41; Lk. 23:32–49; Jn. 19:18–37. In the third hour soldiers nailed Jesus to the cross, posting a titulus (sign or inscription) above his head that read, "The King of the Jews." They also crucified two robbers, one on each side of Jesus. The chief priests, teachers, and soldiers mocked and insulted Jesus, saying, "He saved others . . . but he can't save himself!" (Mk. 15:31–32). In the ninth hour Jesus cried out, "My God, my God, why have you forsaken me?" (15:34). Not long after, he "breathed his last" (15:37). EXAMPLE: *Fieschi Morgan Reliquary*, metalwork by unknown artist, ninth century. Metropolitan Museum of Art, New York, New York. Reportedly, Pope Innocent IV owned this elegant reliquary to store a sliver of Christ's cross. On the sliding lid, the metalworker fashioned a crucifixion scene surrounded by saints in cloisonné enamel, gold, niello, silver, and silver-gilt.

THE DEPOSITION OR DESCENT FROM THE CROSS Mt. 27:57–61; Mk. 15:42–47; Lk. 23:50–54; Jn. 19:38. Joseph of Arimathea, a Sanhedrin member, asked Pilate for Jesus' body and, accompanied by the Pharisee Nicodemus, took his friend down from the cross. EXAMPLE: *Descent from the Cross*, relief sculpture by Benedetto Antelami, twelfth century. Parma Cathedral, Parma, Italy. Antelami disregarded the lonely act of taking Christ down from his cross and fused three scenes into one frame: mourners at the cross (left); the descent from the cross (center); and soldiers casting lots for Christ's clothing (right). This sculpture originally decorated the cathedral's choir screen or pulpit.

LAMENTATION OR *PIETÀ* Mk. 15:47; Lk. 23:55; Jn. 19:42. Mary Magdalene and Mary the mother of Jesus witnessed his crucifixion and burial. Although Scripture did not mention this scene, artists depicted Mary the mother of Jesus grieving while holding the dead body of her son. **EXAMPLE:** *Pietà*, painting by Giovanni Bellini, sixteenth century. Academy Gallery, Venice, Italy. In Italian *pietà* means "pity." Several famous painters titled their works *Pietà*, depicting a mourning Virgin Mary holding Jesus on her lap. Against a landscape background, Bellini painted an aging Mary grasping a body slipping away from her.

PREPARING CHRIST'S BODY Mt. 27:57–61; Mk. 15:42–47; Lk. 23:50–54; Jn. 19:38–39. Before burying Jesus, Joseph of Arimathea and Nicodemus, both Sanhedrin members, wrapped the body in linen and spices, according to Jewish tradition. **EXAMPLE:** *Lamentation over the Dead Christ*, painting by Andrea Mantegna, sixteenth century. Brera Art Gallery, Milan, Italy. With startling reality, Mantegna partially shrouded the dead Christ on a marble slab and positioned his uncovered, wounded feet in the foreground. He then added the Virgin Mary and disciple John, weeping and reckoning with the stiffening body and its preparation for burial.

THE ENTOMBMENT Mt. 27:57–61; Mk. 15:42–47; Lk. 23:50–56; Jn. 19:38–42. After preparing Jesus's body for burial, two Jewish believers, Joseph of Arimathea and Nicodemus, laid it in a nearby tomb. They placed a rock in front of the tomb to seal it. **EXAMPLE:** *The Entombment* or *The Deposition*, painting by Raphael (Raffael Sanzio de Urbino), sixteenth century. Borghese Gallery, Rome, Italy. Raphael actually positioned his painting between the lamentation and the entombment, showing mourners carrying Christ's dead body.

HARROWING OF HELL OR DESCENT INTO HELL Acts 2:27–31; Eph. 4:8–10; 1 Pet. 3:19–20; 4:6. Between his death and resurrection, Christ descended into hell and released captives. Although based on Scripture, this concept has stirred controversy about its validity. **EXAMPLE:** *Descent into Hell* or *Anastasis* (Greek for "resurrection"), painting by unknown artist, fourteenth century. Monastery of the Holy Savior, Chora, Istanbul, Turkey. In this energetic apse fresco, artists celebrated Christ pulling Adam, Eve, and other biblical characters from their graves. Byzantine artists repeated this image many times on icons.

THE RESURRECTION Mt. 28:1–7; Mk. 16:1–8; Lk. 24:1–12; Jn. 20:1–9. Three days after Christ's crucifixion, Mary Magdalene, Mary the mother of James, Salome, and Joanna walked to the tomb with spices for anointing the Lord's body. To the women's surprise, they witnessed an angel and an empty tomb. Jesus had risen from the dead. The angel, with a form like lightning, frightened the guards, who shook in fear. E X A M P L E : *The Resurrection*, painting by Piero della Francesca, fifteenth century. Municipal Art Gallery, Sansepolcro, Italy. Francesca painted an almost defiant fresco of Christ's resurrection: the Lord standing up, holding a standard with a cross on it, staring directly at the viewer, raising his left leg and propping his foot on the edge of his sarcophagus (stone coffin)—all without disturbing four sleeping watchmen.

JESUS APPEARS TO MARY MAGDALENE Mk. 16:9–11; Jn. 20:10–18. After Jesus's resurrection, Mary Magdalene encountered him first. Arriving at the tomb and finding his body missing, Mary presumed someone stole the corpse, and she wept. Jesus appeared, and Mary initially mistook him as a gardener until he revealed his identity. He then told Mary to announce his return to their friends. E X A M P L E : *Christ Appearing to Magdalene*, painting by Francesco Albani, seventeenth century. Louvre, Paris, France. Albani painted angels watching Christ clutch his grave clothes and speak to Mary Magdalene.

POSTRESURRECTION APPEARANCES Mt. 28:8–10; Mk. 16:12–13; Lk. 24:13–49. After Jesus rose from the dead, he appeared to numerous individuals, beginning with Mary Magdalene and Mary the mother of James. He then talked with two men journeying through the country to a village called Emmaus. However, they didn't recognize Jesus as their traveling partner. The two men invited Jesus to dinner, and when he broke bread, their eyes opened to his identity. E X A M P L E : *Supper in the House of Emmaus*, painting by Caravaggio (Michelangelo Merisi da Caravaggio), seventeenth century. Brera Art Gallery, Milan, Italy. In this first of two versions of Caravaggio's Emmaus supper, he painted the life-sized figures of Jesus, Luke, and Cleopas gesticulating during an intense conversation. Caravaggio painted a more reserved second version of the conversation.

THE ASCENSION Mk. 16:12–20; Lk. 24:50–53; Acts 1:1–11. For forty days after the Resurrection, Christ spoke to people about the kingdom

of heaven. His last speech to the disciples explained their new role: evangelizing the world. Then before their eyes, Jesus ascended into heaven. **EXAMPLE :** *The Ascension*, mosaic by unknown artists, ninth century. Hagia Sophia, Thessaloniki, Greece. The designer of an Ascension mosaic in the church's dome used the space metaphorically. When Christ ascended into heaven, the disciples looked up, even after he disappeared. In the same way, Byzantine worshipers gazed up to an ascending Christ in the dome.

CHRIST IN MAJESTY OR CHRIST ENTHRONED

Rev. 4–5. Christ appeared in this vision about the end times. Looking like jasper and carnelian, God sat on his throne in heaven. Twenty-four elders dressed in white, with golden crowns on their heads, surrounded him. Along with four living creatures, they continually worshiped the Lord. Jesus appeared as a slain lamb with the authority to open the scroll with seven seals. No one else, in heaven or on earth, held this power. The elders and creatures sang praises to Jesus. Then thousands upon thousands of angels joined in the chorus, singing, "Worthy is the Lamb, who was slain, to receive power and wealth and wisdom and strength and honor and glory and praise!" (Rev. 5:12). **EXAMPLE :** *Vision of Christ in Majesty*, mosaic by unknown artists, late fifth or early sixth century. Holy (Hosios) David Church, Thessaloniki, Greece. During the Byzantine ban on icons and images of deity, workers supposedly covered this apse mosaic with cowhide, mortar, and bricks to hide it from harm. Uncovered, the mosaic highlighted Christ in heaven, holding a scroll and raising his hand in blessing.

THE MAN OF METAPHORS

While praying with the disciples in private, Jesus asked them, "Who do the crowds say I am?" They answered, "Some say John the Baptist; others say Elijah; and still others, that one of the prophets of long ago has come back to life."

"Who do you say I am?" he asked.

Peter replied, "God's Messiah" (Lk. 9:18–20, paraphrased).

Throughout his ministry, Jesus and others offered metaphors to describe him and his mission on earth. Christians elaborated on these descriptions in art and added a few metaphors of their own. These images emerged frequently in ancient Christian art, representing the Lord's intended relationship with humanity.

Alpha and Omega. "He said to me: 'It is done. I am the Alpha and the Omega, the Beginning and the End. To him who is thirsty I will give to drink without cost from the spring of the water of life' " (Rev. 21:6 NIV1984). In the many Byzantine images of Christ Pantokrator, he appeared with the Greek symbols for Alpha and Omega, the first and last letters of the classical Greek alphabet. **E X A M P L E :** *Christ in Majesty*, painting from the Saint Clement Church of Taüll, Spain, by unknown artist, twelfth century. National Museum of Catalonia, Barcelona, Spain. For this apse fresco celebrating Christ's reign in heaven, painters positioned the Greek letter *alpha* by Christ's right shoulder and the letter *omega* by his left.

Bread of Life. "I am the bread of life. . . . I am the living bread that came down from heaven. Whoever eats this bread will live forever. This bread is my flesh, which I will give for the life of the world" (Jn. 6:48, 51). In the earliest Christian images, bread symbolized Jesus as the Bread of Life and the Last Supper represented him as the Bread, broken for the world. **E X A M P L E :** *Fish and Bread*, painting by unknown artist, third century. Catacomb of Callixtus, Rome, Italy. A catacomb painter quickly created this simple fresco of fish and bread. Early Christians recognized these as the Bread of Life and the call to be fishers of men (Mt. 4:19), or considered together, perhaps the Eucharist meal.

Bridegroom. "At that time the kingdom of heaven will be like ten virgins who took their lamps and went out to meet the bridegroom" (Mt. 25:1). In the parable of the ten virgins, the women waited for the bridegroom, who represented Christ and the Second Coming. The wise women kept their lamps filled and burning; the foolish did not. **E X A M P L E :** *Last Judgment and the Wise and Foolish Virgins*, painting by an unknown artist, fifteenth century. Berlin State Museum, Berlin, Germany. In this Flemish representation of the Last Judgment, an artist later added the biblical ten virgins, looking up at Christ in heaven. Stressing the urgency of salvation, the artist placed the wise virgins to the right of Christ with the "saved," and the foolish virgins to his left with the "damned."

Door. "I am the door. If anyone enters by Me, he will be saved, and will go in and out and find pasture" (Jn. 10:9 NKJV). Jesus used a door to illustrate that he offered the only way to salvation. He served as the portal between God and man, death and life. **E X A M P L E :** *After His Death Christ Turns to Lead the Souls of the Just into Paradise*, illuminated-manuscript page by unknown artist, fifteenth century. Royal Library, Turin, Italy. In this unusual and lonely composition, the artist illustrated Christ knocking on the door to Paradise, with one man behind him, carrying a cross to represent Christians waiting to enter a beautiful afterlife.

THE MAN OF METAPHORS continued

Friend. "You are my friends if you do what I command. I no longer call you servants, because a servant does not know his master's business. Instead, I have called you friends, for everything that I learned from my Father I have made known to you" (Jn. 15:14– 15). Early Christian viewers inferred Jesus as a friend in images of him with the disciples or saints. **EXAMPLE:** *Christ and Saint Menas*, painting by unknown artist, sixth or seventh century. Louvre, Paris, France. Ancient Coptic Christians memorialized the martyred Menas, a miracle worker. In this icon an artist painted him as Christ's friend, with the Lord's hand on the saint's shoulder.

■ Christ as a friend, from *Christ and Saint Menas* icon, sixth century.

Good Shepherd. "I am the good shepherd. The good shepherd lays down his life for the sheep. . . . I am the good shepherd; I know my sheep and my sheep know me" (Jn. 10:11, 14). Especially during the early centuries of Christianity, artists painted and sculpted Jesus as the Good Shepherd who lovingly cared for and protected his people. **EXAMPLE:** *The Good Shepherd*, sculpture by unknown artist, fourth century. Museum of Christian Antiquities, Vatican City, Italy. Scholars discovered this virile shepherd tenderly shouldering a sheep in the Catacomb of Domitilla in Rome, Italy. They also identified it as a Christian image. Because of the Roman Empire's agrarian economy, the shepherd spoke to both pagans and Christians.

Lamb of God. "The next day John saw Jesus coming toward him and said, 'Look, the Lamb of God, who takes away the sin of the world!'" (Jn. 1:29). In the Old Testament, Jews followed God's instructions and sacrificed lambs to atone for their sin. In the New Testament, Jesus became the "sacrificial lamb" who died for people's sins. **EXAMPLE:** *Adoration of the Mystic Lamb*, painting by Jan van Eyck and Hubert van Eyck, fifteenth century. Saint Bavo Cathedral, Ghent, Belgium. In this elaborate painting, the artists depicted the Lamb of God standing on an altar, with kneeling angels and the faithful surrounding, adoring, and singing to him. They included this image in a larger work, the famed Ghent Altarpiece.

Light of the World. "When Jesus spoke again to the people, he said, 'I am the light of the world. Whoever follows me will never walk in darkness, but will have the light of life' " (Jn. 8:12). Halos and rays of light streaming from the Lord's head signified his holiness, but also his role as Light of the World. **EXAMPLE:** *Christ as Helios the Sun God*, mosaic by unknown artists, third century. Mausoleum of the Julii, Vatican Grottoes, Vatican City, Italy. In this Roman catacomb mosaic, an artist portrayed a chariot-driving Jesus as the true Sun God, possibly to claim the Light of the World outshone Apollo, the pagan sun god.

THE MAN OF METAPHORS continued

■ Christ as teacher, from *Christ Teaching, Seated Among the Apostles* mosaic, fifth century.

Teacher. [Jesus said,] "Nor are you to be called 'teacher,' for you have one Teacher, the Christ" (Mt. 23:10 NIV1984). Early on, artists dressed Jesus in the robes of a Roman scholar—seated with his hand raised—posing him as the Great Teacher surrounded by his students, the disciples. **EXAMPLE:** *Christ Teaching, Seated Among the Apostles*, mosaic by unknown artists, fifth century. Church of San Lorenzo Maggiore, Milan, Italy. Scholars interpreted this symmetrical mosaic of Christ holding a book, flanked by his disciples, as Christ teaching his disciples or giving them the law. The teaching interpretation emerged because of Christ's seated position and raised hand.

The Vine. "I am the vine; you are the branches. If you remain in me and I in you, you will bear much fruit; apart from me you can do nothing" (Jn. 15:5). Just as the main vine fed its branches, Jesus said his followers couldn't grow spiritually or bear fruit without him. Vines in Christian art usually represented Christ the Vine. **EXAMPLE:** *Three Shepherds and Vine Harvest*, relief sculpture by unknown artist, third century. Lateran Museum, Rome, Italy. Roman citizens recognized grape vines and shepherds as integral to their daily work and sustenance. However, Christians interpreted the vines and shepherds on this sarcophagus (stone coffin) as Christ the True Vine and Good Shepherd.

The Way, Truth, and Life. "Jesus answered, 'I am the way and the truth and the life. No one comes to the Father except through me'" (Jn. 14:6). Usually the artist inscribed or painted this familiar verse near an image of Christ. **EXAMPLE:** *Christ as Emperor*, mosaic by unknown artist, sixth century. Archbishop's Palace, Ravenna, Italy. To express Christ's spiritual authority and power, the artist suited him up in military garb, stomping on a serpent (Satan) and holding a book with an inscription of John 14:6.

The Word. "In the beginning was the Word, and the Word was with God, and the Word was God. He was with God in the beginning. . . . The Word became flesh and made his dwelling among us" (Jn. 1:1–2, 14). This symbolism referred to Christ's role as the Word that dwelt with God from the beginning. **EXAMPLE:** *Gospel Cover with Scenes from Christ's Life*, relief sculpture by unknown artist, ninth century. Bodleian Library, University of Oxford, Oxford, England. A sculptor carved detailed scenes from Christ's life on this ivory cover, with a triumphant Lord in the center, holding a Scripture book so viewers could see the inside pages. This stance proclaimed him as the Word.

8

Miracles of Jesus

The force of the Early Christian miracles images is their radical novelty.
Over and over again they show Christ in the very moment his . . .
power takes effect. This was a new kind of imagery, for which,
surprisingly enough, non-Christian art had no answer.

—THOMAS F. MATHEWS

During the second century Quadratus of Athens, a Greek and one of the first
Christian apologists, emphasized his belief in Christ's miracles. In one of the remaining
fragments of his work, he wrote, "But the works of our Saviour were always present,
for they were genuine: those that were healed, and those that were raised from the
dead, who were seen not only when they were healed and when they were raised,
but were also always present." Quadratus then explained that miracles continued after
Christ's departure, "even to our day." Consequently, early Christian images of Jesus
didn't just concentrate on his character or teachings. They repeatedly emphasized his
role as healer and wonderworker, forming the largest body of early artistic works.

In response, the Greek philosopher Celsus, also writing in the second century,
accused Christians of following a sorcerer—a common occupation in the first- and
second-century Roman culture. Celsus considered Christ no more than a magician.
Fifty years later, Origen, the biblical scholar from Alexandria, Egypt, refuted this
accusation. Origen conceded that Christ's miracles looked like magic. But then
he noted the differences. "Christ took no money for his tricks; he did them not
for entertainment but to lead his spectators to conversion; he needed no spells or
incantations but performed them by his own name; and while magicians' tricks are
illusions, Christ's were permanent and real."

Today it's difficult to imagine the reality and scope of such miracles, particularly
when Christ raised the dead or healed the terminally ill. What did it feel like to
die and then breathe again? To return to an everyday life in a skeptical community
after a miraculous healing? To answer these questions, Christian artists enhanced
faith and imagination, bringing sorrow and joy, color and texture, to the marvelous
aspects of Jesus's ministry on earth. Scripture states he performed many miracles,
but the following supernatural acts appeared most often in Christian art.

CALMING THE STORM Mt. 8:23–27; Mk. 4:35–41; Lk. 8:22–25. One evening Jesus and his disciples embarked on a boat ride. As they crossed a lake, a fierce storm terrified the disciples, who quickly woke the sleeping Jesus. He got up and rebuked the winds and waves into an obedient stillness. Afterward, the disciples feared and wondered about his power. **E X A M P L E :** *The Storm on the Sea of Galilee*, painting by Rembrandt van Rijn, seventeenth century. Isabella Stewart Gardner Museum, Boston, Massachusetts. With wild, vertical waves, a boat about to capsize, and terrified sailors, Rembrandt invigorated his canvas with the horror of a sea storm.

CASTING OUT A GIRL'S DEMON Mt. 15:21–28; Mk. 7:24–30. While in the vicinity of Tyre, Phoenicia, Jesus met a Canaanite woman who begged him to drive out a demon possessing her young daughter. Jesus initially said he couldn't help. However, because of the woman's faith and persistence, the Miracle Worker healed her daughter that hour. **E X A M P L E :** *The Exorcism*, Very Rich Hours of the Duke of Berry (Les très riches heures du Duc de Berry), illuminated-manuscript page by the Limbourg brothers, fifteenth century. Condé Art Gallery, Chantilly Château, Chantilly, France. In this manuscript page from a book of hours, the Limbourg brothers mellowed the tragedy of a writhing victim by painting beautiful architecture, brilliant colors, and still figures.

CATCHING A DRAFT OF FISH Lk. 5:1–11. Jesus spoke to a crowd near the Sea of Galilee when he noticed two fishing boats on the shore. He stepped into one of the boats and asked the owner, the disciple Simon, to row out so he could teach the people on shore. After Jesus finished teaching, he told the fisherman to enter deeper waters and throw in his nets. Simon hesitated because he hadn't caught anything all night, but he obeyed and pulled in so many fish, his nets broke. Another boat arrived to help, and the two boats overflowed with fish and began to sink. **E X A M P L E :** *The Miraculous Draft of Fishes*, painting by Jacopo Bassano, sixteenth century. National Gallery of Art, Washington, DC. Bassano based his painting's composition on a work completed by Raphael thirty years earlier. After studying a woodcut of Raphael's cartoon (sketch), Bassano chose a moment after the miracle, when Simon Peter confessed his sinfulness to Christ.

CURSING THE FIG TREE Mt. 21:18–22. One morning Jesus approached a fig tree because he felt hungry. The tree bore nothing but leaves.

Jesus cursed the tree, saying, "May you never bear fruit again!" (21:19). Instantly, the tree withered and died. E X A M P L E : *Withering the Fig Tree and Feast in the House of Simon the Pharisee*, painting by Dionisy, fifteenth century. Museum of Dionisy's Frescoes, Saint Ferapont Belozero Monastery, Vologda Region, Russia. In a narrow space of a church nave, the great Russian iconographer Dionisy painted a fresco of Christ looking back at his astonished disciples after withering the unfruitful fig tree.

F E E D I N G T H E F I V E T H O U S A N D Mt. 14:15–21; Mk. 6:35–44; Lk. 9:12–17; Jn. 6:5–14. A crowd of five thousand, not including women and children, listened to Jesus teach late into the day. As evening approached, Jesus instructed his disciples to feed the people. Dismayed, the disciples explained they only possessed five loaves of bread and two fish. Jesus took the food, thanked God, and told the disciples to distribute portions. After everyone ate, the disciples picked up twelve baskets of leftovers. E X A M P L E : *The Loaves and Fishes*, painting by Tintoretto (Jacopo Comin), sixteenth century. Metropolitan Museum of Art, New York, New York. In this wide painting, Tintoretto centered Jesus in the middle of a mostly seated crowd, handing a bread loaf to a disbelieving Andrew.

F I N D I N G A C O I N I N A F I S H ' S M O U T H Mt. 17:24–27. Tax collectors approached the disciple Peter, asking for two drachmas as a temple tax for him and for Jesus. The Lord told Peter to throw his line in the lake and after catching the first fish, to open its mouth. Inside the fish, Peter found a four-drachma coin to pay for the taxes. E X A M P L E : *The Tribute Money*, painting by Masaccio (Tommaso di Ser Giovanni di Simone), fifteenth century. Brancacci Chapel, Florence, Italy. Masaccio painted three moments in one scene: the tax collector's request (center); Peter catching the fish and finding the coin (left); and Peter paying the tribute money to the tax collector (right). Masaccio completed this fresco during a controversy in Florence that resulted in tax reform.

G I V I N G S I G H T T O T W O B L I N D M E N Mt. 9:27–31. Two blind men followed Jesus, requesting healing. Jesus asked if they truly believed he could restore sight. They replied yes, so the Lord touched the men's eyes and restored their vision. E X A M P L E : *Christ Heals Two Blind Men*, Sinope Gospels, illuminated-manuscript page by unknown artist, sixth century. National Library of France, Paris, France. A fragment of an ancient Greek Gospels book, the Sinope Gospels retained only forty-four folios (pages) and five miniature

illustrations. In one surviving miniature, the artist painted Jesus lovingly reaching out to heal two blind men.

HEALING A BLEEDING WOMAN Mt. 9:20–22; Mk. 5:25–34; Lk. 8:43–48. A woman who suffered from a bleeding disorder for twelve years touched the Lord's cloak. She healed immediately. As a result, Jesus felt power leave his body and asked who touched him. The woman fell before Jesus and explained what happened. Jesus said, "Daughter, your faith has healed you. Go in peace and be freed from your suffering" (Mk. 5:34). EXAMPLE: *Woman with the Issue of Blood Touching Christ's Hem*, painting by unknown artist, third century. Catacomb of Saints Peter and Marcellinus, Rome, Italy. In one of the oldest images of this incident, the painter roughly portrayed Jesus turning to extend his hand to the woman kneeling behind him.

HEALING A LEPER Mt. 8:1–4; Mk. 1:40–46; Lk. 5:12–15. A man with leprosy knelt before Jesus and insisted, "Lord, if you are willing, you can make me clean" (Mt. 8:2). Expressing mercy, Jesus said, "I am willing" (Mt. 8:3). Jesus touched the man and cured him. EXAMPLE: *Healing a Leper*, Sermons of Maurice de Sully, illuminated-manuscript page by unknown artist, fourteenth century. Notre Dame Cathedral, Paris, France. The compilation of Sully's sermons included two illustrations with lepers: the first with Jesus healing one leper, and the second with a leprous group asking for a miracle, too.

HEALING A MAN BORN BLIND Jn. 9:1–7. Seeing a man blind from birth, the disciples asked whether he or his parents had sinned to cause this suffering. Jesus said neither; it happened so the Lord could display his glory. Then Jesus took dirt and mixed it with his saliva. He smeared the mud on the man's eyes and told him to wash in the Pool of Siloam. The man obeyed and returned to Jesus with his sight. EXAMPLE: *Christ Healing a Blind Man*, painting by Gioacchino Assereto, seventeenth century. Carnegie Museum of Art, Pittsburgh, Pennsylvania. Assereto took liberties and painted Jesus as an over-zealous healer. He depicted the Lord jabbing a blind eye as the startled man pulled his head back.

HEALING PETER'S MOTHER-IN-LAW Mt. 8:14–15; Mk. 1:29–31; Lk. 4:38-39. Jesus visited Peter's home and found the disciple's

mother-in-law in bed with a fever. Jesus rebuked the fever and it dissipated. The woman then served them a meal. EXAMPLE: *The Healing of Peter's Mother-in-Law*, Codex Egberti, illuminated-manuscript page by unknown artist, tenth century. Municipal Library, Trier, Germany. The illustrations of Jesus in the Codex Egberti depict the earliest cycle of his life in the history of book painting. The artist symmetrically designed and simply rendered the fifty-one miniatures, including the image of Jesus healing Peter's mother-in-law.

HEALING TEN LEPERS Lk. 17:11–19. As Jesus traveled between Samaria and Galilee, ten lepers called out, asking for healing. Jesus instructed the lepers to show themselves to the priests. On their journey, the leprosy fell away. Only one man, a Samaritan, returned praising and thanking Jesus. EXAMPLE: *Jesus Healing Lepers*, mosaic by unknown artists, twelfth century. Monreale Cathedral, near Palermo, Sicily. In a heartfelt scene, mosaic artists captured the pleadings of spotted lepers reaching out and Jesus compassionately extending his arm to them.

HEALING THE PARALYTIC BY THE POOL OF BETHESDA Jn. 5:1–16. Meeting a man paralyzed for thirty-eight years, Jesus asked the invalid if he wanted to get well. The man replied that no one would help him step into the healing pool. Jesus told the man to pick up his mat and walk. Immediately the man walked. EXAMPLE: *Christ Healing the Paralytic at the Pool of Bethesda*, painting by Bartolomé Esteban Murillo, seventeenth century. National Gallery, London, England. Murillo painted this scene, along with five others, for the Charity Hospital in Seville, Spain. The commission required six paintings, along with an altar sculpture, recalling the seven acts of charity. The Bethesda pool healing encouraged viewers to visit the sick.

RAISING A WIDOW'S SON FROM THE DEAD Lk. 7:11–16. In the town of Nain in Galilee, Jesus encountered mourners carrying a deceased young man, followed by his widowed mother. Jesus admonished her not to cry and he touched the bier. He commanded, "Young man, I say to you, get up!" (7:14). The man sat up and talked. Amazed, the witnesses spread news about Jesus throughout Judea. EXAMPLE: *Christ Raises the Son of the Widow of Nain*, painting by Domenico Fiasella, seventeenth century. John and Mable Ringling Museum of Art, Sarasota, Florida. Bursting with realism, this monumental

work typified the miraculous scenes painted during the Counter-Reformation, the Roman Catholic Church's fight against Protestantism. The painting promoted faith and devotional reflection.

RAISING JAIRUS'S DAUGHTER FROM THE DEAD Mt. 9:18–26; Mk. 5:22–24, 35–43; Lk. 8:41–42, 49–56. A synagogue leader named Jairus informed Jesus that his young daughter lingered at death's door. He asked the Healer to lay hands on the girl so she'd live. By the time Jesus arrived, the girl had already died. Jesus took the daughter's hand, saying, "Little girl, I say to you, get up!" (Mk. 5:41). She immediately arose and walked. EXAMPLE: *The Raising of Jairus' Daughter*, painting by unknown artist, twelfth century. Saint Michael and All Angels Church, Copford, Essex, England. Unlike other paintings in this church, this fresco diverged from the structure's Byzantine style and escaped the heavy restoration of the late nineteenth century. The painter left behind a fluid, unusual scene of Christ standing with his legs crossed as he greets Jairus in the home's vestibule.

RAISING LAZARUS FROM THE DEAD Jn. 11:1–45. Mary and Martha's brother Lazarus fell seriously ill. As friends of Jesus, the sisters sent word to him, expecting the Lord to heal their brother. Instead, Jesus stayed away two more days, and Lazarus died. After arriving, talking to the grieving sisters, and weeping, Jesus visited the brother's tomb. He told men to roll away the stone from the entrance. Jesus thanked God and commanded, "Lazarus, come out!" (11:43). Promptly Lazarus stirred and stumbled out, wearing his grave clothes. EXAMPLE: *Raising of Lazarus*, painting by Giotto di Bondone, fourteenth century. Scrovegni Chapel, Padua, Italy. In this fresco, Giotto painted the moment Lazarus stepped forward, before his prostrate and pleading sisters recognized their brother's resurrection.

SENDING DEMONS INTO PIGS Mt. 8:28–34; Mk. 5:1–20; Lk. 8:26–39. A demon-possessed man, naked and living among tombs, turned violent and couldn't be subdued. Jesus approached and the demons pleaded to be hurled into a nearby herd of pigs rather than into the abyss. Jesus did this, and the herd stampeded into a lake and drowned. The man's sanity returned, and he spread the news about his deliverance. EXAMPLE: *Healing the Demon-Possessed Man*, mosaic by unknown artist, sixth century. New Saint Apollinare Basilica,

Ravenna, Italy. Artists portrayed youthful and naturalistic figures, including Jesus and the former demoniac, with Hellenistic-Roman clothing and short-cropped hair. When Catholics acquired this Arian church later in the sixth century, they added a halo above the Lord's head.

TURNING WATER INTO WINE Jn. 2:1–11. Jesus attended a wedding banquet with his mother and disciples, and the party's wine ran out. Jesus asked the servants to find six stone water jars, each big enough to hold twenty to thirty gallons, and fill them with water. Then Jesus told a servant to pour out the water-transformed-into-wine and offer it to the banquet master. After tasting the wine, the master took the bridegroom aside and exclaimed, "Everyone brings out the choice wine first and then the cheaper wine after the guests have had too much to drink; but you have saved the best till now" (2:10). This was Jesus's first miracle. E X A M P L E : *The Marriage at Cana*, painting by Paolo Veronese, sixteenth century. Louvre, Paris, France. Veronese emphasized the feasting crowd of guests at the wedding, cramming them into every available space, except for a cloudy sky between buildings in the painting's background. Veronese sat Jesus at a table in the composition's center, surrounded by celebrants and separated from the servants in the lower-right foreground, pouring out wine at their master's command.

WALKING ON WATER Mt. 14:22–33; Mk. 6:45–52. After teaching a crowd all day, Jesus instructed the disciples to travel ahead of him by boat while he dismissed the people. Afterward, he hiked up a mountainside to pray. When Jesus finished, the boat had sailed to the middle of the lake, so he walked on the water toward it. Jesus announced himself to the disciples and said not to fear. "'Lord, if it's you,' Peter replied, 'tell me to come to you on the water.' 'Come,' he said" (Mt. 14:28–29). Peter walked on the water toward Jesus until the wind scared him; then he began to sink. Jesus caught Peter and rebuked him for a lack of faith. E X A M P L E : *Jesus Walking on Water*, relief sculpture by Lorenzo Ghiberti, fifteenth century. Saint John Baptistery, Florence, Italy. Ghiberti won a competition to sculpt the huge bronze north doors of the baptistery. The doors' small panels included twenty scenes from Christ's life and eight representations of saints. The realism and perfection of the *Jesus Walking on Water* panel helped to initiate the Renaissance style. Later, Ghiberti sculpted the east doors with Old Testament stories, and other artists nicknamed them *The Gates of Paradise*.

OTHER MIRACLES Artists illustrated Christ's lesser-known miracles, included in this list with Scripture references. Casting Out a Boy's Evil Spirit, Mt. 17:14–21. Casting Out a Man's Evil Spirit, Mk. 1:34; Lk. 4:33–36. Catching More Fish Miraculously, Jn. 21:1–14. Feeding the Four Thousand, Mk. 8:1–9. Giving Sight to a Blind Man at Bethsaida, Mk. 8:22–26. Healing a Crippled Woman, Lk. 13:10–17. Healing a Deaf and Mute Man, Mk. 7:31–37. Healing a Mute Demonic, Mt. 12:22. Healing a Sick Man, Lk. 14:1–6. Healing an Official's Son at Cana, Jn. 4:46–54. Restoring Bartimaeus' Sight, Mt. 20:29–34; Mk. 10:46–52; Lk. 18:35–43. Healing the Centurion's Servant, Mt. 8:5–13. Restoring a Man's Ear, Lk. 22:49–51. Restoring a Shriveled Hand, Mt. 12:9–13.

9

The Christian Cross

Symbolism is so powerful that if one takes two sticks to form a cross,
the whole message, including the theology, is conveyed.
More than a design with one of its two members transposed on
the other at a ninety-degree angle, a cross is a statement about the nature of God.

—EDWARD N. WEST

The Dominus Flevit cemetery near the Mount of Olives in Jerusalem dates to the first century and contains more than one hundred ossuaries, vessels holding bones of the deceased. The engravings scratched inside and outside the ossuaries reflect Christianity's symbolism. Based on this site and the iconography of later dates, some scholars believe these Palestinian Christians borrowed common Jewish images to covertly represent the cross at their burial sites. These symbols included the axe, ladder, lintel, serpent, star, and tree. Even if these early Christians could only scratch a symbol in a forgotten cemetery, they chose the cross.

The cross represented what Christians believed, how they managed life, and what they hoped for the future. In addition, Christians believed Christ's death and resurrection atoned for their sins and heaven awaited their arrival. John's Gospel promised them, "For God so loved the world that he gave his one and only Son, that whoever believes in him shall not perish but have eternal life" (Jn. 3:16). As a result, Christ's cross stood with him at the center of Christian art.

Artists fashioned crosses in many styles and mediums, from the plain wood sign for graves to the glittering showpieces for royalty. Creative hands shaped them short and long, curved and budded; with circles, creatures, and symbols. Yet the cross message never varied, rooted in eternity. The medieval monk Thomas à Kempis explained, "In the Cross is salvation; in the Cross is life; in the Cross is protection against our enemies; in the Cross is infusion of heavenly sweetness; in the Cross is strength of mind; in the Cross is joy of spirit; in the Cross is excellence of virtue; in the Cross is perfection of holiness. There is no salvation of soul, nor hope of eternal life, save in the Cross."

In turn, artists brought the cross and its symbolism to life, keeping fresh the reality and power of Christ's sacrifice. Many cross variations developed, but Christian art often depicted these:

A G N U S D E I *Agnus Dei* translates from ancient Latin as "Lamb of God." Accordingly, this cross represented Jesus as a lamb holding a cross on its shoulder. **E X A M P L E** : *Agnus Dei with Halo and Cross*, relief sculpture by unknown artist, fourth century. Euphrasian Basilica, Poreč, Croatia. An artist sculpted this stone of a haloed lamb craning his neck to look back at the cross while steadying it with his right leg. The awkward pose might have resulted from fitting the animal into a circular frame. Whatever the reason for this strained composition, the sculptor portrayed the lamb looking back at the cross, paying homage to its role in the world's redemption.

A N C H O R Before early believers could openly express their faith, an anchor with its crossbar sometimes represented Christ's cross. Christians used this symbol in the catacombs and marketplace. **E X A M P L E** : *Anchor with Two Fish*, etching by unknown artist, fourth century. Catacomb of Priscilla, Rome, Italy. On a catacomb wall, an artist etched into the tufa stone, creating two fish hanging from an anchor and joining two Christian symbols: the anchor for the cross and the fish for Christ beckoning his disciples to become "fishers of men" (Mt. 4:19).

B U D D E D In its simplest form artists designed this cross with a "bud" at the top of the vertical beam and the two ends of the horizontal beam. The three buds symbolized the Holy Spirit. In turn, each bud typically divided into three parts, like a three-leaf clover. Through the years assorted styles developed, varying the number of buds on this cross. **E X A M P L E** : *Crucifix*, metalwork by Lorenzo Ghiberti, fifteenth century. Saint Mary of Impruneta Church, Impruneta, Italy. The brilliant metalworker Ghiberti varied the budded cross by adding three extra buds to his crucifix. He fused one bud behind Christ, where the beams cross, and two more below the Lord's feet.

CELTIC An inexplicable round disc called a "wheel of glory" connected the four arms at the center of this cross. The Irish called it Saint Columba's or Saint Patrick's cross, named after their cherished saints. **EXAMPLE**: *The South Cross* or *Castledermot Cross*, relief sculpture by unknown artist, ninth century. County Kildare, Ireland. Artisans carved narrative and ornamental panels into this weathered stone sculpture. They incised narrative scenes from the Old and New Testaments, along with the lives of saints, on the body and arms of the cross. Then they added traditional Celtic scrollwork at the base.

CHI-RHO OR LABARUM The *Chi-Rho* or labarum formed a cross that encompassed the first two Greek letters of Christ's name. Before a crucial battle the Emperor Constantine claimed he saw this sign in the sky, with the words "Conquer by this." The next day, the emperor's soldiers carried banners with this symbol emblazoned on them. The *Chi-Rho* developed into a monogram or Christogram, an abbreviation for "Christ." **EXAMPLE**: *Monogram of Christ*, relief sculpture by unknown artist, no date. Museum of Christian Antiquities, Vatican City, Italy. Designing an unusual stone composition, the sculptor positioned this *Chi-Rho* within a flowery wreath, a symbol for victory. He also hung the letters for *Alpha* and *Omega* from the top crossbar, representing "the beginning" and "the end."

COPTIC The Copts, the first Egyptian Christians, adopted the ancient *ankh* symbol for their cross. The Egyptian ankh symbolized life and looked like a cross with a loop on top. **EXAMPLE**: *Tombstone with Looped Cross*, relief sculpture by unknown artist, sixth century. Coptic Museum, Cairo, Egypt. This stone Coptic cross, originally part of a tomb, memorialized the deceased as victorious. The sculptor embedded two victory symbols: a wreath pattern formed the loop and a palm branch framed it. A Greek cross inside the loop confirmed this victory belonged to a Christian in heaven.

CRUSADER OR JERUSALEM Artisans imprinted this cross on the banners Pope Urban II awarded soldiers of the First Crusade in 1095, intended to recapture Jerusalem from the Muslims. The designers created a large Greek cross surrounded by four smaller Greek crosses, each in a quadrant of the larger image. **EXAMPLE:** *Silk Cover Binding with Jerusalem Cross*, Queen Melisende's Crusader Psalter, illuminated-manuscript cover by unknown artist, twelfth century. British Library, London, England. For this crusader psalter, artisans used Byzantine silk and silver thread to stitch the red, blue, and green Crusader or Jerusalem crosses on the spine. Because of the uneven stitching, Westerners trained in the Byzantine style probably created these images. Most likely, they couldn't fully imitate the smooth stitching of the Eastern artists.

CRUCIFIX The crucifix—an image of the suffering Christ hung from a Latin cross—did not emerge in art until the fifth century and rarely appeared until the seventh century. **EXAMPLE:** *Gero Crucifix*, sculpture by unknown artist, tenth century. Cologne Cathedral, Cologne, Germany. This gilded-oak crucifix is the oldest known depiction of a dead Christ hanging on the cross. The sculptor broke tradition by allowing Christ's head to slump down, over a twisted body. Earlier Crucifixion art showed Christ looking outward or at his mother standing below.

FLEUR DE LIS Adapted from medieval heraldry, artisans stylized this cross to resemble an iris. Until the early thirteenth century this cross appeared with images of Jesus, its three petals representing the Trinity. Later it symbolized the Virgin Mary and purity. Translated from French, *fleur de lis* means "lily flower." **EXAMPLE:** *Charlemagne*, painting by Albrecht Dürer, sixteenth century. Germanic National Museum, Nuremberg, Germany. For this commanding portrait of Emperor Charlemagne, Dürer emphasized the symbols of kingship: a sword for military leadership, a *globus cruciger* (an orb topped with a cross) for earth-bound authority, and three fleur de lis images on a crest for his commitment to Christianity and the renewed Holy Roman Empire.

GLOBUS CRUCIGER In ancient Christian kingdoms, a cross on top of a small orb or globe represented Christ's rule and authority over the world. Kings often carried the globus cruciger at their coronations. Some still do today. When held by Christ in a painting, artists called the work *Salvator Mundi* or "Savior of the World." EXAMPLE: *Salvator Mundi*, painting by unknown artist, sixteenth century. German Historical Museum, Berlin, Germany. In this work, the artist painted a larger-than-usual globe for Christ to hold, resting it against his chest. In many versions of the globus cruciger, the cross dominated because of its size or color. However, this painter emphasized the globe's world map topped by a thin Latin cross receding into the dark background.

GREEK Early Christians and Byzantines designed this cross with four arms of approximately equal length. At times the arms flared out wider toward the tips. EXAMPLE: *Beresford Hope Cross*, metalwork by unknown artist, ninth century. Victoria & Albert Museum, London, England. This cloisonné enamel Greek cross probably served as a reliquary, holding a piece of the alleged True Cross in its center compartment (which is now empty). Most likely, the owner wore this small cross around his neck, showcasing the crucified Christ with the skull of Adam at his feet.

HEALING The desert-stranded Moses and his bronze snake on a pole foretold Christ's role as healer (Num. 21:6–9; Jn. 3:14–15). Christians retained the snake wrapped around a Latin or *tau* (T-shaped) cross to remind them of the Lord's healing power. EXAMPLE: *Moses and the Brazen Serpent*, painting by unknown artist, sixteenth century. Dronninglund Church, Dronninglund, Denmark. For this fresco, the artist painted Moses pointing to a snake hanging from a tau-shaped, lopped tree with two short crossbeams at the top. For the Christians of this congregation, the tree represented the Israelites' rescue and Christ's cross. The painter dressed Moses and the man next to him in sixteenth-century clerical vestments.

L A T I N Most Western painters created Crucifixion images with Christ nailed to a Latin cross. For a Roman crucifixion, the vertical beam on this cross extended longer than the horizontal beam. The two beams intersected about a third of the way down from the vertical beam's top. **E X A M P L E :** *Christ Carrying the Cross*, painting by Giovanni Battista Moroni, sixteenth century. Sanctuary of Our Lady of Tears, Bergamo, Italy. In a simple composition, Moroni only painted Christ carrying his Latin cross against a grassy background. Moroni gave the cross nearly equal emphasis with the bent-over Christ, emphasizing the wood's unbearable weight.

L O R R A I N E The Cross of Lorraine belonged to French heraldry and supposedly symbolized Joan of Arc's fifteenth-century battles with the English. The original "double cross" consisted of a long vertical beam and two short horizontal beams of equal length attached toward the top. In later versions the bottom horizontal beam appeared longer. **E X A M P L E :** *Cross of Lorraine*, miniature relating to René II, Duke of Lorraine, illuminated-manuscript page by unknown artist, fifteenth century. Library of the Institute of France, Paris, France. The illuminator painted a tidy version of Christ's cross, as if someone refurbished and restaked it in the countryside. If so, he hung a wreath around the top crossbar of this Lorraine cross and reinserted the nails in their original spots, suggesting Christ's victory and resurrection.

M A L T E S E The Maltese cross represented the medieval Knights Hospitaller who helped poor, sick, injured, or threatened pilgrims traveling to the Holy Land. At the center, the distinctive cross joined four flared arms, each of equal length with two sharp end points. The eight points represented the aspects of courage, the Beatitudes, or the traits of a person who provided aid to those in jeopardy. **E X A M P L E :** *Portrait of a Knight of the Order of Malta*, painting by Titian (Tiziano Vecellio), sixteenth century. Uffizi Gallery, Florence, Italy. Titian painted his solemn knight wearing a Maltese cross pinned to his garment as a symbol of his allegiance to the Order of Malta and a Latin pectoral cross worn around his neck.

In another portrait at the Prado Museum in Madrid, Spain, Titian painted a large, prominent cross covering a Malta knight's chest.

P A P A L As a symbol of spiritual leadership and authority, before the thirteenth century popes began carrying a cross with three bars of diminishing lengths at the top. The crossbars represented the three crosses at Golgotha. **E X A M P L E :** *Pope Sylvester I*, outdoor sculpture by unknown artist, unknown century. Mantua, Italy. The creator of this powerful outdoor statue projected both authority and compassion. The sculptor shaped a towering pope in full regalia holding a papal cross while kindly looking and reaching down to a *putto* (small angel) figure.

P A T R I A R C H A L Originally carried by Christ in art, the patriarchal cross positioned two crossbeams at the top of its vertical beam. Artists created the top horizontal bar shorter than the second bar. Sometimes they also attached a short, slanted horizontal beam toward the bottom, and this cross eventually became the Byzantine and Russian cross. **E X A M P L E :** *Betrayal of Christ*, painting by unknown artist, thirteenth century. Monastery Church of the Holy Apostles, Pec, Serbia. The fresco artist added an unusual, extra-biblical element to the betrayal of Christ by painting two men marching ahead of Christ, each carrying a patriarchal cross.

P R O C E S S I O N A L As early as the sixth century, during an outdoor or indoor Christian procession, a participant carried a cross or crucifix on a long pole. After a procession, the cross usually detached and sat on a stand in the church. A church decorated its processional cross in the best style it could afford. Crosses with precious metals and jewels customarily belonged to large churches and royal regalia. **E X A M P L E :** *Cross of Lothair*, metalwork by unknown artist, early eleventh century. Aachen Cathedral, Aachen, Germany. Part of the Aachen Cathedral treasury, the bejeweled Cross of Lothair dates back to the year 1000. The creator encrusted the gold- and silver-plated cross with jewels, engraved gems, and a cameo of the ninth-century ruler Lothair II. The cathedral still uses the cross in processions on high feast days.

PROCLAMATION The letters *INRI* appeared on a sign atop a proclamation cross, representing the titulus (sign or inscription) nailed above Christ's head during his crucifixion. In Latin, *INRI* stood for *Iesus Nazarenus, Rex Iudaeorum* or "Jesus of Nazareth, the King of the Jews" (Jn. 19:19). EXAMPLE: *The Sibiu Crucifixion*, painting by Antonello da Messina, fifteenth century. Brukenthal National Museum, Sibiu, Romania. Although Messina positioned Christ's cross and its *INRI* sign in the painting's center, the true focal point became the agonizing thief with an arched back, suffering on a cross to the viewer's right.

SAINT ANDREW'S OR SALTIRE Tradition claims Andrew the apostle died on a cross in the shape of an *X*, the configuration of this cross. EXAMPLE: *Saint Andrew on the Cross*, painting by Frans Francken II (also known as the Younger), sixteenth century. Schloss Museum, Gotha, Germany. Francken created an absurd image of Andrew's death. Besides painting an overwhelmingly large cross bearing a small apostle, he crammed seated crowds around Andrew, watching the spectacle with scant feeling.

SAINT PETER'S Peter the apostle didn't feel worthy to die like Christ, so soldiers crucified him on an upside-down Latin cross. Consequently, an inverted Latin cross became known as Saint Peter's Cross. EXAMPLE: *The Crucifixion of Saint Peter*, painting by Ventura di Arcangelo Salimbeni, sixteenth century. National Gallery of Ancient Art, Rome, Italy. Salimbeni narrowed this scene's emotion to the suffering Peter as two soldiers plunged him, nailed to an upside-down cross, into the ground. However, the artist suggested some relief for Peter by placing two winged putti (small angels) above the saint.

SHEPHERD'S This lesser-known cross combined a shepherd's crook with a cross, memorializing Christ as both Shepherd and Savior. The top of the cross shaped into a slight crook, but the curl didn't look as pronounced as the curvilinear lines of a crosier.

E X A M P L E : *Shepherd's Cross*, relief sculpture by unknown artist, sixth century. Saint John's Basilica, Ephesus, Turkey. The sculptor formed this shepherd's cross with a serpentine twist at the crook's tip.

T A U Dating to early Christianity, this cross looked like a capital *T*. The twelfth-century monk Saint Francis of Assisi told his friars their habits represented the shape of a tau cross, and he adopted it as his cross sign. **E X A M P L E :** *An Angel Carrying the Cross*, tapestry by unknown artists, sixteenth century. Angers Château, Angers, France. In this tapestry of angels carrying instruments of Christ's Passion, one winged messenger holds a tau cross in his right hand and points to it with the index finger of his left hand. This cross scene looks casual and unrealistic, perhaps because the tapestry designer needed to create beauty for his patron.

10
The Holy Spirit

The Spirit has his own existence and personal function in the
inner life of God and the economy of salvation . . . [he] imparts to
this unity a personal, and hence diversified, character.

—JOHN MEYENDORFF

Not long before the terrors of Passion Week, Jesus told the disciples he'd soon
leave them. To comfort his followers, he promised, "I will ask the Father, and he will
give you another advocate to help you and be with you forever—the Spirit of truth"
(Jn. 14:16–17). Later, he explained, "But when he, the Spirit of truth, comes, he
will guide you into all the truth. He will not speak on his own; he will speak only
what he hears, and he will tell you what is yet to come" (Jn. 16:13).

Although Jesus referenced the Holy Spirit's role after the Ascension, the Spirit
existed from the beginning with the Father and Son, ministering in the world before
descending to believers on the day of Pentecost (Acts. 1:1–4; 2:1–3). In addition to
guidance, Scripture promised the Holy Spirit would convict people of their sin (Jn.
16:7–11), baptize believers into the Body of Christ (1 Cor. 12:13), and help them
live righteously (Rom. 8:9). In Christian art the Holy Spirit appeared symbolically,
fulfilling these roles.

However, artists frequently depicted the Holy Spirit as a dove, patterning after
the belief of early church fathers. In the second century Clement of Alexandria
reasoned why a dove image represented the Spirit. He explained, "God here
assumed the likeness, not of man, but of a dove, for He wished by a new apparition
of the Spirit in the likeness of a dove, to declare His simplicity and His majesty."
Yet despite Clement's opinion, varied Holy Spirit images graced church walls and
private canvases. They included:

C L O U D At the Annunciation the angels told Mary, "The Holy Spirit will
come on you, and the power of the Most High will overshadow you" (Lk. 1:35). At
the Lord's transfiguration on the mountain, a cloud enveloped the disciples and a
voice spoke to them (Lk. 9:34–35). In the Old Testament, the Israelites followed a

pillar of cloud by day as they traveled the wilderness (Exod. 13:21). **E X A M P L E :** *Moses Parting the Red Sea, Luther Bible,* hand-colored print by unknown artist, sixteenth century. Duchess Anna Amalia Library, Weimar, Germany. In a literal interpretation, an artist colored the sea's vertical waves red, making it the dominant hue in this image of the Israelites after crossing the Red Sea. In this illustration from Luther's Bible, the Israelites and a cloud pillar stand still as the pharaoh's army approaches its death.

D O V E After Jesus emerged from the water at his baptism, the Holy Spirit as a dove rested upon him (Mt. 3:16). In art and symbolism, the dove became the most common expression of the Holy Spirit. **E X A M P L E :** *The Baptism of Christ,* from the Camaldolese Abbey, painting by Piero della Francesca, fifteenth century. National Gallery, London, England. In this painting of Jesus's baptism, Francesca foreshortened the dove above the Lord's head into the same shape as the clouds. It's possible God the Father originally appeared in a roundel above this altarpiece panel, one of Francesca's earliest surviving works.

F I R E During Pentecost "what seemed to be tongues of fire" descended and separated, filling each person with the Holy Spirit (Acts 2:3). In the Old Testament a fire lit the Israelites' path at night as they traveled the wilderness (Exod. 13:21). **E X A M P L E :** *Pentecost,* painting by Duccio di Buoninsegna, fourteenth century. Siena Cathedral, Siena, Italy. Duccio's style turned the powerful, soul-rattling Pentecost into an orderly event. He seated a grim Mary, the mother of Jesus, and eleven somber disciples in a row, with sizeable nimbuses and tiny, individual flames above their heads.

O I L In Scripture, anointing someone with oil for healing or consecration symbolized the Holy Spirit (2 Cor. 1:21; 1 Jn. 2:20, 27). **E X A M P L E :** *The Anointing of David,* painting by Paolo Veronese, sixteenth century. Museum of Fine Arts, Vienna, Austria. Veronese painted David's kingly anointing as an intimate, crowded ceremony. In this painter's unusual version of the event, family members in the foreground, pushing inward to witness the informal ritual, distracted from David and Samuel as the focal point.

W I N D When the Holy Spirit descended at Pentecost, a sound from heaven rushed like a "violent wind" (Acts. 2:2–4.) The apostle John described the Spirit as

a wind blowing "wherever it pleases" (Jn. 3:8). E X A M P L E : *Pentecost*, painting by Joseph Ignaz Mildorfer, eighteenth century. Hungarian National Gallery, Budapest, Hungary. Mildorfer unleashed the restraint of earlier painters, creating a fiery, wind-swept Pentecost accompanied by magnificent angels and a brilliant dove. In the group below, some looked up in fearful astonishment while others fell to the ground, covering their faces.

PART THREE

The Unseen World

Every beauty which is seen here by persons of perception resembles more than anything else that celestial source from which we all are come.

—MICHELANGELO BUONARROTI,
SIXTEENTH CENTURY

11
Choirs of Angels

Let us consider the whole multitude of angels—
how they stand always ready to minister to his will.
For the Scripture says, "Thousands upon thousands attended him;
ten thousand times ten thousand stood before him" (Dan. 7:10).

—CLEMENT OF ROME, FIRST CENTURY

In the eighth century BC the prophet Isaiah unexpectedly witnessed God's glory. While praying in the temple, his eyes opened to a heavenly vision. Isaiah saw the Lord seated on a glorious throne, "high and exalted" (Isa. 6:1). Surpassing the splendor of priestly liturgical vestments, the Lord's robe overflowed the temple. A thundering whoosh of six-winged creatures flew above the throne, calling to one another, "Holy, holy, holy is the LORD Almighty; the whole earth is full of his glory" (Isa. 6:3). Their voices shook the doorposts and thresholds of the smoke-filled temple.

Faint and distraught, Isaiah cried, "Woe to me! I am ruined! For I am a man of unclean lips, and I live among a people of unclean lips, and my eyes have seen the King, the LORD Almighty" (6:5). Then one of the creatures flew to Isaiah, holding a fiery coal pulled from the altar. The creature touched the prophet's mouth and proclaimed, "See, this has touched your lips; your guilt is taken away and your sin atoned for" (6:7).

The six-winged creatures were seraphim. They belonged to a vast hierarchy of angels, the wondrous and terrifying creatures who obeyed and ministered, warned and protected, worshiped and celebrated in heaven and earth.

Like the ancient Jews, the burgeoning number of Christians believed in angels and their interactions with the divine and human. However, few people beyond the clergy understood the many types of angels hovering in the universe. Accordingly, artists portrayed the wonder of angels from the following three spheres of responsibility.

First Sphere

In Christian art, angels of the first sphere guarded God's throne.

S E R A P H I M Seraph (singular). Isa. 6:1–7. "Holy, holy, holy is the LORD Almighty," cried the worshiping seraphim, the highest choir of angels (6:3). In Isaiah's vision these six-winged angels attended and guarded God's throne. Two wings covered the seraphim's faces and two wings hid their feet. They flew with the other two wings. In ancient Hebrew the name *seraphim* meant "the burning ones." E X A M P L E : *Madonna and Child with Angels*, relief sculpture by Antonio Rossellino, fifteenth century. Metropolitan Museum of Art, New York, New York. One of the most gifted sculptors of his time, Rossellino shaped a seated, haloed Mary with a protective arm shielding the baby Jesus on her lap. Always attentive to detail, the sculptor framed the Virgin with the heads and wings of seraphim, creating a feathery background.

C H E R U B I M Cherub (singular). Heb. 9:5. According to Scripture, these angels protected the Garden of Eden after Adam and Eve's departure (Gen. 3:24). Artisans carved cherubim for the Tabernacle's cover (Exod. 25:18–22) and wove their images into the curtains (36:35). Gold cherubim sheltered the Ark of the Covenant (1 Chron. 28:18). Ancient Jewish and Christian traditions believed these double-winged angels guarded God's glory. However, generations of art lovers have confused biblical cherubim with the chubby, baby-faced cherubs of popular art. In fact, calling them "cherubs" is a misnomer. The correct name is putti, plentiful in Renaissance and Baroque art. A putto (singular) also indicated Cupid, the Roman mythical god of love and beauty. E X A M P L E : *The Ark of the Covenant Supported by Cherubim*, mosaic by unknown artists, fifth century. The Oratory of Theodulf of Orléans, Germigny-des-Prés, France. Scholars suggest Western Christians imported this Byzantine mosaic from Ravenna, Italy, and restructured it in the dome of this ninth-century Carolingian church. If not, mosaicists from the East—perhaps escaping iconoclasm—migrated to the West to practice their skills. In this predominantly blue, black, and gold dome, artists allowed cherubim to dominate the scene, joining wings and hovering over the ark, their robes whipping in the wind.

THRONES Col. 1:16. In the Bible, thrones symbolized God's justice and authority and expressed peace, humility, and submission. These high celestial beings allowed the lower angels access to God. Also called *ophanim* (Hebrew), the thrones don't fit the common perception of angels. They took the form of fiery wheels with multiple eyes. E X A M P L E : *The Choirs of Angels*, mosaic by unknown artists, thirteenth century. Saint John Baptistery, Florence, Italy. Venetian mosaicists amplified the Last Judgment in this ceiling dome, with an enormous Christ flanked by two Judgment Angels, and grisly images of sinners suffering in hell. However, the artists also pieced together seven tiers around the ceiling's uppermost lantern, and the first row depicted thrones, dominions, and powers on a gilded background.

Second Sphere

Artists also represented angels of the second sphere, who served as heavenly governors.

DOMINIONS Eph. 1:21. In early Christian belief, dominion angels announced God's commands. In a leadership role over created matter, they ruled as the highest angels in the cosmos watching over order, discipline, and human happiness. They also regulated the duties of other angels. E X A M P L E : *Madonna and Child with Saints and Angels*, painting by Lippo Memmi, fourteenth century. Metropolitan Museum of Art, New York, New York. Memmi painted the nine choirs of angels holding their visual attributes and surrounding the Madonna and Child. Although artistic tradition usually depicted dominions holding swords or scepters, Memmi painted them carrying censers, which usually represented the people's prayers. This panel formed a diptych with the Crucifixion panel at the Louvre in Paris, France.

VIRTUES Eph. 1:21. Early Christians believed virtues managed the elements of nature, primarily supervising the movements of the heavenly bodies so the cosmos remained orderly. They controlled seasons, stars, the moon, and the sun. These almost transparent angels also created miracles and offered grace and courage. E X A M P L E : *The Assumption of the*

Virgin, painting by Francesco Botticini, fifteenth century. National Gallery, London, England. Botticini detailed his painting with colorful choirs of angels, divided into three hierarchies, witnessing the Virgin Mary's entrance into heaven. In an unusual stroke, for the second tier he mingled saints with the angelic dominions, virtues, and powers. Perhaps he illustrated the belief that virtues encouraged saints.

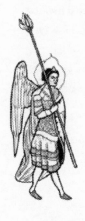

P O W E R S Eph. 1:21. In Scripture and tradition, the powers served as warrior angels who protected humans and the cosmos. They fought evil spirits who stirred up chaos through humans, and they distributed earthly power among the world's peoples. Some scholars believe no power angel ever fell from grace; others think Satan was a power before he left heaven (Eph. 6:12). **E X A M P L E :** *Chasuble*, Gosser Ornat Pontifical Set, embroidery by unknown artists, thirteenth century. From the Goess Convent, Styria, Austria. Austrian Museum of Applied Arts, Vienna, Austria. Aside from archangels, specific angels in art usually appeared in illustrations of the nine choirs, crowded together around Christ or his mother. Unusually, this chasuble designer represented each of the choirs with a single angel standing underneath nine arches, including a power. However, this artist differentiated the angels more by color and size than by visual attributes.

Third Sphere

Most frequently mentioned in Scripture and depicted in art, angels in the third sphere worked as heavenly messengers and soldiers.

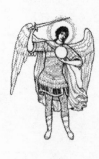

A R C H A N G E L S Jude 1:9. Artistic renditions of the archangels Michael, Gabriel, and Raphael varied, but they almost always revealed splendor, especially with their magnificent demeanors and wings. Translated from ancient Greek, archangels meant "chief angels" and "messengers." In Scripture they delivered messages at important times in spiritual history, such as the Annunciation and the Apocalypse. **E X A M P L E :** *The Three Archangels and Tobias*, painting by Fra Filippino Lippi, fifteenth century. Sabauda Gallery, Turin, Italy. Looking more feminine than

masculine—with gentle facial features and long, curly hair—the three archangels accompanied Tobias on his walking journey. Lippi painted Michael displaying a sword for protection, Raphael holding the young man's hand for guidance, and Gabriel shouldering a long-stemmed lily to symbolize purity.

P R I N C I P A L I T I E S Principality (singular). Rom. 8:38–39. According to tradition, God created these angels to carry out orders from the dominions, bless the material world, oversee people groups, and inspire human endeavors. Unfortunately, the principalities rebelled, fell from heaven, and remained hostile toward God. However, principalities couldn't usurp God's power. **E X A M P L E**: *The Last Judgment: The Damned*, painting by Luca Signorelli, fifteenth century. Orvieto Cathedral, Orvieto, Italy. Signorelli's disturbing fresco joined 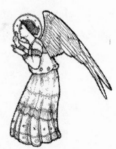 a group of paintings in the chapel's ceiling, foretelling events of the Last Judgment. The artist painted demons, perhaps principalities, carrying terrified sinners to hell while archangels with swords watched from the sky above, protecting the entrance to heaven.

A N G E L S Ps. 103:20. In biblical stories angels drew closest to humans and the physical world. They delivered prayers to God and his messages to people. Angels assisted those who needed help and accessed other angels at any time. **E X A M P L E**: *Linaioli Tabernacle*, painting by Fra Angelico, fifteenth century. Saint Mark's Museum, Florence, Italy. On the inside of this altarpiece, Fra Angelico painted twelve musician angels bordering a painting of the Madonna and her Child. Fra Angelico is best known and beloved for his Renaissance paintings of angels.

12
The Afterlife

God hath given to man a short time here upon earth,
and yet upon this short time eternity depends.

—JEREMY TAYLOR, SEVENTEENTH CENTURY

Especially in the eleventh and twelfth centuries, artists and patrons planned works of art that extolled the majesty of a heavenly Jerusalem. In frescoes and mosaics, images of Christ in glory covered apses and walls, assuring Christians of God's supremacy and the promise of heaven. In this image Christ dominated, positioned in the center and surrounded by saints, angels, and evangelists. Both Eastern and Western artists emphasized his eternal kingship and inferred Satan's ultimate defeat.

In a sobering theology about the afterlife, the early church fathers extolled heaven as a reward for those who persevered in the faith, and hell for those who didn't. The third-century theologian Origen explained, "The apostolic teaching is that the soul . . . after its departure from the world, will be recompensed according to its deserts. It is destined to obtain either an inheritance of eternal life and blessedness if its actions will have procured this for it, and to be delivered up to eternal fire and punishments if the guilt of its crimes will have brought it down to this."

Medieval and Renaissance art, especially church art, warned people about their eternal destination. Accepting Christ rewarded them with heaven; rejecting him condemned them to hell. The sculptor Gislebertus carved the front portal for the Saint Lazarus (Lazare) Cathedral in Autun, France, with the unpleasant prospect of the archangel Michael weighing souls in the afterlife. Christ stood at the composition's center, dividing groups of the "saved" and the "damned." Each Sunday, the parishioners were reminded of a coming judgment. Later, the seventeenth-century English poet John Milton claimed death is the golden key that opens the palace of eternity. Christians hoped for that eternal palace.

The basic Christian lexicon about the afterlife included these people, creatures, and places.

D A M N E D Mk. 16:16. Beginning with early Christian theology, damned people rejected God, died in sin, and spent eternity in hell. **E X A M P L E :** *The Fall of the Damned*, painting by Frans Francken II (known as the Younger), seventeenth century. Museum of Fine Arts, Vienna, Austria. Francken painted a picture of terror with naked, writhing bodies falling downward after God condemned them to a perpetual hell. Many images of people sentenced to hell depicted them miserably descending toward an often unseen abyss.

D E M O N S A N D A R C H D E M O N S 1 Tim. 4:1. Scripture and early Christian theology pointed to the belief that angels who fell from heaven turned into demons who constantly harassed and tempted people to sin. In the Middle Ages, scholars believed archdemons existed as evil parallels to God's archangels. The archdemons included Lucifer for pride; Mammon for avarice; Asmodeus for lechery; Satan for anger; Beelzebub for gluttony; Leviathan for envy; and Belphegor for sloth. **E X A M P L E :** *Saint Michael Vanquishing the Devil*, painting by Bonifacio Veronese (Bonifazio de' Pitati), sixteenth century. Saints John and Paul Basilica, Venice, Italy. Veronese emphasized that God always triumphs, by painting a powerful image of an archangel striking down Lucifer. In this composition, the painter showed the archangel literally maintaining the "upper hand" by brandishing a sword and causing the demon to fall backward toward a desolate landscape below.

H E A V E N Mt. 18:3. From the beginning of the faith, Christian images depicted heaven as a magnificent place reserved for the "redeemed," those who repented and asked God to absolve their sins. In turn, the redeemed dwelt with God for eternity. **E X A M P L E :** *The Last Judgment, Detail of Heaven*, painting by Fra Angelico, fifteenth century. Saint Mark's Museum, Florence, Italy. Heaven is virtually unexplainable, so Fra Angelico painted the eternal dwelling in images understood on earth. In this detail of a larger painting, he organized angels and the redeemed in a circle, dancing and celebrating in a lush garden setting.

H E L L Mt. 18:9. Christian art depicted hell as a place of eternal annihilation and alienation from God—a dark underworld where he punished the damned for their sins. **E X A M P L E :** *Hell*, painting by Master of the Triumph of Death, fourteenth century. Sinopie Museum, Pisa, Italy. In this fresco depicting hell, an artist painted the grotesque and unconscionable: a gigantic devil with horns;

people boiling in hot liquid; naked men in chains; and more. Most images of hell represented the worst possible an artist could imagine about a tormented afterlife, beyond the bounds of decency. The patron clergy intended these images to frighten people toward belief, repentance, and participation in the church.

I N D U L G E N C E An indulgence pardoned part or all of the punishment for confessed sins, supposedly reducing time spent in purgatory before progressing to heaven. In the eleventh century, Pope Urban II issued the first plenary indulgences for people who participated in the Crusades and confessed their sins. Later, cash contributions substituted for personal involvement in the Crusades. In the next centuries the church eventually abused indulgences, awarding them for promoting its spiritual, political, and financial missions. In the late fifteenth century Pope Innocent VIII pawned his tiara, sold sacred titles and appointments to the highest bidders, and bestowed generous indulgences to rescue his papal and personal cash flow. By the sixteenth century, the monk Martin Luther protested scandalous indulgences and launched the Protestant Reformation. E X A M P L E : *Letter of Indulgence to the Church of Saint Nicolas*, illuminated text by unknown artist, fifteenth century. State Archives, Hamburg, Germany. The letter of indulgence to the Church of Saint Nicolas dated June 22, 1484, earned its place in history as a work of art, displaying sacred people, flowered borders, fanciful script, and nine red papal seals stitched and dangling from the bottom edge.

L A S T J U D G M E N T 2 Cor. 5:10. Since Christ's ascension, his followers have believed that after his second coming and resurrection of the dead, he will conduct a final judgment of all people. Especially during the Middle Ages, Last Judgment art showed Christ separating the "saved" from the "damned." The sinners sentenced to eternal punishment stood on his left, and believers who received eternal life appeared on the right. Especially at the end of the first millennium, these images proliferated because many believed Christ would return at the dawn of AD 1000. E X A M P L E : *The Last Judgment*, painting by Giorgio Vasari and Federico Zuccari, sixteenth century. Florence Cathedral, Florence, Italy. Vasari and Zuccari painted a detailed fresco in the cupola of the famous cathedral. The wealthy art patron Duke Cosimo I de' Medici commissioned the work as a response to the Council of Trent's revision and clear delineation of the Roman Catholic Church's beliefs. The design carefully divided into sections, with themes incorporating men from the Apocalypse; an angelic chorus with instruments of the Passion; saints

and the Elect; gifts of the Holy Spirit; a region of hell; Christ in glory with the Madonna and Saint John; the virtues of faith, hope, and charity; allegorical figures of time; and the church triumphant. Vasari drew his inspiration from Michelangelo Buonarroti's Sistine Chapel frescoes.

PARADISE Rev. 2:7. In art and some Christian belief systems, paradise encompassed a lovely place in the afterlife where believers stayed temporarily, waiting for God to create a new heaven and earth. In some works, artists depicted paradise as the Garden of Eden. EXAMPLE: *Paradise*, painting by Bartolomeo Neroni, sixteenth century. National Art Gallery, Siena, Italy. Neroni envisioned paradise with crowds clamoring for God the Father and the Virgin Mary. In this Renaissance composition, he populated every inch of a panel's surface with angels, saints, biblical people, and other believers drawing near to these two sacred figures.

PURGATORY In some Christian traditions, artists depicted purgatory as a temporal punishment for believers who didn't complete penance for all their sins. Purgatory refined and purified believers from their past transgressions. EXAMPLE: *Initial "P" Showing Dante Setting Sail for Purgatory*, *The Divine Comedy*, illuminated-manuscript page by unknown artist, fifteenth century. British Library, London, England. With a full-page, historiated letter *P*, the illuminator announced a metaphorical voyage through purgatory drawn from the epic poem *The Divine Comedy*, written by Dante Alighieri in the thirteenth century. Within the initial letter, the artist painted Dante's boat sailing into the dark mystery of a punishing and purifying land between hell and heaven.

SATAN OR DEVIL 1 Pet. 5:8. Formerly an angel, Satan rebelled against God, and Scripture mentions his subsequent outcast from heaven. The former worshiper transformed into a worst enemy, railing against God and his people. The apostle Peter described Satan, also known as the devil, as a roaring lion, seeking Christians to devour. Accordingly, he admonished Christ's followers to recognize and defeat the devil's surprise and subversive attacks. EXAMPLE: *Saint Margaret of Cortona Vanquishing the Devil*, painting by Domenico Fetti, seventeenth century. Pitti Palace, Florence, Italy. In this dramatic scene, Fetti painted Margaret chaining and defeating the devil, then looking upward to ask God a question. Most likely, the artist represented the saint's former struggle, living with

and bearing a child to a man she never married. After his murder, she repented and joined a Franciscan convent.

S A V E D Acts 16:31. In art about the afterlife, people who repented of their sins and received baptism became "the saved" and spent eternity in heaven with God. **EXAMPLE:** *The Calling of the Chosen to Heaven*, painting by Luca Signorelli, fifteenth century. Orvieto Cathedral, Orvieto, Italy. In the lunette (arch) of this important cathedral church, Signorelli painted a fresco of angels playing lutes and harps in the sky, drawing Christians toward their eternal life in heaven. He included the naked and partially clothed Elect ("saved" people) gathered below, looking up with wonder.

Faithful Followers

A knowledge of symbolism is highly requisite for those who study the works of Christian art; for there is scarcely a picture handed down to us from the Middle Ages, containing sacred figures, that symbols are not in some way introduced; and, as a rule, these symbols exercise no mean influence on the composition.

—W.G. AUDSLEY

13

Old Testament People

If all things were made through him, clearly so must the splendid revelations
. . . made to the fathers and prophets, and became to them the symbols
of the sacred mysteries of religion.

—ORIGEN, THIRD CENTURY

After the first Christians transitioned from Judaism, they retained their connection to the Hebrew Scriptures' stories and teachings. Although their new theology freed them from Old Covenant laws (Rom. 8:1–3), they revered the Torah's contribution and eventually included it in the canonical books of the Bible. Christians held to the Old Testament, along with the more recent writings from apostles. They believed many ancient Jewish stories formed typologies, serving as metaphors or "types" foreshadowing Christ, the church, or Christian sacraments.

The study of typology began with the teachings of Philo of Alexandria in Egypt, a contemporary of the apostle Paul in the first century, followed by the third-century teacher Origen, also from Alexandria. Origen taught three levels of scriptural interpretation: first, the literal or historical meaning utilizing the human senses; second, the moral or typological meaning touching the soul; and third, the allegorical or transcendent meaning reaching the spirit. As Christians looked at Old Testament art, they often searched for these meanings. The stories and images of ages past prophesied and offered insights to their New Covenant beliefs centered on Christ.

Minimally, Hebrew Scriptures told stories that warned, instructed, and inspired Christians. Whatever believers gleaned from these ancient narratives, they claimed the Old Testament as their spiritual heritage. Especially in Christianity's early years, art focused on Old Testament stories for encouragement, especially during times of persecution. Accounts of Moses crossing the Red Sea, the big fish swallowing Jonah, and Esther saving her people from slaughter reminded them of God's grace and power to sustain and rescue his people.

The following list, although not comprehensive, presents Old Testament characters commonly featured in Christian art. The biblical references narrate these characters' biographies or major parts of their life stories.

A A R O N Exod. 4:14–12:51. The older brother of Moses and Israel's first high priest. He also served as Moses's spokesperson and assistant during the Israelites' exodus from Egypt. Moses commanded, and Aaron stretched out his rod to punish Egypt with the first three plagues. **E X A M P L E :** *Aaron*, stained-glass window by unknown artists, thirteenth century. Chartres Cathedral, Chartres, France. Artisans showcased the beauty of stained-glass colors by decorating Aaron with multiple bright hues. Positioning Aaron in a place of honor, below the north rose window, the designer fused a brilliant budding rod in Aaron's hand and a Jewish priestly ephod (liturgical garment) on his shoulders.

A B E L Gen. 4:2–8. The second child of Adam and Eve. Abel worked as a shepherd, and his jealous brother, Cain, killed him. Cain raged and murdered because God accepted Abel's sacrifice and not his. **E X A M P L E :** *Abel Slain by Cain*, drawing by Peter Paul Rubens, seventeenth century. Fitzwilliam Museum, University of Cambridge, Cambridge, England. Rubens envisioned a dead Abel who looked like an anatomy lesson from classical art. He drew a naked, muscular young man sprawled across the ground, with his tousled, godlike hair and frontal body parts in precise and full view.

A B R A H A M Gen. 11:29–25:8. The father of the Jewish nation. The Lord often tested Abraham's faith and character. For example, Abraham waited many years for a son, Isaac, and then God asked the father to sacrifice his child. Abraham obeyed and prepared, but the Lord saved his son with a ram sacrifice instead. **E X A M P L E :** *The Sacrifice of Isaac*, painting by Jacob Jordaens, sixteenth century. Brera Art Gallery, Milan, Italy. Although Abraham and Isaac dominated the biblical story, visually Jordaens moved them aside to focus on the flaring, white wings of a rescuing angel. Before the angel arrived, a trembling father raised an arm to slay his son. In turn, the humble boy knelt on an altar, wrists tied and head bowed.

A B S A L O M 2 Sam. 13:1–19:4. Prince of Israel. Born to King David and his wife Michal, Absalom turned heads as Israel's handsome prince. Absalom attempted to usurp his father's kingdom and died in the ensuing battle after losing his horse. Despite the prince's repeated mistakes and rebellions, David loved and mourned his son. **E X A M P L E :** *The Death of Absalom*, painting by Francesco di Stefano Pesellino, fifteenth century. Tesse Museum, Le Mans, France. Pesellino painted Absalom's death scene more pretty than tragic, reflecting the Renaissance

preference for beauty. As Absalom's white horse with red regalia pranced forward, looking like a carousel pony, the prince's golden hair tangled in branches of a flowering tree. Pesellino depicted Absalom dramatically flinging out his arms, as if for stage effect.

A D A M Gen. 2:7–3:24. According to Scripture, the first human created by God. He named the animals and birds, living in perfect fellowship with their Maker. However, when Adam and his wife, Eve, ate forbidden fruit, they broke their pure relationship with God. The Lord banished the couple from Eden. **E X A M P L E**: *Adam and Eve Banished from Paradise*, painting by unknown artist, fourteenth century. Episcopal Archaeological Museum, Vic, Spain. In this unusual interpretation of the Fall's aftermath, a painter from the Catalan school depicted a scrawny couple holding fig leaves over their pubic areas and exiting Eden's pink, turreted gates. They've been accompanied by a red-winged angel who carries a sword but exudes maternal kindness, as if to wish them well.

B A T H S H E B A 2 Sam. 11:1–12:24. King David's wife. David lusted after Bathsheba, the wife of Uriah the Hittite. When Bathsheba conceived David's child, the king ordered Uriah into the fiercest battlefront, where he died. David then married Bathsheba. The Lord told the prophet Nathan to rebuke David, and the king repented. The child died, but Bathsheba later gave birth to another son, Solomon. **E X A M P L E**: *Bathsheba*, painting by Paris Bordone, sixteenth century. Hamburg Art Gallery, Hamburg, Germany. Bordone's version of Bathsheba's bath contradicted the biblical impression of a private ritual. He painted a background of classical buildings suggesting a city, with the famed beauty, nude and unabashed, seated in the foreground, pouring water from a public fountain into a bowl.

C A I N Gen. 4:1–17. The first son of Adam and Eve. When Cain murdered his brother, God confronted him about Abel's death. Cain acted churlish and evasive. Consequently, God cursed Cain but marked him so no one would kill him. Cain then fled to the land of Nod and founded the city of Enoch. **E X A M P L E**: *The Killing of Abel*, Grabow altarpiece, painting by Master Bertram of Minden, fourteenth century. Hamburg Art Gallery, Hamburg, Germany. Master Bertram used colors and body types symbolically in this altarpiece painting. The painter applied a fiery red reminiscent of Satan to Cain's garment, wrapped tightly against a thin, angular body. For Abel, he applied a peaceable green to a loose robe worn

by a more rounded figure. With a pleading Abel thrown to the ground and Cain hovering over him, ready to strike, Master Bertram constructed an allegory of good and evil.

D A N I E L Book of Daniel. A prophet in Babylon. Daniel lived for years as a Babylonian prisoner. Because of his wisdom and gift for dream interpretation, he became a high official in the kingdom. Jealous government officials plotted to kill Daniel in the lion's den, but God saved him. E X A M P L E : *The Dream of Daniel*, ceramic plate painting by unknown artist, sixteenth century. Detroit Institute of Arts, Detroit, Michigan. Although apocalyptic images constituted an unusual choice for a decorative plate, at least the anonymous painter recreated Daniel's frightening dream about "the end of days" in beautiful colors. He dominated the ceramic plate with blues, usually a calming color, to represent the terrifying images in Daniel's dream. He also employed a palette of oranges and yellows, especially in the wings of an angel descending to interpret the prophet's dream.

D A V I D 1 Sam. 16:1–1; Kgs. 2:11. King of Israel. The prophet Samuel anointed young David, a shepherd and musician, to be Israel's future king. As a youth David defeated the Philistine giant, Goliath, with a simple slingshot. His sins and foibles notwithstanding, Jews and Christians memorialized him as "a man after [God's] heart" (Acts 13:22). David wrote psalms and ruled his kingdom for forty years. E X A M P L E : *David and Goliath*, illuminated-manuscript page by Jean Colombe, fifteenth century. Marmottan Museum, Paris, France. Many medieval and Renaissance visual depictions of David and Goliath featured the young conqueror admiring or holding the slain giant's severed head. In contrast, Colombe painted the moment when the unarmed shepherd readied to hit the towering and unconcerned giant in full battle armor.

D E B O R A H Judg. 4–5. A judge and prophetess to Israel. Deborah and the military leader Barak warred against the Canaanites and won. She predicted that Sisera, the Canaanite leader, would die at the hands of a woman. This prophecy materialized when Jael nailed a tent peg into Sisera's head while he slept. E X A M P L E : *Jael, Deborah, and Barak*, painting by Salomon de Bray, seventeenth century. Catharijneconvent Museum, Utrecht, the Netherlands. De Bray painted the three key figures in conquering the ancient Canaanites. With an astonishingly realistic style, the painter presented each face with deep emotion: a wrinkled

Deborah lifting tired and serious eyes to heaven; a defiant Jael, holding a hammer and peg, disdainfully challenging the viewer; and a sober Barak, wearing his battle armor, projecting a confident serenity.

E L I J A H 1 Kgs. 17–19; 2 Kgs. 1:1–2:11. A prophet to Israel. Elijah's prophecy that no rain would fall in Israel except at his command enraged the wicked King Ahab. The prophet further angered Ahab and his wife, Jezebel, when he shamed and killed the prophets of Baal. At the end of Elijah's life, God delivered the prophet to heaven in a chariot of fire. **E X A M P L E :** *The Prophet Elijah*, painting by unknown artist, thirteenth century. State Tretyakov Gallery, Moscow, Russia. The Byzantine and early Orthodox artists painted many prophet portraits on icons. An iconographer from the Pskov School in Russia painted this Elijah portrait, portraying the prophet in a thoughtful mood and framing him with images from his life, biblical characters, and archangels.

E L I S H A 2 Kgs. 2:1–13:21. A disciple of Elijah and prophet to Israel. Elisha succeeded Elijah's ministry and received a "double portion" of Elijah's spirit (2:9). Elisha raised the dead, multiplied food, healed the sick, and prophesied the future. When mourners placed a dead body in Elisha's tomb, contact with the prophet's corpse revived the recently deceased man. **E X A M P L E :** *Miracle of Elisha's Tomb*, from the *Nuremberg Bible*, colored woodcut by unknown artist, fifteenth century. Private collection. A German artist depicted this Old Testament miracle in a late medieval setting, with startled figures clothed in garments from that era. He imagined a cemetery near a castle, where frightened Moabite grave robbers drew back at the sight of a resurrected man and an animated skeleton probably representing Elisha's bones.

E S A U Gen. 25:24–34; 26:34–27:45; 33:1–16. A twin son of Isaac and Rebekah. Esau, a hunter, sold his birthright to his twin brother, Jacob, for a bowl of stew. Jacob and Rebekah also tricked Isaac into giving Jacob his brother's firstborn blessing. This treachery caused a breach between the brothers for many years. **E X A M P L E :** *Isaac Rejects Esau*, painting by Giotto di Bondone, thirteenth century. Saint Francis of Assisi Basilica, Assisi, Italy. As part of a famous fresco series, Giotto painted Isaac partially rising from a medieval-style bed and rejecting Esau's rightful request for a firstborn's blessing. He stood the guilty Rebekah directly behind the desperate Esau reaching his hands out, begging his father.

E S T H E R Book of Esther. Queen of Persia. King Ahasuerus of Persia chose Esther, a beautiful Jewess, to be his queen. When Esther learned about the evil Haman's plot to exterminate the Jews, she risked her life to save them. **EXAMPLE:** *Scenes from the Story of Esther*, painting by Sandro Botticelli and Fra Filippino Lippi, fifteenth century. Louvre, Paris, France. Accepting a commission, Botticelli designed scenes from Esther's life on a bridal chest, probably leaving the actual painting to his disciple, Filippino Lippi. The scenes on this panel include the *Lamentation of Mordecai, Esther's Uncle*; the *Swooning of Esther, Who Has Come to Ask Her Husband, King Ahasuerus of Persia, to Save the Kingdom's Jews*; and the *Grand Vizier Aman Pleads in Vain with Esther to be Spared*. Two other images from this chest belong to different museums: *Mordecai in Tears* (Pallavicini Collection, Rome, Italy) and the *Triumph of Mordecai* (National Gallery of Canada, Ottawa, Ontario, Canada).

E V E Gen. 2:18–3:24. According to Genesis, the first woman created by God. In Hebrew her name meant "Mother of All Living." A serpent tempted Eve to eat forbidden fruit in the Garden of Eden. She sampled it and so did her husband, Adam. Their eyes opened to good and evil, and God banished the couple from their perfect garden home. **EXAMPLE:** *Eve*, painting by Albrecht Dürer, sixteenth century. Prado Museum, Madrid, Spain. Dürer mastered a simple panel painting of Eve, with legs crossed, contemplating her decision to eat the fruit, with a snake wrapped around a tree branch, watching her. Although Eve hadn't yet decided to sin, the artist painted her wearing a fig leaf.

E Z E K I E L Book of Ezekiel. A priest and prophet to Israel. King Nebuchadnezzar's soldiers dragged the young Ezekiel into exile. Then at thirty years old, Ezekiel accepted God's call to prophesy to the rebellious Israel. His stirring vision of dry bones rattling to life promised spiritual renewal, if the people repented. **EXAMPLE:** *Roundel of the Prophet Ezekiel*, stained-glass window by unknown artists, fifteenth century. Victoria & Albert Museum, London, England. Artisans fashioned a "message panel" for Ezekiel, in which a prophet held a scroll with an anticipatory text. Ezekiel's scroll presented this promise in Latin: "I shall pour out pure water upon you" (Ezek. 36:25, paraphrased).

G I D E O N Judg. 6:11–8:35. A judge in Israel. God raised up Gideon to defeat the Midianites. Gideon tested the Lord's promise first and then, with only three hundred men, he defeated the large Midianite army. **EXAMPLE:** *Gideon*

and the Fleece, painting by unknown artist, fifteenth century. Little Palace Museum, Avignon, France. The artist placed a lamb-shaped fleece on the ground in front of the full-armored Gideon. Praying toward heaven, Gideon witnessed an angel listening to his plea.

H A N N A H 1 Sam. 1:11–2:11. Mother of the prophet Samuel. The barren Hannah begged God for a baby, promising to dedicate the child to him. God granted this request, and she named her son Samuel. When Hannah weaned Samuel, she took him to the temple to live with Eli the priest. **E X A M P L E :** *Hannah's Prayer*, Paris Psalter, illuminated-manuscript page by unknown artist, tenth century. National Library of France, Paris, France. With brilliant shining colors, the iconographer transformed Hannah's pleading stance toward heaven from simple to spectacular. By gilding her halo and painting royal red-and-blue garments, the artist honored Hannah's place in biblical history.

H E Z E K I A H 2 Kgs. 18–20. King of Judah. Under Hezekiah's leadership, Levites cleansed the temple and restored worship. The Assyrians threatened Hezekiah's nation when he fell terminally ill. The king prayed for healing and a longer life. God healed Hezekiah and lengthened his life by fifteen years. **E X A M P L E :** *King Hezekiah*, stained-glass window, thirteenth century. Chartres Cathedral, Chartres, France. In the north rose window, artisans regally seated King Hezekiah in a tilted square, pointing toward his scepter, a sign of royal authority. The window designer created a thematic rose window featuring the Kings of Israel and Judah, both virtuous and villainous.

I S A A C Gen. 21:1–28:5; 35:27–29. The son of Abraham and Sarah. Isaac married Rebekah, who gave birth to twins, Jacob and Esau. Isaac's wealth grew and God blessed him, despite his propensity to lie when in danger, claiming Rebekah as his sister. In turn, Rebekah tricked Isaac into giving Jacob an undeserved blessing. **E X A M P L E :** *Isaac*, relief sculpture by Pietro Lombardo, fifteenth century. Saint Mary of the Friars Basilica, Venice, Italy. Lombardo sculpted a middle-aged Isaac in high relief, accompanied by intense emotion in his weary face. The artist centered the patriarch in a protruding octagonal shape, a symbol for spiritual rejuvenation.

I S A I A H Book of Isaiah. A prophet to the nation of Judah. Isaiah prophesied in the last year of King Uzziah's reign and through the kingships of Jotham, Ahaz,

and Hezekiah. The prophet denounced idolatry and the sinful practices of his people. He also delivered messianic prophecies and messages of hope, redemption, and reconciliation. **EXAMPLE:** *Prophet Isaiah*, painting by Fra Bartolommeo, sixteenth century. Academy Gallery, Florence, Italy. The seated-but-turned Isaiah mimics the pose of Michelangelo Buonarroti's prophets on the Sistine Chapel's ceiling at the Vatican in Vatican City, Italy. However, Bartolommeo painted Isaiah in a Renaissance hat, holding a huge scroll and pointing away from the picture plane.

J A C O B Gen. 25:21–35:29; 37:1–35; 45:25–49:33. A twin son of Isaac and Rebekah. With a name that meant "supplanter or deceiver," Jacob stripped his brother Esau of his birthright and rightful blessing. Jacob married Leah, whom he did not love, and then Rachel, whom he loved. He met and wrestled with God in the desert, and the Lord renamed him "Israel." **EXAMPLE:** *The Dream of Jacob*, painting by Alessandro Allori, sixteenth century. Sabauda Gallery, Turin, Italy. Allori painted the sleeping Jacob with the ascending and descending angels in shades of gold, contrasting them with a nighttime background. Overall, the image looks as if God highlighted the characters in a narrative with his heavenly light.

J E R E M I A H Book of Jeremiah. A prophet to Judah. Jeremiah contended with kings and false prophets as he proclaimed the Lord's words. Imprisoned, clamped in stocks, and thrown into a muddy cistern, Jeremiah suffered for his obedience to God. He became "the weeping prophet" because of his mournful, gloomy prophecies. **EXAMPLE:** *The Prophet Jeremiah*, sculpture by Donatello (Donato di Niccolò di Betto Bardi), fifteenth century. Florence Cathedral, Florence, Italy. Donatello sculpted a sober Jeremiah wearing the draped toga and short-cropped hair of an ancient Roman, instead of an Old Testament prophet's robes.

J O B Book of Job. A wealthy man from Uz. At Satan's request, God allowed Job's extreme suffering. The Lord proved that Job's faithfulness to him sprang from love, not because of his riches. Although Job lost his family and possessions, he didn't lose faith in God. **EXAMPLE:** *Satan Asking God to Tempt Job*, painting by Bartolo di Fredi, fourteenth century. Collegiate Church of San Gimignano, Gimignano, Italy. Fredi developed two simultaneous scenes in this fresco for the main church, formerly a cathedral. He devoted most of the image space to Job: prosperous, crowned, and eating like a king. However, in the upper left corner, he painted a small foreboding scene of Satan asking God for unlimited access to tempting and torturing Job.

J O N A H Book of Jonah. A prophet to the city of Ninevah in Assyria. God called Jonah to deliver a message of judgment and repentance to Ninevah. Jonah refused and boarded a ship to escape. Eventually, the ship's crew threw the prophet overboard and a large fish swallowed him. Jonah spent three days and nights in the belly of the fish before it spit him onto dry land. When God again commanded Jonah to preach in Ninevah, he obeyed. The Ninevites repented and God forgave them. **E X A M P L E :** *Jonah*, sculpture by Giovanni Lorenzo Bernini, seventeenth century. Saint Mary of the People Church, Rome, Italy. Contrary to the usual Jonah images, Bernini painted a nude young man attempting to pull a cloth over himself. With polished marble, the sculptor suggested the smooth skin of youth.

J O S E P H Gen. 37; 39:24–50:26. Egyptian ruler and son of Jacob. Jacob called Joseph his favorite son, but his ten older brothers hated him. The brothers sold Joseph to slave traders and claimed wild animals killed him. In Egypt Joseph served Potiphar, a government official. Potiphar's wife falsely accused Joseph of seducing her, and he landed in prison. However, Joseph's gift for interpreting dreams gained attention from prominent Egyptians. Released from jail, Joseph advanced to a position second only to the pharaoh. Joseph reconciled with his brothers when they traveled to Egypt, seeking food during a famine. **E X A M P L E :** *Joseph Sold by His Brothers*, painting by Jacopo da Bologna, fourteenth century. National Art Gallery, Bologna, Italy. In a remnant of an Old Testament fresco, the artist painted Joseph's brothers negotiating the price of their youngest brother. Bologna clothed some figures in Renaissance flowing cloaks and front-pointed hats.

J O S H U A Book of Joshua. Israel's leader into the Promised Land. After Moses died, Joshua led the Israelites out of the desert. Marching around Jericho, Joshua and his warriors defeated the city by blowing trumpets, shouting, and carrying the Ark of the Covenant. When the Israelites fought Jerusalem's king and his army, Joshua asked God for more time. The sun stood still until his men defeated the enemy. **E X A M P L E :** *Joshua*, Morgan Picture Bible or Maciejowski Bible, illuminated-manuscript page by unknown artist, thirteenth century. Morgan Library, New York, New York. Illuminated in Paris, this Bible journeyed to Persia as a papal-mission gift to Shah Abbas the Great. On this page with brilliant hues, the artist featured Joshua conquering the city of Ai and later in league with the Gibeonites.

L E A H Gen. 29:16–30:21. Jacob's wife. Jacob worked seven years to marry Rachel, but her deceitful father, Laban, declared Leah the bride instead. Although Jacob married Rachel later and loved her more, Leah gave birth to six of his sons. They led six tribes of Israel. E X A M P L E : *Rachel and Leah*, sculpture by Michelangelo Buonarroti, sixteenth century. Saint Peter in Chains Church, Rome, Italy. For the tomb of Pope Julius II, Michelangelo sculpted a masterful image of Moses, with smaller sculptures of Leah and Rachel at his sides. He sculpted Leah looking downward, personifying the active life, and Rachel looking upward, depicting the contemplative life. These women represented a belief that the *vita activa* and the *vita contemplativa* marked the two roads to God.

L O T Gen. 13–14; 19. Abraham's nephew. Lot pitched his tent near Sodom. When Canaanite kings captured and defeated Lot, Abraham rescued him. After two angels predicted God would destroy Sodom, Lot fled with his wife and daughters. God warned the family not to look back at the destruction, but Lot's wife cast her eyes on the burning city and turned into a pillar of salt. E X A M P L E : *Lot and His Daughters*, painting by Lucas van Leyden, sixteenth century. Louvre, Paris, France. Against the backdrop of a burning Sodom, Leyden's Lot pitched a tent in the hills and consoled his daughters for the loss of their mother and home.

M O S E S Exod. 2–20; Deut. 1:1–34:7. Deliverer and leader of the Hebrew nation. Adopted and raised by the pharaoh's sister, Moses grew up with royal advantages. However, he killed an Egyptian for abusing an Israelite slave, fled to Midian, and worked as a shepherd. God called Moses back to Egypt to set free the Hebrew slaves. On a forty-year journey to the Promised Land, Moses witnessed many miracles and received the Ten Commandments from God on Mount Sinai in Egypt. E X A M P L E : *David and Moses, Well of Moses*, relief sculpture by Jean Malouel and Claus Sluter, fifteenth century. Carthusian Monastery, near Dijon, France. The sculptors created monumental images of Moses and five other prophets for the burial site of Duke Philip the Bold. Originally, Sluter sculpted the statues for the Carthusian monastery featuring the six prophets who foresaw Christ's death on the cross: Moses, David, Jeremiah, Zachariah, Daniel, and Ezekiel. Each prophet occupied one side of this octagonal work. Malouel painted and gilded the figures.

N A O M I Book of Ruth. Ruth's mother-in-law. Naomi and her family moved to Moab to find relief from Israel's famine. When her husband and two sons died,

she and her Moabite daughter-in-law Ruth returned to Bethlehem in Judea. Naomi advised Ruth to seek protection from Boaz, who acted as her kinsman protector. He fell in love with Ruth and married her. A contented Naomi cared for their son, Obed. **E X A M P L E** : *Ruth and Naomi in the Field of Boaz*, painting by a follower of Jan van Scorel, sixteenth century. Art History Museum, Vienna, Austria. In contrast to the image of impoverished women from ancient Israel, this painter absurdly overdressed Naomi—and especially the short-skirted Ruth—in fanciful sixteenth-century clothing. He painted Naomi's fabric to resemble brocade.

N E H E M I A H Book of Nehemiah. Cup-bearer to the king of Persia and prophet. At Nehemiah's own request, he led Jerusalem's restoration. Eventually named governor of the city, he motivated citizens to rebuild its walls. **E X A M P L E** : *The Prophet Nehemiah*, illuminated-manuscript page by unknown artist, thirteenth century. Saint Genevieve Library, Paris, France. In this miniature the illuminator drew the court official Nehemiah informing the King of Susa that Jerusalem lacked walls. The painter constructed a hieratic scale with the king looming over his subject, indicating royal superiority.

N O A H Gen. 5:29–10:32. Farmer turned prophet. According to Genesis, God tired of humanity's wickedness and vowed to destroy the earth with a flood. However, he told Noah, a righteous man, to build an ark to save his family and the earth's creatures. Noah took seven pairs of every clean animal and two of every unclean animal into the ark with him (Gen. 7:2). After the flood destroyed civilization, the ark floated on high waters for 150 days. When the waters receded, God promised he would never destroy the earth by flood again. A rainbow in the sky symbolized this covenant. **E X A M P L E** : *Noah and the Ark*, mosaic by unknown artists, twelfth century. Monreale Cathedral, near Palermo, Sicily. Noah's story joined one of the most spectacular mosaic displays in the world. Looking up at the realism on the cathedral's west wall, visitors could almost hear Noah and his sons hammering boards, leading reluctant animals into the ark, and holding their collective breath as he released a dove into the air.

R A C H E L Gen. 29:6–35:20. Shepherdess and Jacob's beloved wife. Jacob wed Leah, and seven years later he also married her sister, Rachel. For years the barren Rachel grieved and complained while Leah bore children. After pleading with God, Rachel eventually gave birth to Joseph and Benjamin. **E X A M P L E** :

Jacob and Rachel, painting by Jacopo Palma, sixteenth century. Old Masters Picture Gallery, Dresden, Germany. In this painting, Palma relied on his imagination rather than the biblical account. He painted Jacob and Rachel in clothing contemporary to the artist's day, with Jacob planting a passionate kiss on Rachel, in front of two curious shepherds.

R E B E K A H Gen. 24; 25:21–27; 27; 49:31. Isaac's wife. The patriarch Abraham commissioned his servant to find a wife for his son Isaac. When he met Rebekah at a well near her home, she gave him a drink and also watered his camels. Earlier, the servant prayed such kindness would be a sign to him. With her family's permission, Rebekah traveled with the servant to a new home, where Isaac married her. She became the mother of Jacob and Esau. **E X A M P L E :** *Laban Searching for Eliezer at the Well*, painting by Maarten de Vos, seventeenth century. Museum of Fine Arts, Rouen, France. Most artists focused on Rebekah meeting the servant Eliezer at the well, but Vos emphasized a brother's concern and pursuit of his sister's betrothal. The painter created palatable tension as Laban searches for the servant, on behalf of his father, Bethuel, and his sister Rebekah. Laban proved instrumental in arranging Rebekah's marriage to Isaac.

R U T H Book of Ruth. A Moabite widow. Both newly widowed, Ruth and her mother-in-law, Naomi, traveled to Bethlehem in Judea. Following Naomi's advice, Ruth gleaned in the fields of Boaz, her kinsman protector. Boaz noticed Ruth and married her. They became the parents of Obed, the grandfather of King David. **E X A M P L E :** *Historiated Initial "I" Depicting Ruth with Her Husband and Sons*, Book of Ruth (Livre de Ruth), illuminated-manuscript page by unknown artist, thirteenth century. Laon Municipal Library, Laon, France The illuminator told the outcome of Ruth's story in elongated form, with Boaz, Ruth, and their sons virtually stacked on top of one another in a historiated capital *I*. The illuminator also chose to reveal the rewarding outcome of Ruth's trials, rather than depict her difficulties, like many other medieval artists.

S A M S O N Judg. 13–16. A Nazarite judge. Known for great physical strength, Samson fell in love with a Philistine woman, Delilah. The enemy Philistines bribed Delilah to find the source of Samson's strength: his uncut hair. After shearing Samson's hair, Delilah handed him to the enemy, who gouged out his eyes and took him prisoner. In the end, Samson's hair grew back and he died while destroying the

Philistines. **E X A M P L E** : *Samson and Delilah*, painting by Girolamo Romanino, sixteenth century. Buonconsiglio Castle, Trento, Italy. In a lunette (arch) high above a lavish room, Romanino painted a sixteenth-century version of an aged Samson and a youthful Delilah, huddling together while he sleeps on her knee and she snips his hair. In an interesting addition to the biblical story, the fresco painter added a putto (small angel) watching the calamity.

S A M U E L 1 Sam. 1–28. Prophet to Israel. Samuel's mother, Hannah, prayed earnestly to conceive and dedicated her unborn child to God. From boyhood Samuel lived in the temple and served Eli the priest. As a prophet he led the Israelites to repent of their idolatry. He anointed Saul and his successor, David, as kings of Israel. **E X A M P L E** : *Anointing of David by Samuel*, Ingeborg Psalter, illuminated-manuscript page by unknown artist, thirteenth century. Condé Art Gallery, Chantilly Château, Chantilly, France. The open spaces in a capital *B* allowed the illuminator to present two scenes from Samuel's life. In the upper part, he illustrated an angel greeting the elderly Samuel; in the bottom, the prophet anointing David as king of Israel.

S A R A H Gen. 11:29–25:10. Wife of Abraham. When God told Abraham his wife would conceive in old age, she laughed. Despite the couple's doubt, Sarah delivered Isaac at age ninety. She followed the Lord with her husband to the Promised Land. Sarah retained her integrity when Abraham protected himself and twice passed her off as his sister. **E X A M P L E** : *Abraham, Sarah, and an Angel*, painting by Jan Provost, sixteenth century. Louvre, Paris, France. Provost painted an animated discussion between Abraham and an angel, raising their hands and pointing fingers, as if the aged patriarch doesn't quite understand the angel's message. He positioned Sarah peeking from behind a door, as if she'd like to intervene, even though Scripture claims she laughed.

S O L O M O N 1 Kgs. 1:10–11:14; 2 Chr. 1:1–9:30. Son of David and Bathsheba. After David's death, Solomon reigned as Israel's king. The Lord appeared to Solomon in a vision and asked what the king desired. Solomon requested a wise and understanding heart. This pleased God, and he granted Solomon wisdom, honor, and riches. Israel and many nations marveled at the king's wealth and wisdom. **E X A M P L E** : *The Judgment of Solomon*, painting by Giacomo Pacchiarotti, sixteenth century. Little Palace Museum, Avignon, France.

Pacchiarotti painted the dramatic moment when a servant held a disputed baby upside down, ready to split it according to the king's instructions. Simultaneously, the real mother has turned toward Solomon to request mercy; the other woman looks more interested in the servant.

14

New Testament People

The New Testament presents, in its way, the same union of the divine
and human as the person of Christ. In this sense also
"the word became flesh, and dwells among us."

— Philip Schaff

What did Jesus do? In the fourth century, pilgrims to Jerusalem obsessed about this question. They wanted to not only see, but experience the places where Jesus lived and died. Devout pilgrims wanted to "walk in the footsteps of the Master" and respond with emotion and devotion. In the fourth century, Saint Paulinus of Nola, Italy, explained, "No other sentiment draws men to Jerusalem than the desire to see and touch the places where Christ was physically present, and to be able to say from our very own experience 'we have gone into his tabernacle and adored in the very places where his feet have stood.'"

Every week Christians gathered to reenact the Thursday through Sunday events of the Passion. Pilgrims wept, prostrated, worshiped, communed, and imagined themselves agonizing with Jesus as he prayed in the garden, stood before Pilate, and hung from the cross. These believers wanted to imitate Christ.

However, realistically a Holy Land pilgrimage offered only a few Christians a once-in-a-lifetime itinerary and spiritual high point. Being like Christ required a daily commitment to his teachings. For this, faithful followers listened to stories about his life and the apostles' letters to the earliest Christians. Each Sunday priests read pages that admonished them to emulate Christ in their spiritual devotion and everyday relationships. Eventually, in the same century as Paulinus's pilgrimages, church leaders collected these writings into a canon of approved Scripture, the New Testament.

Artists enhanced people's motivation to walk with Christ by illustrating the characters and events of this newly formed testament. During the eras when most Christians couldn't read, these images became their visual Scriptures. Looking at Jesus pulling a frightened Peter from the water reminded them not to fear. Observing the prodigal son embracing his father taught them forgiveness. Centuries later, as literacy expanded, visual interpretations of the New Testament increased, too. Word and image powerfully taught the imitation of Christ.

Aside from Jesus, the following entries introduce New Testament people commonly featured in Christian art. The biblical references overview their stories.

C O R N E L I U S Acts 10. A Roman centurion. Cornelius hungered for God so he sent men to request a visit from Peter. The apostle preached the gospel to Cornelius, his relatives, and close friends. After the Holy Spirit fell on them, Peter baptized the first Gentiles in his ministry. E X A M P L E : *Saint Peter Baptizing the Centurion Cornelius*, painting by Francesco Trevisani, seventeenth century. Private collection. Trevisani painted a humble Cornelius, bowed low in his centurion uniform, receiving the baptismal water from Peter. The painter allowed Peter one free hand, raising a pointed finger upward, reminding the soldier of the Living Water who washed away his sin.

THE MOTHER OF GOD

"If anyone does not believe that Holy Mary is the Mother of God, such a one is a stranger to the godhead," claimed Saint Gregory Nazianzen, the fourth-century bishop of Constantinople. Byzantine artists reverently painted Christ's mother, whom in Greek they called the *Theotokos*, the "Mother of God." Aside from scriptural representations of Mary, Eastern painters depicted her birth, betrothal, death, and coronation in heaven.

Images of Mary as Christ's mother usually featured her holding him as a baby or young child. She often wore a red veil that dropped to her shoulders, representing her suffering and holiness. Artists decorated the veil with three stars to symbolize Mary's virginity before, during, and after the Nativity. A blue garment worn under the veil symbolized her humanity.

Byzantines also honored their Mother of God, frequently the subject of icons, with varied titles that illustrated characteristics of dignity, strength, and sorrow. Some of these include:

Agiosortissa. "Intercessor." Mary stood in profile, alone and with her hands spread out in supplication. She usually faced another icon of Christ.

■ *Agiosortissa*
"Intercessor"

■ *Eleusa*
"Tender Mercy"

E L I Z A B E T H Lk. 1:5–25, 39–80. Mother of John the Baptist. Elizabeth conceived John the Baptist at an advanced age, after an angel appeared to her husband, Zechariah, and announced the impending birth. When the Virgin Mary learned about her own pregnancy, she visited Elizabeth, her cousin. Hearing Mary's voice, the unborn baby in Elizabeth's womb leapt for joy. **E X A M P L E :** *The Visitation*, altarpiece from the Carthusian Monastery near Dijon, France, painting by Melchior Broederlam, fourteenth century. Fine Arts Museum, Dijon, France. On the left side of this altarpiece, Broederlam painted a touching version of the Visitation, when the newly pregnant Mary traveled to spend time with Elizabeth. As the cousins greeted each other, their body language indicated an intimacy only those chosen for a sacred, unique mission could share.

THE MOTHER OF GOD continued

Eleusa. "Tender mercy." The *Theotokos* held her baby, who touched his face to hers. In some images his neck looked unnaturally craned. Jesus placed at least one arm around his mother's neck or shoulder. Mary represented pure love in the bosom of the church.

Hodigitria. "She who shows the way." In this image, the Mother of God held Jesus and pointed to him as the way to salvation.

Oranta. "Praying." Also titled *Panagia*, "Lady of the Sign." Mary stood in an orant or praying position, with a circle under her bosom. The circle enclosed Jesus and represented her womb. Jesus in the womb referred to Isaiah 7:14, "Therefore the Lord himself will give you a sign: The virgin will conceive and will give birth to a son, and will call him Immanuel."

Panakranta. "All merciful." Mary sat on a throne, facing the viewer and holding the baby Jesus in her lap. The throne symbolized her royalty and perfection. In effect, she presided with Christ over the world's destiny.

■ *Hodigitria*
"She Who Shows the Way"

■ *Oranta*
"Praying"

■ *Panakranta*
"All Merciful"

JOHN THE BAPTIST Matthew 3. A prophet and cousin to Jesus. John preached a message of repentance and baptized many in the Jordan River. He also baptized Jesus. The baptizer spoke out against King Herod's marriage to his brother's wife, Herodias. Herod imprisoned but didn't execute John because people called him a prophet. When Herodias' daughter, Salome, danced for Herod, he promised her anything she asked. At her mother's prodding, the daughter requested the head of John the Baptist on a platter. EXAMPLE: *John the Baptist*, painting by Ugolino di Nerio, fourteenth century. National Museum, Warsaw, Poland. Like many icons of John, for this panel painting the artist rendered him in the rugged garb and wild hair of a wilderness prophet. Based on John 1:29, the scroll he holds states, "Behold the Lamb of God Who Takes Away the Sins of the World."

JOSEPH OF ARIMATHEA Jn. 19:38–42. A Sanhedrin member. Joseph secretly followed Jesus. But after Jesus died, he risked asking Pilate for the Lord's body. Joseph and Nicodemus prepared the body with oils and buried it in a sepulcher belonging to Joseph. EXAMPLE: *Descent from the Cross*, painting by Rogier van der Weyden, fifteenth century. Prado Museum, Madrid, Spain. The Netherlandish artist recorded the Lord's friends sorrowfully taking him down from the cross. Weyden endowed the dead Jesus and his fainting mother with similar visual language: they both limply fall to the viewer's left, with loving mourners holding up their bodies.

JOSEPH OF NAZARETH Mt. 1:18–27. Earthly father of Jesus, and a carpenter. Twice an angel appeared to Joseph in a vision. When Joseph discovered his betrothed Mary's pregnancy, an angel explained she'd conceived by the Holy Spirit. The angel encouraged Joseph to marry her. In a second vision, an angel warned Joseph about a life-threatening danger to Jesus, so he moved his family to Egypt. EXAMPLE: *Marriage of Mary and Joseph*, illuminated-manuscript page by unknown artist, fifteenth century. Royal Library, Turin, Italy. With intense red, blue, and gold colors, the manuscript illuminator memorialized the wedding of the Lord's parents, dressed in fifteenth-century clothing. According to this image, a dove—a symbol of the Holy Spirit—watched over the ceremony.

JUDAS ISCARIOT Mk. 14:43–44. Jesus's disciple and his betrayer. Judas served as treasurer for the disciples. For thirty pieces of silver, he

betrayed Jesus to the Jewish authorities. This set in motion the Savior's path to the Crucifixion. **EXAMPLE:** *The Kiss of Judas*, illuminated-manuscript page by unknown artist, thirteenth century. National Library of France, Paris, France. In this image the illuminator combined two sequential events into one scene: Judas kissing Jesus and Peter lopping off a soldier's ear.

LAZARUS Jn. 11:1–44. Brother to Mary and Martha of Bethany. When Lazarus fell ill, his sisters Mary and Martha sent for Jesus. However, the Lord tarried and didn't arrive until after Lazarus died. Jesus wept and then raised Lazarus from the dead. Many believed in Jesus as the Messiah that day. **EXAMPLE:** *The Resurrection of Lazarus*, relief sculpture by unknown artist, sixth century. Louvre, Paris, France. With a simple ivory carving on the remains of a post, a Coptic sculptor crafted a wide-eyed Lazarus wrapped in his grave clothes, waiting for Jesus to release him into the world.

MARY AND MARTHA OF BETHANY Lk. 10:38–42; Jn. 11:1–44. Sisters to Lazarus and friends with Jesus. Jesus often visited the home of Mary and Martha in Bethany. Mary sat at Jesus's feet and listened to him while her sister, Martha, pursued household tasks. Martha complained, but Jesus responded that Mary chose the best action. **EXAMPLE:** *Christ in the House of Martha and Mary*, painting by Jan Vermeer, seventeenth century. National Galleries of Scotland, Edinburgh, Scotland. Stripping away the surroundings, Vermeer tightly focused on the three friends together: a relaxed Jesus with Mary sitting at his feet and Martha interrupting to serve them bread. Looking up at Martha, Jesus casually points to the contemplative Mary.

MARY MAGDALENE Lk. 8:1–3. Follower of Jesus. Tradition claims the Lord cast seven demons out of Mary Magdalene. As a result, she became a disciple and supported his ministry. Mary Magdalene witnessed the Crucifixion and visited the tomb where friends buried him. As she sat near the tomb and wept, the resurrected Jesus appeared to her. **EXAMPLE:** *Saint Mary Magdalene, Saint Benedict, Saint Bernard of Clairvaux, and Saint Catherine of Alexandria*, painting by Agnolo Gaddi, fourteenth century. Indianapolis Museum of Art, Indianapolis, Indiana. On this altar polyptych, Gaddi painted Mary Magdalene leading the group of saints, one on each panel, with palm fronds in their hands, a sign of their spiritual victories.

MARY, MOTHER OF JESUS Lk. 2. Wife of Joseph. The archangel Gabriel appeared to Mary, a virgin, and announced she'd give birth to the Messiah. While greatly pregnant, she traveled with Joseph, her betrothed husband, to Bethlehem in Judea to register for the census. With no rooms available for rent in Bethlehem, Mary gave birth to Jesus in a stable. Later Mary and Joseph took the infant Jesus to the temple to present him to God. She heard both Simeon's and Anna's prophecies concerning her son. Mary stood near the cross at Jesus's crucifixion and prayed in the upper room with the disciples after his ascension. E X A M P L E : *Census at Bethlehem*, painting by Pieter Bruegel the Elder, sixteenth century. Royal Museum of Fine Arts of Belgium, Brussels, Belgium. Bruegel rendered Joseph and Mary waiting their turn in the census queue. However, the snowy weather and skates in the background suggested Bruegel's Flemish environment instead of the couple's real encounter in Bethlehem.

NICODEMUS Jn. 3:1–21. A Sanhedrin member. Nicodemus visited Jesus at night to question him. He believed in Jesus and defended him before the Pharisees. When the Lord died, he brought spices to anoint him and assisted Joseph of Arimathea in burying the body. E X A M P L E : *Nicodemus Visits Christ*, illuminated-manuscript page by unknown artist, fifteenth century. Royal Library, Turin, Italy. The artist painted Nicodemus in royal red robes, accompanied by Renaissance servants. In turn, he flanked Jesus with a few disciples. The painter also depicted both men holding out their hands, using them to gesture during an animated conversation.

PAUL OR SAUL OF TARSUS Acts 9:1–31. The apostle to the Gentiles. A zealous Jew, Saul persecuted Christians. While Saul traveled to Damascus, the risen Jesus appeared and asked, "Saul, Saul, why do you persecute me?" (9:4). Saul converted, changed his name to Paul, and served as an influential leader in the early church. He embarked on missionary journeys, suffered in prison for the gospel, and wrote several New Testament Epistles. E X A M P L E : *Saint Paul the Apostle*, painting by Marco Pino, sixteenth century. Borghese Gallery, Rome, Italy. Pino painted a mature, seated Paul with his hands folded, gazing toward heaven. In this image the painter endowed the praying apostle with a full head of hair, contrary to most images that showed him balding as he aged.

P E T E R O R S I M O N P E T E R Mt. 4:18–20; 14:22–33; Mk. 14:66–72. Disciple of Jesus. Jesus called Peter and his brother Andrew to be "fishers of men" (Mt. 4:19). Peter walked on water to reach Jesus and, before anyone else, proclaimed him the Christ. But Peter also denied the Lord three times on the night authorities arrested him. After the Resurrection, Peter became a leader in the early church and the first pope. Tradition claims enemies crucified Peter on an upside-down cross. **EXAMPLE:** *Saint Peter Blessing and Donor*, painting by Bartolomeo Montagna, sixteenth century. Academy Gallery, Venice, Italy. In an unusual depiction, Montagna painted Peter as a stern, middle-aged man with a bald scalp, but holding his usual symbol, a key to the kingdom of heaven. The painter positioned Peter standing up, pointing to heaven, and also holding a book of God's Word, unaware that a small male donor in the lower-right corner folds his hands in prayer, as if to honor the saint.

P H I L I P Jn. 1:43; 6:5–14. Disciple of Jesus. The Lord tested Philip, asking the disciple to feed a hungry crowd of five thousand with a few loaves and fishes. Jesus multiplied the food to satisfy the crowd's hunger, and the disciples collected leftovers. After the Ascension, Philip performed miracles in Samaria and led an Ethiopian eunuch to salvation and baptism. **E X A M P L E :** *The Baptism of the Ethiopian Eunuch by Saint Philip*, painting by Lambert Sustris, sixteenth century. Louvre, Paris, France. Sustris painted a grassy pastoral scene in which Philip baptized the eunuch, an official of Candace, Queen of Ethiopia. The eunuch left a servant waiting in a carriage nearby, calming two restless horses.

S A M A R I T A N W O M A N Jn. 4:4–30. A woman married five times. Jesus met this woman when he stopped to rest with his disciples in the village of Sychar in Samaria. Jesus asked the Samaritan woman for a drink from the well and then offered her Living Water. She believed in him, returned to her village, and told people, "Come, see a man who told me everything I ever did. Could this be the Messiah?" (4:29). **E X A M P L E :** *Christ and the Woman of Samaria at the Well*, painting by Philippe de Champaigne, seventeenth century. Museum of Fine Arts, Caen, France. Champaigne framed Christ in a Baroque tondo (round circle), pointing upward toward heaven while speaking to the woman at the well. She responded by placing a hand on her chest, as if talking about herself.

S T E P H E N Acts 6–7. First Christian martyr. Luke the apostle described Stephen as a man "full of faith and of the Holy Spirit" (6:5). He cared for the physical needs of early Christians. An angry mob stoned Stephen to death, falsely accusing him of blasphemy. **EXAMPLE**: *The Stoning of Stephen*, painting by unknown artist, twelfth century. Benedictine Convent of Saint John, Müstair, Switzerland. On the north side of the apse, a fresco painter created a stylized version of Stephen's stoning, expressing the flat perspective, beautiful colors, and angular slim figures of Romanesque art.

T H O M A S Jn. 20:24–29. A disciple of Jesus. Thomas doubted the Resurrection until he saw Jesus in the flesh. Then he cried, "My Lord and my God!" (20:28). Jesus blessed Thomas for his belief. **EXAMPLE**: *The Apostle Thomas*, painting by Nicolaes Maes, seventeenth century. Old Masters Picture Gallery, Kassel, Germany. Maes painted a melancholy Thomas sitting at a paper-cluttered desk, writing instrument in hand, still looking doubtful. Perhaps the artist believed Thomas never recovered from his propensity toward doubt and melancholy.

T I M O T H Y 1 Tim.–2 Tim. A coworker with Paul. Timothy's mother, Eunice, and grandmother, Lois, raised him to love and serve God. Paul mentored Timothy in the Christian faith and ministry. Paul wrote the Epistles 1 Timothy and 2 Timothy to his "true son in the faith" (1 Tim. 1:2). Tradition claimed Paul appointed Timothy the bishop of Ephesus. Later Timothy died by stoning. **EXAMPLE**: *Saint Timothy with the Martyrs' Palm*, from Neuwiller Abbey, stained-glass window by unknown artist, twelfth century. Museum of the Middle Ages, Paris, France. The stained-glass designer created a confident Timothy looking straight at the viewer. He also raised the saint's hand in blessing, similar to Christ's common gesture, and leaned a palm branch against his opposite shoulder, a symbol of martyrdom.

Z A C C H A E U S Lk. 19:1-10. A tax collector. Because of his small stature, Zacchaeus climbed up a sycamore tree to see Jesus in a crowd. The Lord called the despised man down from this perch and visited his home. Zacchaeus repented of his dishonest financial dealings and promised to return what he'd stolen, times four. **EXAMPLE**: *Zacchaeus*, woodcut by unknown artist, sixteenth century. Private collection. This hand-colored woodcut caught Zacchaeus climbing up a palm tree, struggling to reach the first outstretched branch. The artist emphasized the small man's physical helplessness—a metaphor for his spiritual state—even though he wielded power as a tax collector.

THE FOUR EVANGELISTS

Christian tradition revered Matthew, Mark, Luke, and John as the authors of the Gospels, the first four books of the New Testament. The church also named them apostles, saints, and evangelists. Christian art honored each evangelist with a symbol, shown with the saint or alone. Each symbol usually presented a creature with wings.

The symbol assigned to an evangelist depended on the nature of his Gospel. A winged man or angel represented Matthew because his book opened with Jesus's lineage and then emphasized the Lord's humanity. Mark's Gospel highlighted Christ's kingship, so his symbol became the lion, king of the beasts. Artists drew Luke's symbol as a bull or ox because the Hebrew nation sacrificed these animals according to God's law. His Gospel stressed the sacrificial aspects of the Lord's life. Tradition ascribed to John an eagle because his book seemed the most soaring and revelatory.

Eadfrith of Lindisfarne, the artist-illuminator for the seventh-century manuscript the *Lindisfarne Gospels*, created the images below for the evangelists. These Gospels reside in the British Library, London, England.

■ Matthew
(Angel)

■ Mark
(Lion)

■ Luke
(Ox)

■ John
(Eagle)

15
Church Doctors and Saints

While some of the saints . . . are remembered for their courageous lives
and others for the legends woven around them, all have inspired the world's
greatest artists to commemorate them gloriously in painting.

—CAROLE ARMSTRONG

To end a twelfth-century struggle between the Roman Catholic Church and the English monarchy, King Henry II encouraged the assassination of his former chancellor, Thomas Becket, the archbishop of Canterbury in England. Consequently, four knights slaughtered Becket as he prayed Vespers in the cathedral. Angry about the murder, the populace rose up against Henry and demanded his penance at Becket's tomb in Canterbury Cathedral. Within a short time, people reported miracles at the burial site and pilgrims flocked to visit the church.

Monks feared robbers might steal Becket's body so they placed his marble coffin in the cathedral's crypt and built a stone wall in front of it. Two gaps in the wall allowed pilgrims to insert their heads and kiss the saint's tomb. Later the clergy moved Becket's coffin to a gold-plated, jeweled shrine behind the high altar. Canterbury already served as a pilgrimage site, but after Becket's death pilgrims swamped the town, increasing its financial resources and religious prestige.

When the focus on deceased saints and their relics bloated into a massive industry, Christians lost sight of the sacred reason for calling selected Christians "saints." The church originally honored these Christians for their piety, humility, service, and sacrifice—not for their ability to draw crowds and produce income. As Christianity grew, so did the list of sanctioned saints. The church assigned them feast days, and Christian art honored them with symbols that encapsulated their ministries and miracles. The church also eventually corrected its course and remembered the real reasons for sainthood.

The Eastern and parts of the Western church revered saints, both biblical and extrabiblical, and the numbers accumulated into the thousands. Church leaders called some of the earliest saints "church fathers" because of their pioneering leadership, and some also earned the title Doctor of the Church. Through the

centuries, their teachings influenced the worldwide body of believers. The following list represents well-known saints and Doctors of the Church often included in Christian art.

Western Doctors

The Western or Latin Church named these four church leaders Doctors of the Church during the Middle Ages. In alphabetical order, they are:

A M B R O S E Fourth century. The Honey-Tongued Doctor. Ambrose worked as prefect for two Roman provinces and then served as the bishop of Milan. Famous for his eloquent preaching, Ambrose bestowed a fresh dignity and respect for the church. He also originated the Ambrosian chant for the liturgy. **EXAMPLE**: *Saint Ambrose*, painting by unknown artist, seventeenth century. Private collection. A sensitive, thoughtful artist painted Ambrose in old age, preparing a quill pen so he can continue his commitment to writing and preaching. The artist painted a large illuminated manuscript open on the desk below Ambrose, evoking respect and tenderness for the saint's lifetime devotion to Scripture.

A U G U S T I N E O F H I P P O Fourth–fifth centuries. Doctor of Grace. Augustine became a Christian under the influence of Bishop Ambrose in Milan, Italy. Later he moved home to Africa, established a monastery, and served as bishop of Hippo. He fought heretics and challenged other religions. Augustine, a noted theologian, also wrote literary works that profoundly impacted the church. **EXAMPLE**: *Saint Augustine*, painting by Piero della Francesca, fifteenth century. National Museum of Ancient Art, Lisbon, Portugal. Francesca memorialized Augustine in full liturgical garb and accessories, including a miter (bishop's hat) secured on his head, a pastoral crosier grasped with his left hand, and an illuminated manuscript of Scripture held firmly in his right hand. The solidity of Augustine's grip represented his secure hold on his faith.

G R E G O R Y T H E G R E A T Sixth–seventh centuries. The Greatest of the Great. Gregory sold his possessions and converted his home into a Benedictine monastery. He also built six other monasteries. After living seven years as a monk, the church ordained him as a Roman deacon and later named him pope by acclamation. Gregory used his papal power to denounce slavery, stop war, and develop missions. **EXAMPLE**: *Saint Gregory the Great and His Deacon Saint*

Peter, Hebrew Bible of Saint Gregory the Great (Biblia Hebraica of Saint Gregory the Great), illuminated-manuscript page by unknown artist, eleventh century. Montecassino Abbey, Monte Cassino, Italy. The artist deemed Saint Gregory so great, he illustrated this scene with the first pope, Saint Peter, serving as his deacon. With rich, bejeweled hues, the illuminator painted Gregory holding a copy of the Hebrew Bible, relying on colors to express the pope's and the book's importance.

J E R O M E Fourth–fifth centuries. Father of Biblical Science. Jerome became a priest in Rome, Italy, but eventually moved into a hermit's cell near Bethlehem in Judea. He spent the rest of his life writing and translating the Bible into Latin, the common people's language. His version of the Bible, the Vulgate, dominated church study, thought, and worship for centuries. E X A M P L E : *Saint Jerome Doing Penitence in the Desert*, painting by Lorenzo Lotto, sixteenth century. Louvre, Paris, France. Painting an image of solitude, Lotto creviced Jerome between huge stone boulders, bowing his head over a biblical text. Lotto contrasted magnificent rocks and a setting sun against the austerity of this saint's simple garment, only covering him from the waist down.

Eastern Doctors

The Eastern or Byzantine Church named these saints as their Doctors of the Church. In alphabetical order, they are:

A T H A N A S I U S Fourth century. Father of Orthodoxy. As bishop of Alexandria, Athanasius fought against the spread of Arianism, a movement that claimed Jesus wasn't equal to God the Father. One of his greatest contributions to the church, the doctrine of *homoousianism*, declared the Father and the Son of the same substance. E X A M P L E : *Saint Athanasius*, painting by Peter Paul Rubens, seventeenth century. Schloss Museum, Gotha, Germany. Indicative of the artist's style, Rubens painted a full-bodied Athanasius about to pierce a heretic at his feet, with an angel brandishing a scroll and flying above, cheering the saint's action. The viewer's perspective flows from the ground upward, as if standing underneath the scene, looking up.

B A S I L T H E G R E A T Fourth century. Father of Eastern Monasticism. Because Basil struggled with pride from success, he sold his possessions and became a monk. He founded several monasteries, and later the church consecrated

him as bishop of Caesarea. Basil possessed eloquent speaking abilities, engaged in relief work, and triumphed over Arianism in the Byzantine East. **EXAMPLE:** *The Mass of Saint Basil*, painting by Pierre Subleyras, eighteenth century. State Hermitage Museum, Saint Petersburg, Russia. In this narrative image, Roman Emperor Flavius Julius Valens has fainted while watching Basil celebrate the Feast of Epiphany. Valens visited Basil with his retinue after he failed to banish the headstrong bishop. Subleyras created this oil painting as a study for a work commissioned by Pope Benedict XIV for Saint Peter's Basilica in Rome, Italy.

GREGORY NAZIANZEN Fourth century. The Theologian. Gregory helped Basil with his exegetical works of Origen and the compilation of monastic rules. He became a priest and later served as bishop of Caesarea and Sasima, and as archbishop of Constantinople. Gregory tried to bring Arians back to a belief in Christ's divinity, and he preached powerful sermons on the Trinity. **EXAMPLE:** *The Fathers of the Church*, Panegyric of Bruzio Visconti by Bartolomeo da Bologna di Bartoli, illuminated-manuscript page by unknown artist, fourteenth century. Condé Art Gallery, Chantilly Château, Chantilly, France. In this portrait, the illuminator ranked Nazianzen among important fathers of the church, each seated with a scroll of biblical text in his hand. Both Western and Eastern Christians honored the same saints before the church split in the early eleventh century.

JOHN CHRYSOSTOM Fourth century. Doctor of the Eucharist. John retreated to the desert to live as a monk. However, because of his health, he returned to Antioch two years later and became a lector. Over the years, the church elevated him to the positions of priest and bishop of Constantinople. John preached passionately about holy living and emphasized providing for the poor. **EXAMPLE:** *The Pardon of Saint John Chrysostom*, painting by Mattia Preti, seventeenth century. Cincinnati Art Museum, Cincinnati, Ohio. In frustration over new taxes, angry Antiochians tore down statues of the Roman emperor, Theodosius. In response, Chrysostom displayed his profound oratorical skills by delivering a sermon, "On the Statues," and a series of twenty sermons that incited the people, but also worried them about the ruler's reprisal. In this image, the painter depicted the moment the emperor pardoned Chrysostom for his diatribes.

Other Church Doctors

As Christianity expanded and time passed, the Western church honored more saints as Doctors of the Church, with some shared by the Eastern Church. The following entries describe more—but not all—spiritual doctors and saints in art, along with images honoring their contributions to the church at large.

ALBERT THE GREAT OR ALBERTUS MAGNUS Thirteenth century. Universal Doctor of the Church. Albert attended the University of Padua and joined the Order of Saint Dominic. An accomplished scientist, he advocated for the coexistence of science and religion. He influenced the church's position on Aristotelian philosophy. EXAMPLE: *Portrait of Saint Albertus Magnus*, painting by Joos van Gent and Pedro Berruguete, fifteenth century. National Gallery of the Marche, Urbino, Italy. The painters depicted the master of Saint Thomas Aquinas as a teacher-scholar. They robed Magnus in liturgical garb, balancing a large illuminated text on his lap and raising his right hand as if accentuating a doctrinal point or granting a blessing.

ANSELM OF CANTERBURY Tenth–eleventh centuries. Father of Scholasticism. Ordained as a monk in Normandy, Anselm eventually rose to abbot and then archbishop of Canterbury. A noted theological writer, he opposed slavery in England and supported celibacy for clergymen. EXAMPLE: *Scenes from the Life of Saint Anselm of Canterbury*, Mirror of History (Le Miroir historial) by Vincent de Beauvais, illuminated-manuscript page by unknown artist, fifteenth century. Condé Art Gallery, Chantilly Château, Chantilly, France. The illuminator divided the manuscript page horizontally into two registers. In the upper register, he showed Anselm entering the Bec monastery to serve as abbot. In the lower, he painted the story of a sick monk who described his illness as two wolves attacking him. Anselm signed the cross over the man and cured him.

ANTHONY OF PADUA Twelfth–thirteenth centuries. Doctor of the Gospel. Anthony sought out Saint Francis of Assisi and led the educational work for the Franciscan order. In his later years, he traveled in Italy and France, preaching the gospel. A gifted orator, he spoke multiple languages. EXAMPLE: *The Legend of the Mule and Saint Anthony of Padua*, painting by Sir Anthony van Dyck, seventeenth century. Augustins Museum, Toulouse, France. When a mule knelt down and wouldn't eat or move for three days, Saint Anthony showed the

Blessed Sacrament to the animal. The mule recovered. Van Dyck painted the moment before the miracle, a legend claimed by the cities of Bruges in Belgium, Rimini in Italy, and Toulouse in France.

BEDE THE VENERABLE Seventh–eighth centuries. Father of English History. Bede became a Benedictine monk and spent most of his life in a monastery. He wrote about theology, science, history, and other topics. The church recognized Bede for his wisdom, knowledge, and contribution to English literature. He wrote *The Ecclesiastical History of the English People.* **EXAMPLE:** *A Scribe (Probably Bede) Writing*, Life and Miracles of Saint Cuthbert by Bede, illuminated-manuscript page by unknown artist, twelfth century. British Library, London, England. In this image reminiscent of Northumbrian evangelist portraits, the illuminator drew Bede studiously holding a quill and bending over to write on parchment pages.

BERNARD OF CLAIRVAUX Eleventh–twelfth centuries. Mellifluous Doctor. Bernard joined the Cistercian order, founded a monastery in Clairvaux, and became its abbot. He founded other monasteries and performed miracles. Bernard also helped convince King Louis VI to join the Second Crusade. **EXAMPLE:** *Saint Bernard of Clairvaux*, mosaic by unknown artists, fifteenth century. Crypt of Saint Peter, Saint Peter's Basilica, Vatican City, Italy. The mosaicist dressed the persuasive Clairvaux as a tonsured monk with a pensive, if not worried, facial expression.

BONAVENTURE Thirteenth century. Seraphic Doctor. Bonaventure enrolled in the Franciscan order and later became its minister general. He also served as the bishop and cardinal of Albano and wrote reasoned theological treatises. **EXAMPLE:** *The Last Communion of Saint Bonaventure*, painting by Luigi Mirandori, sixteenth century. Old Masters Picture Gallery, Kassel, Germany. Mirandori imagined angels circling the altar, waiting for Bonaventure to finish celebrating the Eucharist so they can transport him to heaven.

CATHERINE OF SIENA Fourteenth century. Seraphic Virgin. As a young girl, Catherine dedicated her life to God. She often sat in prayer and meditation, and joined the convent of Saint Dominic as a teenager. Catherine influenced Pope Gregory XI to reinstate the Florentines into the church after

excommunicating them for disobedience. She received mystical visions and took care of the poor and sick. **EXAMPLE**: *The Mystic Marriage of Saint Catherine*, painting by Barna da Siena, fourteenth century. Museum of Fine Arts, Boston, Massachusetts. The painter illustrated Catherine the nun embracing her role as the "Bride of Christ." In particular, Catherine shared a vision in which she married Jesus in a mystical wedding ceremony. In this painting, the artist depicted Christ and Catherine reaching out and touching with their fingertips.

CYRIL OF ALEXANDRIA Fourth–fifth centuries. Doctor of the Incarnation. As the archbishop of Alexandria, Cyril looted and closed the churches of Novatian heretics and expelled Alexandrian Jews. A controversial figure, he supported orthodoxy by fighting Nestorianism, the belief Christ harbored two natures, divine and human. **EXAMPLE**: *Saint Cyril of Alexandria*, painting by unknown artist, seventeenth century. Private collection. In this portrait, the iconographer mimicked Christ's stance of blessing, holding a Scripture text and raising one hand in blessing. While portraits like the sixth-century Sinai Christ confidently gazed at the viewer, this icon shifted Cyril's eyes to the side. However, the saint could just be looking at his raised hand.

FRANCIS DE SALES Sixteenth–seventeenth centuries. The Gentlemen Doctor. Francis studied law and theology at the University of Padua and earned doctorates in both fields. However, he felt God calling him into the ministry and accepted the position of provost for the Geneva diocese. He worked to break the area free from Calvinists and returned many to the Roman Catholic Church. A published writer, Francis eventually served as bishop of Geneva. **EXAMPLE**: *Saint Francis de Sales Preaching to the Heretics of Chablais*, engraving by unknown artist, seventeenth century. National Library of France, Paris, France. A French engraver worked realistic detail into this image of de Sales preaching to Protestants and urging their return to Catholicism. His detailed faces revealed some listening in dismay and others with interest.

HILARY OF POITIERS Fourth century. Doctor of Christ's Divinity. The church elected Hilary as bishop of Poitiers when clergy hotly debated Arianism. Because Hilary opposed the Arians, supporters of this belief managed to exile him. Hilary used his time in exile to write literature explaining the Trinity and theology. These works proved fruitful for converting people to an orthodox faith.

EXAMPLE: *Saint Hilary of Poitiers Blessing Saint Triaise*, relief sculpture by unknown artist, twelfth century. Saint Croix Museum, Poitiers, France. Although the sculptor honored each saint with a circular nimbus (halo), he chiseled Hilary looming larger than Triaise, perhaps indicating Hilary's greater importance to the commissioner of this work.

ISIDORE OF SEVILLE Sixth–seventh centuries. Schoolmaster of the Middle Ages. Isidore became the bishop of Seville, succeeding his brother. He worked at uniting Spain as a center of knowledge and culture during a time of conflict between two groups: Arian Goths and Catholic Romans. Isidore contributed to educational works and compiled knowledge into a dictionary, an encyclopedia, and two history books. **EXAMPLE**: *Scenes from the Life of Saint Isidore*, The Mirror of History (Le Miroir historial) by Vincent de Beauvais, illuminated-manuscript page by unknown artist, fifteenth century. Condé Art Gallery, Chantilly Château, Chantilly, France. Beauvais emphasized Isidore's ministry through teaching, showing him addressing a seated group of eager listeners in one frame, and speaking by a baptismal font in another. Isidore repeatedly advised Christians to seek good company and learn the way of the saints.

JOHN OF THE CROSS Sixteenth century. Doctor of Mystical Theology. John attended a Jesuit college to become a hospital chaplain, but felt better suited for life as a monk. He joined the Carmelite order. Saint Teresa of Ávila asked John if he would join her in returning the convent to a life of prayer. He agreed, but some Carmelite monks kidnapped John, confined him to a cell, and beat him three times a week. During nine months of imprisonment, he wrote mystical poetry about God's love. Despite a difficult life, John wrote many books on spiritual growth and prayer. **EXAMPLE**: *Saint John of the Cross and Saint Teresa of Ávila*, engraving by unknown artist, sixteenth century. National Library of France, Paris, France. The engraver portrayed the two saints kneeling before a crucifix on an altar, receiving divine messages and inspiration from the Holy Spirit hovering above them in the form of a dove. The artist also showed them with reached-out arms to indicate wonder, worship, and receptiveness.

JOHN OF DAMASCUS Seventh–eighth centuries. Doctor of Christian Art. John gave his wealth to relatives and joined the Mar Saba Monastery near Bethlehem in Judea. An organizer and writer, John wrote about

his opposition to the iconoclasts, works on theology and philosophy, and many poems. **EXAMPLE:** *The Triumph of the Catholic Doctrine, Detail of Practical Theology and Boethius, Hope and Saint John Damascene, Faith and Saint Denys the Areopagite, Charity and Saint Augustine,* fresco painting by Andrea di Bonaiuto, fourteenth century. New Saint Mary's Church, Florence, Italy. Although Christians often consider John part of Orthodox history, he also belongs to the Roman Catholic Church's story. He lived before the church split into Catholic and Orthodox traditions. Consequently, the painter included John in a fresco supporting Catholic doctrine.

LEO THE GREAT Fifth century. Doctor of the Unity of the Church. As Roman Pontiff, Leo developed the doctrine that all popes held universal authority over all bishops. With this conviction, he worked on unifying the beliefs and practices of churches in Africa, Gaul, and Spain. Leo also quelled the debate about Jesus's attributes, believing the Lord inhabited both human and divine natures. The Council of Chalcedon agreed. **EXAMPLE:** *The Meeting of Leo the Great and Atilla,* fresco painting by Raphael (Raffaello Sanzio da Urbino) and Giulio Romano, sixteenth century. Vatican Museums, Vatican City, Italy. The artists painted the meeting between the great pope and the mighty warrior, when the religious leader convinced the Hun to turn back his armies. In the sky, the painters added Saints Peter and Paul bearing swords.

PETER DAMIAN Eleventh century. Monitor of the Popes. Peter left his professorships to join the Benedictines. He grew so rigorous about praying, studying, and fasting that his health deteriorated. He accepted a position as an abbot, and during this time he established five new hermitages. Later he became the cardinal bishop of Ostia in Italy, where he worked to eliminate clergy vices. Peter also contributed to the church through written sermons, letters, poems, and biographies. **EXAMPLE:** *Bust of Peter Damian,* sculpture by unknown artist, Renaissance era. Saint Mary of the Angels Basilica, Florence, Italy. As with this sculpture, artists usually portrayed Damian with a cardinal's hat and a Benedictine monk's habit.

ROBERT BELLARMINE Sixteenth–seventeenth centuries. Prince of Apologists. A Tuscan, at age eighteen Robert decided to join the Jesuit school in Rome, Italy. He studied there for ten years, plus at Padua and Louvain,

joining the priesthood. Robert lectured, studied, and wrote about the controversial Protestant theology. His most famous work comprised a three-volume collection, *Disputations on the Controversies of the Christian Faith Against the Heretics of This Age.* **EXAMPLE:** *Portrait of Robert Bellarmine, Cardinal Archbishop of Capua,* engraving by Johannes Valdor, seventeenth century. Private collection. Underneath a bust portrait of Bellarmine, the engraver playfully added putti (small angels) struggling to carry his crest and symbols of his ministry: liturgical hats; crosier, healing, and budded crosses; and materials for writing and drawing.

TERESA OF ÁVILA Sixteenth century. Doctor of Prayer. At forty years old, Teresa revived her prayer life and received mystical visions. A few years later the nun sensed God calling her to start a convent focused on prayer. Despite threats, Teresa opened the first Discalced Carmelite convent. Over the next nine years, she started twelve foundations, although not without hardship. **EXAMPLE:** *The Ecstasy of Saint Teresa,* sculpture by Giovanni Lorenzo Bernini, seventeenth century. Our Lady of Victory Church, Rome, Italy. Considered Bernini's masterpiece, this sculpture expressed Teresa's agony and ecstasy when an angel visited her in a vision. The angel plunged a golden spear into her heart, and after pulling it out, he left her consumed by God's love.

THOMAS AQUINAS Thirteenth century. Angelic Doctor. Thomas Aquinas was the son of Landulph, Count of Aquino. At five years old, he enrolled in an Italian Benedictine school in Monte Cassino, Italy, and then furthered his education in Naples, Italy, at the Order of Saint Dominic, to the dismay of his family. He earned a doctorate at the University of Paris and a professorship, teaching Christian doctrine. His *Summa Theologica* formed the foundation for much Roman Catholic doctrine. **EXAMPLE:** *Temptation of Saint Thomas Aquinas,* painting by Diego Rodriguez Velázquez, seventeenth century. Orihuela Cathedral, Orihuela, Spain. Aquinas struggled through three great temptations when he chose to become a Dominican priest, all instigated by family members who loathed his decision. Velázquez illustrated the aftermath of the third temptation. The saint's brothers locked him in a tower with a seductive woman, whom he drove away with a red-hot poker. *The Catholic Encyclopedia* described the result: "When the temptress had been driven from his chamber, he knelt and most earnestly implored God to grant him integrity of mind and body. He fell into a gentle sleep, and, as he slept, two angels appeared to assure him that his prayer had been heard."

PART FIVE

Sacred Symbols

Religious symbolism is effective precisely in the measure in which it is sufficiently natural and simple to appeal to the intelligence of the people.

—The Catholic Encyclopedia

16
Flowers and Plants

A lily, a rose, a columbine, a violet, a pansy, an iris—all are pleasingly decorative to the casual observer. For the medieval and the Renaissance artists, flowers were part of a rich visual symbolism.

—ANDREA OLIVA FLORENDO

In the fifteenth century Leonardo da Vinci painted a lesser-known work simply titled *Madonna and Child*. In this painting a pensive Mary handed a red carnation to a chubby Jesus who struggled to grasp it. A shadow cast over the carnation. For contemporary viewers, this painting offers another variation on thousands of Mary-and-Jesus images hung in museums, galleries, churches, and homes. We might note that Mary wore the clothing and jewelry of the Renaissance but miss the painting's impassioned theme wrapped in a singular, common flower. But Renaissance art spectators—especially Christians—would have identified the message. They recognized the sermon built into blood-red petals.

In traditional Christian art, a flower seldom existed just for decoration. Botanical images—from a single green plant to a flower garden spilling with riotous color—exuded symbolism. Often this symbolism endowed a plant or flower with several interpretations. Consequently, it required considerable time to tease out the meaning of a flourishing garden, woodland forest, or flower garland.

Today most of us wouldn't bother. But we can contemplate the interpretation of a few flowers or plants and how they contributed to the moral or devotional meaning of a mosaic, painting, or tapestry. As we enjoy botanical beauty, we can also appreciate its exquisite messages, delicately designed to nourish the spiritual senses. The following plants and flowers sometimes served as focal points, but more often they peeked out from the borders and backgrounds of art.

ANEMONE In early Christianity, the triple-leaf anemone symbolized the Trinity. Later this flower with many species suggested illness, death, or mourning. Sometimes the anemone appeared in scenes of the Crucifixion, or with the Virgin Mary to

express her sorrow for Jesus's death. Legend claimed anemones sprang up at the Crucifixion and their red spots symbolized the Lord's spilled blood. **E X A M P L E :** *Virgin of Pomata with Saint Nicholas of Tolentino and Saint Rose of Lima*, painting by unknown artist, early eighteenth century. Brooklyn Museum of Art, New York, New York. The Peruvian artist embellished the Madonna and Child with garlands of flowers. In particular, anemones and roses expressed Mary's suffering.

B U L R U S H Drawn from the Old Testament, a bulrush foretold Christ's gift of salvation because the pharaoh's daughter rescued baby Moses from the bulrushes and adopted him (Exod. 2:1– 10, KJV). In addition, bulrushes—a common plant growing near the water—represented faithful and humble Christians who dwelled near the Living Water. **E X A M P L E :** *The Finding of Moses*, tapestry designed by Jan van Orley and Augustin Coppens, mid-eighteenth century. Temple Newsam House, Leeds, West Yorkshire, England. Toiling in the workshop of Frans and Pieter van de Borcht in Brussels, weavers focused on the pharaoh's daughter cradling Moses. They confined the bulrushes, an important element in the early story, to a lesser role in the tapestry's foreground.

C A R N A T I O N O R P I N K In the Middle Ages a carnation suggested pure love or motherly love, with legend claiming this flower sprang up from the Virgin's tears as she walked to Calvary. During the fifteenth century it stood for Christ or his mother. The carnation also represented marriage. Drawn from Flemish tradition, carnations appeared in engagement and wedding portraits. **EXAMPLE:** *Mary of Burgundy at Prayer*, Hours of Mary of Burgundy, illuminated-manuscript page by the Vienna Master of Mary of Burgundy, fifteenth century. Austrian National Library, Vienna, Austria. The only child of Charles the Bold, Mary of Burgundy enjoyed the comforts of court life, evidenced in this illustration of her reading a book of hours. The illuminator stressed Mary's piety and purity, showing her reading in front of a large Madonna portrait. He also painted two red carnations lying on a ledge between the wealthy heiress and the Virgin Mother.

C L O V E R In sacred art a three-leaf clover (shamrock) or trefoil exemplified the Trinity. Legend claimed Saint Patrick used the clover to explain the Father, Son, and Holy Spirit while evangelizing Ireland. According to popular myths, a four-leaf clover meant good luck. The quatrefoil, suggesting four leaves, became a

popular decorative element in Gothic architecture. **EXAMPLE**: *Saints Cosmas and Damian*, painting by Bicci di Lorenzo, fifteenth century. Florence Cathedral, Florence, Italy. The wealthy Medici family honored their patron saints with this panel painting, commissioned for the Florence Cathedral. In turn, the painter honored Christ by posing him in a quatrefoil above the saints' heads.

COCKLE OR TARES The cockle weed invaded and intermingled with healthy grain, signifying evil intertwining with good, especially in the church (Job 31:40). Jesus told a parable about the wheat and tares when the devil sowed weeds into a field while the workers slept (Mt. 13:24–30, 36–43). **EXAMPLE**: *Parable of the Sower of Tares*, painting by Domenico Fetti, seventeenth century. Courtauld Gallery, London, England. To illustrate the Lord's parable, Fetti painted three workers sleeping in the composition's foreground during a windswept day. A conniving man plundered this laziness and sowed tares into their plowed field.

COLUMBINE Columbine derived from the Latin word for "dove" because its flowers resembled flying doves. Accordingly, in art this flower symbolized the Holy Spirit and the gifts of the Holy Spirit if it produced seven petals (Rev. 5:12). Some medieval artists intended the columbine to recall the Seven Sorrows of Mary. According to this symbolism, these sorrows comprised Simeon's prophecy of Mary's grief; the flight into Egypt; losing Jesus in the temple; Jesus carrying his cross; the Crucifixion; receiving her son's body from the cross; and placing him in the tomb. **EXAMPLE**: *The Virgin and Child with a Columbine*, painting by Bernardino Luini, sixteenth century. Wallace Collection, London, England. Luini painted a prophetic image with Mary and her toddler holding a single columbine stem together. Although Mary gave birth to God-in-the-flesh, she repeatedly grieved the events of his suffering life on earth.

CYCLAMEN The early church dedicated this flower to Mary because a red spot in the middle of a white cyclamen represented her bleeding heart. **EXAMPLE**: *Still Life with Flowers*, painting attributed to Jan Brueghel the Younger, seventeenth century. Museum of Fine Arts, Saint Petersburg, Florida. Both Jan Brueghel

the Elder and his son Brueghel the Younger created gorgeous still-life paintings crowded with flowers of differing species and meanings. Combined, the flowers in various stages of bloom reminded viewers that every living thing eventually dies. According to Christian symbolism, Brueghel crowned the bouquet with red cyclamens to represent Mary's sorrow about her son's death. At the same time, five butterflies tucked into the arrangement remembered the Resurrection and eternal life.

D A I S Y In Renaissance paintings of the Adoration, a daisy emphasized the baby Jesus's innocence. With the daisy's round, seeded center, Christians also regarded it as "the eye of God." E X A M P L E : *Adoration of the Shepherds*, painting by Nicolas Poussin, seventeenth century. National Gallery, London, England. Poussin borrowed a long-established motif, turning a simple manger into the ruins of a classical building, representing Christ's abolition of the Old Covenant. He playfully added putti (small angels) high among the columns, dropping daisies on the holy family and adoring shepherds below.

D A N D E L I O N The dandelion, a bitter herb, appeared in early Flemish and German images of the Crucifixion, and generally represented the Passion Week. In paintings of the Madonna and Child, it foretold the bitterness ahead for Mary and her baby. Some scholars assumed the Israelites ate dandelions on Passover night, so the herb also meant grief. E X A M P L E : *Group of Women at the Crucifixion*, from the Saint Thomas Altar, Saint John's Church, painting by Master Francke, sixteenth century. Hamburg National Library, Hamburg, Germany. The artist painted this group of grieving women wearing brilliant colors, an unusual choice for a mournful scene. He envisioned these friends comforting Christ's mother during the Crucifixion, with a deeply rooted dandelion in the foreground, symbolizing Mary's bitter loss.

F E R N When hidden in the shadows of a garden or forest, the fern underscored humility and sincerity. E X A M P L E : *The Start of the Hunt*, tapestry by unknown artist, fifteenth century. The Cloisters, Metropolitan Museum of Art, New York, New York. In a famous tapestry series about a unicorn, one interpretation considered the mythical animal a Christ figure. In this image, the weavers skillfully depicted hunters and their dogs tromping through fern and other foliage, invading the humble unicorn's woodsy habitat.

FORGET-ME-NOT In bygone days, forget-me-nots represented fidelity in love. **EXAMPLE:** *Historiated Initial "D" Depicting Two Shepherds Looking Up to the Glory of Sun-Rays*, illuminated-manuscript page by unknown artist, sixteenth century. Fitzwilliam Museum, University of Cambridge, Cambridge, England. The illuminator illustrated a border larger than the manuscript page's text and illustration, full of symbolic flowers. Along with the forget-me-nots, these flowers communicated divine qualities affecting Christ's life.

HOLLYHOCK OR MALLOW Because the hollyhock's leaves resembled upward-turned palms, in art they sometimes symbolized prayers for forgiveness. However, it more commonly represented fruitfulness. **EXAMPLE:** *Saint Joseph with the Flowering Rod*, painting by Jusepe de Ribera, seventeenth century. Brooklyn Museum, New York, New York. According to apocryphal sources, the Virgin Mary had so many suitors, a high priest required each man to present a rod in the temple. When Joseph's rod bloomed, he betrothed the young woman. Ribera captured Joseph in a moment of surprise, holding his flowered rod, including a hollyhock.

HYACINTH In the Middle Ages and beyond, the hyacinth symbolized peace of mind, prudence, or heavenly desire. **EXAMPLE:** *Large Bouquet of Flowers in a Wooden Vessel*, painting by Jan Brueghel the Elder, seventeenth century. Museum of Fine Arts, Vienna, Austria. In one of the most famous paintings of flowers ever created, Brueghel the Elder amassed 130 species, including the grape hyacinth. Brueghel didn't intend the arrangement to look realistic: in nature these flowers don't bloom at the same time. Rather, the still-life master visually cataloged flower species and their meanings.

HYSSOP In Scripture hyssop related to purification rites and spiritual cleansing from sin (Ps. 51:7; Heb. 9:19–22). In Middle Eastern climates hyssop grew among stones and symbolized penitence and humility, along with baptism and renewed innocence. **EXAMPLE:** *Doni Tondo* or *Holy Family with Saint John*, painting

by Michelangelo Buonarroti, sixteenth century. Uffizi Gallery, Florence, Italy. Michelangelo added the hyssop plant growing in a wall and a citron tree in the background to represent a quote by the Benedictine monk Rabanus Maurus: "From the Cedar of Lebanon to the hyssop which grows on a stony wall we have an explanation of the Divinity which Christ has in his Father and of the humanity that he derives from the Virgin Mary."

I R I S Early Flemish masters painted the iris, with the lily or instead of the lily, to represent the Virgin Mary. Spanish painters considered the iris symbolic of the Immaculate Conception and the Queen of Heaven. **EXAMPLE:** *Christ Child Adored by Angels*, Portinari Altarpiece, painting by Hugo van der Goes, fifteenth century. Uffizi Gallery, Florence, Italy. On the center panel of this altarpiece, the artist painted Mary, Joseph, shepherds, angels, and donors kneeling around the baby Jesus, exalting his membership in the Holy Trinity. To add floral symbolism, he placed a vase of irises and violets in the foreground, referencing Mary's purity and humility.

I V Y Because ivy clung and stayed evergreen, in sacred art it symbolized faithfulness, enduring friendship, and eternal life. **EXAMPLE:** *The Penitent Saint Peter*, painting by El Greco (Domenikos Theotokopoulos), sixteenth century. San Diego Museum of Art, San Diego, California. In at least six different known versions of a repentant Peter, El Greco showed the disciple looking heavenward in remorse with ivy hanging near his head. The ivy emphasized Peter's broken loyalty when he denied Christ three times.

J A S M I N E The white color of the jasmine flower gathered multiple meanings. It symbolized the Virgin Mary, plus the traits of grace and elegance. **EXAMPLE:** *Saint Catherine*, painting by Bernardino Luini, sixteenth century. State Hermitage Museum, Saint Petersburg, Russia. Luini painted two charming putti (small angels) peeking over Saint Catherine's shoulders as she paged through a small Scripture book. The artist wove jasmine blossoms into her hair, a way to symbolically highlight her elegance.

LILY OR *FLEUR-DE-LIS* Originally the lily symbolized virginity and later it became the Virgin Mary's flower. Especially during the Renaissance, the lily appeared in paintings of the Annunciation, with the Archangel Gabriel holding this flower. Because of the lily's reference to purity, it also represented several saints. A variation of the lily, the fleur-de-lis, highlighted Mary's purity and also symbolized the Trinity. **EXAMPLE:** *Angel of the Annunciation*, painting by Lorenzo Lotto, sixteenth century. Civic Museum, Recanati, Italy. Lotto's muscular Archangel Gabriel startled Mary with his presence and announcement. Lotto painted the stunning angel offering the young woman a white lily, a symbol of her virginity and conception by the Holy Spirit.

LILY OF THE VALLEY A first flower of spring, the lily of the valley symbolized the Resurrection and occasionally the Virgin or the Immaculate Conception. **EXAMPLE:** *Desiderius Erasmus of Rotterdam*, engraving by Albrecht Dürer, sixteenth century. Blanton Museum of Art, Austin, Texas. The lily of the valley in a vase on Erasmus's desk represented the Resurrection, but also the theologian's love of beauty and learning. Dürer added the Greek inscription, "His writings offer a better likeness."

MARGUERITE OR MEADOW DAISY In images from the Middle Ages, the marguerite memorialized the suffering and death of Christ and Christian martyrs. **EXAMPLE:** *Presentation of the Virgin in the Temple*, painting by Francisco de Zurbarán, seventeenth century. Royal Monastery of Saint Lawrence, El Escorial, Spain. An apocryphal narrative recounted how Joachim and Anna dedicated their young daughter, Mary, to God and presented her at the temple. Mary lived in the temple until Joachim betrothed her to Joseph. In this painting of the presentation, Zurbarán scattered flowers, including the marguerite, across the temple's steps. The flowers memorialized not just Mary, but also her future son.

N A R C I S S U S O R D A F F O D I L Drawn from an ancient myth about the self-focused Narcissus, this flower epitomized self-love and indifference. However, in Christian symbolism, images of the Annunciation and Paradise included a narcissus, referring to divine love, sacrifice, and eternal life. These attributes overcame sin and selfishness. **EXAMPLE**: *Paradise*, painting by Jan Brueghel the Younger, seventeenth century. Berlin State Museum, Berlin, Germany. Brueghel the Younger painted a fanciful paradise with peaceable animals, luscious fruit, and delicate flowers, including the narcissus, flourishing in a perfect beautiful woodland.

P A N S Y Although the pansy rarely appeared in Christian art, it represented reflection and remembrance. It usually sprang up in images of the Virgin Mary. **EXAMPLE**: *Virgin with the Infant Christ Holding a Pansy*, painting by Adriaen Isenbrandt, sixteenth century. Bonnat Museum, Bayonne, France. In contrast to Mary's pensive mood, Isenbrandt presented her wearing a brilliant red shawl while cradling the baby Jesus who, in turn, clutches a drooping yellow pansy.

P E O N Y The peony belonged among the ancient symbols for Mary because medievals called the flower "a rose without a thorn." **EXAMPLE**: *Garland Surrounding the Virgin Mary*, painting by Nicolaes van Verendael, seventeenth century. Prado Museum, Madrid, Spain. During the Baroque period, Flemish painters created a popular motif of the Virgin surrounded by flower garlands. Verendael engulfed this barely visible bust of Mary in flowers, with pink and white peonies at the forefront. A Latin inscription at the bottom of the bust added, "I am the flower of the field."

P L A N T A I N A lowly plant growing along roads, the plantain honored Christians who persevered and traveled the way of Christ. **EXAMPLE**: *The Unicorn Leaps Out of the Stream*, tapestry by unknown artist, fifteenth century. The Cloisters, Metropolitan Museum of Art, New York, New York. This well-preserved tapestry belonged to a group illustrating the hunt for an elusive unicorn, a symbol for Christ. In this scene, the unicorn just leapt out of a stream into the piercing swords of his pursuers. Plantain plants touching the unicorn's front hooves reminded medieval viewers to persevere in life, just as Christ endured suffering on the cross.

P O P P Y Particularly during the Renaissance, a poppy's red color symbolized Christ's blood. In contrast, the poppy also pointed to sleep, fertility, and extravagance. **EXAMPLE:** *Madonna and Child* or *Madonna of the Poppy*, painting by Paolo Veneziano, fourteenth century. Saint Pantaleon Church, Venice, Italy. In this gentle painting of a seated mother and child, Veneziano foretold a God-intended tragedy. He painted Mary holding the baby Jesus on her lap and a poppy in her raised right hand. With childish curiosity, Jesus has reached for the flower, symbolizing his blood-stained future.

R O S E Christian symbolism designated the white rose as the mark of purity, the red rose as a sign of martyrdom, and the gold or yellow rose as impossible perfection. The red rose symbolized the Virgin Mary, and those with only five petals represented the Five Joys of Mary. Medieval Christians considered these joys the Annunciation, Nativity, Resurrection, Ascension, and Mary's heavenly coronation. **EXAMPLE:** *The Virgin of the Rose Garden*, painting by Master of the Saint Lucy Legend, fifteenth century. Detroit Institute of Arts, Detroit, Michigan. Although this master framed the Virgin Mary with a red rose trellis, he gave one of her companions a lily. Both flowers represented the Virgin in art: the white lily for her physical purity and the red rose for her son's martyrdom. Especially with flowers, artists often gathered several symbols for an individual or event into one painting.

S N A P D R A G O N In ancient Greek, a snapdragon meant "like a nose," but its symbolism associated it with strength and graciousness. **EXAMPLE:** *Herbal*, illuminated-manuscript page by unknown artist, eleventh century. Saint Augustine's Abbey, Canterbury, England. For much of the Middle Ages, botanical studies didn't differentiate between the secular and the spiritual. People believed everything traced back to God. Consequently, an herbal book might belong to an abbey or monastery and consider all possibilities for a plant's or flower's meaning.

T H O R N In the Old and New Testaments, thorns harbored several prickly meanings: God's judgment of sin (Gen. 3:18); afflictions (Num. 33:55); Saint Paul's thorn in the flesh (2 Cor. 12:7); Christ's crown of thorns (Mt. 27:29); the fruit of dead works (Heb. 6:7–8); and evil (Mt. 13:7). A doctor of the church, Thomas Aquinas, used thorns to symbolize minor sins and brambles to represent greater

sins. **EXAMPLE**: *Ecce-Homo*, sculpture by José Risueño, seventeenth century. Museum of Fine Arts, Granada, Spain. When Pontius Pilate presented a bloody Jesus to the crowd for crucifixion, he announced "Ecce homo," or "Behold, the man." These words eventually described a popular devotional image of a scourged Jesus wearing his crown of thorns. Through the centuries, many artists recreated the Savior at this moment, but Risueño especially emphasized the devastating effects of thorns.

VIOLET The violet grew close to the ground and symbolized humility, especially expressed by Christ and the Virgin Mary. **EXAMPLE**: *Portrait of a Gentleman with His Right Hand Pointing to a Skull and His Left Hand Holding a Glove with a Protruding Yellow Violet*, painting by Master of the 1540s, sixteenth century. Private collection. Pointing to a skull with one hand and holding a single violet in another, the man in this painting expressed humility toward human vanity and mortality.

WORMWOOD The bitter extract from this plant, used for making absinthe and flavoring wines, warned of the Last Judgment's pain and bitterness (Jer. 9:15). **EXAMPLE**: *The Third Trumpet and the Wormwood Star*, The Apocalypse of Angers, tapestry by Nicolas Bataille, fourteenth century. Angers Château, Museum of Tapestries, Angers, France. Bataille illustrated this description from the powerful Apocalypse of Angers: "And the third angel sounded the trumpet, and a great star fell from heaven, burning as it were a torch, and it fell on the third part of the rivers, and upon the fountains of waters: And the name of the star is called Wormwood. And the third part of the waters became wormwood; and many men died of the waters, because they were made bitter" (Rev. 8:10–11 DRA).

17
Fruit, Nuts, and Grains

During the Renaissance most art depicted religious themes.
The same flowers, fruit, and trees that once adorned medieval and
early Renaissance gardens . . . can still be found in today's gardens.
Today museum and gallery visitors, who may no longer be aware
of the earlier significance of these symbols, can become informed
and discover enhanced enjoyment of the paintings.

—SUZANNE HILL

In the beginning, fruit prominently figured into God's relationship with people.
In the Genesis story, God told Adam and Eve not to eat the fruit of a certain garden
tree. But the fruit tantalized them. "When the woman saw that the fruit of the tree
was good for food and pleasing to the eye, and also desirable for gaining wisdom,
she took some and ate it. She also gave some to her husband, who was with her,
and he ate it. Then the eyes of both of them were opened, and they realized they
were naked; so they sewed fig leaves together and made coverings for themselves"
(Gen. 3:6–7). Although the biblical text doesn't mention an apple, in Christian
art this fruit recalled humanity's fall from grace. Likewise, in ancient cultures fruit
represented sin and passion.

In contrast—and consistent with a redemptive message—fruit acquired positive
symbolism in the New Testament and early church life. Paul likened fruit to the gifts
of the life-transforming Holy Spirit. The fruit of the Spirit included love, joy, peace,
patience, kindness, goodness, faithfulness, gentleness, and self-control (Gal. 5:21–
23). This fruit evidenced Christ's triumph over sin and the "new life" of believers.
As with the following list, Christian art took on a positive symbology for fruit.

ACORN The acorn symbolized potential physical and
spiritual strength because it grew into an immense oak tree.
EXAMPLE: *Harvesting Acorns to Feed Swine*, Queen Mary's
Psalter, illuminated-manuscript page by unknown artist, fourteenth
century. British Library, London, England. Illuminated-manuscripts
of Scripture sometimes included images of everyday work and

activities. Although this manuscript contained a psalter for devotional readings, it also recorded scenes such as peasants harvesting acorns. Aside from recognizing this farming task, most medieval people understood the symbolic spiritual strength of acorns.

A L M O N D In symbolism the almond evoked God's favor, reminiscent of Aaron's rod that budded and produced almonds (Num. 17:1–8). It also implied the Virgin birth and Mary's purity. In paintings the almond-shaped mandorla surrounded Christ, his mother, and the Trinity, indicating their holiness. E X A M P L E : *The Death of the Virgin*, painting by Bartolomeo Vivarini, fifteenth century. Metropolitan Museum of Art, New York, New York. In the thirteenth-century Golden Legend, illuminated manuscript, a compilation of core Christian stories, Jacobus de Voragine described the Virgin's death, enveloped by the eleven apostles who returned from around the world to honor her. They surrounded her deathbed, and the Lord appeared to accompany Mary to heaven. Representing this event, Vivarini painted Christ in an almond-shaped mandorla, escorted by angels.

A P P L E The interpretation of an apple depended on who appeared in the overall image. When Adam or Eve extended an apple, it represented sin because of the couple's temptation and fall from grace (Gen. 3:3). If Christ held an apple, it symbolized the "new" or "last" Adam who died for humanity's sins (1 Cor. 15:45). In the same way, the Virgin Mary with an apple signified the "new Eve" and salvation. E X A M P L E : *Virgin and Child Under an Apple Tree*, painting by Lucas Cranach the Elder, sixteenth century. State Hermitage Museum, Saint Petersburg, Russia. The Virgin sitting under an apple tree harkened back to Eve's sin, but the image also anticipated humanity's redemption through Mary's child. Cranach stood Jesus on Mary's lap, clutching an apple and offering the viewer a crust of bread, a symbol of his to-be-broken body.

C H E R R Y Christians honored the cherry as the fruit of paradise because of its red, sweet attributes. Accordingly, the cherry tree symbolized eternal life or heaven. In the hands of the Christ child, a cherry denoted the delights of the blessed. E X A M P L E : *Madonna of the Cherries*, painting by Quentin Massys, sixteenth century. State Museum, Amsterdam, the Netherlands. Massys revealed a tender moment when a mother affectionately kisses her baby. During the Renaissance, the cherries in Mary's hand symbolized heaven, so the painter might have envisioned a blissful scene in the afterlife.

C H E S T N U T The chestnut pointed to chastity, symbolized by thorns surrounding a husk. Despite the thorns, the chestnut's meat remained unharmed. **E X A M P L E** : *The Rest on the Flight into Egypt*, painting by Gerard David, sixteenth century. National Gallery of Art, Washington, DC. In one of several paintings of the holy family's trip to Egypt, David showed Joseph in the background, beating chestnuts from a tree. Chestnuts served as a staple in the Netherlands during this time, but also symbolized Mary's chastity.

F I G Most often the fig—its fruit, leaf, and tree—represented lust. Accordingly, after giving in to temptation, Adam and Eve recognized their nakedness and covered themselves with sewn-together fig leaves (Gen. 3:7). However, the fig tree also symbolized good works and fruitfulness. **E X A M P L E** : *Roundel Depicting the Parable of the Fig Tree*, stained-glass window by unknown artist, twelfth century. Canterbury Cathedral, Canterbury, England. In the north window of the choir, artisans reminded parishioners of Jesus's Parable of the Fig Tree (Lk. 13:6–9). The owner of the vineyard (God) told the gardener or vineyard keeper (Jesus) to cut down a fig tree that bore no fruit (individuals bearing no spiritual fruit). Some believed the parable also represented a lack of repentance from the nation of Israel.

G O U R D When Jonah resented God's forgiveness of Nineveh's people, the Lord provided a gourd to shade the depressed prophet (Jon. 4:9–10 KJV). The gourd became a symbol of the Resurrection because the Lord saved Jonah from the big fish and the Ninevites from their depravity. **E X A M P L E** : *The Marriage at Cana*, painting by Leandro da Ponte Bassano, sixteenth century. Louvre, Paris, France. Bassano married symbolism and reality in this wedding image. The painter arranged gourds in the painting's foreground, representing the Resurrection. He squarely sat Jesus—the actual participant in and meaning of the Resurrection—in the center of the composition.

G R A I N O R W H E A T A symbol of the Eucharist (Communion), bread and grain revered Christ's humanity and his role as the Bread of Life (Jn. 6:35). He taught that a grain of wheat falls to the ground and dies before it produces a plentiful harvest (Jn. 12:24). **E X A M P L E** : *The Miraculous Multiplication of the*

Grain, Saint Nicholas of Bari altarpiece, painting by Jaime Cabrera, fourteenth century. Saint Mary Basilica, Manresa, Catalonia, Spain. According to a fourth-century legend, the beloved Nicholas, bishop of Myra in Asia, intervened on behalf of his famine-starved people. When a ship loaded with wheat for the Byzantine emperor anchored in Myra's port, Nicholas requested grain for the town. At first the sailors declined because the cargo needed to meet weight requirements at their destination, but Nicholas prevailed. Arriving at the Byzantine capital, the grain's weight hadn't changed, and the wheat supply in Myra lasted two years. For this altarpiece image, the painter caught Bishop Nicholas supervising as workers poured grain into baskets for Myra. The wheat miracle echoed Jesus's multiplying the loaves and fishes (Mt. 14:13–21) and his never-ending supply of spiritual nourishment.

GRAPES Like grain, grapes abounded in the Roman Empire's agricultural society and translated easily to spiritual symbolism. Grapes naturally represented Christ the True Vine (Jn. 15:1), and their color recalled his shed blood, uplifted in the Eucharist (Communion) service. **EXAMPLE**: *The Grape Harvest*, mosaic by unknown artists, fourth century. Saint (Santa) Costanza Church, Rome, Italy. Originally a mausoleum for Emperor Constantine's daughter, Princess Constantina, the fourth-century building eventually served as a church. Depending on the visitor's viewpoint, mosaics on the ceiling celebrated an actual grape harvest of an agrarian Roman Empire, or they referred to Christ as the True Vine and the Holy Blood in the shared Communion cup.

LEMON The lemon symbolized love and fidelity, sometimes appearing with the Virgin Mary. **EXAMPLE**: *The Virgin and Child with Saint Anne*, Holy Mary of the Staircase Church, Verona, Italy, painting by Gerolamo dai Libri, sixteenth century. National Gallery, London, England. Libri posed this three-generation family portrait in front of a lemon tree, a symbol of the love and faithfulness among them. However, this central panel from an altarpiece also symbolized the ending of a siege on Verona, the church's location. The olive branch held by Christ and the dead dragon at Mary's feet heralded peace and victory.

O R A N G E At times the orange tree replaced the fig tree in images about the fall from grace, recalling original sin and humanity's redemption. The orange and its tree also represented chastity, purity, and generosity. **E X A M P L E :** *Madonna and Child*, painting by Cosimo Tura, fifteenth century. Civic Museum, Padua, Italy. Tura painted a rare image of the Holy Mother and Child. Posed against a backdrop of oranges, the Madonna folds her hands to worship the holy baby sprawled on her lap. Jesus relaxes with one hand propping up his head, the other hand resting on his tummy, and his legs casually crossed together.

P E A C H The pit within the peach symbolized a charitable nature, heart, and tongue. Or quietness, because the pit didn't call attention to itself. Sometimes the peach replaced the apple in paintings of Mary and the Christ child, symbolizing salvation. **E X A M P L E :** *Madonna and Child*, painting by Matteo di Giovanni, fifteenth century. Russell-Cotes Art Gallery and Museum, Bournemouth, England. The artist painted a pensive mother Mary, baby Jesus, and two adoring putti (small angels) for an unidentified altarpiece. He placed Jesus sitting on his mother's lap and holding a peach in one hand, a reminder of his gift of salvation. He's lifted his other hand toward Mary, as if asking for attention.

P E A R The pear often appeared with images of the Incarnate Christ. It represented his love for humanity. **E X A M P L E :** *Madonna of the Taper*, painting by Carlo Crivelli, fifteenth century. Brera Art Gallery, Milan, Italy. As if to emphasize a point, Crivelli framed a regal but somber Mary and Jesus in a garland of pears and their branches, with the child holding a taper. A taper or candle generally represented Christ as the Light of the World. Combining the symbolism, Crivelli presented the Christ child as loving the world and shedding his saving light into spiritual darkness.

P L U M Often a decorative element in Renaissance paintings, the plum alluded to fidelity and independence. **E X A M P L E :** *Portrait of a Man with a Laurel Branch and Plums*, painting by Dosso Dossi (Giovanni di Niccolò de Luteri), seventeenth century. Unspecified location. For this painting, Dossi showcased the man's fidelity and independence by hanging plum branches over his left

shoulder. He also indicated victory by placing a laurel branch in his subject's left hand. Based on the man's plain clothing and the painter's Protestant leanings, this image might have been a Reformation statement of freedom from the Roman Catholic Church.

 POMEGRANATE For medieval and Renaissance Christians, the seeds in a pomegranate brought to mind the universal church with its countless members. An open pomegranate allegorized the stone rolled away from Christ's tomb and his resurrection. This fruit's many seeds also referred to eternity and fertility. EXAMPLE: *Madonna of the Pomegranate*, painting by Sandro Botticelli, fifteenth century. Bonnat Museum, Bayonne, France. Botticelli painted at least two versions of this image, with Jesus nestled in his mother's arms. He showed Mother and Child holding a pomegranate that's been cut away to expose its seeds, a symbolic prediction of the future Resurrection.

 QUINCE Shaped like an apple, the quince symbolized sin and temptation, but it also represented marriage. EXAMPLE: *The Marriage at Cana*, painting by Paolo Veronese, sixteenth century. Louvre, Paris, France. Veronese combined the sacred and the profane in this painting, turning a first-century wedding celebration in Cana into a boisterous, sixteenth-century Venetian feast. In the center, the painter positioned a servant slicing meat, an obscure foretelling of Christ's speared body. In contrast, he painted other workers serving quinces, an obvious symbol of marriage.

STRAWBERRY In a strawberry ancient Christians saw the emblem of a righteous person, especially the Virgin Mary. In addition, a strawberry with three leaves introduced the Holy Spirit. EXAMPLE: *Jacob's Ladder*, embroidery by unknown artist, sixteenth century. Holburne Museum of Art, Bath, England. Embroiderers framed the story of Jacob's ladder in an oval and then surrounded it with fruit, flowers, and animals. Strawberries contributed to a sense of the heavenly descending to earth.

V I N E Jesus called himself the Vine and his followers the branches (Jn. 15:1). The vine also symbolized the vineyard where God protected his people (Isa. 5:7). **E X A M P L E :** *Impost Capital with Vine Leaves and Grapes*, relief sculpture by unknown artist, date unknown. Saint Mark's Basilica, Rome, Italy. From paintings to mosaics to relief sculptures, vines appeared throughout Roman art and architecture, recalling Christ as the Vine. A vine also represented winemaking, but in a Christian basilica, it held spiritual meaning.

W A L N U T Saint Augustine compared the walnut to Christ's redemptive work. He likened the shell to the wood of the cross; the bitter substance surrounding the nut to Christ's flesh; and the meat to sweet, divine revelation. In the Jewish tradition, the walnut symbolized Scripture. **E X A M P L E :** *Fruit Still-Life with Squirrel and Goldfinch*, painting by Abraham Mignon, seventeenth century. State Museum, Kassel, Germany. For this busy still life, Mignon imagined a squirrel releasing itself from a chain, wearing a bell collar, and munching on a walnut. In the Middle Ages a squirrel signified evil and this particular collar represented a fool or a sinner. Consequently, the former sinner chose Christ's life-giving nature.

18
Trees and Bushes

The tree has played an important part in Christian symbolism. In general,
the tree is a symbol of either life or death, depending upon whether it is healthy
and strong, or poorly nourished and withered.

— GEORGE FERGUSON

The biblical message of salvation extended across thousands of years, from one tree
to another. In works depicting Adam and Eve, artists featured the tree from which
the first woman plucked fruit and offered it to her husband. Based on Scripture,
early Christians believed this disobedience—sampling from a God-forbidden tree—
plunged humanity into sin and cast the couple out of the Garden of Eden.

Tertullian, a third-century church father, commented on this far-reaching act,
"Man was condemned to death for tasting the fruit of one poor tree. From that,
there proceeded sins with their penalties. And now all are perishing, even though
they have never seen a single sod of Paradise."

In the fifteenth-century Missal of Archbishop of Salzburg, an artist created an
intriguing painting of the first couple's disobedience. In *The Tree of Death and Life*
the forbidden tree stood between a naked and sorrowful Adam and Eve. A skull
hung from the tree's branches, foretelling death's punishment for them and future
generations. But with a creative twist, the unknown artist also hung a crucifix from
the Garden's tree. He painted the despair and hope of that moment.

The artist believed hope resided in another tree, the cross of Christ's crucifixion.
Biblical writers and early church fathers referred to these two wood beams as a tree.
In the first century Paul the apostle described how Christ's tree supported redemp-
tion. He wrote, "Christ hath redeemed us from the curse of the law, being made a
curse for us: for it is written, Cursed is every one that hangeth on a tree" (Gal. 3:13
KJV). A century later the apologist Irenaeus explained, "By means of a tree, we were
made debtors to God. Likewise, by means of a tree we can obtain the remission of
our debt." Spiritually, Christians depended on trees.

Practically, people from the Age of Faith also relied on trees in their workaday
lives. They needed wood to build homes, cook meals, and generate warmth. Conse-
quently, they recognized the trees and bushes symbolized in art.

A C A C I A The leaves of the acacia bush resembled flames of fire, so some Christians associated it with Moses and the burning bush (Exod. 3:2). Wood from this bush remained durable and symbolized permanence and immortality. **E X A M P L E :** *Moses and the Burning Bush and the Tables of Law*, Ingeborg Psalter, illuminated-manuscript page by unknown artist, thirteenth century. Condé Art Gallery, Chantilly Château, Chantilly, France. The illuminator divided this manuscript page into two horizontal registers. At the top, Moses knelt before a burning bush shaped into a mandorla outlining an image of Christ. Below, hands from heaven bestowed on Moses tablets inscribed with the Ten Commandments, an expression of God's permanent laws.

B R A M B L E Many early Christians considered a bramble the true burning bush that Moses encountered (Exod. 3:2). The bramble also symbolized the Virgin Mary because she burned with love but wasn't consumed by lust. **E X A M P L E :** *Moses and the Burning Bush*, painting by unknown artist, second century. National Museum of Damascus, Damascus, Syria. Although this painting originated in the Dura-Europos Synagogue in Syria, Christians recognized this scene and the bramble rising up before Moses as a conduit for God's message of redemption not just for Israel, but for every nation.

C E D A R The prophet Ezekiel used the majestic cedar tree as a symbol for the Messiah's kingdom (Ezek. 17:22). In particular, the Cedar of Lebanon also symbolized Christ (S. of S. 5:15). **E X A M P L E :** *The Tree of Good Bearing Medallions of the Virtues*, Very Rich Hours of the Duke of Berry (Les très riches heures du Duc de Berry), illuminated-manuscript page by the Limbourg brothers, fifteenth century. Condé Art Gallery, Chantilly Château, Chantilly, France. The illuminator personified a cedar tree with the virtues of faith, hope, charity, justice, prudence, fortitude, and temperance—all characteristics of Christ and his kingdom.

CYPRESS In a carryover from pagan times, the cypress tree is associated with death because of its dark leaves. Christian cemeteries and tombstones often featured the cypress, representing eternity and the afterlife. **EXAMPLE:** *Annunciation*, painting by Alesso Baldovinetti, fifteenth century. Uffizi Gallery, Florence, Italy. Cypress trees in the background of this Annunciation scene foretold how Jesus shed light on a spiritually dark world, welcoming his followers into eternal life with God.

E L M The elm's expansive growth and spreading branches represented the devout and the dignity of life. **EXAMPLE:** *Signet Ring with Elm*, engraving by unknown artist, sixteenth century. Victoria & Albert Museum, London, England. A business owner used a signet ring to seal his transactions and maintain a good reputation. An inscribed elm symbolized the devout nature of this ring's owner.

FIR The fir tree symbolized patience and the Christian elect in heaven. **EXAMPLE:** *Madonna Under the Fir Tree*, painting by Lucas Cranach the Elder, sixteenth century. Bishop's Residence, Wrocław, Poland. Cranach the Elder painted fir trees hovering over the Madonna and Child, a promise of heaven for those who accepted Christ as Savior.

HOLLY This evergreen bush or tree often appeared in paintings of John the Baptist, who predicted Christ's Passion, or of Saint Jerome contemplating the Crucifixion. A holly's thorny leaves symbolized the Savior's crown of thorns. **EXAMPLE:** *The Lady and the Unicorn: Sight*, tapestry by unknown artists, fifteenth century. Museum of the Middle Ages, Paris, France. This tapestry could be interpreted in both sacred and secular terms. In Christian imagery the unicorn represented Christ. Combining the unicorn and the holly in this tapestry pointed to his Passion and Crucifixion.

L A U R E L In the Roman Empire the laurel meant triumph and victory, and Christians adopted this interpretation. The evergreen laurel tree also suggested immortality. **EXAMPLE:** *Tombstone of Plenis*, relief sculpture by unknown artist, sixth century. Coptic Museum, Cairo, Egypt. In the style of many early Christian tombs, stone masons built this funerary structure to resemble a house. The sculptor filled the lower part with a cross and a Christian monogram. He chose laurel leaves for the upper section, suggesting Christian immortality.

M Y R T L E The myrtle symbolized love or the Gentiles who converted to Christ (Zech. 1:8). **EXAMPLE:** *Book of Hours with Illustrations of Pilgrims, Jews, Sun, Moon, and Myrtle*, illuminated-manuscript page by unknown artist, fifteenth century. Mazarine Library, Paris, France. In separate, arched panels the illuminator gathered together Gentile pilgrims converted to Christianity, Jews whom the church wanted to convert, and a myrtle tree that symbolized God's love for them all.

O A K The solidity of the oak tree symbolized faith and endurance in adversity, especially Christian perseverance. **EXAMPLE:** *The Holy Family of the Oak Tree*, painting by Raphael (Raffael Sanzio de Urbino), sixteenth century. Prado Museum, Madrid, Spain. Raphael introduced a classical theme in this painting of the holy family, leaning Joseph on Roman ruins and painting the Baths of Caracalla in the background. The painter created a casual Joseph watching Mary, the toddler Jesus, and the boy John the Baptist. John has unrolled a scroll with the words, *Ecce Agnus Dei*, which meant "This is the Lamb of God" in ancient Latin. Before this revelation, an oak tree spread its branches over the group, foretelling their individual and collective endurance.

O L I V E The olive branch turned into a symbol of peace because Noah's dove brought this branch to him (Gen. 8:11). The olive tree's oil represented God's provision. Sometimes instead of

a lily, the Annunciation angel carried an olive branch in paintings. Sienese painters favored this substitution. **E X A M P L E :** *Sermon on the Mount, Scenes from the Life of Christ*, mosaic by unknown artists, sixth century. New Saint Apollinare Basilica, Ravenna, Italy. The Sermon on the Mount focused on peacefully living in God's kingdom. Consequently, mosaicists depicted Jesus delivering his great sermon with olive trees behind him. This tree abounded in the Holy Land and the Roman Empire, so viewers recognized and understood its practical and spiritual significance.

P A L M Palm symbolism in Christianity derived from the Roman Empire's use of the plant to claim victory. This Christian symbol represented the martyrs' victory over death and Jesus's entry into Jerusalem, when people waved palm branches and called, "Hosanna" (Jn. 12:12–13). **E X A M P L E :** *Saint Barbara*, painting by unknown artist, fifteenth century. Coptic Museum, Cairo, Egypt. When Barbara converted to Christianity, the saint's father locked her in a tower. Later he convinced a judge to order her beheading. The iconographer painted Barbara looming above her tower, holding a tall palm branch, symbolizing her victory over death.

P L A N E With its high and spreading branches, the plane tree symbolized Christ's charity, along with strong character and inscrutable morality. **E X A M P L E :** *Four Trees Depicting Four Beatitudes*, Book of Flowers (Liber Floridau), illuminated-manuscript page by Lambert de Saint-Omer, fifteenth century. Condé Art Gallery, Chantilly Château, Chantilly, France. In the twelfth century Lambert, canon of the Church of Our Lady in Saint-Omer, France, created the Book of Flowers, an unusual encyclopedia combining sacred and secular knowledge. On pages addressing the Sermon on the Mount, the artist chose a plane tree and its charitable symbolism to illustrate the Beatitude: "Blessed are the pure in heart, for they will see God" (Mt. 5:8). Illuminators copied several versions of the Book of Flowers.

T H I S T L E In scenes of Adam and Eve after the Fall—and in other images—the bristly, hard-to-eradicate thistle represented

sin and sorrow. **EXAMPLE**: *A Hermit at Prayer*, painting by Gerrit Dou, seventeenth century. Wallace Collection, London, England. Dou visualized a holy man's spiritual struggle. He painted the hermit praying before an open window, ignoring a large thistle growing in his cave. Even an isolated monk wrestled with temptation.

TREE OF JESSE
Referring to the genealogy at the beginning of Matthew's Gospel, the makers of this tree visually explained how Christ descended from Jesse. The Christ child, the Virgin Mary, and their ancestors appeared in the conceptual Tree of Jesse. **EXAMPLE**: *The Tree of Jesse*, Macclesfield Psalter, illuminated-manuscript page by unknown artist, thirteenth century. Fitzwilliam Museum,

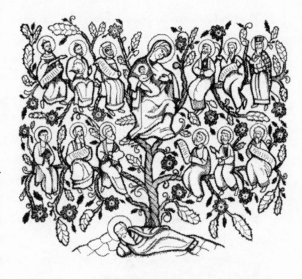

University of Cambridge, Cambridge, England. In this manuscript the illuminators introduced Psalm 1 with a Tree of Jesse, encapsulating the psalter's relationship to Christ. The genealogy traced the relationship between King David and Christ, and the Old and New Testaments.

WILLOW In ancient times the willow represented penitence, weeping, and mourning. On the other hand, the flourishing willow tree also symbolized Christ's gospel, distributed across the world. **EXAMPLE**: *Coin from the Jewish War Against Rome*, metalwork by unknown artist, first century. Private collection. On the obverse side of this ancient coin, the artisan posed a willow tree with its branches sloping downward. Although not a Christian coin per se, it showcased the willow in mourning, an interpretation adopted by Christians during this time.

19
Real and Mythic Animals

In Christian art animal forms have always occupied a place of far greater
importance than was ever accorded to them in the art of the pagan world.
— *The Catholic Encyclopedia*

In the Old Testament, when Job suffered at the hands of Satan, he referred to the
innate spiritual knowledge implanted in animals. He implored his friend Zophar to
recognize their wisdom: "But ask the animals, and they will teach you, or the birds
in the sky, and they will tell you; or speak to the earth, and it will teach you, or let
the fish in the sea inform you. Which of all these does not know that the hand of
the LORD has done this? In his hand is the life of every creature and the breath of
all mankind" (Job 12:7–10).

Christians integrated Job's assertion into their religious convictions, believing
the animals and birds of sacred art conveyed messages for them. These insights
resided in metaphors, biblical stories, moral lessons, and religious theology. Even
more, Christians believed God purposely created some of the earth's creatures to
represent his salvation story. For example, pelicans revived their dead offspring after
three days, symbolizing Christ's resurrection, saving humanity from sin. Peridexion
trees shielded doves from dragons, just as the church sheltered Christians from
Satan. Dogs remained loyal to their owners, just as husbands and wives practiced
fidelity. In this sense, all creation reflected the Creator, if Christians paused and
observed. Sacred art encouraged them to appreciate and learn from God's creatures.

Consequently, animals and birds populated Christian art. Although these crea-
tures proliferated in illuminated manuscripts, they also appeared in jewelry, paint-
ings, sculpture, tapestries, and other art forms. These works honored God's crea-
tures, and his splendor in the earth, sky, and water. For example:

APE OR MONKEY The ape symbolized sin, lust, sloth, cunning,
and Satan. Sometimes it appeared in chains as a symbol of triumph over sin. An
ape occasionally joined the animals in paintings of the Magi visiting the holy
family. **EXAMPLE:** *The Adoration of the Magi*, painting by Giovanni B. Castello,

il Genvoese, sixteenth century. Private collection. In this painting, the artist warned of Satan's plans for destruction. He painted a crowded group of Magi and other worshipers approaching the Christ child on Mary's lap, while a monkey wandered in the painting's foreground.

B A S I L I S K A fictitious creature that largely disappeared after the Middle Ages, the basilisk symbolized the devil or the antichrist. Half cock and half snake, it killed at a glance. **E X A M P L E :** *Basilisk Capital,* from Notre Dame Cathedral at Reims, relief sculpture by unknown artist, thirteenth century. French Monuments Museum, Paris, France. Once crowning a column in a cathedral, this capital sported a basilisk hiding among leaves, as if ready to strike. Although places of worship, cathedrals housed images of good and evil, reminding parishioners that sin lurked in every corner.

B E A R An Old Testament symbol for ancient Persia, the bear evoked evil and cruelty. However, some legends portrayed a saint taming a bear. For example, a bear worshiped Saint Euphemia rather than mauled her. **E X A M P L E :** *Hours of the Cross: Compline, The Entombment,* Very Rich Hours of the Duke of Berry (Les très riches heures du Duc de Berry), illuminated-manuscript page by the Limbourg Brothers, fourteenth century. Royal Library of Belgium, Brussels, Belgium. On a page for Compline, or evening prayers, the illuminator portrayed Christ's friends lovingly placing him on a flat-topped sepulcher. Flowers and animals framed the image, including a bear with his front paws raised as if in prayer. Christians saying Compline believed the Resurrection conquered this bearish moment, releasing them from sin and damnation.

B U L L In the Old Testament, the bull symbolized the pagan god Baal. However, in Christianity the bull represented strength, fertility, and sacrifice. A winged bull represented Luke the Evangelist, attributed with writing the Gospel bearing his name. **E X A M P L E :** *The Flagellation of Christ,* painting by Jaume Huguet, fifteenth century. Louvre, Paris, France. In a panel painting of Jesus's flagellation before his crucifixion, Huguet envisioned two angels praying at the Lord's feet. He also framed this scene with creatures and symbols for the four Evangelists. Luke's bull emphasized the Lord's strength and sacrifice.

C A M E L The camel symbolized temperance because of its ability to endure long stretches without water. It appeared in depictions of the Magi visiting the Christ child and his family, representing persistence. **EXAMPLE**: *Adoration of the Magi*, painting by Andrea Mantegna, fifteenth century. Uffizi Gallery, Florence, Italy. Mantegna painted one depiction of this adoration in an intimate close-up among the holy family and the Magi, hanging at the Getty Museum in Los Angeles, California. On the spectrum's other end, he painted this cluttered image of the Magi and an entourage approaching the family situated in a cave. He included angels fluttering around Mary and servants calming the camels that persistently bore the three foreigners to their destination, a symbol of spiritual determination.

C A T The cat mistakenly represented lust and laziness. Legend revealed a cat gave birth to kittens in the same stable as Jesus, mirroring Mary's motherhood and maternal care. **EXAMPLE**: *The Holy Family with a Cat*, painting by Federico Barocci, sixteenth century. Condé Art Gallery, Chantilly Château, Chantilly, France. In this representation of family joy, Barocci conceived Mary holding the baby Jesus and a toddler, John the Baptist. He painted both boys smiling at a cat on its haunches, ready to bat a ribbon in John's hand. Typical of many holy family portraits, Barocci reduced Joseph to watching from the background.

C E N T A U R Half human and half horse, the centaur represented excess and adultery. It also symbolized heretics and people torn between good and evil. **EXAMPLE**: *Historiated Initial "H" Depicting a Centaur and Historiated Initial "I" Depicting the Eagle of Saint John Silencing the Heretic Arius*, Gospel of Saint John, Bible of Saint Stephen Harding, illuminated-manuscript page by unknown artist, twelfth century. Dijon Municipal Library, Dijon, France. The centaur represented Arius, whose teachings led to Arianism, the belief that Jesus wasn't equal in divinity to God the Father. The First Council of Nicea in the fourth century, convened by Emperor Constantine, opposed this belief.

D O G The dog represented fidelity and watchfulness. In paintings it often sat at the feet or in the lap of a married woman. However, the dog also represented lust, and in some cases the desire to conceive a child. **EXAMPLE**: *The Arnolfini Portrait*, painting by Jan van Eyck, fifteenth century. National Gallery, London,

England. The Netherlandish painter depicted a wealthy couple, the Arnolfinis, holding hands in a Flemish bedchamber. Scholarly debate questioned whether this image with an elaborate signature on the back constituted a betrothal, wedding, or marriage portrait. They've also speculated whether the dog represented loyalty and fidelity or lust, because the couple desired to conceive a child.

D O L P H I N This graceful and friendly marine mammal transitioned into an emblem of salvation and resurrection due to its habit of swimming alongside boats, as if showing the way like Christ guiding believers. The dolphin also signified the story of Jonah and the big fish. **E X A M P L E :** *Dolphin Carrying a Cross*, relief sculpture by unknown artist, unknown century. Czartoryski Museum, Kraków, Poland. The sculptor carved an obvious Christian symbol of salvation: the dolphin showing God's way with a sign of the cross.

D O N K E Y O R A S S The donkey usually symbolized the humility of those who believed in Christ as the Messiah. It appeared in images of the Nativity, the holy family's flight into Egypt, and Christ's entry into Jerusalem. **E X A M P L E :** *The Entry of Christ into Jerusalem*, Altarpiece of Saint Stephen, from Saint Wolfgang Church, Saint Wolfgang, Austria, painting by Michael Pacher, fifteenth century. Art and Archaeology Museum, Moulins, France. Pacher emphasized a large gray donkey in this version of the Triumphal Entry, filling his composition with the lowly animal's body. Against the norm, he assigned Jesus a secondary role. Although the forthcoming Savior's purple robe and gold nimbus denoted royalty, symbolically the donkey insisted on humility.

D R A G O N O R L E V I A T H A N Christian tradition considered the dragon symbolic of evil, Satan, or God's enemy. A dragon in chains represented conquered evil. **E X A M P L E :** *Christ Running Through the Leviathan*, Mirror of Human Salvation (Speculum Humanae Salvationis) by Jean Miélot, illuminated-manuscript page by unknown artist, fifteenth century. Condé Art Gallery, Chantilly Château, Chantilly, France. In a manuscript about salvation, a Flemish illuminator interpreted the Resurrection as Christ's triumph over Satan. He showed Christ with a foot on the leviathan, victoriously running a cross-topped spear through the beast's neck.

E R M I N E The ermine honored purity and innocence because legend said it would rather die than soil its white coat. Clerics and royalty wore ermine in Christian portraits and paintings. **E X A M P L E :** *The Holy Family*, painting by unknown artist, sixteenth century. Private collection. According to this painter, Mary covered her naked baby in an ermine blanket, symbolizing his lifetime purity.

F O X Often a fox symbolized the devil, guile, and trickery. **E X A M P L E :** *Holy Family with Animals*, painting by Jan Brueghel the Elder, seventeenth century. Doria Pamphilj Gallery, Rome, Italy. Brueghel the Elder evoked safety and danger in this painting of the holy family. He painted a lion sleeping at Mary's feet, representing the fierce Lion of Judah at rest, but a fox also lingers there, a symbol of Satan the beguiler.

G O A T A goat represented the sinner, especially in relationship to the righteous. It also symbolized a damned person in Last Judgment paintings (Mt. 25:31–46). **E X A M P L E :** *The Parable of the Good Shepherd Separating the Sheep from the Goats, Scenes from the Life of Christ*, mosaic by unknown artist, sixth century. New Saint Apollinare Basilica, Ravenna, Italy. In a preview of the Last Judgment, mosaicists depicted Christ the Shepherd sitting on a throne, flanked by two judging angels, and separating sheep from the goats. The sheep, symbolizing the "saved" who followed Christ, stand at his right hand. The goats, representing the "damned" who rejected Christ, stand at his left hand.

G R I F F I N A mythical character combining an eagle's head and wings with a lion's body, the griffin represented Christ and his power. **E X A M P L E :** *A Griffin*, mosaic by unknown artists, thirteenth century. Saint John the Evangelist Basilica, Ravenna, Italy. At this basilica, a majestic mosaic griffin reminded congregants of Christ's power, perhaps as a comfort and a warning.

H O G O R P I G The hog represented the demon of gluttony and sensuality, recalling the parable of the prodigal son who tended pigs before returning to his father (Lk. 15:15). **E X A M P L E :** *The Prodigal Son as a Swineherd*, painting by Abraham Bloemaert, seventeenth century. Chiswick House, London, England. In a

setting looking like seventeenth-century England, Bloemaert materialized two peasants pointing to the humiliated prodigal son and his custodial swine.

H O R S E In the Renaissance the horse represented lust (Jer. 5:8). **EXAMPLE:** *Horse and Cavalier*, sketch by Leonardo da Vinci, fifteenth century. Academy Gallery, Venice, Italy. Leonardo's simple, pen-and-ink, muscular horse exuded the power to throw its restraining rider aside, galloping at its own pleasure. Da Vinci might not have intended his horse to represent lust, but the animal's untamed energy embodied it.

H Y E N A The hyena symbolized avarice and a person who thrived on false doctrine (Jer. 12:9). **EXAMPLE:** *Earth*, or *The Earthly Paradise*, painting by Jan Brueghel the Elder, sixteenth century. Louvre, Paris, France. Brueghel the Elder created a Garden of Eden where Adam and Eve resided peaceably with animals. However, these creatures turned dangerous or acquired negative symbolism after the couple's fall from grace. These included the horse, hyena, tiger, peacock, and wolf.

L A M B When John the Baptist recognized Jesus, he called his cousin the Lamb of God (Jn. 1:29). The lamb symbolized Christ in all periods of Christian art, especially his role as the lamb sacrificed for humanity's sins. **EXAMPLE:** *Madonna and Child with Saint John and the Lamb*, painting by Bernardino Luini, sixteenth century. Indianapolis Museum of Art, Indianapolis, Indiana. Luini placed the babies Jesus and John under Mary's watchful care, playing with a kneeling lamb. With this endearing image, the painter foretold a sacrificial future for them all.

L E O P A R D The leopard signified sin and Satan due to John's description of the animal in the Apocalypse. John wrote, "The beast I saw resembled a leopard, but had feet like those of a bear and a mouth like that of a lion. The dragon gave the beast his power and his throne and great authority" (Rev. 13:2). **EXAMPLE:** *Lion and Leopard*, tapestry by unknown artist, sixteenth century. Private collection. Posing a lion and leopard together intensified the evil symbolism for these animals—that is, Satan and his destruction.

LION A lion acquired its meaning depending on the context. Generally, the lion exuded courage, strength, and majesty. He represented Christ, the Lion of Judah (Rev. 5:5). In reverse, the lion also symbolized Satan because of its pride and ferocity (Ps. 91:13). With wings, the lion symbolized Mark the Evangelist. **EXAMPLE**: *Lion Passant*, from Saint Peter of Arlanza Monastery, Bergos, Spain, painting by unknown artist, thirteenth century. The Cloisters, Metropolitan Museum of Art, New York, New York. Contemporary texts state this lion and its dragon companion merely decorated walls. However, the fresco's location and prominence in a monastery begs an interpretation of Jesus, the Lion of Judah, prowling around Satan, the dragon enemy.

LIZARD An ancient tale reported an old lizard regained its eyesight by looking into the rising sun. This led to the lizard as a symbol of spiritual sight gained through the gospel. The reptile's shedding skin also represented renewal and the Resurrection. **EXAMPLE**: *Temptation of Saint Anthony*, painting by David Teniers the Younger, seventeenth century. Private collection. Beginning in the tenth century, the temptation of Saint Anthony became a popular subject for medieval images, based on the hermit's confession to visions while traveling in the Egyptian desert. Teniers the Younger employed wildlife with contrasting symbolism in his version: the owl for Satan and darkness, or solitude and wisdom; the vulture for evil and greed, or innocence and purity; and the lizard for spiritual insight. All these interpretations represented Anthony's spiritual story.

LYNX Medieval symbolism considered the lynx related to the devil, probably because of its reddish coat. **EXAMPLE:** *Lynx*, from *A History of the Northern Peoples*, woodcut by Olaus Magnus, sixteenth century. British Library, London, England. In this history book, Magnus described medieval Nordic life and beliefs. His densely illustrated work informed Christian Europe about Swedish gods and paganism. In this woodcut, Magnus illustrated the devilish lynxes and other wild animals roaming the countryside.

O X A sacrificial animal for the Israelites, an ox represented the Jewish nation. It also symbolized Christ, the true sacrifice, and figured into Nativity scenes. The ox also symbolized patience and strength. **E X A M P L E** : *The Ox Symbol of Saint Luke*, mosaic by unknown artist, date unknown. Saint Mark's Basilica, Venice, Italy. High in the church's choir dome, a mosaicist spread the golden wings of a magnificent ox wearing a nimbus, the symbol for Luke the Evangelist.

R A B B I T O R H A R E The defenseless hare symbolized people who placed their trust in Christ. However, it also identified lust. Sometimes a rabbit sat at the Virgin Mary's feet, representing her victory over lust. **E X A M P L E** : *Presentation of Mary at the Temple*, painting by Vittore Carpaccio, sixteenth century. Brera Art Gallery, Milan, Italy. Carpaccio added detail to the traditional story of Mary's presentation at the temple. While a priest received the Virgin standing on the portal's staircase, a rabbit sat in a corner nearby, representing her purity.

R A M In the Old Testament, the ram caught in a bush sub-stituted as a sacrifice for Isaac (Gen. 22:13), foretelling how Christ offered himself for humanity. **E X A M P L E** : *A Misericord Depicting a Clean-Faced Ram with Elaborate Curved Horns and Conventional Curled Hair*, relief sculpture by unknown artist, fourteenth century. New College Chapel, University of Oxford, Oxford, England. Churches often decorated their misericords, the small wooden ledges underneath folded seats. Called "mercy seats," they allowed relief for choir members or others who folded their chairs and stood during worship services. They could lean against the misericords. A sculptor decorated this misericord with a ram, most likely representing Christ.

S H E E P Jesus declared himself the Good Shepherd who cared for and sacrificed his life for the sheep (Jn. 10:11). The sheep symbolized Christ's followers. **E X A M P L E** : *The Good Shepherd*, sculpture by unknown artist, fifth century. State Hermitage Museum, Saint Petersburg, Russia. Carving a repeated image in early Christianity, the sculptor depicted a muscular young shepherd with a lamb slung over his shoulders. Archaeologists found this sculpture in the ruins of a Byzantine village church in Asia Minor, so the artist intended the shepherd to represent Jesus. A similar *Good Shepherd* sculpture resides at the Vatican Museums, Vatican City, Italy.

S N A I L In the fall season the snail hid in its shell and emerged after winter. This practice represented the Resurrection. **EXAMPLE**: *The Agony in the Garden*, Stafford Prayer Book, illuminated-manuscript page by unknown artist, sixteenth century. Arundel Castle, West Sussex, England. The illuminator decorated the borders of this image with symbols related to Christ and the Passion, including a snail crawling up one side of the page. Although Jesus sweat blood in the garden before his death, the snail predicted his ultimate Resurrection.

S N A K E O R S E R P E N T In Genesis the serpent tempted Adam and Eve in the Garden of Eden, causing them to sin. Ever after, the snake symbolized the devil or Satan, sin, and deceitfulness (3:1–8). **EXAMPLE**: *The Creation of Woman, and the Serpent*, painting by unknown artist, twelfth century. Abbey Church, Saint-Savin-sur-Gartempe, France. In a vault above the nave, the fresco painter created a continuous image of two creation scenes, from right to left. In the temptation image at the left, the snake rises up taller than Eve, in an act of beguiling intimidation.

S T A G The stag symbolized piety and purity (Ps. 42:1). This nimble animal wandered in high mountains, so it also typified solitude. **EXAMPLE**: *Stags and Birds*, Arundel Psalter, illuminated manuscript page by unknown artist, fourteenth century. British Library, London, England. Medieval people lived close to nature, so animals and vegetation often appeared in the borders of sacred texts. At the bottom of a page in this psalter, the illuminator posed a stag in the woods, representing purity and piety.

U N I C O R N The white unicorn, a mythical animal, stood for purity, Christ, or the Virgin Mary. The Christian interpretation evolved from a myth that a unicorn couldn't be tamed or caught until it lay in the lap of a virgin and fell asleep. **EXAMPLE**: *The Lady and the Unicorn: Sight*, tapestry by unknown artist, fifteenth century. Museum of the Middle Ages, Paris, France. Part of a series about the senses, this tapestry probably communicated Christ's and Mary's purity when a unicorn knelt before a virgin and a peaceable lion stood nearby.

W H A L E The whale took on devilish qualities because folktales claimed mariners sometimes mistook its back for a small island. Once sailors anchored to the whale, the mammal pulled a ship to its demise. The whale also represented the story of Jonah and Christ's death and resurrection. **E X A M P L E :** *Jonah Swallowed Up by the Whale*, painting by Giotto di Bondone, fourteenth century. Scrovegni Chapel, Padua, Italy. Giotto's painting looks humorous to modern viewers, with the prophet's torso already hidden in the whale's mouth and his legs sticking straight up, into the sea air. Giotto painted the familiar Old Testament story in a small quatrefoil next to his Lamentation fresco, a mourning scene after Christ's death. Beginning in the earliest centuries of Christianity, believers considered Jonah's story a prophetic archetype of the Lord's death and resurrection.

W O L F Roman Christians associated the wolf with evil. Early Christians considered the wolf a symbol for heretics and hypocrites because Jesus called false prophets wolves in sheep's clothing (Mt. 7:15). **EXAMPLE:** *Scenes from the Life of Saint Anselm of Canterbury*, Mirror of History (Le Miroir historial), illuminated-manuscript page by Vincent de Beauvais, fifteenth century. Condé Art Gallery, Chantilly Château, Chantilly, France. In the lower register of this page, an illuminator illustrated the story of a sick monk who described his illness as two wolves or devils attacking him. Saint Anselm traced the sign of the cross above the monk and healed him.

THE BEASTS OF THE BESTIARY

Early Christians believed the earth's creatures magnified God's greatness. Along with the ancient psalmist, they thought these creatures praised God. The psalmist explained, "Praise the Lord from the earth, you great sea creatures and all ocean depths . . . wild animals and all cattle, small creatures and flying birds" (Ps. 148:7, 10).

Consequently, believers developed a religious symbology based on God's creatures, great and small. In the second or third century, the allegorical ancient Greek *Physiologus* (*physis* meant "nature" and *logos* meant "word" or "reason") grew into a bestseller in Europe and Asia Minor, describing animals and assigning them spiritual meanings. The *Physiology* combined oral stories, mythology, Scripture, and works by natural historians to explain the parallels between nature's creatures and their heavenly archetypes.

Eventually this Greek text expanded and combined with other works about animal lore, creating the Latin bestiary of the Middle Ages. However, artists took liberties with animals they never encountered in life. At times illustrators drew the crocodile as a dog-beast or a whale as a scaled fish. The ostrich walked with hooves, and a serpent sprouted feet or wings. Some illustrators lacked the skill to accurately portray a creature, but others mastered true works of art. Despite some fanciful entries, Christians adopted these spiritual allegories for moral and religious instruction.

Overall beasts, birds, reptiles, insects, and fish populated sacred art, often based on images in bestiaries. These works honored God's creatures and his splendor in the earth, sky, and water.

- Dog-Beast Crocodile - Ostrich with Hooves

- Whale with Scales

20

Birds, Fish, and Insects

What was once well-known during medieval and Renaissance times—
such as the meaning of symbols like the stork, goldfinch, peacock,
eagle, sparrow, and dove—is less well-known today
but can be learned and enjoyed
in order to more thoroughly appreciate paintings.

—SUZANNE HILL

When Jesus comforted worried Galileans, he talked about birds. He pointed upward and said, "Look at the birds of the air; they do not sow or reap or store away in barns, and yet your heavenly Father feeds them. Are you not much more valuable than they?" (Mt. 6:26). When the Lord girded his apostles for ministry, he spoke about sparrows. He assured them, "Do not be afraid of those who kill the body but cannot kill the soul. Rather, be afraid of the One who can destroy both soul and body in hell. Are not two sparrows sold for a penny? Yet not one of them will fall to the ground outside your Father's care. And even the very hairs of your head are all numbered. So don't be afraid; you are worth more than many sparrows" (Mt. 10:28–31).

Jesus often referenced God's creation when he taught spiritual principles or inspired confidence in his followers. He commissioned his disciples with the words, "Come, follow me, . . . and I will send you out to fish for people" (Mt. 4:19). Scripture says the fishermen immediately dropped their nets and followed him. He explained the kingdom of heaven as follows: "Once again, the kingdom of heaven is like a net that was let down into the lake and caught all kinds of fish. When it was full, the fishermen pulled it up on the shore. Then they sat down and collected the good fish in baskets, but threw the bad away. This is how it will be at the end of the age. The angels will come and separate the wicked from the righteous" (Mt. 13:47–49).

In the same manner, creatures of the sky and sea taught lessons and encouraged Christians through art's symbolism. Flying or swimming, nesting or singing, they exalted God's kingdom.

A N T The ant symbolized industry and wisdom (Prov. 6:6). **EXAMPLE**: *Signet Ring with Ant*, engraving by unknown artist, first or second century. Victoria & Albert Museum, London, England. By wearing this signet ring, its owner wanted to communicate his industry, trustworthiness, and quality workmanship—all reliable Christian traits in the Roman marketplace.

B E E In Christian art, the beehive suggested community, sweetness, eloquence, and sometimes the Virgin Mary and Christ. The bee also exemplified industry, diligence, and vigilance. In contrast, its sting tortured sinners. **EXAMPLE**: *The Damned Being Led by Demons and Tormented by Bees, Inferno, The Divine Comedy* by Dante Alighieri, illuminated-manuscript page by unknown artist, fourteenth century. Condé Art Gallery, Chantilly Château, Chantilly, France. Illustrating Dante's book from the thirteenth century, the illuminator marched the "damned," covered with bee stings, and menacing demons across the bottom of a page, leading them to hell.

B L A C K B I R D With its dark feathers, a blackbird embodied the tainted nature of sin and evil. In addition, the bird's appealing melody symbolized the temptations of the devil and fleshly desires. **EXAMPLE**: *Madonna and Child with Saint Francis and Saint Bernard of Siena*, painting by Girolamo di Benvenuto, fifteenth century. York Art Gallery, York, North Yorkshire, England. Benvenuto placed the Virgin and Child in the center of his canvas, with Saint Francis and Saint Bernard standing behind them. He painted Francis with his stigmata wounds and Jesus holding a blackbird, expressing their spiritual power over evil.

B U T T E R F L Y The butterfly represented a perfect symbol of renewed life because it reflected life (caterpillar), death (chrysalis), and eternal life (butterfly). In art the butterfly often landed in the palm of Jesus's hand, a symbol of his resurrection. **EXAMPLE**: *Page with Floral Border and Text with Historiated Initial "G" Depicting a Bishop Holding Pincers with a Tongue in Them*, book of hours, illuminated-manuscript page by unknown artist, fifteenth century. Fitzwilliam Museum, University of Cambridge, Cambridge, England. In this illumination, the painter depicted a bishop holding a tongue in his pincers, to indicate the

deserving penalty for a backbiter. However, in the illustration's flowered border he prominently displayed a butterfly, offering the hope of transformation.

COCK OR ROOSTER The cock's vigilant behavior of crowing in the early morning denoted the attributes of watchfulness and hope. However, if the cock stood near Saint Peter, it suggested the disciple's repeated denial of Christ, as well as his repentance. The cock also recalled the Passion of Christ. **EXAMPLE:** *The Cock and the Tortoise Decorative Pavement Depicting Christian Images and Pagan Symbols,* mosaic by unknown artists, fourth century. Aquileia Basilica, Province of Udine, Italy. Although the tortoise usually represented patience and wisdom, the mosaicist probably intended an evil symbology because it looks ready to fight the cock, a symbol of Saint Peter. On the other hand, the artisan might have created an allegory for wisdom joining with hope.

CRANE An ancient tale claimed that every night cranes encircled their king and certain members of the clan kept watch. The protectors couldn't fall asleep, so they stood on one leg. In the raised foot, the watchful bird held a stone. If the crane fell asleep, the stone hit his other foot and the bird woke up. Consequently, the crane symbolized good works, order, alertness, and devotion. **EXAMPLE:** *A Crane and a Stork,* English Bestiary, illuminated-manuscript page, thirteenth century. Fitzwilliam Museum, University of Cambridge, Cambridge, England. The illuminator painted an alert and eager crane tromping across the parchment page, a visual symbol for Christian devotion.

DOVE The dove filled many prominent roles in Scripture that translated into Christian symbolism. It represented peace in the story of Noah and the flood. After Noah released the dove, the bird returned bearing an olive branch, indicating the water had receded. God had made peace with humanity (Gen. 8:8–12). The Israelites used the dove in cleansing sacrifices where it symbolized purity (Lev. 5:7). The dove also represented the Holy Spirit. At Jesus's baptism, the Holy Spirit descended on him in the form of a dove (Mt. 3:16). **EXAMPLE:** *Madonna and Child with a Dove,* painting by Piero di Cosimo, fifteenth century. Louvre, Paris, France. In this instance, Cosimo painted the obvious. He drew a chubby, naked Christ child pointing to a dove in the foreground, as if to make a point about the Holy Spirit, or maybe to identify the child with the bird.

E A G L E This majestic bird symbolized renewal or resurrection. Ancient beliefs held that eagles flew near the sun, singeing their feathers, regenerating new plumage, and clearing their eyesight. The eagle's upward soar memorialized Jesus's resurrection and ascension into heaven. However, in some translations of the book of Revelation, the eagle announced the earth's impending doom. E X A M P L E : *The Fourth Trumpet and the Eagle of Woe*, Apocalypse of Angers, tapestry by Nicolas Bataille, fourteenth century. Museum of Tapestries, Angers Château, Angers, France. According to the illuminator, an eagle prophesied the darkening of the sun, moon, and stars during apocalyptic events. The bird stood on a scroll trailing behind an angel, above a city of collapsed buildings.

E G G An egg represented resurrection and hope because a chick broke free from its shell into new life. Pagans originally used egg symbolism for spring festivals, signifying fertility and fresh starts. Later Christians adopted the egg as a metaphor for new beginnings in Christ. E X A M P L E : *Rearing Hens*, Maintenance of Health (Tacuinum Santiatis Codex Vindobonensis), illuminated-manuscript page by unknown artist, fourteenth century. Austrian National Library, Vienna, Austria. Even in an everyday image of raising hens, a woman holding an egg harbored a spiritual message of new life.

F A L C O N A wild or domesticated falcon represented two types of humanity. The wild bird allegorized a sinful, unconverted person, whereas the domesticated falcon depicted a holy person. E X A M P L E : *Calendar Page for October, Hawking*, The Julius Calendar and Hymnal, illuminated-manuscript page by unknown artist, eleventh century. British Library, London. Religious manuscripts sometimes included images from daily life, such as the falconer and falcon in this inked illustration. The illuminator drew a tamed falcon so in this hymnal it could represent a holy person.

F I S H Early Christians used the first letters of Christ's name in Greek (Jesus Christ, God's Son, Savior) in a fish shape known as the *Ichthys* to represent him. A fish also symbolized the miracle of the loaves and fishes (Mt. 14:13–21) or an ancient Eucharist meal. Less commonly, a fish also meant baptism. E X A M P L E : *Miracle of the Bread and the Fishes*, mosaic by unknown artists, fifth–sixth centuries.

Church of the Multiplication of the Loaves and the Fishes, Tabgha, Israel. With two bread loaves and a basket of fish, Byzantine mosaicists reminded viewers of Christ and his ability to perform miracles. Artists laid this floor mosaic next to a large rock. Scholars speculate that the early church believed Jesus stood on this rock before blessing the food to feed a crowd of five thousand.

FLY A fly symbolized sin and evil. When a fly neared the Virgin Mary and the Christ child, it represented the evil Jesus would overcome. **EXAMPLE**: *Virgin and Child*, painting by Carlo Crivelli, fifteenth century. Victoria & Albert Museum, London, England. Crivelli painted a suspicious-looking Mary gripping her somber toddler and looking at three flies on a ledge in front of her. She could be recognizing multiple evils waiting to pursue her child in the future.

FROG God plagued Egypt with a flood of frogs from the Nile (Exod. 8:6) and they became a symbol of devil-like qualities and the repugnance of sin. Frogs also alluded to heresy or false prophets (Rev. 16:13). **EXAMPLE**: *Dragons Vomiting Frogs*, *Apocalypse of Angers*, tapestry by Nicolas Bataille, fourteenth century. Museum of Tapestries, Angers Château, Angers, France. Bataille based this tapestry image on Revelation 16:13, "Then I saw three impure spirits that looked like frogs; they came out of the mouth of the dragon, out of the mouth of the beast and out of the mouth of the false prophet." However, the tapestry's beautiful red, blue, and green colors visually modified this horrific apocalyptic image, making it more bearable for viewers.

GOLDFINCH The goldfinch referenced the Passion because it lived in thistles and thorny vegetation, alluding to the crown of thorns placed on the Savior's head. **EXAMPLE**: *The Madonna and Child with a Goldfinch*, painting by Bernardo Daddi, fourteenth century. Isabella Stewart Gardner Museum, Boston, Massachusetts. In this gentle mother-and-child image, Daddi introduced a goldfinch sitting on the Christ child's outstretched finger—a foreshadowing of the thorns pressed on his head.

GOOSE A legend recounted a surprise attack by the Gauls on Rome, Italy, in the fourth century BC. The ambush startled geese and they honked, alerting the Romans and saving them from devastation. This story bestowed the qualities of providence and vigilance upon the goose. **EXAMPLE**: *The Goose with the Thurible*, mosaic by unknown artist, thirteenth century. Saint John the Baptist Basilica, Ravenna, Italy. A mosaicist endowed this goose with vigilant character because he carries a thurible (censer), representing prayers of the people, to God's heavenly throne.

GRASSHOPPER OR LOCUST Grasshoppers or locusts plagued the Egyptians because their pharaoh refused God's demands through Moses (Exod. 10:13–14). In art the Christ child sometimes held a grasshopper to symbolize nations who converted to Christianity. **EXAMPLE**: *The Plague of Locusts,* Commentary on the Apocalypse of John by Beatus of Liébana, illuminated-manuscript page by unknown artist, eleventh century. National Library, Madrid, Spain. A number of versions of the eighth-century monk's commentary exist. This eleventh-century illuminator divided the manuscript page into three horizontal registers, each with locusts torturing Egyptians and their livestock. In this image, a black-winged Angel of the Abyss orchestrated the Old Testament tragedy.

HEN AND CHICKS Using a maternal metaphor, Jesus compared God the Father to a hen protecting her young (Mt. 23:37). **EXAMPLE**: *Allegory of the Trinity*, painting by Frans Floris, sixteenth century. Louvre, Paris, France. In this Netherlandish painting of the Crucifixion, Floris nestled a hen and her chicks in the foreground. He added this description, "God gathers and protects his people under the grace of the Crucifix."

LARK Because the lark soared to a great height and hovered there, singing, it appeared to praise God. Consequently, the lark symbolized joyful prayers to God, and also the priesthood. **EXAMPLE**: *Larks*, Book of Kells, illuminated-manuscript page by unknown artist, ninth century. Trinity College, Dublin, Ireland. The Book of Kells illuminators incorporated nature into the manuscript's borders. On this page illuminators intertwined birds, including singing larks, in richly decorated borders.

O W L Because the owl stayed awake at night, in art Christians associated it with Satan, death, cold, and darkness. However, owls also suggested solitude and wisdom. Sometimes they perched in compositions with scholarly saints. **E X A M P L E** : *Motif with Putti*, painting by Matteo di Giuliano di Lorenzo Balducci, sixteenth century. Lindenau Museum, Altenburg, Germany. Balducci carved and painted a complicated motif on softwood, featuring twin putti (small angels) presided over by a wise owl.

P E A C O C K The peacock ushered in thoughts of immortality because legend said its flesh didn't decay. This bird shed its feathers each year and grew new ones. In this regard, it appeared in scenes of the Nativity. However, a strutting peacock symbolized pride and vanity because the feathers spread upward and outward for all to admire. **E X A M P L E** : *Peacock*, painting by unknown artist, third century. Catacomb of Priscilla, Rome, Italy. Above the famous painting of the Donna Velata orans, a veiled woman praying with lifted hands, fresco painters positioned a peacock with folded feathers. The peacock repeatedly appeared in Christian catacombs to remind believers of eternal life.

P E L I C A N The pelican recalled Christ's sacrifice and the Eucharist because people mistakenly believed the mother bird sacrificed its life for her young. A female pelican pressed into its chest to fully empty the throat pouch when feeding her babies. People misinterpreted this action as the bird ripping apart its chest to feed her offspring. **E X A M P L E** : *Pelican*, mosaic by unknown artist, fifth–sixth centuries. Small Basilica, Heraclea Lyncestis, Bitola, Republic of Macedonia. As Byzantine congregants walked on this basilica's narthex floor, a pelican beneath their feet reminded them of Christ's everlasting sacrifice for humanity's salvation.

P H O E N I X Artists depicted this mythical bird with the body of an eagle and the head of a pheasant. According to legend, it lived for five hundred years. When the phoenix grew old, it self-ignited, died in a fire, and later rose from the ashes. This renewal exemplified Christ's resurrection. **E X A M P L E** : *Reliquary Cross with a Phoenix*, relief sculpture by unknown artist, sixteenth century.

Saint Bavo Cathedral, Ghent, Belgium. A Flemish metalworker decorated the small reliquary box on this cross with a phoenix. Perhaps the bird's Resurrection symbolism related to the alleged True Cross relic that once resided within the silver-and-gold container.

R A V E N These black birds, with their croaking sounds and carrion diets, warned about death, the devil, and evil. More positively, ravens with saints recalled protection and provision. **EXAMPLE:** *Christ Speaking to Angels and Scenes of Medieval Daily Life*, Four Books of Sentences (Liber Quatuor Sententiarum), illuminated-manuscript page by unknown artist, thirteenth century. Mazarine Library, Paris, France. Petrus Lombardus, the twelfth-century bishop of Paris, wrote this theology textbook for study and teaching. It became a standard text from the thirteenth through sixteenth centuries. The illuminator of this thirteenth-century edition filled the space below the text with medieval scenes of farming and fishing. In between the figures, he painted a raven participating in these provision-gathering activities.

S C A L L O P The scallop shell symbolized baptism, if the shell held three drops of water. Or it represented pilgrimages to Santiago de Compostela in Spain, reportedly where Christians buried the apostle James. In this region, called Galicia, scallop shells littered the shore. **EXAMPLE:** *Pilgrim's Hat*, textile work by unknown artist, sixteenth century. Germanic National Museum, Nuremberg, Germany. Not many pilgrim hats survived their trips and time's ravages, but this unusual German version prominently displayed a scallop, helping its owner broadcast that he participated in a holy pilgrimage.

S C O R P I O N The scorpion's bite caused agony and it symbolized the traitor Judas and evil (Rev. 9:5). Sometimes a scorpion appeared on the flags and shields of soldiers at the Crucifixion. **EXAMPLE:** *Crucifixion*, painting by Giovanni Boccati, fifteenth century. National Gallery of Marche, Urbino, Italy. In the lower right of this Crucifixion image, Boccati painted a soldier's flag with two scorpion emblems, verifying the presence of evil and betrayal.

S P A R R O W Considered the lowliest of birds, the sparrow alluded to poor and common people. Christ referred to sparrows when he explained God's care for the lowliest creatures, assuring his followers the Father would provide for them (Mt. 10:28–31). **E X A M P L E :** *A Sparrow Standing on a Hillock*, illuminated-manuscript page by unknown artist, fourteenth century. Fitzwilliam Museum, University of Cambridge, Cambridge, England. The bestiary painter boosted this sparrow's stature by not only standing the bird on a small hill, but also making it nearly as big as the surrounding trees leaning their branches toward it. With this hieratic scale—upsizing the bird in relationship to other elements—the illuminator indicated its importance in the scene, and perhaps in God's universe.

S P I D E R The spider carried three meanings about sin: the miser who drains people of their money; the devil who set traps for the righteous; and people whose deceitful webs eventually perish. The cobweb warned about human weakness. **E X A M P L E :** *A Dragon-fly, Two Moths, a Spider and Some Beetles, with Wild Strawberries*, painting by Jan van Kessel the Elder, seventeenth century. Ashmolean Museum, University of Oxford, Oxford, England. If interpreted as an allegory, Kessel's painting exposed devouring natures. The spider and other insects compete to taste the strawberry's sweetness, but eventually they will destroy it.

S T O R K Appearing in late winter as if to proclaim spring, the stork recalled the archangel Gabriel's announcement to the Virgin Mary. The stork also represented prudence, chastity, and piety. **E X A M P L E :** *Representation of One of the Virtues*, painting by Franco Battista, sixteenth century. Saint Francis of the Vineyard Church, Venice, Italy. In a series representing virtues, painted on the Grimani Chapel ceiling, Battista placed a visually out-of-context stork behind a woman talking to a seated man and pointing toward heaven. However, from a symbolic standpoint, the bird possibly emphasized her piety and chastity.

S W A L L O W According to legend, the swallow hibernated in the mud of riverbanks during the winter months and emerged in the spring. It symbolized Christ's incarnation and resurrection. **E X A M P L E :** *The Madonna and Child with a Swallow*, painting by Francesco di Stefano Pesellino, fifteenth century. Isabella Stewart Gardner Museum, Boston, Massachusetts. In this Virgin and Child image, Pesellino painted Jesus clutching a sparrow in his hand as a sign of his adult resurrection.

S W A N Because of the swan's white feathers and life in pure water, it implied purity, chastity, love, courage, and a clean conscience. It also symbolized Christ and the Virgin Mary. However, a swan also exemplified a hypocrite. The swan wore white feathers, but once plucked, the bird exposed its black flesh. In turn, hypocrites seemed trustworthy on the outside but proved corrupt inside. **E X A M P L E :** *The Marriage of the Virgin*, Very Rich Hours of the Duke of Berry (Les très riches heures du Duc de Berry), illuminated-manuscript page by the Limbourg brothers, fifteenth century. National Library of France, Paris, France. In this version of the Virgin Mary's wedding, the illuminator prominently placed a white swan in the page's right border, an obvious representation of the young woman's purity and courage.

T U R T L E D O V E The turtledove symbolized fidelity because it tended to be monogamous and mate for life. **EXAMPLE:** *Turtledoves in a Cage*, Maintenance of Health (Tacuinum Sanitatis), illuminated-manuscript page by unknown artist, fourteenth century. National Library of France, Paris, France. In this medieval treatise on health and well-being, illuminators depicted these turtledoves in a cage, perhaps representing fidelity's sacred and self-appointed sexual boundaries.

V U L T U R E Although a vulture often depicted death, evil, and greed because it ate carrion, the bird also characterized innocence and purity. In medieval times people believed the east wind fertilized the vulture's eggs. Thus, the vulture also symbolized the Virgin Mary, with the wind as a symbol of the Holy Spirit. **E X A M P L E :** *Battle Scene*, Bible of the House of Alba (Biblia de la Casa de Alba), illuminated-manuscript page, fifteenth century. Liria Palace, Madrid, Spain. Spanish illuminators chose brilliant reds and oranges contrasted against gray to color this raging attack on a castle and its occupants. In the middle ground and foreground, vultures pick at the dead bodies, perhaps symbolic of greed's relationship to spiritually deadened souls.

W O O D P E C K E R Because the woodpecker damaged wood, this bird symbolized heresy and the devil who undermined human souls. **EXAMPLE:** *Woodpecker*, Sherborne Missal, illuminated-manuscript page by John Siferwas (chief illustrator) and John Whas (scribe), fifteenth century. British Library, London, England. The Sherborne Missal illuminators incorporated forty-eight naturalistic depictions of birds, with unusual methods of integrating them into the manuscript. For example, the illustrator drew a stately woodpecker in blue, white, and red colors sitting atop a roundel of pious women singing from a prayer book. The singers could be warding off the symbolic evils of the woodpecker, but the bird's countenance makes this interpretation hard to believe.

W O R M Viewed as a lowly creature, the worm illustrated humility and weakness. The worm also represented death and decay because it decomposed matter. **EXAMPLE:** *Still Life of a Forest Floor with Flowers, a Mouse, and Butterflies*, painting by Elias van den Broeck, seventeenth century. Private collection. Although only an arranged still-life painting, the worm carried the message of decay and humility to those who understood religious symbolism.

21

The Human Body

The oldest, the most profound, the most universal of all
symbols is the human body.

—JOHN BRUNO HARE

For ancient Christians, the body caused concern or celebration, depending on whether it entertained a sinful or saintly nature. Jesus warned about the body as a gateway to sin. He emphasized that body parts worked in unity, for good or evil. If one part sinned, it affected the entire body. The Lord elaborated: "If your right eye causes you to stumble, gouge it out and throw it away. It is better for you to lose one part of your body than for your whole body to be thrown into hell. And if your right hand causes you to stumble, cut it off and throw it away. It is better for you to lose one part of your body than for your whole body to go into hell" (Mt. 5:29–30). "Therefore, if your whole body is full of light, and no part of it dark, it will be just as full of light as when a lamp shines its light on you" (Lk. 11:36).

After Christ's ascension the apostle Paul continued this instruction. He asked, "Do you not know that your bodies are temples of the Holy Spirit, who is in you, whom you have received from God? You are not your own; you were bought at a price. Therefore honor God with your bodies" (1 Cor. 6:19–20). From the beginning, Christians believed they honored God with their bodies by allowing the Spirit to fill and guide them, choosing to live righteously and refusing their sinful natures and earthly temptations.

Symbolism in Christian art reflected these beliefs about the body. In most cases, specific body parts represented important aspects of Christ's redemptive story or positive attributes of his followers. For example:

B L O O D Beginning in early Christianity, blood drew to mind Christ dying on the cross for humanity's sins (Eph. 2:13). In turn, Christians believed the Communion chalice held his actual or symbolic blood (Mt. 26:27–28). Overall, blood symbolized life and the human soul. **EXAMPLE**: *Angel Collecting Blood from the Wounds of Christ*, painting by Lorenzo Lotto, sixteenth century. Museum

of Fine Arts, Vienna, Austria. Lotto painted a mass of angels winging the dead Jesus toward heaven. In the foreground, he strategically placed an angel holding a chalice, collecting blood from the Savior's wounds, not wasting the sacred substance.

B R E A S T S Female breasts represented motherhood, nourishment, and protection. In some Renaissance paintings, artists portrayed Mary nursing the baby Jesus at her breast. **E X A M P L E :** *Madonna Suckling the Christ Child*, painting by Carlo Crivelli, fifteenth century. Parish Museum, Corridonia, Italy. Crivelli captured a common mother-and-child moment: coaxing a distracted baby to nurse when he looks away from her. The painter emphasized Mary's protective nature when she firmly grasped Jesus with a spread-fingered hand and with the other hand, gripped his chubby, wiggly leg.

E A R The Virgin Mary heard the archangel's birth announcement, and early Christian tradition believed she conceived through her ear. In the eleventh century, some artists painted a light shining into her ear during the Annunciation. By the twelfth century, certain images showed a dove, representing the Holy Spirit, flying toward her ear. More often, an ear related to Passion Week, when Peter the disciple cut off the right ear of the high priest's servant arresting Jesus in the Garden of Gethsemane (Jn. 18:10). **E X A M P L E :** *The Annunciation*, painting by Carlo Crivelli, fifteenth century. National Gallery, London, England. For an altarpiece painting, Crivelli emphasized the Immaculate Conception as Mary knelt with folded hands before the angel Gabriel and Saint Emidius. He painted a light shining into Mary's ear to indicate her moment of conception.

E Y E An eye often represented the all-seeing and protective eye of God. **E X A M P L E :** *Christian Allegory*, painting by Jan Provost, sixteenth century. Louvre, Paris, France. Provost crammed Christian symbols into his allegory, creating a surreal painting with a book, dove, lamb, orb, and hands surrounding Christ and his bride, the church. He imagined Christ single-handedly grasping the Sword of the Word, his bride holding a Lily of Mercy, and a huge eye of God protecting them.

F O O T In ancient times feet touched the earth's dirt and dust, so the foot turned into a symbol for humility. The foot also referred to foot washing, for example, the woman who washed Jesus's feet with her hair (Lk. 7:38) and Jesus washing the disciples' feet (Jn. 13:5). These New Testament stories exemplified

humility. **EXAMPLE**: *Saint Andrew's Portable Altar*, metalwork by unknown artist, tenth century. Trier Cathedral Treasury, Trier, Germany. Archbishop Egbert commissioned this golden-foot reliquary mounted on a portable altar to enshrine the sandal sole of Andrew the apostle. Legend claimed Saint Helena, the mother of the Emperor Constantine, brought the apostle's sole from the Holy Land to Trier in the fourth century. The archbishop asked for a portable altar so it could be carried by kings and bishops when they prayed at home or traveled.

H A I R In the Old Testament hair represented strength, based on the story of Samson whose long locks energized him (Judg. 16:15–17). In the New Testament hair recalled penitence, like the woman who washed Jesus's feet with her hair (Lk. 7:38). **EXAMPLE**: *Samson and Delilah*, painting by Sir Anthony Van Dyck, seventeenth century. Dulwich Picture Gallery, London, England. Van Dyck caught Samson asleep and undone by Delilah and her conspirators. They've cut the strong man's hair. The painting indicates Van Dyck believed Delilah was a whore, as suggested by the opulent apartment, her exposed breasts, and an old procuress standing behind her.

H A N D A singular hand indicated God's presence. Early Christian and Byzantine artists avoided illustrating the divine, and just showed God's hand playing a minor role in a composition but a pivotal part in a biblical story. **EXAMPLE**: *The Annunciation*, painting by Fra Filippo Lippi, fifteenth century. Doria Pamphilj Gallery, Rome, Italy. Lippi painted this Annunciation scene with the angel offering Mary a lily, a symbol for virginity. Above them, two hands of God have released a dove, announcing the Holy Spirit's presence at the Virgin's conception.

H E A D This symbolized Christ as the head of the church (Eph. 5:23), just as the human head governs the body. **EXAMPLE**: *Head of Christ*, Abbey Church of Saints Peter and Paul in Wissembourg, stained-glass window by unknown artists, eleventh century. Museum of Notre Dame, Strasbourg, France. This head of Christ is the oldest stained-glass figure preserved in France. Its primitive style and coloring originally graced the Benedictine abbey of Wissembourg in Alsace, France.

H E A R T Throughout sacred art eras, the heart resided as the center of deep emotions: love, joy, courage, and sorrow. A flaming heart represented religious

fervor. A heart pierced by an arrow indicated contrition and devotion during trials.
E X A M P L E : *Saint Gertrude the Great Carrying the Sacred Heart of Jesus*, painting
by unknown artist, seventeenth century. Saint Mary of the Holy Savior Monastery,
Cañas, Spain. Saint Gertrude identified with the sacred heart of Jesus, especially his
redemptive desire toward humanity. Consequently, her motto became "Work while
it is day." A Spanish artist posed her with a shepherd's staff, holding a sacred heart
emblem to her chest.

N U D I T Y Renaissance art depicted four different types of nudity:
nakedness at birth; not owning possessions; purity and innocence; or lust and a
lack of virtue. E X A M P L E : *Adam and Eve*, painting by Lucas Cranach the Elder,
sixteenth century. Uffizi Gallery, Florence, Italy. Cranach the Elder painted several
versions of Adam and Eve, each with a surprising nudity. In the Uffizi version,
Cranach barely covered their pubic areas with fig leaves. He sculpted their bodies
and realistically painted Adam with facial and underarm hair. The Cranach figures
depicted innocence before the couple sinned.

S K E L E T O N According to Scripture, the dead will rise when Christ
returns in the Second Coming (1 Thess. 4:16). Artists foretold this event with
bodies or skeletons leaving their tombs. Generally, skeletons symbolized death
and the afterlife. E X A M P L E : *The Last Judgment: The Dead Rise from the Grave*,
illuminated-manuscript page by unknown artist, fifteenth century. Royal Library,
Turin, Italy. The unknown artist painted a ghoulish version of the dead rising.
Rather than bodies or skeletons rising from their graves, he scattered bones and
skulls around open sarcophagi (stone coffins) with wrapped corpses inside them.

S K U L L A skull symbolized death and impermanence. In some paintings
of the Crucifixion, a skull sat at the bottom of the cross, representing Adam.
E X A M P L E : *Crucifixion*, illuminated-manuscript page by unknown artist,
fifteenth century. Barnes Foundation, Merion, Pennsylvania. The illuminator
symbolically connected Christ's crucifixion to his plan to redeem sinners from
death and punishment. He positioned a skull below the cross, along with two small
figures suffering in hell's flames.

THE ART OF GESTURES

Certain gestures and body-part placements in Judeo-Christian art added meaning to images, beyond the obvious signs and symbols. Most likely, viewers from the corresponding art eras understood these subtleties, but contemporary viewers don't always catch them.

When a person raised one hand, it indicated *blessing* a person, group, thing, or event. A hand to the head, with eyes cast down, represented *despair.* So did a person bowing the head and covering the eyes. A person in *distress* flailed the arms. Full prostration on the ground meant *humility.* Both hands or arms raised reflected *praise or prayer.* Arms crossed across the chest suggested *resignation.* Positioning a body part, such as an arm or foot, in front of someone else projected *superiority.*

For example, in a sixth-century mosaic of Emperor Justinian I at San Vitale Church in Ravenna, Italy, artists placed the ruler and his retinue standing in a straight line, staring at the viewer. On the mosaic's left, mosaicists placed the emperor's right foot overlapping the official next to him. On the right, they positioned Bishop Maximian's left foot overlapping the man next to him. Among other symbols, the foot placement denoted superiority.

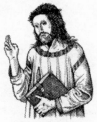

- BLESSING
Blessing Christ by Giovanni Bellini, sixteenth century.

- DESPAIR
Damned sinner from *The Last Judgment* by Michelangelo Buonarroti, sixteenth century.

- DISTRESS
John the disciple from a *Crucifixion* icon, Byzantine era.

- HUMILITY
Prodigal son and father from *The Return of the Prodigal Son* by Rembrandt van Rijn, seventeenth century.

- RESIGNATION
Mary from *Annunciation* by Ambriogio Lorenzetti, fourteenth century.

- PRAISE OR PRAYER
Saint Apollinare mosaic from Saint Apollinare in Classe Basilica, sixth century.

22
Sacred Colors

One finds a decorative and didactic use on the walls of churches and in paintings
and stained glass. . . . Colors, geometrical figures, jewels, and heavenly bodies
all have ethical meanings attached to them.

—KATHERINE LEE RAWLINGS JENNER

Artists and clerics of the Middle Ages believed the visual arts promoted learning
and faith, especially through color and light. The artist Theophilus described the
value of multicolored paintings in a church. He wrote, "By setting off the ceiling
panels and walls with a variety of kinds of work and a variety of pigments, you have
shown the beholders something of the likeness of the paradise of God, burgeoning
with all kinds of flowers, verdant with grass and foliage."

Color not only introduced congregants to a scene or concept, but also
encouraged them to feel emotion. Theophilus further explained, "If a faithful
should see the representation of the Lord's Crucifixion in strokes of the artist, it is
itself pierced." Color enriched the senses, enhanced learning, and participated in
the symbology of Christian art and faith.

In Christian art, color didn't appear for color's sake. Hues frequently lent insight
to the overall meaning of a work and signified the role and importance of a figure
or group. Because colors incurred multiple meanings throughout church history,
it's crucial to think about how each hue contributed to an entire work of art. For
example, did the black indicate sin or mourning, or possibly both?

Colors also played a key role in the Christian year and worship. They indicated
a season, holiday, ritual, or attitude, but varied according to different Christian
traditions. The following list presents the major symbolic colors of Christian art.

BLACK As Christian art developed, black symbolized sin, witchcraft, or
Satan, the prince of darkness. Black also suggested death, illness, mourning, and
Good Friday, the day of Jesus's crucifixion. However, a combination of black and
white represented purity and humility, like the apparel worn by nuns. EXAMPLE:
Bust of a Nun, sculpture by Niccolò dell'Arca, fifteenth century. Estense Gallery and

Museum, Modena, Italy. Dell'Arca sculpted the Catholic sister in terra cotta and painted her habit in subdued colors, except for a white wimple and a black veil. He matched this restraint with her pose: eyes cast down and a hand to her heart to express humility.

B L U E In the earliest images, artists began painting the Virgin Mary wearing blue, the color of truth and heavenly grace, while holding the baby Jesus. Christ sometimes wore blue during his ministry. The color also represented heaven, hope, health, and servanthood. **EXAMPLE**: *Madonna and Child Enthroned with Saints Lucy, John Gualberto, Benedict, and Catherine*, painting by Lorenzo Monaco, fifteenth century. Civic Museum, Prato, Italy. Monaco painted Mary in a brilliant blue cape with gold underlining and a star on her shoulder. The star represented her virginity, the bright light that led her to a manger, or her child who called himself "the bright Morning Star" (Rev. 22:16). The artist coordinated the garment underneath by painting it white, scattered with gold stars.

B R O W N The color of the earth, brown represented poverty, degradation, spiritual death, and renunciation of the world. It also associated with monastic life. Franciscans and Capuchins wore brown habits. **EXAMPLE**: *Portrait of a Franciscan Friar*, painting by Peter Paul Rubens, seventeenth century. Doria Pamphilj Gallery, Rome, Italy. The monk slightly turned aside and tucked his hands into the brown habit's generous sleeves, an indication of humility and separation from the world.

G R A Y The color of ashes, gray symbolized death and immortality. Sometimes it denoted Lenten repentance. Occasionally Christ wore gray in Last Judgment paintings. **EXAMPLE**: *The Last Judgment*, painting by unknown artist, thirteenth century. Saint Vitus Church, Kottingworth, Oberbayern, Germany. The artist painted a fresco with Christ in a pose reminiscent of the Savior who blessed his spiritual children, with his hand raised, but the gray robe announced his role as the final Judge of humanity.

G R E E N The color of vegetation, green meant bounty, hope, freedom, rejuvenation, and the triumph of life over death. Sometimes John the Baptist wore a green mantle. **EXAMPLE**: *Saint John the Baptist*, painting by Jacopo Palma, sixteenth century. York Art Gallery, York, England. Palma wrapped John the Baptist

in a green mantle that foretold Christ's triumphant gift of eternal life. Furthering the Savior symbols, the artist added John carrying a staff terminating with a small cross, and a lamb resting behind his legs.

O R A N G E Recalling fire and flames, orange symbolized courage, strength, and endurance. It also colored the fires of hell. **E X A M P L E :** *Hell*, painting by Hieronymus Bosch, fifteenth century. State Hermitage Museum, Saint Petersburg, Russia. In the background of a horrific scene, Bosch painted hell's fires raging in red and orange. The painter imagined sinners swarmed together, fearful of unrecognizable torture and torturers.

P U R P L E In ancient art and beyond, purple associated with both royalty and penitence. God the Father and Christ in Glory often wore purple. **E X A M P L E :** *Christ in Majesty*, Godescalc Gospel Lectionary, illuminated-manuscript page by Godescalc, eighth century. National Library of France, Paris, France. Adhering to a Carolingian style, the illuminator painted Christ with large eyes and rounded features, wearing a purple garment and seated on a throne. These obvious signs of royalty emphasized that after the Ascension, Christ sat down on the right hand of his Father in heaven to rule over all (Rev. 3:21).

R E D The color of blood, crimson red memorialized Christian martyrs. Also the symbol of fire, red served as the liturgical color of Pentecost, when the Holy Spirit descended in tongues of fire on early Christians gathered in an upper room (Acts 2:1–3). Thus, red represented the Holy Spirit, power, and importance. But it also denoted atonement and humility. **E X A M P L E :** *A Holy Martyr*, illuminated-manuscript page by unknown artist, fourteenth century. Marmottan Museum, Paris, France. The illuminator identified this forward-gazing Christian martyr with a red robe, a Gospel book, and a staff with a laurel leaf on top, a sign of victory.

V I O L E T Violet carried varied meanings: love, truth, passion, penance, or suffering. In images the penitent Mary Magdalene often wore violet, and sometimes the Virgin Mary dressed in this color after the Crucifixion. **E X A M P L E :** *Saint Mary Magdalene with Eight Scenes from Her Life*, painting by Master of the Saint Mary Magdalene, fourteenth century. Academy Gallery, Florence, Italy. This master positioned Mary Magdalene in the middle of a panel painting, standing erect and tall, wearing a reddish-violet garment. Behind Mary, he painted eight rectangular

scenes from her life, including anointing Jesus's feet and encountering him in a garden after the Resurrection.

W H I T E White symbolized holiness, innocence, and purity, but sometimes silver substituted for it. Angels appeared in white, and Christ wore this color after the Resurrection. Mary, his mother, also donned white in scenes before the Annunciation. Clergy wore white in the early Christian era. **E X A M P L E :** *Christ on a White Horse*, painting by unknown artist, twelfth century. Auxerre Cathedral, Burgundy, France. A fresco painter mounted Christ side-saddle on a white horse, wearing a white robe and raising both hands in blessing or victory. This crypt image comforted mourners, reminding them Christ triumphed over death, and their departed lived in heaven.

Y E L L O W O R G O L D E N Y E L L O W This color held two opposite meanings. A golden yellow represented the sun, divinity, and truth. Renaissance artists painted a golden glow to represent sacredness. Saint Joseph and Saint Peter sometimes wore yellow. In contrast, yellow represented deceit, jealousy, and treason. Judas the traitor often appeared in a dingy yellow. In the Middle Ages, artists painted heretics in yellow. **E X A M P L E :** *Saint Dominic Sending Forth the Hounds and Saint Peter Martyr Casting Down the Heretics*, painting by Andrea di Bonaiuto, fourteenth century. Saint Mary the New Hospital, Florence, Italy. Painting a fresco on a chapel wall, Bonaiuto spotlighted the ruthless side of medieval Christianity with two saints calling bloodhounds to chase after religious heretics. As the dogs aroused from sleep, an angry crowd formed and a defiant man in yellow pointed an index finger at the saints.

COLORS OF THE CHURCH

As the church developed holidays and rituals, it added liturgical colors to its calendar, enhancing the meaning of celebrations. However, color usage varied according to specific church traditions: Anglican, Roman Catholic, Orthodox, and others. At the same time, Roman and Byzantine colors most frequently figured into Christian art. Western and Eastern feasts, rituals, and seasons appear below, and many Christians still honor these colors today.

COLOR	ROMAN/WESTERN	BYZANTINE/EASTERN
Black	All Souls Day Requiem Masses (for the deceased), except for baptized children who died before the age of reason Weekdays in Lent	Funerals Weekdays during Holy Week Weekdays during Great Lent, except Holy Thursday
Gold	Gold replaced white, red, or green	Used when no color was specified
Blue	Feast of the Immaculate Conception, in some regions	Feast of the Theotokos (light blue)
Green	Ordinary Time, including time after Epiphany and time after Pentecost	Feast of the Cross, in some places Feasts of Venerable Monastic Saints Palm Sunday Pentecost
Purple	Ash Wednesday Lent Holy (Maundy) Thursday Good Friday	Saturdays and Sundays during Great Lent, or also red
Red	Confirmation Masses Feasts of the Apostles and Evangelists, except Saint John Feasts of the Lord's Passion, Blood, and Holy Cross Feasts of Martyred Saints Palm Sunday Pentecost The Passion	Saturdays and Sundays during Great Lent, or also purple Pascha, in some places

COLORS OF THE CHURCH continued

COLOR	ROMAN/WESTERN	BYZANTINE/EASTERN
Violet	Advent Ember Days, except for Pentecost Good Friday Lent Holy Saturday, liturgies other than Lent Rogation Days Sacrament of Reconciliation Season of Septuagesima Vigils, except for Ascension and Pentecost	
White	Baptism Christmastide Easter Season Feast of All Saints Feasts of Angels, Mary, and Non-Martyred Saints Feast of Saint John the Apostle Feast of the Conversion of Saint Paul Feasts of Our Lady Feasts of Our Lord, other than the Passion Feasts of the Angels Holy Thursday Nativity of Saint John the Baptist Requiem Masses, for baptized children who died before the age of reason Weddings	Funerals Pascha Theophany The Nativity Other Great Feasts of the Lord

23
Geometric Shapes

In Christian tradition even simple shapes are symbolically potent.

—CHARLES HENDERSON

One of the most sophisticated geometric formations in artwork appeared in a stained-glass church window. During the thirteenth century, artisans created the spectacular and symbolic rose window for the Notre Dame Cathedral in Lausanne, Switzerland. The center of this Gothic masterpiece focused on a square contained within a circle, with repeating sequences of geometric shapes. The sophisticated design represented an *imago mundi*, or "schematized creation." Symbolism within the window included the four elements, the four seasons, the four rivers of paradise, the eight winds, the eight monstrous races, the twelve signs of the zodiac, and the twelve labors of the months.

The Lausanne rose window exemplified how geometry figured into Christian art, using shapes to honor the sacred and invisible. Geometrical shapes expressed pagan concepts before the dawn of Christianity, but the new believers redeemed these forms to symbolize their spiritual beliefs. Ordered shapes easily signified an ordered universe created by an orderly God. Although sometimes these geometrical patterns featured obscure imagery only a few could interpret, their overall harmony pleased the eye. Especially in the eleventh and twelfth centuries, secular and biblical geometric shapes broadly influenced Christian art.

But long before, Byzantine iconographers freely painted this type of symbolism into their icons, paying attention to shape and size. They illustrated this practice in a famous icon from Saint Catherine's Monastery at Mount Sinai in Egypt. In *The Virgin and Child Enthroned with Angels and Saints*, the artist painted each of the five figures with a halo, a symbol designating sacred personages. In particular, every halo formed a circle, indicating perfection or everlasting life. The painter also suggested the Trinity's perfection by positioning the three large figures—Mary and the two saints—in a straight row and equal in size.

From the beginning of sacred art, shapes and their size mattered. These shapes included the following:

C I R C L E For ancient Christians, the ring or circle indicated eternity or an endless life. It also represented the perfect God who is everlasting, without beginning or end. A circular nimbus (halo) also defined sacred individuals: Jesus, Mary, and the saints. **E X A M P L E :** *Christ Is Protected by a Circle of Angels*, Codex of Predis, illuminated-manuscript page by unknown artist, fifteenth century. Royal Library, Turin, Italy. The illuminator conceived an unusual nautical scene: Christ with folded hands in prayer, standing atop a flat rock on a beach, circled by five kneeling or standing angels. A ship just launched in the waters behind them, off the coast of a fifteenth-century Italian town.

C U B E Scripture described the heavenly Jerusalem as foursquare, and artists generally used the cube to represent stability and permanence (Rev. 21:16). **E X A M P L E :** *Vision of Heavenly Jerusalem*, Commentary on the Apocalypse by Beatus of Liébana, illuminated-manuscript page by Maius, tenth century. Morgan Library, New York, New York. Maius said he created this manuscript so the "wise may fear the coming of the future judgment of the world's end." However, on this page he illuminated the joy of heaven with a square, rug-like pattern that presented twelve saints, each in a squared section of the outer border. An angel and the Lamb of God occupied the middle square.

H E X A G R A M Created from two intersecting triangles, the hexagram in Jewish and Christian traditions comprised a six-pointed star and referred to the Star of David, in which heaven touched the earth. Legend claimed King Solomon called forth angels and exorcised demons with this sign. **E X A M P L E :** *Christ Blessing*, painting by Barna da Siena, fourteenth century. Chartreuse Museum, Douai, France. In this panel painting with Christ in a traditional blessing pose—right hand raised and left hand holding a Scripture book—the artist placed a Star of David high above his head. Like this star, Jesus touched the earth with heaven's glory.

O C T A G O N For medieval Christians, the eight-sided octagon defined spiritual regeneration. It combined a circle, a symbol of the eternal, and a square, a symbol of the temporal. An octagon could also be interpreted as the eighth day, one day beyond the human structure of a seven-day week. **E X A M P L E :** *Octagon Lantern*, dome lighting designed by William Hurley, eleventh century. Ely Cathedral, Ely, Cambridgeshire, England. Evoking a star, an architect designed the dome lantern shedding light on the cathedral's nave as a symbol "linking earth and

heaven, time and eternity." He fashioned the ceiling decoration and angel panels below it as the heavenly hosts, and the window figures as time and space.

O R B A globe with a cross on top, the orb demonstrated Christ's power and authority over the world. In art, the young Jesus or Christ the Pantokrator (Greek for "all-powerful ruler") sometimes held an orb. Christian kings and queens carried orbs in their coronations. **E X A M P L E :** *God Blessing the Earth*, painting by Benvenuto Tisi da Garofalo, sixteenth century. National Museum, Stockholm, Sweden. Garofalo painted an enormous, gray-haired God raising his hand in blessing over the earth, a globe-like orb with a small cross on top. By adding a cross, the painter indicated God's foreknowledge of Christ's life and death on earth.

P A R A L L E L O G R A M Early in Christianity, many theologians believed the world was flat. Some argued theologically that God shaped the earth as a four-sided parallelogram enclosed by four oceans. Working from biblical texts, they also believed the Ark of the Covenant represented God's universe. Some ancient cartographers worked from this supposition. **E X A M P L E :** *World Picture*, Christian Topography (*Topographia Christiana*), illuminated-manuscript page by Cosmas Indicopleustes, sixth century. Laurentian Library, Florence, Italy. Indicopleustes drew his world map as a parallelogram and placed a bust of Christ at the top of it. His illustration ranks among the world's oldest surviving maps.

P E N T A G R A M In early Christianity, this five-pointed figure suggested the five wounds of Christ or his star. However, through the ages this symbol also took on controversial meanings not related to Christian beliefs. **E X A M P L E :** *Pentagram in North Transept Window*, stained-glass window by unknown artists, fourteenth century. Notre Dame Cathedral, Amiens, France. Although workers installed the pentagram window during the fourteenth century, modern mosaicists mounted its multicolored glass replacements. They centered the pentagram inside a circular Gothic rose window.

Q U A T R E F O I L Shaped like a leaf with four lobes or foils, the quatrefoil often represented the four Evangelists—Matthew, Mark, Luke, and John—or framed images of them. **E X A M P L E :** *Ox from a Processional Cross*, Ballymacasey, County Kerry, Ireland, metalwork by unknown artist, fifteenth century. National Museum

of Ireland, Dublin, Ireland. In silver gilt, a metalworker created four quatrefoils, each with a symbol of the four Evangelists, on an Irish processional cross. A patron commissioned the cross as a gift for the Franciscan friary of Lislaughtin.

R E C T A N G L E Based on the ratio of 4:3, the Greeks called the rectangle the Golden Section and a symbol of harmony. Iconographers called it the Divine Proportion and produced icons in this shape, considering it a mystery of God. According to Scripture, God designed Noah's ark and the Ark of the Covenant as rectangles (Gen. 6:14–17; Exod. 25:10–17). E X A M P L E : *Noah Heeding God's Instructions to Fill the Ark*, engraving by Étienne Delaune, sixteenth century. New College, University of Oxford, Oxford, England. Delaune engraved thirty-six black-on-white scenes from Genesis, including this image of a praying Noah, the ark built in a rectangular shape, and animals approaching its open door.

S Q U A R E Particularly in early cartography, a square signified the earth and balance, referencing the four corners of the earth (Isa. 11:12) or the four points of a compass. In addition, artists identified a living saint with a square nimbus (halo) around his or her head. E X A M P L E : *Pope Paschal*, mosaic by unknown artists, ninth century. Saint Pressede (Praxedes) Basilica, Rome, Italy. Mosaicists arranged a square nimbus above the pope's head because he financed building the basilica in honor of Saint Praxedes, replacing a crumbling, fifth-century church. The artist also depicted the pope holding a model of the new church.

T R E F O I L Especially in stained-glass window and metal-work production, artists shaped a trefoil to look like a three-leaf clover symbolizing the Father, Son, and Holy Spirit. E X A M P L E : *North Rose Window*, stained-glass window by unknown artists, thirteenth century. Saint Peter and Saint Paul's Church, Wissenbourg, Alsace, France. Stained-glass artists rimmed this rose window with eight trefoils, each uniquely decorated with multiple colors and shapes. This magnificent work dodged the French Revolution's destruction, becoming the world's oldest surviving rose window with its original glass.

T R I A N G L E Artists used the equilateral triangle to represent the Trinity: Father, Son, and Holy Spirit. They also sometimes endowed a member of the

Trinity with a triangular nimbus (halo). A monogram of the Trinity combined a triangle with three circles. **EXAMPLE:** *Christ the Redeemer Holding a Symbol of the Trinity*, painting by Giovanni Pedrini Giampietrino, sixteenth century. Brera Art Gallery, Milan, Italy. Giampietrino envisioned a questioning Christ, holding up a triangle and pointing to himself. With blazing eyes, he seems to ask, "Don't you understand who I am?"

TRIQUETRA To create another symbol of the Trinity— Father, Son, and Holy Spirit—the triquetra divided a circle into three parts and transformed them into three interlaced ovals. **EXAMPLE:** *Trinity Window*, stained-glass window by unknown artists, fifteenth century. Saint Mary Church, Orchardleigh, Somerset, England. Stained-glass artisans designed a triquetra that from a distance resembled a giant insect with wings. Actually, they intended the triquetra to symbolize the Holy Spirit, with Christ in the middle oval.

24
Monogram Letters

Christograms [monograms] represent an effort to convey the profound
teachings of Christianity in a precise way, which is closely associated
with an understanding of Christ as the power of the Word.

—*Funk & Wagnalls New World Encyclopedia*

In Fra Angelico's *Descent from the Cross*, the fifteenth-century painter used letter
symbolism to emphasize Christ's deity. The painter crossed Christ's body over the
vertical lines of the composition so his legs, torso, and arms formed an *X*. The letter's
shape repeated in the figures standing on ladders and kneeling on the ground. In
symbolism, the letter *X* traditionally signified Christ.

Aside from letters disguised in paintings, Christian symbolism more often
integrated Christograms into compositions or featured them alone. These
monograms employed a combination of letters representing Christ's name. Both
Western and Eastern artists painted them into compositions. Other artisans etched
Christograms on gravestones and memorials, sometimes alone or with doves, fish,
wreaths, palm branches, and garlands. These letters and images represented their
faith in Christ, on earth and in the afterlife.

Along with other aspects of Christian art, sacred letters and monograms
originated in Jewish tradition. Jews deemed God's name so sacred, they couldn't
write or speak it. Consequently, they used the four Hebrew consonants *YHWH* to
stand for Yahweh, the name of their one, true God. This name meant "I Am Who
I Am" (Exod. 3:14). Later, Christians elaborated on the Greek letter *upsilon* or *Y*.
For them, the *Y* or *yod* represented the first letter of "Jesus" in Hebrew. Centered in
a triangle or surrounded by rays, the letter symbolized *YHWH*, In turn, three yods
together denoted the Trinity.

Overall, artisans incorporated these commonly understood monograms into
Christian art.

A Ω O R α ω These first and last letters of the classical Greek alphabet represented the symbols for alpha and omega. Jesus declared himself the Alpha and Omega, the Beginning and the End (Rev. 21:6). In images these letters appeared next to Christ or on a Scripture book held in his arm. **E X A M P L E :** *Paradise*, painting by Giusto de' Menabuoi, fourteenth century. Cathedral Baptistery, Padua, Italy. Giusto and his assistants painted frescoes on every wall surface in the baptistery. In the dome they intricately painted tiers of saints and angels surrounding a huge bust of Christ in glory, holding a book with the letters for Alpha and Omega inscribed on it. This enormous image fit into one of the building's major themes, the Last Judgment.

I C X C O R N I K A These Greek letters interpreted as "Jesus Christ the Conqueror." The *I* and *C* formed the first letters for the word "Jesus." The *X* and *C* belonged to the first and last letters of "Christ." *Nika* interpreted as "Conqueror." The letters *IC XC* could also stand alone. On the icons and other images of Eastern Christianity, the *IC* and *XC* split with the *IC* on the left and the *XC* on the right of Christ. **E X A M P L E :** *The Crucifixion*, painting by unknown artist, thirteenth century. Church of the Holy Virgin, Studenica Monastery, near Kraljevo, Serbia. Fresco painters covered most of the church's western wall with an emotional scene of the Crucifixion, foretelling a style that developed in the next century. To the right and left of Jesus's head, they painted the letters IC and XC, respectively.

I C H T H Y S Early Christians used this acrostic, in the shape of a fish, to communicate their faith and identify themselves as Christ's followers. The Greek letters represent "Jesus Christ, God's Son, Savior." Transliterated, the letters appear as *Iota* (*I*), the first letter for "Jesus"; *Chi* (*CH*), the first letter for "the anointed"; *Theta* (*TH*), the first letter for "God's"; *Upsilon* (*Y*), the first letter for "Son"; *Sigma* (*S*), the first letter for "Savior." **E X A M P L E :** *Funerary Stele*, engraving by unknown artist, third century, National Roman Museum, Rome, Italy. An engraver inscribed this early Christian grave marker with an anchor, two fish, and symbolic letters for "fish of the living." Excavators discovered it near the Vatican necropolis in Vatican City, Italy.

I H S O R I H C An abbreviation for Christ's name, the characters *IHS* formed the first three letters for the name "Jesus" in Greek. The *S* and *C* sometimes interchanged because they comprised varied forms of the Greek alphabet.

EXAMPLE: *IHS Monogram*, metalwork by unknown artist, sixteenth century. Church of the Gesù, Rome, Italy. Metalworkers placed the letters *IHS* in a golden circle of rays and angels above the church's altar. Resembling a monstrance from the same era, the monogram for Christ's name celebrated a Eucharist service.

I N R I The Latin initials *INRI* stood for *Iesus Nazarenus Rex Iudaeorum*, or "Jesus of Nazareth, the King of the Jews." Pilate dictated this inscription for the *titulus* (sign) above Christ's head during the Crucifixion (Jn. 19:19). The abbreviation appeared in Western sculpture and paintings of Christ on the cross. **EXAMPLE:** *Crucifix*, sculpture by Sandro Botticelli, fifteenth century. Prato Cathedral, Prato, Italy. Botticelli hung a solitary, deceased Jesus from a wood cross and painted him with tempera and gold leaf. Evoking a stark and lonely mood, the painter sparsely garbed the Savior in a loin cloth around his hips. A nimbus circling Jesus's head recalled his former glory. In large letters, Botticelli painted *INRI* on a short cross bar above the body's drooping head, a mark of humiliation.

X P OR L A B A R U M The Greek letters *Chi* (*X*) and *Rho* (*P*) form the first two letters for "Christ." Combining these letters often created a cross. In the fourth century the Emperor Constantine claimed he glimpsed a Chi-Rho cross in a vision before his pivotal battle at Milvian Bridge. He instituted using the Chi-Rho symbol in the battle and later as a monogram for the Roman Empire. In art, the Chi-Rho stood alone as a symbol or integrated into images of Christ after his resurrection. **EXAMPLE:** *Sion Treasure Paten*, silverwork by unknown artist, sixth century. Dumbarton Oaks Research Library, Washington, DC. Priests carried the Eucharist bread in patens (plates), and the largest one in the Sion Treasure looks stunning. A gilded Chi-Rho dominates the multilayered surface and a broad rim embossed in repoussé looks animated when hit by light.

25

Popular Numbers

Numbers in Christian art represent not only quantities but ideas;
their symbolism is very ancient.

—GERTRUDE GRACE SILL

What's in a number? Biblically and theologically, numerals and the number of figures or objects in a composition added meaning to sacred art. In *The Last Judgment: The Damned* painting by Luca Signorelli, the Renaissance painter depicted three archangels in the sky, as if standing on air, in the upper-left corner of the composition. The artist depicted Gabriel, Michael, and Raphael as emotionally indifferent to the three-winged demons below them, carrying and dropping three horrified individuals to join the chaotic scene below. In the foreground, he painted swarms of demons and sinners clashing in agony as they prepare for hell.

Looking up at this ceiling fresco in the Orvieto Cathedral in Italy, the three archangels reminded viewers of the three members of the godhead—Father, Son, and Holy Spirit—who determined the fate of the "saved" and the "lost." Perhaps the artist also intended the three demons and the three sinners to recall the Trinity, too. Without depicting the godhead, their presence permeated the painting.

Like the disturbing Signorelli painting, Christian artists employed symbolic numbers to emphasize spiritual messages beyond the obvious images. These numbers drew from biblical concepts and stories, creating a unique visual language, interpreted by knowing Christians. Common symbolic numbers included the following:

O N E symbolized unity, of the godhead and the universal church (Jn. 10:30).
EXAMPLE: *The Trinity*, painting by unknown artist, sixteenth century. H. Shickman Gallery, New York, New York. In an attempt to visualize the three-in-one Trinity, a Flemish artist painted Jesus typically holding a globus cruciger (cross-bearing orb) and raising his hand in blessing. The painter also incorporated three sides to the figure's face: looking forward, to the left, and to the right. The Trinity symbolism probably satisfied early sixteenth-century Christians, but contemporary viewers could interpret Jesus in a moment of confusion, uncertain about which way to go, look, or decide.

T W O meant duality, especially regarding Christ's two natures, divine and human (Col. 1:15, 19–20). **EXAMPLE:** *The Father and Son*, Macclesfield Psalter, illuminated-manuscript page by unknown artist, fourteenth century. Fitzwilliam Museum, University of Cambridge, Cambridge, England. In a historiated (storytelling) capital letter of an East Anglican psalter, the illuminator imagined God and Jesus seated together, with arms flailing, in an animated discussion. The painting could be interpreted as an expression of Christ's two natures.

T H R E E represented the Trinity: Father, Son, and Holy Spirit (Mt. 28:19). **EXAMPLE:** *The Holy Trinity*, painting by unknown artist, sixteenth century. Prado Museum, Madrid, Spain. The painter emotively portrayed a dead Jesus fallen back into the arms of a haggard God, with red robes trailing behind the Father as if he just descended from heaven. But the artist only painted these two in human form. He represented the Holy Spirit as a dove joining a circle of angels that frame this tragic scene.

F O U R symbolized the four Evangelists, the four corners of the earth, and the four seasons. Ancient scholars attributed the first four books of the New Testament, the Gospels, to the four Evangelists: Matthew, Mark, Luke, and John. The early church symbolized each of the Evangelists as follows: Matthew, an angel; Mark, a lion; Luke, an ox; and John, an eagle. **EXAMPLE:** *Jesus and the Four Evangelists*, Roman Missal with Calendar (Missale Romanum cum Calendario), illuminated-manuscript page by unknown artist, fourteenth century. Tarazona Cathedral, Aragon, Spain. This Spanish illuminator seated Jesus in a mandorla (almond shape), raising his hand in blessing and holding an orb, representing his supremacy over the earth. The artist tucked each of the four Evangelists' symbols in the corners of the page, significantly reduced in size, perhaps commenting on their humble comparison to Christ.

F I V E memorialized the five wounds of Christ: two hands, two feet, and his side. In art they're represented by five circles on a cross; five roses; a five-pointed star; or the Jerusalem Cross with five smaller crosses within it. Similarly, the number five also represented suffering (Jn. 19:34; Acts 2:23). **EXAMPLE:** *Badge of the Five Wounds of Christ*, embroidery by unknown artist, sixteenth century. Arundel Castle, West Sussex, England. Thomas Constable of Everingham carried this badge

in the Pilgrimage of Grace in 1536. This uprising in Yorkshire, England, protested King Henry VIII's break from the Roman Catholic Church and dissolution of the country's monasteries. The badge emphasized suffering with a heart on a pedestal in the middle; two nailed hands in each top corner; and two crucified feet in each bottom corner. Banners with these images motivated 40,000 protestors who marched on Lincoln and seized the town's cathedral.

■ *Badge of the Five Wounds of Christ,* sixteenth century.

S I X recalled the total days of Creation. This number also indicated imperfection because it fell one short of the perfect seven (Gen. 1:3–31). **EXAMPLE:** *The Six Days of the Creation*, Bible of Saint Sulpicius of Bourges, illuminated-manuscript page by unknown artist, twelfth century. Bourges Municipal Library, Bourges, France. A Romanesque illuminator painted six interlocking roundels along the left side of this page, each highlighting God's task during every day of Creation. He created images of God resembling a beardless Christ centered in front of a cross inside a nimbus (halo), much like the prototypical Sinai Christ icon from the sixth century.

S E V E N represented perfection. God rested on the seventh day and Jesus spoke seven statements from the cross. These statements were: (1) "My God, my God, why have you forsaken me?" (2) "Father, forgive them, for they do not know what they are doing." (3) "Truly I tell you, today you will be with me in paradise." (4) "Father, into your hands I commit my spirit." (5) "Woman, here is your son," and "Here is your mother." (6) "I am thirsty." (7) "It is finished!" (Gen. 2:1; Mt. 27:46; Lk. 23:34, 43, 46; Jn. 19:26–28, 30). The church also developed seven sacraments of baptism, confession or reconciliation, confirmation, Eucharist or Communion, extreme unction or anointing of the sick, marriage, and ordination. **EXAMPLE:** *The Seven Sacraments Altarpiece*, painting by Rogier van der Weyden, fifteenth century. Royal Museum of Fine Arts, Antwerp, Belgium. A Netherlandish painter, Weyden painted a triptych of the Crucifixion on the center panel and fifteenth-century Christians practicing the seven sacraments on the two side panels. Surprisingly, he showed the Crucifixion scene in the nave of a basilica with the parishioners in the side aisles.

E I G H T denoted resurrection and regeneration, especially in baptism. Jesus rose from the grave the eighth day after he rode into Jerusalem. Many ancient

baptismal fonts were octagonal (Mt. 28:6). **EXAMPLE:** *Baptismal Font*, stonework by unknown artist, fourth century. Orthodox Baptistery, Ravenna, Italy. Ancient Byzantine artisans cut, sculpted, and polished this marble-edged baptismal font into an eight-sided symbol. Christians immersing in these baptismal waters believed eight (resurrection) was the sum of seven (perfection) plus one (God).

N I N E invoked mystery or angels, representing the nine choirs of angels (Ps. 148:2–5). **EXAMPLE:** *Chasuble with Choirs of Angels*, from the Goess Convent, Styria, Austria, textile work by unknown artist, thirteenth century. Austrian Museum of Applied Arts, Vienna, Austria. Skillful textile workers masterfully created this chasuble in linen and covered it with silk embroidery. On the back, embroiderers represented the nine choirs with single angels, varied in appearance, standing in archways. They appear below images of the four Evangelists surrounding Christ in heavenly glory.

T E N referred to completion, patterned after the Ten Commandments God gave to Moses. They were: (1) You shall have no other gods before me. (2) You shall not make unto you any graven image. (3) You shall not take the name of the LORD your God in vain. (4) Remember the Sabbath day, to keep it holy. (5) Honor your father and your mother. (6) You shall not kill. (7) You shall not commit adultery. (8) You shall not steal. (9) You shall not bear false witness against your neighbor. (10) You shall not covet. (Exod. 20:2–17, paraphrased.) **EXAMPLE:** *The Ten Commandments*, painting by Lucas Cranach the Elder, sixteenth century. Luther House, Wittenberg, Germany. The German artist Lucas Cranach the Elder divided his horizontal composition into ten squares, each illustrating the temptation to break one of the Ten Commandments. In each scene, Cranach painted Satan or an evil spirit luring someone into sin. In some images, he also included an angel prompting the person to obey God's commandment.

T W E L V E signified the whole church, recalling the twelve tribes of Israel and the twelve disciples or apostles. The twelve tribes were Asher, Benjamin, Dan, Gad, Issachar, Joseph, Judah, Levi, Naphtali, Reuben, Simeon, and Zebulun (Gen. 49:1–28). The twelve apostles were Andrew, Bartholomew, James the son of Alphaeus, James the son of Zebedee, John, Judas Iscariot, Matthew, Peter, Philip, Simon the Zealot, Thaddeus, and Thomas (Lk. 6:13–16). **EXAMPLE:** *The Immaculate Conception*, painting by Francisco de Zurbarán, seventeenth century.

Prado Museum, Madrid, Spain. The painter represented this miraculous moment by standing Mary on a cloud, hands folded in prayer, and twelve stars crowning her head. John the apostle described a woman with a crown of twelve stars on her head. She gave birth to a male child who ruled the nations and then ascended to God's throne (Rev. 12:1–2, 5). The Roman Catholic Church interpreted this woman as the Virgin Mary and her relationship to the church. Other Christian traditions believed she represented Israel and its twelve tribes.

T H I R T E E N implied betrayal because thirteen men, Jesus and the disciples, attended the Last Supper, where Jesus said a disciple would betray him (Lk. 22:1–23). E X A M P L E : *The Last Supper*, painting by Jacopo Bassano, sixteenth century. Borghese Gallery, Rome, Italy. Leonardo da Vinci's *Last Supper* inspired this painting. However, Bassano painted a crowded composition with unruly, barefooted fishermen questioning who will betray Jesus. Bassano used unusually bright hues of green, orange, and pink that nineteenth-century artists covered with more serene colors. A later restoration revealed the original colors.

F O R T Y signified trial or testing, recalling Noah's flood (Gen. 7:12); Moses's communion with God on Mount Sinai (Exod. 24:18); Jesus's sojourn in the wilderness (Mk. 1:13); and other forty-day, biblical encounters. In addition, as early as the fourth century, the church instituted the liturgical season of Lent, lasting forty days. **EXAMPLE:** *The Temptation of Christ in the Desert by the Devil*, painting by unknown artist, twelfth century. Saint Aignan Church, Brinay-sur-Cher, France. The fresco painter conjured a frightening Satan with wings and horns, a beard, and a sneer. He taunted the famished Jesus to turn stones into bread, dropping the rocks into a pile at the Lord's feet.

Liturgical Art

Liturgical art is art in service to God and the church.
More accurately it is Sacred Art, set apart for the honor and greater glory of God.
Because of its sacramental character it has the ability to connect us uniquely
to the Incarnation and engage us more deeply in the mystery of Salvation.
Liturgical Art is an expression of Faith and inspires Faith.

—George R. Hoelzeman

26
The Church Year

The Christian church, following earlier Jewish tradition,
has long used the seasons of the year as an opportunity for festivals
and holidays, sacred time set aside to worship
God as the Lord of life.

—Dennis Bratcher

"What time is it?" For early Christians this question addressed not just a day's passage, but also sacred seasons. From the beginning of recorded time, civilized people created systems for tracking time and remembering religious observances. In the Old Testament the Jews marked time by twelve months, seasonal religious festivals, and the passage of years. The Hebrew calendar began in the spring, around March or April, and Jews considered the first day of each month holy, marked by sacrifices and trumpet blowing.

As an agricultural society, Israel observed two New Years: the commercial year beginning in the fall and the religious year starting in the spring. It's no surprise, then, that the holy days and ways of early Christians resembled this biblical rhythm. The first Christians were Jews.

The Christian or liturgical calendar eventually rotated around two major seasons: Advent, commemorating Christ's birth; and Easter or Pascha, remembering his death and resurrection. Other sacred days and times occurred between these two festivals, with Eastertide as the year's most holy season. Artists painted these celebrations or created works to enhance them. Consequently, observing sacred art requires understanding holy days on the church calendar.

This basic calendar has survived almost two millennia, structuring the year, announcing fasts and feasts, and infusing sacred days with meaning. Christians celebrate part of or the entire calendar today. Most dates for these hallowed events, except for Christmastide, vary according to the yearly calendar. Consequently, dates don't appear in most of the following descriptions for major celebrations.

A D V E N T Perhaps as early as the fourth century, the church began its liturgical year with Advent, the four Sundays leading up to Christmas Day. Advent derived from a Latin word for "arrival" or "coming." This season recalls Israel's waiting for the Messiah (First Advent), and the church's anticipating Christ's return (Second Advent). Advent emphasizes a time of reflection, repentance, and fasting. E X A M P L E : *The Seven Joys of the Virgin*, painting by Master of the Holy Parent, fifteenth century. Louvre, Paris, France. In the left altarpiece panel the artist painted one of Mary's greatest joys: the birth of her son, Jesus. Christian tradition developed the Seven Joys of the Virgin as the Annunciation; the Nativity of Jesus; the Adoration of the Magi; the Resurrection of Christ; the Ascension of Christ; Pentecost; and the Coronation of the Virgin. By the seventeenth century, the Assumption of the Virgin combined with or replaced the coronation.

C H R I S T M A S T I D E Beginning with Christmas Day, for centuries the church calendar has celebrated Christ's birth and the Twelve Days of Christmas, from December 25 through January 5. For many, the Christmas season concludes with the Epiphany, commemorating the Magi who visited the child Jesus and his parents. Although many churches still honor these dates, the secular culture celebrates the season between Thanksgiving Day and Christmas Day. E X A M P L E : *Shrine of the Three Kings*, sculpture and metalwork designed by Nicholas of Verdun, thirteenth century. Cologne Cathedral, Cologne, Germany. A metalwork masterpiece, the shrine allegedly holds the bones of the three Magi who visited the child Jesus. The twelfth-century Roman Emperor Frederick Barbarossa gave these relics to the archbishop of Cologne, Rainald of Dassel. The artist sculpted the revered gold shrine with prophets, apostles, and scenes from Christ's life.

O R D I N A R Y T I M E This season's name evolved from the ancient Latin word for "ordinal" which meant "counted time." For many contemporary congregations, this season marks the days between Epiphany and Lent, a time to consider Jesus's life and teachings before the Passion or Holy Week. However, the term *ordinary time* didn't emerge until the twentieth century. Before then the church counted this time as the -*n*th Sunday after Epiphany. E X A M P L E : *Christ Instructing Nicodemus*, painting by Jacob Jordaens, seventeenth century. Fine Arts Museum, Tournai, Belgium. Jordaens painted both Jesus and Nicodemus the Pharisee in an intense discussion, their left arms outstretched. He also depicted

Nicodemus resting his right hand on his chest, as if referring to himself. The artist bathed Jesus in light and Nicodemus in shadow, perhaps to indicate each man's spiritual condition.

L E N T Around the fourth century, Lent served as a time of preparation for those baptized on Easter or Pascha. The Lenten season spread across forty days, from Ash Wednesday through the Saturday before Easter. Lent emphasized prayer, fasting, self-examination, and charitable deeds as a preparation for Easter. In some traditions Christians received a mark of the cross, drawn with ashes, on their foreheads on Ash Wednesday, the first day of Lent. This practice originated in the tenth or eleventh century. The ashes represented mourning over sin and prefigured Christ's suffering. Shrove Tuesday commenced the day before Ash Wednesday. On that day congregants ate together as a community before fasting. Liturgical churches continue these practices today. **E X A M P L E :** *Battle Between Carnival and Lent*, painting by Jan Miense Molenaer, seventeenth century. Indianapolis Museum of Art, Indianapolis, Indiana. Molenaer painted a brawl between peasants, equipped with food and cooking implements, and clergy brandishing similar items. The clash personified Carnival and Lent, symbolizing the struggle between excess and abstinence. Carnival, a time of merrymaking, preceded the Lenten season. Some groups still practice Carnival today.

H O L Y W E E K Early Christians embraced Palm Sunday through the next Saturday, commemorating the events in Christ's life, from his entry into Jerusalem through his time in the tomb. Christians still observe these days, which include:

P A L M S U N D A Y Jesus rode into Jerusalem on a donkey, with crowds cheering him. The multitude cried "Hosanna!" and spread their cloaks and palm branches on the road (Mt. 21:7–9). Some five hundred years earlier, the prophet Zechariah prophesied, "Rejoice greatly, Daughter Zion! Shout, Daughter Jerusalem! See, your king comes to you, righteous and victorious, lowly and riding on a donkey, on a colt, the foal of a donkey" (Zech. 9:9). **E X A M P L E :** *Christ Riding a Donkey*, sculpture by unknown artist, fifteenth century. The Cloisters, Metropolitan Museum of Art, New York, New York. A German sculptor used lindenwood to create a life-sized Christ entering Jerusalem, riding a donkey and raising his right

hand in greeting or blessing. From the fourteenth through the sixteenth centuries, clergy carried statues like this in Palm Sunday processions. These sculptures earned the name *palmesel*, which meant "donkey of Palm Sunday" in German.

HOLY MONDAY Jesus threw the money changers out of the temple and overturned the tables of merchants selling doves. Quoting the prophet Isaiah, he declared, "Is it not written: 'My house will be called a house of prayer for all nations'? But you have made it 'a den of robbers' " (Mk. 11:15–17; Isa. 56:7; Jer. 7:11). EXAMPLE: *The Casting Out of the Moneylenders from the Temple*, painting by Lucas Cranach the Younger, sixteenth century. Old Masters Picture Gallery, Dresden, Germany. Cranach juxtaposed chaos against calm, with money changers scrambling to recover their goods and people behind Jesus calmly watching them. Cranach included his wife, Barbara, and son Hans among the crowd.

HOLY TUESDAY On this day Jesus focused on the world to come. He cursed and withered a fig tree and taught parables about the talents and the ten virgins (Mt. 24:1–46; 25:1–13). He also clashed with the Jewish chief priests and elders about his authority and spoke about the end times (Lk. 21:5–36). EXAMPLE: *The Wise and Foolish Virgins*, Rossano Gospels, illuminated-manuscript page by unknown artist, sixth century. Diocesan Museum, Rossano, Italy. The illuminator emphasized the tragedy of people unprepared for Christ's return. He depicted Jesus on one side of a door with five wise virgins. On the door's other side, he painted five foolish virgins pleading to enter. The artist indicated the virgins' spiritual state with color: the wise virgins dressed in white and the foolish virgins in black and other hues.

HOLY OR SPY WEDNESDAY Judas Iscariot conspired with Jewish Sanhedrin members to betray Jesus for thirty silver coins (Mt. 26:14–16). From this moment on, Judas looked for a time and place to identify Jesus for the Jewish leaders. In the meantime, Jesus visited Simon the Leper's house, where Mary anointed him with oil. EXAMPLE: *Judas Iscariot Asks the High Priests for Thirty Talents*, Codex of Predis, illuminated-manuscript page by unknown artist, fifteenth century. Royal Library,

Turin, Italy. The isolation of Judas with four high priests and the artist's stiff style stressed the malevolence of their clandestine meeting. The artist painted an unsettling encounter. Raised hands, pointing fingers, and open mouths suggest the priests argued with Judas.

HOLY OR MAUNDY THURSDAY Jesus celebrated Passover, also known as the Last Supper, with his disciples. They consumed bread and wine, representing his soon-to-be-broken body and spilled blood on the cross (Mt. 26:26–30). Before Jesus presented this comparison, he indicated one disciple would betray him, and Judas exited the dinner. **EXAMPLE:** *The Last Supper*, painting by Titian (Tiziano Vecellio), sixteenth century. National Gallery of the Marche, Urbino, Italy. Titian painted a worried and questioning group of eleven disciples with Jesus, after Judas left the table. However, the artist still focused on Jesus by painting a nimbus (halo) around his head and making some disciples barely visible in the scene.

GOOD FRIDAY The day of Jesus's brutal crucifixion by Roman soldiers. A few of Christ's followers, jeering soldiers, Jewish leaders, and mocking crowds stood by until Jesus drew his last breath. **EXAMPLE:** *The Crucifixion*, painting by Master of the Codex of Saint George, fourteenth century. The Cloisters, Metropolitan Museum of Art, New York, New York. The artist originally painted a folding altar with this panel hinged to another Passion scene, possibly the Lamentation. In the Crucifixion scene, he painted deep feelings into both the sorrowing and jeering people's faces and hand gestures, accentuated by contrasting light and shadow.

HOLY SATURDAY The Lord's dead body lay in the tomb, guarded by Roman soldiers. Some Christian traditions teach that during this time, Christ descended into hell to release captives. **EXAMPLE:** *The Tomb of Christ Is Guarded by Soldiers*, illuminated-manuscript page by unknown artist, fifteenth century. Royal Library, Turin, Italy. Although the painter placed seven guards around Christ's tomb, he arranged them standing and talking casually among themselves, creating a visual commentary about their lack of respect or concern for the lowly Jewish carpenter buried inside. Also: *Harrowing of Hades* painting by unknown artist, fourteenth century. Chora Church, Istanbul, Turkey. Among its substantial collection of preserved mosaics, Chora houses

The Harrowing of Hades fresco in a *parecclesion* (side chapel). In this energetic narrative, painters depicted Christ pulling Adam and Eve from hell and leading them toward heaven. This famous image has been frequently copied by Byzantine and Orthodox artists who also called it *Anastasis*, which means "Resurrection."

EASTERTIDE Eventually in early Christianity, Easter or Pascha became the centerpiece of the Christian calendar, representing both a day and a season. It began on Easter Sunday, celebrating the Resurrection, and ended honoring the birth of the church. Eastertide encompassed the Ascension, when Christ rose to heaven, and Pentecost, when the Holy Spirit descended on believers. Liturgical Christians still honor this celebratory pattern. **EXAMPLE:** The Resurrection, painting by Albrecht Bouts, sixteenth century. Mauritshuis, The Hague, the Netherlands. Many Resurrection paintings showed the risen Christ with sleeping guards, but Bouts painted three of the four soldiers awake and perplexed. It seems as if one guard scratches his head.

ORDINARY TIME After Pentecost, the second season of ordinary time began. It anticipated the coming of God's kingdom, counting the days until the Advent season returned. Liturgical groups still mark this time on their church calendars. Before the church adopted the term *ordinary time*, it counted each week as the -*n*th Sunday after Pentecost, using ordinal numbers beginning with "first." **EXAMPLE:** *The Pentecost*, painting by Giotto di Bondone, thirteenth century. Scrovegni Chapel, Padua, Italy. Giotto's careful painting style created an orderly descent of the Holy Spirit on believers seated together in an upper room. Giotto indicated the Spirit with rays of light touching believers' haloed heads.

EASTERN CELEBRATIONS The Byzantines celebrated Twelve Great Feasts, and the Orthodox Church continues this tradition. (1) Nativity of the Theotokos (Mary, the Mother of God); (2) Exaltation of the Holy Cross; (3) Presentation of the Theotokos; (4) Nativity of the Lord; (5) Theophany (Baptism of the Lord); (6) Presentation of the Lord; (7) Annunciation; (8) Palm Sunday; (9) Ascension; (10) Pentecost; (11) Transfiguration; (12) Dormition of the Theotokos (Death of Mary).

27
Holy Days

The Lord has commanded offerings and service to be performed.
And these things are not to be performed thoughtlessly or irregularly,
but at the appointed time and hours.

— CLEMENT OF ROME, FIRST CENTURY

"The Greeks and barbarians have this in common that they accompany their sacred rites by a festal remission of labor," wrote the Greek historian Strabo in the first century BC. Later Christians adopted this practice for certain holy days, especially on Sunday when they gathered for the Eucharist service.

For example, in the fourth century Emperor Constantine freed Christian soldiers from work on Sunday so they could attend worship services, and he forbade the courts of law to convene on that day. Emperor Theodosius II, in the fifth century, prohibited games in the Roman circus and theatrical productions on Sunday. Generally, Christians obeyed the Fourth Commandment to keep the Sabbath holy, which implied worship and rest.

The church calendar encompassed other important days of remembrance, but not all required rest from labor. Again, as Christianity spread, the traditions varied and artists represented them. Many Christians still celebrate these days.

C O M M E M O R A T I O N S Along with feasts and festivals, the early church instituted these days to remember exemplary people or significant events that modeled Christian faith and inspired generations. E X A M P L E : *The Forty Martyrs of Sebaste*, relief sculpture by unknown artist, tenth century. Bode Museum, Berlin, Germany. The iconographer crowded this ivory icon with forty men to memorialize Roman soldiers who confessed faith in Christ during the early fourth century. Emperor Licinius ordered them killed near Sebaste in Lower Armenia. Stripped of clothing on a bitterly cold night and shoved outside, the soldiers died from exposure. In the morning, pagan soldiers burned their stiffened bodies and threw the ashes into a river.

EMBER DAYS Based on a Latin phrase meaning "four times," on ember days medieval Christians practiced fasting and abstinence related to specific holy days. In the eleventh century, Pope Gregory VII designated these as Saint Lucia's Day, Ash Wednesday, Pentecost, and the Exaltation of the Cross. In addition to prayer and fasting, Christians thanked God for nature's gifts, vowed to use them in moderation, and assisted the needy. Ember days also preceded the ordination of priests and deacons. EXAMPLE: *The Exaltation of the Cross*, painting by unknown artist, fifteenth century. Nizhny Novgorod State Art Museum, Nizhny Novgorod, Russia. An iconographer originally painted this icon for the Saint Sophia Cathedral, capturing the moment when a priest held up the cross for veneration from a standing congregation.

FEASTS Early in Christianity, feasts or holy days celebrated sacred mysteries and events, in memory of the Virgin Mary, apostles, martyrs, and saints. These days required special services, rest from work, and spiritual reflection. Feasts with elaborate meals often followed fasting. Today some feasts have fixed dates and others move to coincide with shifts in the yearly calendar. Churches often use the terms *feasts* and *festivals* interchangeably. EXAMPLE: *Procession of Saint Gregory to the Castle of the Holy Angel* (*Castel Sant'Angelo* or Mausoleum of Hadrian), painting by Giovanni di Paolo, fifteenth century. Louvre, Paris, France. Paolo painted the legend of Pope Gregory leading a procession around Rome, Italy, ravaged by the plague in the sixth century. While praying at the head of the procession, Gregory claimed he saw an angel at the top of the citadel, sheathing a bloodstained sword. Gregory believed the vision signaled the plague would cease. He renamed the citadel the Castle of the Holy Angel. The church memorialzed this event with a feast.

FESTIVALS The early church began holding festivals or celebrations memorializing events in Christ's life. A festival often incorporated a feast. The two major, enduring festivals were Advent and Easter. Christians also participated in minor festivals honoring people and events. Today celebrants often use the terms *feasts* and *festivals* interchangeably. EXAMPLE: *Feasting, Norman Font Depicting the Labor of the Month for December*, relief sculpture by unknown artist, unknown date. Saint Mary's Church, Burnham Deepdale, Norfolk, England. The artist crowded four primitively sculpted men at a table, eating heartily, during December. This image represented the feasting and celebrating during a medieval Christmas season.

ROGATION DAYS Based on the Latin phrase "to ask," rogation days filled with prayer and sometimes fasting, seeking God's forgiveness for human transgressions. Christians also pled for protection during calamities and requested a bountiful harvest. One major rogation day occurred in the spring, and three minor days preceded Ascension Day. Today's congregations don't commonly celebrate these days. EXAMPLE: *Prayer in the Time of Any Common Plague or Sickness*, Queen Elizabeth's Prayer Book, illuminated-manuscript page by unknown artist, sixteenth century. Lambeth Palace Library, London, England. Queen Elizabeth I's elaborately decorated prayer book included a written prayer for any plague or sickness. Illuminators surrounded the prayer with vines and images of people caring for the sick. This prayer appears in the Anglican *Book of Common Prayer*.

SAINT DAYS In the earliest years of Christianity, believers honored deceased Christians and asked for their intercession. Later the church instituted a process for naming saints and assigning them celebratory days. However, the saints varied according to different traditions, particularly between the Western and Eastern Churches. Liturgical churches still celebrate Saint Days, but the numbers of saints vary. EXAMPLE: *All Saints Day*, painting by Albrecht Dürer, sixteenth century. Museum of Fine Arts, Vienna, Austria. Dürer honored All Saints Day in the Landauer Altarpiece. He painted a crowd of saints surrounding Christ on the cross with God the Father, angels, and the Holy Spirit as a dove hovering above him. Although the painting celebrated saints, the image exalted Christ as Lord of all.

SUNDAYS Christians replaced the Jewish Sabbath with Sunday, the first day of the week, as the time to worship God and rest from labor. *The Didache of the Twelve Apostles*, a Christian treatise or teaching from the late first century, stated, "On the Lord's Day come together and break bread. And give thanks [offer the Eucharist], after confessing your sins that your sacrifice may be pure." EXAMPLE: *The Lord's Day*, woodcut by unknown artist, seventeenth century. Private collection. This woodcut served as the frontispiece to the book *Day of the Lord (Dies Dominica)*, by Thomas Young. Ten panels illustrated what a Reformation Christian should and should not do on Sunday.

28

The Seven Sacraments

*Not only do the Sacraments disclose and reveal God to us, but also they serve
to make us receptive to God. All the Sacraments affect our personal
relationship to God and to one another. The Holy Spirit works through
the Sacraments. He leads us to Christ who unites us with the Father.*

—TOMAS FITZGERALD

When a bold John the Baptist plunged the obscure Jesus into the Jordan River, they initiated the first sacrament, a holy rite of the church (Mt. 3:13–17). To follow the Lord's example, early Christians waded into nature's waters or kneeled at baptismal fonts to signify their faith and conversion. Soon the core of ancient Christian worship centered on seven sacraments, sacred acts modeled on biblical practices and instructions.

In the fourth century Augustine of Hippo described the sacraments as a visible sign of an inner reality. The Byzantine Church called them the Seven Great Mysteries. Later the Anglican *Book of Common Prayer* regarded them as "outward and visible signs of an inward and spiritual Grace." Although names and customs varied among Christian traditions, all sacramental rites manifested God's presence among his people. In turn, they offered Christ's followers a reliable convention for expressing personal faith and commitment.

As the church grew and matured, artists recorded Christians observing the sacraments in a variety of creative forms. Centuries later, the sacraments still thrive, but some believers no longer use the term, and the practice varies according to Christianity's branches, denominations, traditions, and preferences.

BAPTISM OR CHRISTENING An initiation rite that professes repentance and salvation (Mt. 3:13–17). By immersion or sprinkling, in early Christianity water baptism symbolized belief and conversion to Christianity. **EXAMPLE**: *Baptism of the Normans*, illuminated-manuscript page by unknown artist, fifteenth century. Condé Art Gallery, Chantilly Château, Chantilly, France. In ancient times, when a king professed Christianity,

he mandated his subjects to also convert. However, it's not clear whether this miniature baptismal scene represented obligatory or voluntary conversions. The illuminator revealed the stages of a Norman baptism: disrobing before the sacrament begins; receiving the water while kneeling in a baptismal; drying off with a towel; and praying afterward.

CONFESSION OR RECONCILIATION Confessing sins directly to God, or through a priest who mediates between God and the confessing person (Jms. 5:16; 1 Jn. 1:9). Christians practice confession daily or up to yearly, depending on the method and tradition. EXAMPLE: *The Seven Sacraments Altarpiece*, painting by Rogier van der Weyden, fifteenth century. Royal Museum of Fine Arts, Antwerp, Belgium. On the left wing of this altarpiece, Weyden painted the sacraments of baptism, confirmation, and confession (reconciliation) practiced simultaneously in a church with angels hovering above. In the composition's background, he placed confessors kneeling before a priest.

CONFIRMATION A sacrament bestowed on baptized Christians, bringing them fully into their gifts and vocation within the church (Mk. 16:20). In many traditions, during confirmation a bishop or priest lays hands on the heads of candidates and anoints them with oil. The Eastern church calls this process Holy Chrismation. EXAMPLE: *The Seven Sacraments*, pen-and-ink drawing by Master of Cobourg, fifteenth century. Condé Art Gallery, Chantilly Château, Chantilly, France. In this sketch, the Master of Cobourg drew seven chapels in a church, each representing a sacrament. He placed the sacrament of confirmation on the left, identified by a bishop in his liturgical miter (hat).

EUCHARIST, MASS, OR COMMUNION Modeled after Jesus's Last Supper with his disciples (Mt. 26:26–29), this sacrament serves the bread and wine, representing or becoming Christ's actual body and blood. The Eucharist is the most sacred part of a liturgical service. **EXAMPLE:** *The Eucharist*, painting by unknown artist, second century. Catacomb of Priscilla, Rome, Italy. In one of the oldest depictions of this sacrament, a catacomb artist painted seven figures seated at a table, participating in the Eucharist. With catacomb frescoes so ancient and ambiguous, it's difficult for scholars to accurately discern their meaning, but many accept the Eucharist meal interpretation.

EXTREME UNCTION OR ANOINTING THE SICK
Anointing sick people with oil, praying for their healing, and sometimes hearing
their confession (Jms. 5:14). **EXAMPLE**: *The Extreme Unction*, illuminated-
manuscript page by unknown artist, fourteenth century. Condé Art Gallery,
Chantilly Château, Chantilly, France. In a break with convention, the illuminator
poignantly illustrated a nun and a priest at the bedside of a sick man, anointing him
with oil. In the Middle Ages, usually only priests anointed the sick.

HOLY ORDERS OR ORDINATION An initiation rite
for entering the ministry or accepting a special role in the church (Acts 1:20–25).
EXAMPLE: *Ordination of Saint Augustine*, painting by Il Bergognone (Ambrogio
da Fossano), fifteenth century. Sabauda Gallery, Turin, Italy. Il Bergognone
captured a curious clerical group standing behind Augustine as he kneeled before
a bishop, receiving his ordination as bishop of Hippo in the fourth century. Public
acclamation initiated Augustine's earlier ordination into the priesthood.

MARRIAGE A rite joining a man and woman in matrimony, with the
blessing of the church (Mt. 19:4–12). **EXAMPLE**: *Wedding*, illuminated-
manuscript page by unknown artist, fifteenth century. Barnes Foundation, Merion,
Pennsylvania. The illustrator distinguished this wedding scene with bright red-
and-blue clothing contrasted against gray church walls. The painting probably
celebrated the wedding of a high-ranking couple because a bishop, identified by his
miter (hat), presided over the ceremony.

29
Rituals and Customs

Christian worship is never a solitary undertaking. Both on its visible
and invisible sides, it has a thoroughly social and organic character.
The worshiper, however lonely in appearance, comes before God as a
member of a great family; part of the Communion of Saints, living and dead.

—EVELYN UNDERHILL

From the beginning Christians participated in group worship. The New
Testament book of Acts recorded the daily gatherings of the first Christians, and
the writer described their exuberance: "They devoted themselves to the apostles'
teaching and to fellowship, to the breaking of bread and to prayer. . . . They broke
bread in their homes and ate together with glad and sincere hearts, praising God
and enjoying the favor of all the people" (Acts 2:42, 46–47).

As the church grew and spread across cultures, it couldn't maintain this daily
proximity, but worship remained a communal activity. Christians everywhere
worshiped on Sundays and other times during the week, in congregations large
and small. Based on Scripture and tradition, the church developed ways to worship
that helped believers express love, praise, gratitude, and repentance to God and
one another. These worship forms collected into rites, rituals, and customs. A rite
encompassed a formal or ceremonial act, such as the rite of baptism or confirmation.
A ritual prescribed the content and order of a Christian ceremony, for example,
the order of the liturgy in a Sunday morning worship service. A custom reflected a
preferred and habitual action, varied according to different groups, such as bowing
or kneeling or raising hands during prayer.

The following list covers common rites, rituals, and customs that Christians
developed for private and public worship. Many believers still practice them today,
with most patterned after traditions from the Old and New Testaments. A wide
range of artists have depicted these traditions in art.

BLESSING A prayer invoking God's favor on a person, place, or event
(Gen. 5:2). Early Christian frescoes and icons often showed Christ with his hand
raised in blessing. EXAMPLE: *The Blessing of Christ*, mosaic by unknown artists,

thirteenth century. Saint Minias on the Mountain Basilica, Florence, Italy. On the church's front facade, mosaicists pieced together Christ raising his hand in blessing, seated between the Virgin Mary and Saint Minias, the church's patron saint. Depicting Christ with an extended arm suggested a blessing on the church and its people.

BOWED HEAD or BOWED TO THE GROUND
A position of humility and reverence for God while praying (Gen. 24:28).
EXAMPLE: *Madonna in Prayer*, painting by Giovanni Battista Salvi, seventeenth century. National Gallery of Victoria, Melbourne, Australia. Salvi painted the Virgin Mary partially hidden in the shadows, praying with a bowed head and folded hands. He endowed her with youthful perfection and uncommon tranquility.

CELEBRATION The performance of a Christian ceremony, particularly a sacrament (2 Chron. 35:16). Or the feast after a ceremony, if appropriate.
EXAMPLE: *The Christening Feast*, painting by Jan Steen, seventeenth century. Wallace Collection, London, England. While the new mother sits on the bed's edge, the father proudly displays his infant to friends and relatives crowded into a small room. Women prepare a feast in the fireplace as the solemn occasion turns celebratory.

CHANT A simple, repetitive melody characterized by single notes, used by Early Christian, Byzantine, and Roman choirs to sing psalms and canticles (hymns) from the Bible (Eph. 5:19). EXAMPLE: *Double Page with a Plainsong*, Roman Missal (Missale Romanum), illuminated-manuscript page by unknown artist, fifteenth century. Mazarine Library, Paris, France. Plainsong or plainchant comprised a body of chants originating in the third century. Plainsong revived music notation after the Greek system disappeared. Although choirs sang it before the Roman and Byzantine churches split, the Orthodox don't use this term today.

COMMISSION Christ modeled a commissioning when he commanded his disciples to preach the gospel throughout the world (Mk. 16:15). Similar to consecration, clergy past and present have blessed and sent people to minister in specific locations. EXAMPLE: *The Ascension*, relief sculpture by Andrea della Robbia, fifteenth century. Bargello National Museum, Florence, Italy. In glazed terra-cotta, the artist captured Jesus ascending to heaven after commissioning his disciples to preach salvation throughout the world.

C O N S E C R A T I O N Devoting or setting apart someone or something for God's service, such as consecrating priests for the ministry or a church building for the people. Consecration often includes anointing with holy oil or sprinkling holy water (Lev. 8:10). **EXAMPLE:** *Bishop Consecrating a Church*, Pontifical of Sens, illuminated-manuscript page by unknown artist, fourteenth century. National Library of France, Paris, France. Although the illuminator drew the clergy out of proportion to the church, he accurately portrayed a cathedral's consecration, when a bishop sprinkled holy water on the building.

F A S T I N G Forsaking or limiting food and sometimes water as a spiritual discipline. Modeled by Christ in the wilderness (Mt. 4:1–2), some believers still practice fasting. Fasting aims to draw a person closer to God, request his intervention, or battle in the spiritual realm. **EXAMPLE:** *The Temptation of Christ*, painting by Peter Paul Rubens, seventeenth century. Courtauld Gallery, London, England. Rubens painted Jesus raising his arm as a shield against Satan, a hoary, disheveled man offering him bread. This image of Satan departed from many earlier depictions, making him look more human.

E X O R C I S M The ancient ritual of driving out evil spirits from a person, place, or creature (Mt. 10:1), still practiced by some today. The exorcist invokes the name of Jesus and employs prayers, crosses, icons, and other holy rituals and materials to expel demons. **EXAMPLE:** *Tympanum Depicting an Exorcism and the Presentation in the Temple*, relief sculpture by unknown artist, thirteenth century. Chartres Cathedral, Chartres, France. A sculptor shaped the top of this cathedral tympanum into an exorcism scene, showing a possessed man struggling between good and evil. On the left side, clergy work to deliver him. On the right side, Satan strangles him and demons jeer.

F O L D E D H A N D S A position of piety and reverence for God while praying. **EXAMPLE:** *Saint Margaret at Prayer*, painting by Lorenzo Costa, fifteenth century. Museum of Modern Art André Malraux, Le Havre, France. Costa arranged the saint's hands clasped together with her fingers bent. By the Renaissance, praying gestures often showed palms and fingers placed together with hands pointed upward. However, biblical references to praying mention "lifting up" or "spreading out" the hands to God (1 Kgs. 8:54; Ps. 141:2).

FOOT WASHING After Christ's example, washing one another's feet in a ritual representing servanthood (Jn. 13:14). Some traditions still practice foot washing. EXAMPLE: *Christ Washing the Feet of His Disciples*, painting by Tintoretto (Jacopo Comin), sixteenth century. Collection of the Earl of Pembroke, Wilton House, Wiltshire, England. In many paintings of Christ washing the disciples' feet, his followers gathered around him. But Tintoretto depicted most of the disciples preoccupied while the Lord washed one disciple's feet.

HOLY KISS A chaste kiss of greeting or reconciliation practiced by early Christians (Rom. 16:16). In addition, kissing the ring or hand of a priest or pope displayed respect. EXAMPLE: *Meeting at the Golden Gate*, painting by Giotto di Bondone, fourteenth century. Scrovegni Chapel, Padua, Italy. According to Giotto's fresco, the future parents of the Virgin Mary kissed in greeting after the father returned from a journey. Anna then told Joachim about the impending birth.

HOLY OIL OR CHRISM Oil representing the Holy Spirit. Clergy anointed kings with oil at coronations (2 Sam. 2:4). Clerics also anointed Christians with oil during baptism, confirmation, and prayer for the sick—all rites practiced by the early church (Mk. 6:13). EXAMPLE: *The Anointing of David*, painting by Paolo Veronese, sixteenth century. Museum of Fine Arts, Vienna, Austria. Veronese arranged a family pressing around the prophet Samuel as he anointed David with oil, a rite that claimed the young man as future king.

HOLY WATER Water blessed by a priest, representing cleansing. Especially in Byzantine and Roman Catholic practices, holy water blessed, consecrated, and protected people, places, and objects. It also reminded Christians of their baptismal promises. In the narthex (entryway) of some churches, congregants dipped their hands in a holy water fountain and blessed themselves. Sprinkling a congregation with holy water, called *asperges*, derived from the first word of Psalm 51:7. Some current traditions use holy water in their churches and rituals. EXAMPLE: *Base of a Holy Water Fountain with Dolphins*, relief sculpture by unknown artist, twelfth century. Saint Mark's Basilica, Venice, Italy. The dolphin represented salvation and resurrection, an appropriate symbol for a holy water fountain.

INCENSE BURNING Burning incense, usually in a censer, to represent the prayers of God's people (Rev. 5:8). In Christian art it also symbolized devotion and worship. **EXAMPLE**: *An Angel with a Thurible*, painting by Bernhard Strigel, fifteenth century. Private collection. London, England. Strigel's majestic angel probably represented all angels collecting and carrying human prayers in censers to God's throne.

KNEELING A prayer posture expressing humility, reverence, and supplication to God (Ps. 95:6). **EXAMPLE**: *Frontispiece Showing Queen Elizabeth at Prayer*, Queen Elizabeth's Prayer Book, illuminated-manuscript page by unknown artist, sixteenth century. Lambeth Palace Library, London, England. The miniature painting of Queen Elizabeth I kneeling and praying boosted her image as a ruler chosen and directed by God.

LAYING ON OF HANDS Christians placing hands on the sick while praying for their healing. Following Jesus's example (Lk. 4:40) and Jewish tradition, they often anointed the sick with oil before praying. Laying on of hands also occurred while blessing, consecrating, commissioning, or asking for the Holy Spirit. Many Christians still practice this ritual. **EXAMPLE**: *The Miracle Window*, stained-glass window by unknown artists, thirteenth century. Canterbury Cathedral, Canterbury, England. The cathedral constructed a stained-glass window to illustrate miracles occurring after the martyr Thomas Becket's death and burial. Several panel designs incorporated laying on of hands.

LIFTING UP HANDS Paul told his young friend Timothy, "I want men everywhere to lift up holy hands in prayer, without anger or disputing" (1 Tim. 2:8 NIV1984). Accordingly, early Christians lifted their hands to pray and worship, a sign of adoration and abandonment to God. **EXAMPLE**: *Isaiah Praying, Historiated Initial "A,"* Macclesfield Psalter, illuminated-manuscript page by unknown artist, fourteenth century. Fitzwilliam Museum, University of Cambridge, Cambridge, England. The illuminator sketched the Old Testament prophet Isaiah lifting his hands toward heaven while praying to God.

LITURGY The material and order for a public service or celebration, especially for Sunday worship gatherings. Translated from the Greek, *liturgy* meant "public service" or "the work of the people." Written by early church fathers, the

liturgy also referred to a Eucharist service. Many liturgical churches exist today. EXAMPLE: *Saint Gregory and Saint Augustine*, painting by Juan de Borgoña, sixteenth century. Bowes Museum, Barnard Castle, County Durham, England. Although from different centuries, scholars credit Gregory and Augustine with establishing the Roman liturgy and music. In this image, the artist painted the two saints together, bent over liturgy pages, with writing utensils in their hands.

LITURGY OF THE HOURS, DIVINE OFFICE, OR DAILY OFFICE Prescribed prayer times throughout a day. Clergy, religious orders, and some laity prayed during these canonical hours: Matins at midnight; Lauds at 3 AM; Prime at sunrise; Terce at 9 AM; Sext at midday; Nones at 3 PM; Vespers or Evensong at dusk; and Compline, the last service, at 9 PM. During the Middle Ages and the Renaissance, scribes copied this liturgy into beautifully illustrated manuscripts, each called a book of hours. Some groups and individuals still practice the Liturgy of the Hours. EXAMPLE: Hours of Étienne Chevalier by Jean Fouquet, fifteenth century. Pages dispersed throughout Europe and the United States, with most at the Condé Museum, Chantilly Château, Chantilly, France. This book of hours distinguished itself as one of the most lavishly decorated manuscripts from the fifteenth century. Jean Fouquet painted it for France's treasurer, Étienne Chevalier.

MEDITATION, CONTEMPLATIVE PRAYER, OR *LECTIO DIVINA* An ancient spiritual discipline that prayerfully contemplated Scripture and God's presence (Josh. 1:8). According to Roman Catholic tradition, Pope Gregory I and Saint Benedict developed the practice of *Lectio Divina*, a method for prayerfully reading Scripture. In ancient Latin it meant "divine reading." Monastics, clergy, and laypeople still practice this discipline. EXAMPLE: *Meditation*, painting by Domenico Fetti, sixteenth century. Academy Gallery, Venice, Italy. Fetti's painting featured an earnest woman contemplating several manuscripts.

OFFERING A gift to God, financial or material, originating from Old Testament instructions. In the past, churches collected alms, food, and clothing for the poor; oblations of bread and wine for the Eucharist service; and tithes, one tenth of a person's income. Eventually congregations varied the content of their offerings, but mostly the gifts became financial. **EXAMPLE:** *Abel Offering a Lamb*

and Melchizedek Offering Bread at the Altar, mosaic by unknown artists, sixth century. Saint (San) Vitale Basilica, Ravenna, Italy. The mosaicists demonstrated Abel offering tithes on an altar. On the opposite side of the altar, they added Melchizedek, King of Salem, and a high priest, who later fed Abram and received tithes from him.

P A X A greeting among Christians that declared, "The peace of the Lord be with you." *Pax* translated from Latin as "peace." By the second century, Christians exchanged a kiss of peace during the Eucharist service. In some cultures the greeting gradually became a handshake. E X A M P L E : *Farewell of Saints Peter and Paul*, painting by Alonzo Rodriguez, sixteenth century. Regional Museum of Messina, Messina, Sicily. Rodriguez painted an unusual scene: the two apostles sharing a kiss of peace and departure before their martyrdoms.

P E N A N C E An action to atone for sin, still practiced in some Christian traditions. After a person confessed his sin to a priest, the cleric assigned him penance. Penance practices varied widely, and sometimes Christians chose their own penance, especially during Lent. E X A M P L E : *Saint Jerome in the Desert*, painting by Pietro Perugino, sixteenth century. Fine Arts Museum, Caen, France. For five years in the fourth century, Saint Jerome lived in the Desert of Chalcis in Syria. He spent this time praying, studying, and doing penance. Perugino painted a lion behind the kneeling Jerome, recalling the legend about the saint removing a thorn from the animal's paw.

P I L G R I M A G E A journey to a religious site associated with a sacred person or event, with pilgrims seeking holiness, healing, penance, and the miraculous. Practiced by early, medieval, and Renaissance Christians, pilgrimage swelled into a huge industry. E X A M P L E : *Lydgate and the Canterbury Pilgrims Leaving Canterbury, Troy Book, and The Siege of Thebes*, illuminated-manuscript page by John Lydgate, fifteenth century. British Library, London, England. Lydgate illustrated English pilgrims on horseback, reminiscent of the *Canterbury Tales* by Geoffrey Chaucer.

P R A Y E R Communion with God through adoration, confession, intercession, petition, thanksgiving, or praise. Early on, Christians prayed in group unison during liturgical services or privately when alone, and they still do.

EXAMPLE: *Saint Francis of Assisi at Prayer*, painting by Giovanni Andrea Sirani, seventeenth century. Private collection. London, England. Sirani painted Saint Francis in a more wistful than prayerful mood, with the monk's cheek resting on his hand, staring at a thin wooden cross atop a stone altar.

PROSTRATION A prayer stance of repentance and supplication, or a position of reverence, wherein a person lay flat on the floor, face down. **EXAMPLE**: *Historiated Initial "Q" Depicting a Monk and an Angel*, Moralia in Job by Pope Gregory the Great, illuminated-manuscript page by unknown artist, twelfth century. Municipal Library, Dijon, France. For this capital letter, the illuminator inserted a monk lying on his stomach with his head up, in supplication at a charming angel's feet.

READINGS During a worship service, designated people read selected Scripture passages during a liturgical service. These selections, also called lessons, derived from the Old Testament, Epistles, and Gospels. A book called a lectionary listed the readings for each service. Liturgical services today still incorporate these readings. **EXAMPLE**: *Latin Lectionary*, illuminated-manuscript page by unknown artist, tenth century. National Library of France, Paris, France. The French illuminator illustrated this lectionary with a capital letter at the beginning of each Bible verse. Lectionaries were as simple as this example or could be elaborately decorated.

RETREAT A time away for solitude, prayer, meditation, and rest, practiced by members of religious orders, the clergy, and the laity. **EXAMPLE**: *Seeking Asylum in a Convent*, Codex of Entry Into Spain (Codex Entrée d'Espagne), illuminated manuscript page by unknown artist, fourteenth century. National Library of Saint Mark's (Biblioteca Nazionale Marciana), Venice, Italy. In between this manuscript's text, the illuminator painted a horizontal illustration of a monk raising his hand in an instructive gesture, sharing his bread and wisdom with a visiting layperson.

SIGN OF THE CROSS Tracing the sign of the cross on the forehead, chest, or full body. Early believers "signed the cross" to bless, pray, protect, fight evil, and practice sacred rituals. It's a practice certain Christians continue today. **EXAMPLE**: *Window of the Pilgrims of Saint James of Compostela*,

stained-glass window by Pierre Bacon, sixteenth century. Church of Saint-Ythier, Sully-sur-Loire, France. In this multipaneled window depicting several miracle stories, Saint Nicholas of Tolentino—a pilgrim and a vegetarian—brought back to life a chicken served to him by making the sign of the cross.

S I N G I N G Designated times during a church service to sing psalms and hymns. The earliest Christians initiated this practice to praise God and express Christian beliefs. This practice continued throughout church history. **EXAMPLE:** *Historiated Initial "C" with Clerks Singing*, Luttrell Psalter, illuminated-manuscript page by unknown artist, fourteenth century. British Library, London, England. An illuminator stuffed five amusing clerks inside an initial letter at the beginning of a manuscript page, singing from a psalter in the shape of an eagle.

V I G I L A devotional wakefulness during the customary hours of sleep. The early church practiced a vigil the night before selected liturgical celebrations or during and after a person's death. It's an occasional practice now. **EXAMPLE:** *The Death of Saint Bruno*, painting by Eustache Le Sueur, seventeenth century. Louvre, Paris, France. Working only with shades of white and gray, the painter eerily captured the death of Saint Bruno, founder of the Carthusian order, as monks stood and kneeled in prayer around his bed.

30
Objects and Vessels

If golden pouring vessels, golden vials, and golden little mortars are used . . .
to collect the blood of goats or calves, how much more must golden vessels,
precious stones, and whatever is most valued . . . be laid out . . . for the reception
of the blood of Christ! Surely, neither we nor our possessions suffice for this service.

—ABBOT SUGER, TWELFTH CENTURY

Celebrating the Eucharist, early Christians carefully followed the Lord's example at the Last Supper with his disciples (Mt. 26:26–28). In the third century Bishop Cyprian of Carthage explained, "But when something is commanded by God's inspiration and instruction, there can be no choice but for a faithful servant to obey his Master . . . in offering the cup the teachings of the Lord must be observed, and we must do exactly as the Lord first did himself for us."

Christians also believed holy acts deserved sacred vessels, so beyond the cup, they commissioned artists to create simple but elegant liturgical objects for serving the bread and wine. Later, when commissioned by the aristocracy, precious-metal cups and plates burgeoned into bejeweled works of art, fashioned for the King of Heaven. Craftspeople also stitched and embroidered the finest linen for protecting these vessels. Comparing the eighth-century Ardagh Chalice of the Celts with the twelfth-century chalice owned by the French Abbot Suger exemplifies how cultures and eras influenced liturgical vessels. While the Ardagh cup exuded strength and simplicity, Suger's chalice was deemed "one of the most splendid treasures from the Middle Ages."

Over the centuries, clergy, curators, and art collectors preserved liturgical items in ancient churches, private collections, and public museums. Or they safeguarded paintings depicting Eucharist services and Christian rituals. Liturgical objects from a Sunday Mass or Eucharist celebration included the following list. Depending on a church's tradition, many contemporary celebrants use similar objects during worship services.

A E R In a Byzantine Eucharist celebration an elaborate Little Aer or chalice veil covered the wine cup. A second veil protected the consecrated host or bread placed

on a paten (plate). In turn, another beautiful cloth, the Great Aer, covered both the bread and wine. **E X A M P L E :** *Aer*, embroidery by unknown artist, fifteenth century. The Putna Monastery Church, Suceava, Romania. For this aer's image, embroiderers depicted men lowering Jesus into his tomb, while his mother Mary mourned and angels watched with outstretched arms. Artisans also stitched stars and lettering into the brown background.

A L T A R C L O T H Symbolizing Christ's shroud, this cloth covered an altar, extending down on both sides. Depending on a church's preference and financial means, a cloth could be simply or intricately decorated. **E X A M P L E :** *Cloth from the High Altar of Saint Mary's Church in Danzig*, textile work by unknown artist, fifteenth century. Germanic National Museum, Nuremberg, Germany. Out of damask fabric, Italian textile makers wove a cloth busily decorated with scrolls and flowers. It covered the high altar of a Polish church.

A M P U L L A A two-handled glass, gold, pottery, or silver jug for holy oil, a symbol of consecration. Clerics dabbed or poured this oil during baptisms, confirmations, holy orders, holy unctions, royal coronations, and other sacred rituals. **EXAMPLE:** *Ampulla Which Held the Sacred Anointing Oil for the Coronation of Charles I*, metalwork possibly by James Dennistoun, seventeenth century. National Museum of Scotland, Edinburgh, Scotland. Instead of forming two handles, the artisan topped this gold-and-silver-gilt ampulla with double pouring spouts and engraved it with information about the coronation.

A S P E R G I L L U M The cylinder-like utensil used to sprinkle holy water on people or things. In ancient Latin, the word translated to "sprinkler." **E X A M P L E :** *Saint Margaret*, painting by unknown artist, fifteenth century. Private collection. The artist painted an unusual depiction of a female saint holding a pastoral staff and an aspergillum, usually handled by a clergyman. On a much smaller scale, he included the painting's donor kneeling and praying before the saint.

A S T E R I S K O S OR A S T E R I S K During Byzantine worship the priest placed this gilded piece on top of the paten (plate) holding the consecrated bread. An open, four-armed structure shaped like a dome, the *asteriskos* kept a protective veil from touching the sacred particles. The Greek word translated to "little star," and this liturgical vessel memorialized the star of Bethlehem. **EXAMPLE:** *Asteriskos*, metalwork by unknown artist, fourteenth century. Holy Monastery of Vatopedi, Mount Athos, Greece. A metalworker inscribed the four arms of this silver-gilt asteriskos and topped it with a dove where the arms crossed. The corresponding four feet stood on the paten or "sacred dish" that held the Eucharist bread.

B R E A D S T A M P A stone or terra-cotta stamp marked the Eucharist bread dough before the baker placed it in the oven. A stamp bore a Christian sign or symbol, or just the markings for where to tear apart the bread. A cross or Christogram often appeared on a bread stamp. **EXAMPLE:** *Bread Stamp with the Letters Alpha and Omega and an Abbreviation of the Name Jesus Christ*, terra-cotta work by unknown artist, Byzantine Period. Israel Antiquities Authority, Jerusalem, Israel. Potters molded this bread stamp into a common shape and design: a round stone divided into four sections by a cross and inscribed with letters. Although aging broke off part of the left side, it's still possible to decipher the cross and most of the letters.

B U R S E A flat, stiff envelope covered in silk. It stored the corporal (altar cloth) while carrying it to the altar for the Eucharist celebration. **E X A M P L E:** *Burse*, of unknown origin in England, embroidery by unknown artist, fourteenth century. Victoria & Albert Museum, London, England. An embroiderer created this example of Opus Anglicanum (Latin for "English work") for the Mass. The artist stitched one side with Christ crucified, the Virgin Mary, and Saint John. On the other side, he or she embroidered the Coronation of the Virgin.

C A N D L E Generally, a lit candle represented Christ as the Light of the World. However, candles for selected locations or celebrations carried their own meaning. For example, the six lights at an altar and the church's constant

prayer; Eucharist candles and Christ's presence during Communion; and the Paschal candle and Christ's resurrection. Renaissance art often depicted candles for devotional use, Christian processions, and sacred shrines. **EXAMPLE**: *The Penitent Peter*, painting by Matthias Stomer, seventeenth century. Friedenstein Castle, Gotha, Germany. Stomer painted an old and anguished Saint Peter lit by candlelight, holding the keys to God's kingdom and slightly lifting his face in beseeching prayer.

CANDELABRA A metal holder that usually supported three, five, or seven candles, placed on or near a church altar. Respectively, the candles represented the three members of the Trinity, the five wounds of Christ, and the seven gifts of the Holy Spirit. **EXAMPLE**: *Madonna of the Candelabra*, relief sculpture by Antonio Rossellino, fifteenth century. Leighton House Museum, London. Rossellino sculpted a charming terra-cotta image of a chubby baby Jesus sitting on his mother's lap, cradling a bird in his hands. The sculptor framed the pair with a garland-festooned candelabra.

CANDLE LIGHTER AND SNUFFER A long-handled, metal utensil used to light and extinguish candles. A wax taper inside a metal tube, with a short lighted wick sticking out, ignited the candles. An attached metal bell snuffed out the flames. **EXAMPLE**: *Saint Jerome in His Study*, painting by Pieter Coecke van Aelst the Elder, sixteenth century. The Walker Art Gallery, Baltimore, Maryland. The painter imagined Saint Jerome in an agonizing moment of contemplation at his desk, with his right hand on his forehead and his left finger on a skeleton's head. The artist included a golden candle wick trimmer, candle snuffer, and candlestick among the saint's array of desk accessories.

CASKET OR *CHASSE* A decorated small box or chest, used for storing valuables or ecclesiastical items. In the medieval and Byzantine liturgical context, it held sacred relics, serving as a reliquary casket. **EXAMPLE**: *Thomas Becket Chasse*, metalwork by unknown artist, twelfth century. British Museum, London, England. At one point this small chest with a slanted top held some bodily remains of the martyr Thomas Becket, the archbishop of Canterbury. Artisans created at least forty caskets to house his body parts, sold as reliquaries around the world. For this casket, the artisan depicted the archbishop's murder and entombment.

CENSER OR THURIBLE A metal bowl in which the celebrant burned incense during a liturgical service. Often a censer hung from three chains joined at the top so a priest or monk could swing it back and forth, spreading incense throughout a church or monastery. Swinging the censer fanned the coals so smoky incense flowed out. Censers also hung or stood on pedestals in various locations in these buildings. **EXAMPLE:** *Censer Bowl with Chains for Suspension and Decorated with Crosses*, metalwork by unknown artist, Byzantine Period. Franciscan Biblical Studies Museum, Jerusalem, Israel. Found in Jericho, a cross at the censer's top suspended the three chains. In turn, each chain terminated with a cross attached to the bowl. Over time, a green patina covered the censer's metalwork.

CHALICE A metal cup or goblet, usually decorated, that held wine during the Eucharist service. **EXAMPLE:** *Chalice of the Abbot Suger of Saint-Denis*, metalwork by unknown artists, first or second centuries BC (cup) and AD twelfth century (mounting). National Gallery of Art, Washington, DC. Abbot Suger purchased this cup for the French royal Abbey of Saint-Denis. Artisans carved it from sardonyx, probably during the second to first centuries BC in Alexandria, Egypt. Centuries later Suger's goldsmiths mounted the cup in a gold-and-silver setting with filigree and gems. On the foot, artisans displayed Christ and the Greek letters for alpha and omega, indicating the Lord as "the beginning" and "the end."

CHOROS The word *choros* indicated the space underneath a Middle to Late Byzantine church dome, and eventually it referred to the lighting device hung there. The circular choros suspended multiple candles and ornamentation with metal chains. **EXAMPLE:** *Byzantine Choros*, metalwork by unknown artist, thirteenth to fourteenth century. Archeological State Collection of Prehistory and Early History, Munich, Germany. The metalworker attached latticed crosses and glass candle holders to metal chains to create a spectacular chandelier. Filled with slim candles, the copper light fixture gently swayed with air moving through the dome during a worship service.

CHRISMATOR A decorated box that stored conse-
crated vials of chrism (oil) for Christian rites. **EXAMPLE:** *Limoges
Chrismatory*, enamel work by unknown artist, thirteenth century.
Metropolitan Museum of Art, New York, New York. Clergy
probably used this splendid box to hold small oil vials for Christian
rituals such as church consecrations, confirmations, exorcisms,
and last rites. Metalworkers covered the angular chrismatory with
images in circles: primarily busts of angels, crosses, and flowers.

CIBORIUM A covered container housing the consecrated
bread or sacred wafers for a Eucharist service, shaped like a chalice
with a lid. Christians believed the host represented or actually became
Christ's body through transubstantiation. A host box—a round metal
container with a pointed lid—also held the host wafer. **EXAMPLE:**
Ciborium made in Limoges for the Abbey at Montmajour, metalwork
by G. Alpais, thirteenth century. Louvre, Paris, France. The enameler
created a masterpiece of two bulging chalice vessels fitting together,
with one upside down, on a bell-shaped foot. On the top vessel,
he styled a knob decorated with busts of angels. On the exterior
of the ciborium, he crafted more angels, the twelve disciples, four
prophets, and pseudo-Kufic characters similar to Arabic calligraphy.

COLLECTION, ALMS, OR OFFERING PLATE
Parishioners placed their financial offerings into this metal dish. In other eras or
locations, ushers collected the people's gifts with cloth alms bags connected to
long poles, reaching across pews to take each person's contribution. **EXAMPLE:**
Collection Plate, metalwork by John Smith, eighteenth century. Victoria & Albert
Museum, London, England. Smith shaped this simple Scottish pewter collection
plate with a deep basin and wide rims.

CONSECRATION PLATE A consecration plate held
Communion bread carried to the altar. **EXAMPLE:** *The Hague Plate*, metalwork
by Pieter van der Hegge, seventeenth century. Victoria & Albert Museum, London,
England. Part of a set of three, this plate served an austere service for the English
Reformed Church in The Hague, the Netherlands. Pieter van der Hegge engraved
the silver plate with a coat of arms enclosed in a double circle.

CORPORAL A white, usually unadorned linen cloth placed on the altar. The celebrant consecrated the bread and wine over the corporal, but sometimes this cloth also covered the elements. At times the corporal replaced the altar cloth. **EXAMPLE:** *A Mass of Saint Gregory*, Tomb of the Holzschuh Family, tapestry by unknown artists, fifteenth century. Germanic National Museum, Nuremberg, Germany. Flemish tapestry weavers included a corporal on the altar when they wove this detailed, silk-and-wool tapestry about the pope's Mass. In this case, the corporal covered the sacred elements, bread and wine.

CROSIER OR CROZIER A staff with a spiraled crook at the end, carried by high-ranking clergy as a symbol of pastoral leadership. The crosier represented a shepherd's rod because it symbolized an abbot, abbess, bishop, archbishop, or apostle's role as a shepherd of God's flock. **EXAMPLE:** *The Crozier of the Abbesses of the Cistercian Convent*, metalwork by unknown artist, thirteenth century. Lambinet Museum, Versailles, France. The artisans married power and delicacy in this staff. The overall silver gilt exuded power, and the rock crystal lamb and crosses in the crook added a delicate touch.

CRUET OR EWER A small glass or metal pitcher, topped with a stopper. It stored the mixed wine and water for a Eucharist service. Separate cruets or flagons also held the wine and water. **EXAMPLE:** *An Angel Carrying Two Cruets*, sculpture by Évrard d'Orléans, fourteenth century. Louvre, Paris, France. French Queen Jeanne d'Évreux, a great art patron, commissioned this marble, smiling angel for the altarpiece of the Cistercian Abbey of Maubuisson. The artisan stood the angel erect, with a cruet in each hand.

FLAGON A pitcher with a lid. The flagon stored wine before consecrating it for a Eucharist service. Clerics used the flagon for large-group celebrations because it held more liquid than a cruet or ewer. **EXAMPLE:** *Communion Flagon*, metalwork by Abraham Portal, eighteenth century. Victoria & Albert Museum, London, England. This silver flagon belonged

to a Communion set presented by the philanthropist Sir Thomas Hankey to the Asylum for Female Orphans in London. An engraver incised a cartouche (scroll with rolled-up ends) with flowers, scrolls, and putti (small angels) holding a Communion cup and plate.

I C O N An image of Christ or another sacred figure or event, used as an aid to devotion in Byzantine churches. **EXAMPLE**: *Virgin and Child with Enthroned Saints and Angels*, painting by unknown artist, sixth century. Saint Catherine's Monastery, Mount Sinai, Egypt. This monastery collected some of the oldest icons in existence, including an image of the Virgin and Child, flanked by the warrior-saints Theodore and George. Byzantines called Mary the "Seat of Wisdom," and the iconographer sat her on a throne, suggesting the reign of King Solomon.

L A V A B O The small basin a priest used to wash his hands after the offertory in a Mass. In some places the lavabo was a large stone basin with small holes for washing hands before a meal. Water flowed through the holes during a ritual washing. **EXAMPLE**: *Lavabo of Mellifont Abbey*, stonework by unknown artist, thirteenth century. Mellifont Abbey, County Louth, Ireland. Although this abbey fell into ruins after the Reformation, the large lavabo remained as an impressive reminder of the religious order's spiritual influence.

M O N S T R A N C E A receptacle for holding the consecrated host wafers or bread, with a small glass window for viewing them. In the sixteenth century, artists surrounded the monstrance with metal rays. A monstrance could also be a reliquary, a container for holy relics. **EXAMPLE**: *Monstrance Reliquary of the Hand of Saint Martha*, metalwork by Giovanni Leon, fifteenth century. Louvre, Paris, France. A German silversmith working in Venice, Italy, created this ornate, silver-gilt monstrance at the request of nuns from the Saint Martha Monastery in England. He covered the Gothic-style reliquary with images of the four Evangelists, female saints, various depictions of women, and an abbess holding a falcon.

P A L L A stiffened square of white linen covering the chalice during Eucharist preparations. **EXAMPLE:** *Priest Offering His Soul to God*, Missal of Nicolas d'Orgemont, illuminated-manuscript page by unknown artist, fourteenth century. Mazarine Library, Paris, France. The illuminator depicted a priest at confession, before entering prison for an offense against the French king. The artist placed a pall atop a chalice, waiting for the cleric's participation in Communion.

P A T E N A metal plate, often engraved, for serving the consecrated bread during a Eucharist service. **EXAMPLE:** *Paten of Bishop Paternus*, metalwork by unknown artist, fifth century. State Hermitage Museum, Saint Petersburg, Russia. A Byzantine metalworker employed silver and gold to create reliefs of a Chi-Rho or Christogram (a symbol for Christ's name) in the plate's center and animal images around its outer edge. This plate calls to mind another paten belonging to the Sion Treasure from the sixth century.

P A X From the thirteenth century, a plaque decorated with a sacred scene and kissed by the priest and officiates of the Mass. After the clerical kiss, a priest offered it to the congregants. This process replaced the kiss of peace. **EXAMPLE:** *Pax*, metalwork by unknown artist, sixteenth century. New College, University of Oxford, Oxford, England. For this square pax, a silver metalworker gilded a wood relief sculpture of the Crucifixion: Christ on the cross, with Mary, his mother, and John the Evangelist both gazing up at him. He positioned this image in the plaque's recessed center, surrounded by a foliage border.

P U R I F I C A T O R The linen cloth used to wipe the wine chalice after a person drank from it. **EXAMPLE:** *Celebration of Mass*, Decretals of Pope Gregory IX, illuminated-manuscript page by the Master of 1328, fourteenth century. Morgan Library, New York, New York. The artist's illumination of Pope Gregory's Mass emphasized the laity's participation in a service. While a priest prayed, a purificator on the altar awaited the people's participation.

P Y X , P I X , O R P Y X I S In early usage, the word *pyx* referred to any vessel that held the Eucharist bread placed in a tabernacle. Later the word described a container that carried the host to the sick who couldn't attend church.

EXAMPLE: *Pyxis with Christ and the Virgin*, metalwork by unknown artist, sixth to seventh century. Museum of Fine Arts, Boston, Massachusetts. In Syria, the artist molded a round pyx in silver and gilt to represent Christ with a raised hand in blessing, his haloed mother, Mary, and archangels with broad, spreading wings.

RELIQUARY A container for a sacred relic. A reliquary for an icon could contain sacred dust from a place or person, a small section of a body part, or something that belonged to a holy person. **EXAMPLE**: *Reliquary Arm*, metalwork by unknown artist, thirteenth century. Metropolitan Museum of Art, New York, New York. A metalworker shaped this South Netherlandish reliquary into an arm with its hand signing a blessing. The bronze and silver work incorporated plaques of Saints Peter and Paul, who might have served as patrons of the reliquary's church. Because arm reliquaries held the remains of a saintly person, clergy used them to bless people and heal the sick.

RHIPIDION In Byzantium, a silver liturgical fan that symbolized four cherubim flying around God's throne. Clerics carried it on a long pole during solemn processions and liturgical services. Originally made of peacock feathers or parchment, the *rhipidion* fanned away insects from the sacramental bread and wine. **EXAMPLE**: *Gilt-Silver Rhipidion*, metalwork by unknown artist, fifteenth century. The Holy Monastery of Saint John the Theologian, Patmos, Greece. Metalworkers fashioned a superb rhipidion in gilt silver, with five repoussé plaques supporting seraphim images and a central plaque featuring symbols for the four Evangelists.

SANCTUS OR ALTAR BELLS Beginning in the thirteenth century, three bells rung during Mass, emphasizing solemn parts of the liturgy. This included singing the *Sanctus* hymn, a prayer of dedication, and consecrating the bread and wine. These junctures announced Christ's presence in the Eucharist service. **EXAMPLE**: *The Bellshrine of Saint Patrick*, metalwork by Cú Duilig Ua Hlnmhainen and his sons, twelfth century. National Museum of Ireland, Dublin, Ireland. Artisans created this gem-studded bellshrine—with metalwork influenced by the abstraction, birds, and spirals of migratory art—to house the bell of Saint Patrick. The saint actually used a small, simple bell: two

bent and riveted plates with a top handle. After his death in the sixth century, someone dipped the bell in copper and many believed it held miraculous powers. By the twelfth century Donall O'Loghlin, king of Ulster, commissioned the shrine to protect it as a sacred relic.

SITULA A bucket for holy water. Priests blessed and sprinkled this water on congregants during processionals. **EXAMPLE**: *Situla*, relief sculpture by unknown artist, ninth century. Metropolitan Museum of Art, New York, New York. Curators believe this bucket is the earliest surviving ivory situla. Divided into two horizontal registers, it features twelve scenes from Christ's life.

SPOON A serving utensil for the Eucharist bread and wine. In early Eastern traditions a priest mixed the bread and wine together, carefully serving it to partakers with a long-handled spoon. This avoided spilling the Blood of Christ (wine) or dropping the Body of Christ (bread) on the floor. **EXAMPLE**: *Silver Spoon with Crosses and the Greek Inscription "Petrus,"* metalwork by unknown artist, sixth century. Royal Ontario Museum, Toronto, Ontario, Canada. This liturgical silver and niello spoon served parishioners from a flat bowl connected to a long, sculpted handle. It probably belonged to a church treasury of valuable liturgical objects.

STRAINER A metal spoon with small holes in its shallow bowl to filter Eucharist wine. Celebrants strained the wine to remove impurities, especially those that might contaminate the bread, or Body of Christ. The handles varied in length, from short to long. **EXAMPLE**: *Liturgical Strainer*, metalwork by unknown artist, sixth century. Museum of the Middle Ages, Paris, France. Overall, artisans crafted this strainer in silver and niello, with garnets on the handle. The inscription attributed ownership to Saint Aubin, bishop of Angers, in the sixth century.

STRAW A long, thin tube for sipping Eucharist wine. Because many early medieval laity worked the land, they arrived for Communion with dirty hands. Consequently, Western clergy served the wine—the sacred Blood of Christ— with a straw to avoid contamination, spills, and other irreverences. **EXAMPLE**:

Chalice, Paten, and Straw, metalwork by unknown artist, thirteenth century. The Cloisters, Metropolitan Museum of Art, New York, New York. At eight and a half inches, this silver-gilded straw belonged to an ensemble of liturgical items for serving the Eucharist. Few straws survived through the ages.

T A B E R N A C L E A small cabinet designed to hold the consecrated bread or wafers for a Eucharist service. Tabernacles ranged from simple to extravagant, and through the centuries took various shapes, including a church, dove, pyx, or tower. They've been stored under the church altar, suspended above the altar, and in cabinets to the left or right of the altar. However, to serve the Eucharist, tabernacles rested on the altar. E X A M P L E : *Tabernacle* *from Cologne, Germany*, metal and ivory work by unknown artists, twelfth century. Victoria & Albert Museum, London, England. Once mistaken as a reliquary, the imagery and inscriptions on this remarkable container suggest its use as a portable tabernacle. An artist shaped the tabernacle as a miniature, domed cruciform church. He placed sixteen ivory prophets standing in arched niches and Christ with eleven apostles sitting around the dome.

31
Liturgical Books

Before the invention of mechanical printing, books were handmade objects,
treasured as works of art and as symbols of enduring knowledge.
Indeed, in the Middle Ages, the book becomes an attribute of God.

—THE METROPOLITAN MUSEUM OF ART

As Christianity spread, the apostle Paul emphasized the Scripture's importance to Christians. "All Scripture is God-breathed and is useful for teaching, rebuking, correcting, and training in righteousness," he wrote to his protégé, Timothy (2 Tim. 3:16). Paul believed God's Word equipped believers for every good work (2 Tim. 2:21). Taking the apostle's words seriously, Christians wanted to hear, read, and study these God-breathed words to guide not only their lives, but also future generations. Developing illuminated manuscripts of biblical texts fulfilled this desire.

Accordingly, scribes deemed manuscript making a sacred commission. In a sermon to the copyists at Durham Cathedral in England, a medieval bishop reflected this attitude. He told them, "You write with the pen of memory on the parchment of pure conscience, scraped by the knife of Divine fear, smoothed by the pumice of heavenly desires, and whitened by the chalk of holy thoughts. The ruler is the Will of God. The split nib is the joint love of God and our neighbor. Colored inks are heavenly grace. The exemplar is the life of Christ."

Owning a beautifully decorated Scripture manuscript brought dignity and prestige to a church, enhancing the sacred quality of its liturgy and community worship. Overall, the clergy and congregants believed these Bibles belonged to the titular saint of the church or monastery, to assure its attachment to a community and symbolize its longevity. Ordinarily, only the clergy handled an illuminated manuscript, but at times, the church displayed its pages during a holy day, allowing parishioners to admire the elaborate script, historiated (storytelling) capital letters, and brilliant illustrations. With its design and sacred value, an illuminated manuscript transported Christians from their ordinary lives into the glories of church history and their promised heavenly rewards and homes.

Christianity's illuminated manuscripts focused on the complete Bible or parts of it such as the Gospels, and books for public or private worship. However, after the invention of the printing press in the fifteenth century, illuminated manuscripts diminished. Cheaper and less labor-intensive liturgical books replaced them. The following list defines the major types of liturgical books from Byzantium and the Christian West through the sixteenth century.

ANTIPHONAL Also called an antiphonary, antiphoner, chorale book, or office book. A music book for directing the choir during sung portions of the Divine Office, particularly when two or more choirs chanted alternate verses. Illuminators created antiphonals large enough for choir members to read them from a distance. EXAMPLE: Antiphonary of Pope Leo X, illuminated manuscript by unknown artists, sixteenth century. Apostolic Library, Vatican City, Italy. A Medici pope, Leo X commissioned sumptuous choir books for worship in the Sistine Chapel at the Vatican. This antiphonal belonged to that endowment and earned a reputation as one of the most spectacularly decorated manuscripts of the collection—a visual feast in burnished gold and brilliant colors.

APOCALYPSE A vision of the final events on earth, a battle between good and evil. According to tradition, John the Evangelist wrote the Apocalypse or book of Revelation, but scholars debate this authorship. EXAMPLE: Beatus of Liébana's Commentary on the Apocalypse, illuminated manuscript by unknown artists and supervised by Grégoire de Montaner, tenth century. National Library of France, Paris, France. The monk Beatus wrote his end-times commentary in Spain during the late eighth century. Its widespread influence permeated illuminated manuscripts from the ninth through the thirteenth centuries. Approximately twenty copies exist today, but only this version traced to north of the Pyrenees, in the scriptorium of Saint-Sever Abbey in France. Monks filled it with almost a hundred bright images in a surprisingly modern-looking style.

BENEDICTIONAL A book of blessings that priests delivered during Mass, organized according to the liturgical year. Some artists created exquisitely decorated benedictionals for selected bishops. EXAMPLE: Benedictional of Saint Aethelwold, illuminated manuscript by the monk Godeman, tenth century. British Library, London, England. The bishop of Winchester helped lead the tenth-century monastic revival in England. During

that time, Aethelwold's chaplain masterminded this benedictional for the bishop's personal use. With its bold lines and lavish ornamentation, the British Library identified this benedictional from the Winchester School as a masterpiece of Anglo-Saxon manuscript painting.

BIBLE The Roman Catholic Church's official Bible divided into the Old Testament, the Apocrypha, and the New Testament. Later some Protestant denominations eliminated the Apocrypha. Because of size and expense, manuscript illuminators produced fewer full-text Bibles compared to editions of the Gospels and other Scripture portions. **EXAMPLE:** The Bury Bible, illuminated manuscript by Master Hugo, twelfth century. Corpus Christi College, Cambridge, England. Master Hugo created the Bury Bible in two huge volumes, but only the first one—through the book of Job—survived past the English Reformation. Based on Saint Jerome's Vulgate translation, this Bible opened with a letter from Jerome to a Brother Ambrose, explaining the significance of the Scriptures. Master Hugo and his artists drew many of the illuminations on separate parchment sheets and then pasted them into the manuscript. Originally, historians believed priests read from this great work at the high altar, but later a fifteenth-century register referred to it as a Refectory Bible. Consequently, it could have been read to monks and novices while they ate meals.

BOOK OF HOURS OR PRAYER BOOK Also a breviary, primer, or *horae*. A guide for religious houses and the laity to pray eight times a day. The prayer times included Matins at midnight; Lauds at 3 AM; Prime at sunrise; Terce at 9 AM; Sext at midday; Nones at 3 PM; Vespers or Evensong at dusk; and Compline, the last service, at 9 PM. The laity recited a simpler version than the monastics. **EXAMPLE:** Hours of Catherine of Cleves, illuminated manuscript by the Master of Catherine of Cleves, fifteenth century. Morgan Library, New York, New York. Many consider this prayer book one of the greatest Dutch illuminated manuscripts in the world, created by an outstanding original illuminator from the northern Netherlands. In the nineteenth century, someone pulled apart the original manuscript and reconstructed it in a confusing manner. The Morgan copy, complete with 158 miniature illuminations, presents the book in its original order. The Master of Catherine of Cleves painted the miniatures in amazing detail with none of the innovative borders looking alike.

EPISTOLARY OR EPISTLE A service book with readings from the New Testament's Epistles for Mass, arranged according to the liturgical year. EXAMPLE: Epistolary of the Sainte-Chapelle, illuminated manuscript by Jaquet Maci, fourteenth century. British Library, London, England. Used at the royal Holy Chapel in Paris, this epistolary formed a liturgical set with two other manuscripts: an evangeliary at the Library of the Arsenal, also in Paris, and a missal in the Municipal Library in Lyons, France. Brilliant miniature paintings illustrate key episodes from Scripture. Maci probably created the epistle for the church's treasurer, Simon de Braelle.

EVANGELIARY OR EVANGELISTARY Also called a lectionary or a pericope book. The Gospel readings for Mass, arranged according to the liturgical year. EXAMPLE: Godescalc Evangeliary, illuminated manuscript by Godescalc, eighth century. National Library of France, Paris, France. Godescalc wrote the evangeliary text in gold and silver on a background of purple, the color of royalty. He created the manuscript for Emperor Charlemagne.

GOSPELS OR GOSPEL BOOK A manuscript presenting the four Gospel books attributed to the Evangelists Matthew, Mark, Luke, and John. EXAMPLE: Lindisfarne Gospels, illuminated manuscript by the monk Eadfrith, eighth century. British Library, London, England. Eadfrith distinguished the opening of each Gospel book with a carpet page, an image of a cross embedded in a pattern resembling a rug. A miniature painting of each Evangelist as an author-scribe also introduced every Gospel.

GRADUAL A principal choir book for Mass, arranged according to the liturgical year. Its name derived from the practice of singing on the steps of a raised pulpit. EXAMPLE: Gradual from the Monastery of San Jacopo di Ripoli, illuminated manuscript by Giovanni Cimabue, fourteenth century. Saint Mark's Museum, Florence, Italy. Cimabue distinguished this gradual by painting its historiated (storytelling) capital letters at the beginning of sections. He filled the open spaces of capital letters with detailed biblical images, with their descending strokes trailing down the sides of pages.

HEXATEUCH The first five books of the Hebrew Bible or Christian Old Testament and the book of Joshua. This book added Joshua because the

Pentateuch, the first five books of the Old Testament, ended with God's promise to lead the Israelites into the Promised Land. The book of Joshua fulfilled that pledge. **EXAMPLE**: Old English Hexateuch from Canterbury, England, illuminated-manuscript team led by Aelfric, eleventh century. British Library, London, England. The British Library declared this book the oldest surviving biblical manuscript in Anglo-Saxon, or Old English, spoken until the Norman conquest of England. Illustrators created four hundred simple, colorful images unlike similar manuscripts of the time.

H O M I L I E S A book of short sermons on biblical passages—usually the Gospels—arranged according to the liturgical year. **EXAMPLE**: Homilies of James of Kokkinobaphos, illuminated manuscript by unknown artists, twelfth century. Apostolic Library, Vatican City, Italy. The illuminators painted several illustrations for each of the preaching monk's homilies in this manuscript for Irene, the daughter-in-law of Byzantine Emperor John II Comnenos.

L E C T I O N A R Y Lessons from the Old Testament, New Testament, Gospels, and the Epistles, read during Mass. **EXAMPLE**: Cluny Lectionary, illuminated manuscript by the Master of the Cluny Lectionary, twelfth century. National Library of France, Paris, France. The influential Cluny monastery from the Romanesque era housed many sacred manuscripts, including its lectionary. The delicate paintings reflected a dependence on Italian and Byzantine art styles favored by Abbot Hugh, the monastery's leader.

M E N O L O G I O N A calendar featuring a saint's life for each day of the year. **EXAMPLE**: Menologion of Basil II, illuminated manuscript by unknown artists, eleventh century. Apostolic Library, Vatican City, Italy. Created for the Byzantine Emperor Basil II, the menologion painters divided each page into half text and half illustration. They alternated the placement of images so they didn't rub against each other when someone closed the book. The manuscript commemorated one or more saints or church feasts for each day of the year.

M I N I A T U R E A small illuminated manuscript often for personal, devotional use. **EXAMPLE**: Hours of Jeanne d'Évreux, illuminated manuscript by Jean Pucelle, fourteenth century. The Cloisters, Metropolitan Museum of Art, New York, New York. A celebrated Parisian illuminator created this prayer book for Jeanne d'Évreux, Queen of France, to recite from each day. The manuscript

presented two cycles of prayers: one dedicated to the Virgin Mary and the other to the saint King Louis IX, Jeanne's great-grandfather. For a book only three and five-eighths inches high, the manuscript illuminator rendered the main images in grisaille (shades of gray) accented with delicate colors. He also filled the margins with seven hundred tiny illustrations.

M I S S A L A liturgical book with all the texts for a Mass. By the thirteenth century the missal replaced the antiphonary, evangeliary, epistolary, and sacramentary. **EXAMPLE:** Missal of Silos, illuminated manuscript by unknown artists, twelfth century. Monastery of Santo Domingo de Silos, near Burgos, Spain. This missal is the oldest paper manuscript from the Christian West. Islamic Spain probably supplied the paper for this text of the Mozarabic rite, a form of Mass sanctioned by Saint Isidore of Seville in the seventh century before Muslims invaded Hispania.

N E W T E S T A M E N T A compilation of biblical books created by early church writers, including the Gospels, Acts of the Apostles, Epistles, and the apocalyptic book of Revelation. **EXAMPLE:** *Tyndale's New Testament*, printed by Peter Schoeffer, sixteenth century. British Library, London, England. Only two complete copies of *Tyndale's New Testament* translation survived from the three thousand printed in Worms, Germany, during the sixteenth century. It was the first New Testament translated into English and considered heretical by the Roman Catholic Church. Henry VIII accused Tyndale of spreading sedition in England and burned the scholar at the stake. However, seventy-five years later an English translation became that country's sanctioned *King James Bible*.

O C T A T E U C H A Byzantine manuscript containing the first eight books of the Bible: Genesis, Exodus, Leviticus, Numbers, Deuteronomy, Joshua, Judges, and Ruth. **EXAMPLE:** Vatopedi Octateuch, illuminated manuscript by unknown artists, thirteenth century. Holy Monastery of Vatopedi, Mount Athos, Greece. The illustrated Vatopedi Octateuch only contains the books of Leviticus to Ruth, the second volume of the total work. It copied the text and many images from a twelfth-century Octateuch now at the Vatican and incorporated elements from the tenth-century Joshua Roll, a delicate parchment scroll. This indicates the illuminator studied carefully before producing the manuscript and then expressed his individuality. He also avoided the big waists, small hands and feet, and sweeping drapery usually employed during this era.

OLD TESTAMENT A compilation of thirty-nine books created by writers before Christ's time, but also adopted by Christians as part of their Bible. Illuminated manuscripts usually only contained a portion of the Old Testament, or the complete Bible with both the Old and New Testaments. EXAMPLE: The Vienna Genesis, illuminated manuscript by unknown artists, sixth century. Austrian National Library, Vienna, Austria. Made from purple-dyed parchment and probably produced in Syria, this book of Genesis is the oldest surviving, well-preserved, illustrated biblical manuscript. The illustrator relegated the paintings to the bottom of each page, drawn in a naturalistic style common to classical Roman art.

PENTATEUCH A collection of the first five books of the Old Testament, comprising Genesis, Exodus, Leviticus, Numbers, and Deuteronomy, written for Christians in Greek. These books formed the Torah in Jewish Scriptures, originally written in Hebrew. EXAMPLE: Duke of Sussex's German Pentateuch, illuminated manuscript by Hayyim, fourteenth century. British Library, London, England. The Sussex Pentateuch exemplifies the Southern German style of illumination, with contrasting colors, exaggerated faces and animals, and strange creatures in the margins. The manuscript acquired its name from the last owner before the British Library purchased it.

PSALTER A book containing the Book of Psalms from the Old Testament, used for prayer and worship. EXAMPLE: The Stuttgart Psalter, illuminated manuscript by unknown artists, ninth century. Württemberg Regional Library, Stuttgart, Germany. Produced in France, this psalter demonstrated the Carolingian miniscule, a script with unusual clarity and uniformity. Introduced in the eighth century at Charlemagne's Palace School in Aachen, Germany, the script rapidly became the style of his empire's manuscripts.

SACRAMENTARY A book containing the liturgy used to celebrate Mass. A priest used this book to conduct a service. EXAMPLE: Sacramentary of Gelasius, illuminated manuscript by unknown artists, eighth century. Apostolic Library, Vatican City, Italy. This book exists in several editions, but the Vatican owns the oldest, created in the eighth century. The earliest manuscripts didn't contain the Gelasius name and instead bore the title Book of Sacraments of the Church of Rome. Later, because of an ascription, tradition linked it to fifth-century Pope Gelasius I, granting the manuscript greater authority. The sacramentary relied on classical Roman and art styles of Britain and Ireland.

32
Vestments and Adornments

Vestments strikingly remind the participants at [the sacraments] that
they are wonderfully joined to all generations of past believers,
forming but one undivided family of faith which spans both time and space.

—SAINT ANN MELKITE CATHOLIC CHURCH

Before the Age of Constantine in the fourth century, Christian clergy wore street clothes. During times of peace, they probably dressed in their best Greco-Roman garments for celebrating the Eucharist, but nothing distinguished them from pagan fashion. However, by the fourth century Saint Jerome commented, "The Divine religion has one dress in the service of sacred things, another in ordinary intercourse and life." Somewhere in the interim, the clergy donned liturgical vestments.

In ancient Latin, *vestments* simply meant "clothing," especially outer robes. But on the backs of the clergy, vestments acquired a metaphorical capital *V*. The church mandated specific garments as sacred, worn by priests and others during sacramental ceremonies. When priests put on their vestments, most garments carried biblical symbolism and required a specific prayer. For example, when putting on the alb, a priest prayed, "Purify me, O Lord, from all stain, and cleanse my heart, that washed in the Blood of the Lamb I may enjoy eternal delights."

Eventually vestments and colors identified a clergyman's rank, with different garments for popes, bishops, priests, deacons, subdeacons, and the rest. However, in the sixteenth century, as part of the reforming revolt against the Roman Catholic Church, some Christians questioned the legitimacy of clerical vestments. Protestant clergymen radically simplified their garments, and in some cases, official vestments disappeared over time.

Museums house elaborate clerical vestments from the past, considering them works of art. The quality fabric, gold thread, precise stitching, and symbolic ornamentation earned this creative regard, astonishing art lovers around the world. These vestments also appeared in works of art when figures include the clergy. The following list covers selected liturgical garments and accessories worn by Western and Eastern early church, medieval, and Reformation people in service to God within the church. Many clergy still wear most of these vestments today.

ALB A full-length, white garment copied from first-century Romans. It symbolized purity. The roomy alb, made from linen, sported long sleeves and tied at the waist with a cincture. It is the oldest and most common liturgical garment, worn by the clergy and laity who serve the Eucharist. **EXAMPLE**: *Alb of Saint Bernulf,* pleatwork embroidery by unknown artist, twelfth century. State Museum, Utrecht, the Netherlands. Embroiderers distinguished Bernulf by decorating his alb with pleated linen gores (cloth segments) at the neck, wrists, and hemline.

ALMUCE OR AMESS Since the Middle Ages, a fur or fur-lined hood shielded prominent clergy from the cold. When placed on a cleric's head, the ends fell to the front like a stole. University dignitaries have also kept warm with this garment that eventually looked like a cape. **EXAMPLE**: *Coronation of Charles II the Bald, King of the West Franks, by Pope John VIII,* Mirror of History (Le Miroir historial), illuminated-manuscript page by Vincent de Beauvais, fifteenth century. Condé Art Gallery, Chantilly Château, Chantilly, France. According to this painting, the pope and at least two esteemed clergy wore almuces at the king's coronation.

AMICE A short, oblong- or square-shaped white cloth with an opening for the head. Clergymen have worn the amice since at least the eighth century. When putting on vestments, priests began with the amice, pulling it over the head and dropping it to cover the shoulders. Long, ribbon-like pieces dangled down the front of the amice and could be fastened around the shoulders. **EXAMPLE**: *Saint Nicholas and Scenes of His Life,* painting by unknown artist, seventeenth century. Saint John in Bragora Church, Venice, Italy. Keeping with reality, in this icon the iconographer showed an amice peeking out from under the saint's neck and other vestments.

BIRETTA A four-squared, tufted cap similar to the academic hat of the High Middle Ages and worn by many levels of clergy. At one time the church required priests to wear the

biretta when hearing and absolving sins. Wearing the biretta became optional in the twentieth century. **EXAMPLE:** *Pope Honorius III Approving the Order of Saint Dominic in 1216*, painting by Leandro da Ponte Bassano, sixteenth century. Saints John and Paul Basilica, Venice, Italy. At this significant meeting, birettas identified the hierarchal roles of clergymen. The solemn pope and cardinals wore red birettas; the celebratory monks left their heads uncovered.

BUSKINS Silk liturgical stockings, often woven with gold threads or embroidered. Originally, priestly celebrants of the Eucharist wore buskins. By the eighth century only bishops wore them. **EXAMPLE:** *Figurine of a Bishop*, sculpture by unknown artist, fourteenth century. The Department Museum of Antiquities, Rouen, France. In art, these priestly garments usually fell long enough to cover buskins, but this sculptor allowed a glimpse of the clerical stockings on a French bishop.

CAMAURO Beginning in the twelfth century, a skullcap worn by the pope in the winter to stave off cold. Vestment makers trimmed the red wool or velvet skullcap in ermine. Until the fifteenth century, cardinals also wore the camauro. The camauro for a pope fell out of fashion in the 1960s until Pope Benedict XVI wore one in 2005, prompting media comparisons to Father Christmas. **EXAMPLE:** *Pope Julius II*, painting by Titian (Tiziano Vecellio), fifteenth century. Pitti Palace, Florence, Italy. Compared to the contemporary camauro, the skullcaps of late medieval and Renaissance popes looked darker and more modestly trimmed with ermine. However, they carried the same ceremonial significance, worn exclusively by popes.

CAPPA MAGNA A long ceremonial robe with a silk or fur-lined hood and a sweeping train, worn by popes, cardinals, archbishops, bishops, and other dignitaries. In Latin, *cappa magna* meant "great cape," and the garment required a train bearer. The cappa magna represented authority and marked special occasions. **EXAMPLE:** *Dance of Death: Pope (Danse Macabre: Pope)*, painting by Bernt Notke, fifteenth century. Saint Nicholas Church, Art Museum of Estonia, Tallinn, Estonia. In this painting, Notke designated death as the great equalizer, even a medieval pope in his magnificent cape. The painting acted as a sermon on the transience of life.

CASSOCK In Western Christianity a full-length, close-fitting robe for priests, originating from the tunic worn under a Roman toga. Sometimes this black garment bore thirty-three buttons symbolizing the years of Christ's life. In Eastern Christianity the contemporary cassock fit loosely and took two forms: the inner cassock for daily wear and the outer cassock for outdoor warmth. The word *cassock* derived from the Middle French word for "long coat." **EXAMPLE**: *Portrait of Abbot Firmin Tournus Holding a Crucifix*, painting by Jean Restout, eighteenth century. Carnavalet Museum, Paris, France. Holding a crucifix against his chest, the abbot projected his submissive devotion to Christ. Although earlier versions of the cassock exist in paintings, this example clearly shows its close-fitting nature.

CHASUBLE A seamless cape and the last vestment priests put on before celebrating the Eucharist or Mass. The priestly chasuble descended from a first-century coat worn by male and female Romans. In ancient Latin *chasuble* meant "little house" and this aptly described its liturgical role: to cover other vestments. Often embroidered with a cross on the back, this loose-fitting garment with generous arm space varied in colors according to church seasons. Designers decorated the backs of chasubles more elaborately than the fronts, probably because during early church services and beyond, priests' backs faced the congregation. Although priests now face their congregations, they still wear chasubles with designed backs. **EXAMPLE**: *English Work (Opus Anglicanum)*, embroidery by unknown artist, fifteenth century. The Cloisters, Metropolitan Museum of Art, New York, New York. Medieval inventories categorized chasubles as *Opus Anglicanum* or "English work." Although the museum only owns a lower quadrant of this chasuble, the fragment superbly displays the intricate embroidery work of medieval and Renaissance chasubles. The designer included two cherubim, four fleurs-de-lis, four thistles, scrolls, and other designs in this portion of a magnificent work.

CHIMERE A long, loose vest. The sleeveless chimere first appeared in the fourteenth century as a vestment for Anglican priests. Not typically worn for the Eucharist service, priests donned the chimere as part of their choir dress, the clothing for public prayer except for the Eucharist. **EXAMPLE**: *William Laud, Archbishop of Canterbury*, painting by Sir Anthony van Dyck, seventeenth century. Lambeth Palace, London, England. For this formal pose Laud wore a chimere over a loose-fitting alb, the attire for many portraits of Canterbury archbishops.

CHOIR DRESS Clerical garments for public prayer, but not for serving the Eucharist. The garments could be a cassock or habit, a cotta (short surplice), and a biretta. However, choir dress differed among Roman Catholic, Protestant, and Orthodox clergy—and still does. **EXAMPLE:** *Miniature from Gratian's Decretum Showing a Bishop Preaching to a Congregation*, illuminated-manuscript page by the Second Master of the San Domenico Choir Books, fourteenth century. Fitzwilliam Museum, University of Cambridge, Cambridge, England. The illuminator painted clergy members wearing choir dress during the bishop's sermon. Evidently, these priests didn't serve the Eucharist that day.

CINCTURE A rope-like cord or broad sash worn with an alb. A cincture circled the waist or fit just above it. Depending on the Christian tradition, it was also called a girdle or fascia. The cincture has been accepted as a vestment since the ninth century. **EXAMPLE**: *Portrait of Pope Hadrian VI as a Priest*, painting by Francesco Ubertini Bacchiacca II, sixteenth century. Old Masters Picture Gallery, Kassel, Germany. For this painting, Hadrian wore a cincture that matched his black alb. The dark vestments help to set a brooding mood for the skull steadied by the priest's left hand, probably a reminder of life's transience.

COPE Among the most magnificent of the vestments, this cape formed a half circle. An ornamental collar changed according to the liturgical seasons and fell from the shoulders, decorating the back. Priests and popes wore the cope in processions and at solemn ceremonies. By the ninth century, the cope standardized as a garment for liturgical clergy. **EXAMPLE**: *Syon Cope*, embroidery by unknown artist from the Syon Abbey, Middlesex, England,

fourteenth century. Victoria & Albert Museum, London, England. The designer of this elaborate cope favored orphrey, an ornate form of embroidery practiced by the English. The original vestment (now with some images missing) encompassed four rows of quatrefoil-shaped sections with scenes from the lives of Christ, the apostles, and the Virgin Mary. Six-winged seraphim appeared between the sections.

D A L M A T I C A long, wide-sleeved tunic and the traditional vestment of deacons. The church introduced this garment to liturgical worship as early as the fourth century. **E XA M P L E :** *Saint Stephen in Glory*, painting by Giacomo Cavedone, seventeenth century. Estense Gallery and Museum, Modena, Italy. Cavedone painted Stephen, the first deacon of the church, wearing a colorful dalmatic in heaven. Byzantine iconographers painted Jesus wearing a dalmatic in icons of him as King and High Priest.

E P I G O N A T I O N OR *P A L I T Z A* Byzantine bishops first wore this square badge, hanging from the belt over the right thigh. It represented the towel of Christ when he washed the disciples' feet, or in some instances the Sword of the Spirit. In the Greek Orthodox tradition the *epigonation* indicated a high academic degree and the blessing to hear confessions. In the Russian tradition, it rewarded service. **E X A M P L E :** *Saint Gregory the Great*, painting by Master of Aphentico Church (Meister der Aphentico-Kirche), fourteenth century. Aphentico Church, Mistra, Greece. The iconographer accurately represented the great pope's vestments, including a gold epigonation embroidered with an icon of Christ.

E P I M A N I K I A Brocade cuffs worn by Byzantine bishops, priests, or deacons, patterned after those worn by emperors. Clerical *epimanikia* were added later than most of the Byzantine vestments developed in the sixth century. The cuffs laced to the wrists to contain the *sticharion*, a long liturgical garment with loose sleeves. **E X A M P L E :** *Liturgical Cuffs*, embroidery by unknown artist, twelfth century. Nizhny Novgorod State Art Museum, Novgorod, Russia. The oldest-known cuffs in Orthodoxy, these epimanikia

showcase images of Christ, the Virgin, and Saint John the Baptist, embroidered and outlined in pearls.

E P I T R A C H E L I O N OR *E P I T R A C H I L A* long, rectangular stole worn by Byzantine and Orthodox priests. In ancient Greek *epitrachelion* meant "around the neck" and represented the "yoke of Christ" and the divine grace through which the priest administered the sacraments. Usually made of embroidered brocade, the two sides of the epitrachelion were sewn together, leaving space for the priest's head to pass through. **E X A M P L E :** *Epitrachelion of Metropolitan Photios,* embroidery by unknown artist, fourteenth to fifteenth centuries. State Historical Museum, Moscow, Russia. On silk fabric with silver-gilt and colored thread, a textile worker embroidered a bust of Christ on the garment's neck, along with the Virgin and John the Baptist in intercession. The artisan also created eighty-eight roundels (circles) with busts of saints in each and sewed gold buttons along the middle of the stole, to fasten the two sides together.

G A U N T L E T S Elaborate liturgical gloves reserved only for high-ranking clergy. Gauntlets evolved from a simpler glove by adding a cuff. As vestments they became customary in the Western Roman Empire around the tenth century, but the French wore them somewhat earlier. Gauntlets probably developed to complete a vestment ensemble, rather than to protect the hands. **EXAMPLE:** *Pope Leo I,* painting by Francisco Herrera, sixteenth century. Prado Museum, Madrid, Spain. In this formal portrait, Herrera painted red gauntlets that nearly stole the focus from the pope's face because of their bright color.

G E N E V A G O W N A black, full-length gown worn by Protestant ministers of the Reformation, still in use today. This heavy "preaching gown" featured double-bell sleeves with cuffs and velvet panels running down the front. **E X A M P L E :** *Portrait of John Calvin, French Theologian and Reformer,* painting by unknown artist, seventeenth century. Society for the History of French Protestantism, Paris, France. For this portrait in Calvin's study, he wore the Geneva gown but covered it with a fur-lined robe. Calvin usually wore this vestment for his portraits.

H A B I T A plain garment worn by Western monks and nuns. They wore habits as early as the fourth century. Monks often wore a dark, loose tunic covered by a scapular with a cowled hood. Nuns frequently wore a black tunic with a headpiece called a coif. Different colors and types of habits indicated a person's level of profession or commitment. **E X A M P L E :** *Saint Anthony of Padua with a Nun*, painting by Gerard David, sixteenth century. Victoria & Albert Museum, London, England. David painted Saint Anthony with a habit and a tonsured (partially shaved) head, the style for monks of his day. The painter also posed Anthony with one of his saintly attributes, the infant Jesus seated on a book. This referred to his legendary vision of the Virgin and Child.

H O O D A head covering for monks, accompanied by a cowl around the neck. Roman and medieval men and women commonly wore hoods, and monks adopted them as part of their required garments. In the thirteenth and fourteenth centuries, monastic hoods ended in a peak that trailed down the back. By the end of the Middle Ages, hats grew more popular, but monastics never completely abandoned hoods. **E X A M P L E :** *Five Monks*, sculpture by unknown artist, fifteenth century. Victoria & Albert Museum, London, England. These five monks carved in wood probably belonged to an altarpiece and depicted commissioners of the work. The artist carved the men with typical hoods, revealing more of the cowls than the head coverings.

H U M E R A L V E I L A long piece of cloth draping over the shoulders and down the front of a clergyman. Some veils concealed inner pockets so clerics could handle holy vessels without touching them. **E X A M P L E :** *Stole with Images of the Martyrdom of Saint Catherine*, embroidery by unknown artist, thirteenth century. Metropolitan Museum of Art, New York, New York. The cult of Saint Catherine of Alexandria burgeoned in the Middle Ages, and this intricately embroidered veil memorialized her martyrdom. In three panels the embroiderer portrayed Catherine debating the pagan emperor Maxentius; the emperor torturing

Catherine on his spiked breaking wheel; and the emperor holding the saint's limp body. Later Maxentius ordered Catherine beheaded.

KAMILAVKA A stiff hat like a stovepipe but without a brim, worn by Byzantine clergy and monastics. Like other Byzantine vestments, the *kamilavka* patterned after headgear of the Eastern royal court. Some holy men attached a black veil to the hat, depending on their status. Monastics often wore the veil. Orthodox clergy and monks follow these guidelines today. **EXAMPLE**: *Portrait of Theofan Prokopovich*, painting by unknown artist, eighteenth century. Russian State Archive of Literature and Art, Moscow, Russia. As archbishop of Novgorod, Prokopovich implemented reforms for the Russian Orthodox Church. He posed for this official portrait in full liturgical garb, including a kamilavka with its veil descending down his back.

MANDYAS OR MANTLE A full cape worn over the outer garments of Byzantine and Orthodox monastics, except during a Eucharist service. In its early form, the mantle functioned as a garment to ward off cold, and several Old Testament prophets wore them. The *mandyas* attached at the neck and flowed to the floor. **EXAMPLE**: *Appearance of the Most Holy Theotokos to Saint Sergius of Radonezh*, painting by unknown artist, fourteenth century. Trinity Monastery of Saint Sergius, Sergiev Posad, Russia. For this icon, the iconographer painted Sergius of Radonezh encountering a vision of the Theotokos (Mother of God or Virgin Mary) and kneeling before her. His deep bow accentuated the long, flowing nature of his mandyas.

MANIPLE An embroidered silk band that celebrants originally held in one hand and later wore on the left arm during Mass. As early as the sixth century, the clergy used it for wiping their faces and hands. By the twelfth century the band indicated clerical rank, as it does today. **EXAMPLE**: *Maniple of Saint Cuthbert*, embroidery by unknown artist, ninth century. Durham Cathedral Library, County Durham, England. This maniple's superb

artistry indicated that in some locations, medieval embroiderers rivaled the talent of illuminated-manuscript artists. Manuscript illuminators might have been employed to mark designs, but even so, embroiderers applied their skills stitching fine, expensive threads with complicated, painstaking patterns.

MANTELLETTA A sleeveless, knee-length garment: open in front, fastened at the neck, and slit on the sides. First used in the fourteenth century for high-ranking clergy, today it's essentially a garment for the Roman diocese. **EXAMPLE**: *Monk Receiving the Dominican Habit*, illuminated-manuscript page by Pedro Berruguete, fifteenth century. Prado Museum, Madrid, Spain. In this image from the life of Saint Thomas Aquinas, the illuminator dressed the priest or monk to the right in a white mantelletta.

MITER OR MITRE The miter first appeared in images during the early eleventh century. In Western Christianity bishops or abbots wore this tall, ceremonial hat. A miter peaked at the top, with identical sides sewn together. Two lappets (flaps) hung down the back. In the fifteenth century, Eastern Christianity modeled its miter on the bulbous crown of Byzantine emperors. Through the centuries miters have ranged from simple, white caps to fanciful creations of embroidery and jewels. Bishops and abbots still wear them. **EXAMPLE**: *Mitre Belonging to William of Wykeham*, textile and gem work by unknown artists, fifteenth century. New College, University of Oxford, England. Artisans created a triangular miter for the bishop of Winchester with gold cloth, pearls, silver gilt, and imitation turquoise.

MORSE An ornamental clasp worn with the cope, designed to fasten the garment together at the neck. As early as the thirteenth century, the morse became more ornamental than practical, and this characterizes them today. Morses have varied widely in shape, style, and materials, including jewels, precious metals, and miniature paintings. **EXAMPLE**: *Abbot Johann von Ahrweiler and Saint Norbert*, stained-glass window by unknown artist, sixteenth century.

Victoria & Albert Museum, London, England. Artisans designed a stained-glass scene of the window's donor, Abbot Johann von Ahrweiler, and his patron saint, Norbert of Xanten. According to this image, the abbot knelt at a prayer desk with Norbert's hand on his shoulder. Norbert and the abbot both wore large morses to fasten their copes. Displaying unusual detail, artisans pieced together Norbert's morse with an image of Veronica holding the veil with Christ's face imprinted on it. The abbot's morse showed John the Baptist pointing to the Lamb of God.

MOZZETTA A short, elbow-length cape designed for the pope and high-ranking clergy. It covered the shoulders and buttoned over the chest. The mozzetta entered the Western clerical wardrobe in the late Middle Ages, but not for administering the sacraments. The mozzetta's color now varies according to the season and a clergyman's rank. **EXAMPLE**: *Saint Charles Borromeo*, painting by Bonifacio Veronese (Bonifazio de' Pitati), fifteenth century. Academy Gallery, Venice, Italy. The artist painted Borromeo wearing a mozzetta while earnestly praying. The cardinal placed the crosier on his lap, perhaps as a sign of submission to God's authority. Borromeo worked as a cardinal during the Counter-Reformation, implementing Catholic reforms and starting up seminaries for priests.

OMOPHORION The Byzantine version of a long band called the pallium in the West, but cut much wider and worn by bishops. While commonly worn in a *V* shape on the chest, the *omophorion* positioned higher, around the neck. In each case, a long strip hung down from the left shoulder. In the Orthodox Church today only metropolitan archbishops wear it. **EXAMPLE**: *Saint Cyril and Saint Gregory*, painting by unknown artist, Byzantine era. Chora Church, Istanbul, Turkey. In this fresco of Saints Cyril and Gregory, the artist illustrated how wearing the omophorion varied, with it wrapped close to the neck. In Byzantium, Cyril ruled as pope of Alexandria, Egypt, in the fifth century and Gregory served as pope of Rome, Italy in the sixth century.

PALLIUM In the Western church, a narrow band decorated with crosses and worn over the chasuble, used as early as the third or fourth century. In the past this band shaped into a *V* on the chest with one end of it hanging down on the left. Today it forms into a *Y*, with a long strip hanging down the middle of the body. It represents spiritual leaders carrying sheep from their Christian flock. Although worn by other clerics in the past, today only the pope uses the pallium. **EXAMPLE:** *Saint Peter*, relief sculpture by unknown artist, twelfth century. Victoria & Albert Museum, London, England. The artist sculpted Saint Peter with symbols of a bishop: the pallium and crosier for pastoral leadership and the miter for authority.

PECTORAL CROSS A large cross worn on the chest, hung from a chain or cord. Placed on top of vestment robes, it became customary in the Late Middle Ages. Some crosses also functioned as reliquaries to hold sacred relics. The pectoral cross still signifies a member of the clergy. **EXAMPLE:** *Pectoral Cross*, metalwork by unknown artist, seventeenth century. State Hermitage Museum, Saint Petersburg, Russia. The artisan shaped this gold and enamel cross into a reliquary, with the Crucifixion on its front side and a list of its relics on the back. Made in the Kremlin workshops, allegedly the cross once belonged to Patriarch Filaret (Feodor Nikitich Romanov), the Orthodox leader of Moscow and Russia.

RING OF THE FISHERMAN A signet ring worn by popes. This ring received its name because each pope succeeded Saint Peter, a fisherman by trade. Probably first cast in the thirteenth century and once used to stamp documents, the ring featured a relief of Peter fishing from a boat. Artisans cast a new ring for each pope, and church officials crushed it at his death. Today the pope only wears this ring ceremonially. **EXAMPLE:** *Portrait of Pope Paul III*, painting by Titian (Tiziano Vecellio), sixteenth century. State Hermitage Museum, Saint Petersburg, Russia. Titian painted the pope wearing a ring on his right hand, most likely the fisherman's.

R O C H E T A linen over-tunic with narrow sleeves, appearing as a bishop's choir dress in the ninth century. Today lace edges the knee-length Roman Catholic rochet at the shoulders, sleeves, and bottom. The Anglican rochet, worn since the Reformation, extends to the ankles and gathers at the wrists. **E X A M P L E :** *The Virgin and Child with Saint Carlo Borromeo*, painting by Francesco Trevisani, seventeenth century. Wellington Museum, London, England. Trevisani painted the Counter-Reformation cardinal in his rochet, kneeling before the Virgin Mary and the toddler Jesus. He added angels hovering above, forming a scene of adoration.

S A K K O S Lavishly embroidered, the Byzantine brocade *sakkos* sported three-quarter-length sleeves and slit sides. Beginning in the twelfth century, only patriarchs wore the sakkos, but after the fall of Constantinople in the fifteenth century, it also belonged to the vestment of bishops, worn to celebrate the Divine Liturgy and for a few other occasions. **E X A M P L E :** *Vatican Sakkos*, embroidery by unknown artist, fourteenth century. Vatican Treasury, Vatican City, Italy. For a long time, scholars misidentified this sakkos as the dalmatic of Charlemagne. Instead, Byzantine textile artisans created this astonishing sakkos. They organized the front into concentric circles surrounding Christ Emmanuel, the Four Evangelists, Mary the Mother of God, and others. On the back, they featured the Transfiguration of Christ with subsidiary scenes of Christ, Peter, James, and John.

S C A P U L A R A loose, sleeveless monastic garment reaching the ankles. The earliest reference to the scapular occurred in the seventh century, written in the Rules of Saint Benedict. The scapular began as an apron for monks and eventually joined the monastic habit. Today the scapular varies in color, shape, size, and style. **E X A M P L E :** *Pilgrim with a Monk*, painting by Master of the Triumph of Death, fourteenth century. Sinopie Museum, Camposanto, Pisa, Italy. The painter depicted a familiar pilgrimage scene: a kind and friendly monk wearing a scapular and holding the hand of a medieval pilgrim kneeling before him. Perhaps the monk blessed or encouraged the pilgrim to reach his destination and spiritual reward.

STICHARION A long, lightweight garment with loose sleeves, the undermost vestment worn by all levels of Eastern ministers, past and present. Modeled after the ancient Greek chiton, it also roughly resembles the alb for Western clerics. The *sticharion* symbolizes joy, purity, and tranquility. **EXAMPLE**: *Ecclesio, a Bishop of Ravenna*, mosaic by unknown artists, sixth century. Saint Apollinare in Classe Basilica, Ravenna, Italy. The mosaicist presented the bishop in a sticharion with black stripes around the wrists and hemline. Worn as an undergarment, the sticharion showed enough to form a complete vestment with an outer tunic and an omophorion.

STOLE A long, narrow strip of cloth hung from the neck, worn by Western priests and ministers during the Eucharist. The Roman Church adopted it in the seventh century, and several symbolic meanings emerged over time, including the towel Jesus used to wash the disciples' feet or the fetters binding him during the Passion. The stole varied in color according to the Christian feasts not associated with martyrdom. **EXAMPLE**: *Saint Nicholas of Bari*, painting by Mattia Preti, seventeenth century. Fine Arts Museum, Rouen, France. In this pleading image, Preti painted the fourth-century Nicholas looking up and his hand open, as if questioning God. The artist also presented the saint in full liturgical garb, wearing a white stole with crosses and crucifixion scenes painted on it.

SURPLICE A white linen or cotton tunic with wide or moderately wide sleeves. The garment reached the knees or ankles, depending on tradition. Documents mentioning the surplice date back to the eleventh century, and its length gradually shortened through the centuries. Western clergy still wear the surplice. **EXAMPLE**: *Emmanuel-Theodose de la Tour d'Auvergne, Cardinal of Bouillon*, painting by Giovanni Battista Gaulli, seventeenth century. Versailles Chateau, Versailles, France. The young cardinal wore a surplice for this formal portrait, but also held other garments designating his rank, such as the red zucchetto.

TIARA A two- or three-tiered crown with a cross on the top, created in the seventh century and worn by the pope as a symbol of his authority. He donned this nonliturgical adornment for ceremonies. Pope Paul VI set aside his tiara after the Second Vatican Council in the 1960s, with no pope wearing it since then. **EXAMPLE:** *Pope Innocent V*, painting by Fra Angelico, fifteenth century. Saint Mark's Museum, Florence, Italy. For this fresco portrait, Pope Innocent wore signs of his authority: a tiara, a pallium, and representational keys to the kingdom of heaven (Mt. 16:19). The pope also raised his right hand in blessing, reminiscent of Christ's pose as Pantokrator ("ruler" and "all-powerful") in Byzantine icons.

TONSURE The shaved top of a monk's or priest's head as a sign of dedication to God and probably renunciation of worldly fashion. Although the tonsure's origin remains unclear, holy men wore it by the seventh or eighth century. Some Western and Eastern monastics still practice tonsuring. **EXAMPLE:** *Portrait of a Monk*, painting by unknown artist, fifteenth century. Ingres Museum, Montauban, France. This monk's tonsure almost looked like male pattern baldness. An extreme theory about medieval tonsure suggested older, balding monks required younger ones to shave their heads. In this way, older monks exercised power over their subordinates.

VEIL A headdress worn by Western nuns, framing the face and covering the shoulders. The veil belonged to ancient cultures long before Christ, and nuns wore them as early as the third and fourth centuries. Veils varied in length and color, depending on the religious order and vows. Not all nuns wear veils today. **EXAMPLE:** *Bust of a Nun*, sculpture by Niccolò dell'Arca, fifteenth century. Estense Gallery and Museum, Modena, Italy. The sculptor represented a medieval nun wearing a long veil to indicate her status as a bride of Christ. In addition to the veil, the nun's downcast eyes and hand on her heart communicated submission.

W I M P L E A cloth worn by medieval women and adopted by nuns, covering the head, neck, and chin. It's not universally worn today. **E X A M P L E :** *The Boppard Altarpiece*, painting by unknown artist, sixteenth century. Victoria & Albert Museum, London, England. In this wood altarpiece, the left wing depicted Saint Christopher and the right wing memorialized Saint Mary Magdalene dressed in sixteenth-century clothes, wearing a wimple and holding a pear. A pear often symbolized Christ's love for humanity.

Z U C C H E T T O A skull cap worn by Roman Catholic and some Anglican clerics. Its original use was practical: to keep the head warm, especially a tonsured scalp. In Latin it meant "small gourd." The zucchetto has survived as a traditional article of clothing. The color depends on the clergyman's rank. For example, the pope wears white and cardinals wear red or scarlet. **E X A M P L E :** *Louis-Antoine de Noailles, Archbishop of Paris*, painting by unknown artist, eighteenth century. Versailles Château, Versailles, France. Louis-Antoine de Noailles wore his red zucchetto far back on his head, focusing attention on his long hair.

NOTES AND INDICES

QUESTIONS TO ASK ABOUT SACRED ART

Artists created Christian works according to strict standards, so looking at their art centuries later can feel puzzling or profound. It depends on how much information you gather and how the works affect you. You can use some or all of these questions to analyze an artist's approach, a work's meaning, and your response to it.

1. What is the work's title? What insight does it lend to the content?
2. Who was the artist? Do you know anything about this person? If so, what? How might his or her life and other art affect this work?
3. When did the artist create the work? If you know anything about this time period or art era, how did it influence the artist and his or her art?
4. What materials did the artist use to create this work? What did these materials contribute to its overall presence?
5. How would you describe the artist's style? Why might he or she have chosen it?
6. How did composition, color, line, shading, perspective, and other artistic elements or techniques contribute to the overall work?
7. What was the purpose of this work? If you don't know, what would you guess it to be?
8. Did a patron commission this work? How might this have affected the outcome?
9. If figures appear in the work, who are they? What do you know about them? Or how could you learn about them? Why were these figures meaningful to Christians?
10. What was the setting for the figures? What did this location contribute to the work?
11. What symbolism exists in the work? What did it mean to Christians of this era?
12. Was this work based on a biblical story or passage? If so, what was it? Why was it significant?
13. Can you discern a lesson or message in the work of art? If so, what is it?
14. How does this image qualify as Christian art?
15. What is your opinion of the work? Do you like it? Why, or why not?

LOOKING FOR IMAGES ONLINE

You can find most of the images mentioned in this book online. The following art websites can help you locate them. To find an image, enter a title or an artist in the website's search box. This can lead you to the image. As an alternative, you can find a well-known image by simply typing the title and/or artist's name into your browser.

Some of the websites below serve as resources for purchasing permission to reprint images. However, you don't need to buy reprint rights to view the art. The author found many of this book's images online through Bridgeman Art, Culture, and History Images. These websites are current as of December 15, 2011.

About.com: Art History. http://arthistory.about.com
Artcyclopedia. http://www.artcyclopedia.com/index.html
Art History Resources. http://wwar.com/artists
Art History Resources on the Web. http://witcombe.sbc.edu/ARTHLinks.html
Art Images for College Teaching. http://www.arthist.umn.edu/aict/html
Bridgeman Art, Culture, and History Images. http://www.bridgemanart.com
D'Art Internet Database. http://dart.fine-art.com
Digital Librarian: Art. http://www.digital-librarian.com/art.html
Index of Christian Art. http://ica.princeton.edu
Olga's Gallery. http://www.abcgallery.com
Oxford Art Online. Includes Grove Art Online. http://www.oxfordartonline.com
Scholar's Resource. http://www.scholarsresource.com
Smart History. http://smarthistory.org
The Mother of All Art and Art History Links Pages. http://www.umich.edu/~motherha
Web Gallery of Art. http://www.wga.hu
Web Museum. http://www.ibiblio.org/wm
Zeroland. http://www.zeroland.co.nz/art_history.html

GALLERIES, LIBRARIES, AND MUSEUMS

If you're interested in viewing Christian art online or in person, these major galleries, libraries, and museums house collections of sacred art. Many of them host websites that post images from their permanent collections or special exhibitions. The countries that don't use English as a first language often provide English versions of their websites. If you pull up a website that isn't in English, look for a page link to the English version. Or check if Google offers a button for translation. If you're looking for a specific work of art, enter the name or artist in the website's search box.

If a name on this list doesn't host an English website, or you want to learn more, check the library or a bookseller for a text or exhibit catalog from the organization. If a local library doesn't carry the book or catalog, research online through WorldCat.org to discover if one exists. This online catalog allows you to borrow books from libraries around the world. If you want to purchase a book, consult your favorite local or online bookseller.

Of course, many worldwide museums and organizations exhibit Christian art, not just the ones listed below. The following list derives from art examples in this book. However, not all exhibitors mentioned in the text appear in this list. These websites are current as of December 15, 2011.

Academy Gallery. Florence, Italy. http://www.sbas.firenze.it/accademia
Art Institute of Chicago. Chicago, Illinois. http://www.artic.edu
Art Museum of Catalonia. Barcelona, Spain. http://www.mnac.cat
Ashmolean Museum. University of Oxford, Oxford, England. http://www.ashmolean.org
Austrian National Library. Vienna, Austria. http://www.onb.ac.at
Berlin State Museum. Gemäldegalerie, Berlin, Germany.
 http://www.smb.museum/smb/home/index.php
Brera Art Gallery. Milan, Italy. http://www.brera.beniculturali.it
British Library. London, England. http://www.bl.uk
British Museum. London, England. http://www.thebritishmuseum.ac.uk
Brooklyn Museum of Art. New York, New York. http://www.brooklynmuseum.org
Carnegie Museum of Art. Pittsburgh, Pennsylvania. http://www.cmoa.org
Cleveland Museum of Art. Cleveland, Ohio. http://www.clemusart.com
Cloisters, The. Metropolitan Museum of Art. New York, New York.
 http://www.metmuseum.org
Condé Art Gallery, Chantilly, France. http://www.chateaudechantilly.com/fr
Coptic Museum. Cairo, Egypt. http://www.coptic-cairo.com/museum/about/about.html

Detroit Institute of Arts. Detroit, Michigan. http://www.dia.org

Dumbarton Oaks Research Library. Washington, DC. http://www.doaks.org/library

Fitzwilliam Museum. University of Cambridge, Cambridge, England.
http://www.fitzmuseum.cam.ac.uk

Florence Cathedral Museum. Florence, Italy. http://www.operaduomo.firenze.it

Freer Gallery of Art, Washington, DC. http://www.asia.si.edu

Germanic National Museum. Nuremberg, Germany. http://www.gnm.de

Getty Museum. Los Angeles, California. http://www.getty.edu/museum

Isabella Stewart Gardner Museum. Boston, Massachusetts.
http://www.gardnermuseum.org

Israel Antiquities Authority. Jerusalem, Israel. http://www.antiquities.org.il

Israel Museum. Jerusalem, Israel. http://www.english.imjnet.org.il

Louvre. Paris, France. http://www.louvre.fr

Metropolitan Museum of Art. New York, New York. http://www.metmuseum.org

Morgan Library. New York, New York. http://www.themorgan.org

Museum of Byzantine Culture. Thessaloniki, Greece. http://www.mbp.gr

Museum of Fine Arts. Boston, Massachusetts. http://www.mfa.org

Museum of Fine Arts. Vienna, Austria. http://www.khm.at

Museum of the Middle Ages. Paris, France. http://www.musee-moyenage.fr

National Gallery. London, England. http://www.nationalgallery.org.uk

National Gallery of Art. Washington, DC. http://www.nga.gov

National Library of France. Paris, France. http://www.bnf.fr

National Museum. Bonn, Germany. http://www.rlmb.lvr.de

National Museum of Ireland. Dublin, Ireland. http://www.museum.ie

Prado Museum. Madrid, Spain. http://www.spanisharts.com/prado

Pushkin State Museum of Fine Arts. Moscow, Russia. http://www.museum.ru/gmi

Royal Ontario Museum. Toronto, Ontario, Canada. http://www.rom.on.ca

State Historical Museum. Moscow, Russia. http://www.shm.ru

State Hermitage Museum. Saint Petersburg, Russia. http://www.hermitage.ru

Berlin State Museum. Gemäldegalerie, Berlin, Germany.
http://www.smb.museum/smb/home/index.php

State Tretyakov Gallery. Moscow, Russia. http://www.tretyakovgallery.ru

Trinity College Library. Dublin, Ireland. http://www.tcd.ie/Library

Uffizi Gallery. Florence, Italy. http://www.uffizi.firenze.it

Vatican Museums. Vatican City, Italy. http://www.vatican.va/museums

Victoria & Albert Museum. London, England. http://www.vam.ac.uk

GLOSSARY OF ART TERMS

These pages present terms frequently used in Christian art, in addition to definitions presented in this book's chapters.

abstract, abstraction Art that doesn't represent observable objects, or it changes recognizable forms into stylized images.

allegory, allegorical A story or image that represents an idea or principle, usually moral or religious in nature.

altarpiece Also called a retable or reredos. A painted or sculptured panel positioned behind and above an altar. An altarpiece divides into two or more panels for church or home worship. Called a diptych for two panels; a triptych for three panels; and a polyptych for more than three panels. A decorated base or *predella* can support an altarpiece.

Anachtsbilder (German) A devotional image; often a painting or sculpture.

animal interlace A decorative pattern with interwoven creatures, often found in Celtic art.

applied cover Decorated plaques, often in ivory or metalwork, attached to the boards covering an illuminated manuscript.

architectural sculpture A carving on a wall or other part of a building's interior or exterior.

armature A skeletal framework of wire, wood, or other material supporting the clay, plaster, or other soft substance an artist shapes to create a sculpture. The sculptor models the material, adding it in stages. The iron rods for lost-wax casting also serve as an armature.

arriccio (Italian) In fresco painting, a thick, rough undercoat of plaster applied to the wall before transferring the *sinopia* (drawing) to the wall. A base coat; a preparatory step.

articulated A work of art divided into units.

background The part of a composition, usually in a painting, that represents figures and objects appearing farthest away from the viewer. Also, the area behind figures and objects in a composition.

bas-de-page (French) An illuminated manuscript term meaning "at the bottom of the page." It indicates images appearing below the text of a manuscript page.

base Any support, but usually the masonry beneath a column or sculpture.

binding The sewing and covering of an illuminated manuscript. A binder gathers pages called quires into groups, sews them together, and attaches them to a cover.

biomorphic Images that suggest shapes found in nature.

bronze An alloy of copper and tin used for casting sculpture. Typically, molten bronze pours into a mold.

brushstroke The movement of a brush, dabbed or filled with paint, across a surface.

bust A sculpture of a person featuring the head and neck, plus part of the shoulders and chest. A bust sometimes mounts on a base or a column.

calligraphy An ornate form of handwriting, especially featured in illuminated manuscripts.

came A lead strip that holds the glass together in a stained-glass window.

canon table A concordance created in the fourth century by Eusebius of Caesarea in the form of tables set in column pillars. Canon tables usually appear in the front of a biblical book and show how Gospel passages correspond with one another.

canvas In Renaissance art, a flax or hemp textile that's easily cut, handled, stored, and transported.

carpet page An ornamented page, opposite the beginning of a Gospel book in an illuminated manuscript. It resembles a rug and appears in Celtic and Insular manuscripts.

cartoon A preliminary drawing or pattern that outlines images for an icon, painting, tapestry, or other work of art.

carve Cutting or incising into a hard surface to create a shape or figure.

carving To carve, as in the previous entry. Carving is a subtractive process, removing substance bit by bit. Also, the name for a carved sculpture.

casting When a sculptor pours liquid into a mold. The liquid hardens and creates a solid or hollow sculpture.

catacomb An underground cemetery with tunnels and recesses for coffins and tombs.

cell A compartment in cloisonné enamel to be filled with glass.

ceramics A general term for wares created from fired clay.

chamfer (French) To cut at an angle.

champlevé (French) A technique that fuses colored enamel into the grooves of a metal base.

charger A large dish or plate.

chasing Ornamentation created on metal by incising or hammering on its surface.

chasse (French), **casket** A box reliquary, sometimes shaped like a house.

chiaroscuro (Italian) Gradations of light and dark in a picture, with forms shaped by the light and dark areas meeting together and suggesting a three-dimensional form.

chevron A decorative pattern in the shape of an upside-down letter *V*, often incorporated into heraldry designs.

choir screen In a church, a decorated screen between the choir and the nave, separating the clergy from the congregation. Also called a rood screen in England when it supports a cross, and an iconostasis in a Byzantine or Orthodox church because icons hang on it.

chrysography Writing inscriptions or drawing fine lines in gold.

clay An earth-based substance that hardens when baked or fired. A sculptor shapes wet clay into a form before hardening it.

cloisonné (French) An enamel technique that affixes metal wire strips to a surface and fills the in-between spaces with colored glass.

codex A manuscript in book form, instead of a scroll.

colophon The last page of a manuscript, where some scribes and illustrators signed and dated their work.

composition The arrangement of figures or objects in a painting or other work of art.

contrapposto (Italian) A sculpted figure portraying motion or tension by standing with the arms and shoulders slightly twisted in one direction and the hips and legs in the opposite direction. A weight-bearing leg supported most of the figure.

copying Reproducing an icon or other work of art that already exists.

cord The band onto which an artist sews pages into the spine of an illuminated manuscript.

couching An embroidery technique that tacks down threads on a material's surface with overlapping threads from the back.

cubiculum A chamber room for burials in a catacomb, a Roman cemetery.

curvilinear Characterized by curved lines.

cusp The point where two projected curves or foils meet.

diptych Two panels with carvings or paintings of the same size, hinged together and used as a portable altarpiece or icon.

direct method In mosaics, gluing *tesserae* (small glass pieces) directly on a supporting surface.

drapery Loosely woven linen soaked in glue and smoothed over an icon panel. In painting, sculpture, or textiles, the folds of cloth.

drolleries (French) Spontaneous and sometimes humorous marginal decorations in illuminated manuscripts.

earthenware An opaque ceramic ware made of humble clays and fired at low temperatures. It remains porous after firing, unless the artist glazes it.

egg tempera A medium for painting icons: a combination of egg yolk, vinegar, water, and powdered pigment.

emblema or *emblemata* (Italian) An elaborate motif on a mosaic floor, usually made from *tessarae* (small glass pieces) of marble and semiprecious stones.

embroidery Decorative needlework that creates a design with thread on fabric.

enamel Colored glass in powder form, fused to a metal surface and polished.

encaustic A medium for painting an icon, combining wax and vegetal (made from plants or vegetables) pigments to produce brilliant colors.

engraving A hard surface with incised designs or letters.

endpapers Two or more plain or decorated pages at the front and end of an illuminated manuscript, attached to the cover boards.

explicit A visual identifier signaling the end of a text section in an illuminated manuscript.

fibula An ornamental metal brooch resembling a safety pin, worn by the ancient Celts and other migratory tribes.

figurative A sketch, painting, or sculpture of a realistic or stylized human, animal, or mythical creature.

filigree Ornamentation created from fine, twisted wire, resembling lacework.

firing Heating a clay mold or sculpture with fire to harden it.

foil A thin sheet of metal employed as backing for enamel or garnets.

folded icon A portable icon that folds into panels. Called a diptych for two panels; a triptych for three panels; and a polyptych for more than three panels.

folio A leaf (page) in a manuscript.

foreground Part of a composition that represents figures and objects appearing closest to the viewer.

foreshortening The illusion that figures and objects on a flat surface recede or project into space.

fresco (Italian) A mural painting technique applying water-based pigments to plastered walls. *Buon fresco* paints on wet plaster. *Fresco secco* paints on dry plaster.

frontispiece The first page, title page, or illustration in a book or illuminated manuscript.

genre A type of artistic form, style, medium, or technique.

gesso A mineral powder mixed with glue and used as a primer for panel painting with tempera.

gilding Applying a thin layer of gold to parts of an icon or metalwork.

giornata (Italian) The section of a *buon fresco* (wet plaster painting) mural that could be plastered and painted in one day.

gisant (Italian) On a tomb, an effigy of the deceased person.

glaze or glazing A layer of glassy material that, when fired in a kiln, preserves a decoration and makes ceramics waterproof.

gloss Commentary on a text. Also, a clay slip applied to pottery. When fired, it produces a shiny surface.

gold leaf Thin sheets of gold applied to *tesserae* (small glass pieces), creating brilliance and shimmer in a mosaic composition.

gouache A painting created mostly with opaque watercolors.

grisaille A monochromatic style of drawing or painting in shades of gray.

grotesque Odd or unnatural in shape and appearance. Also, a decorative element combining bizarre human and animal forms.

ground The main surface of a painting, such as a canvas or panel. In mosaics, a smooth surface for applying the *tessarae* (small glass pieces).

grout In mosaics, cement-based filler applied in the interstices (spaces) between *tesserae* (small glass pieces). Grout adds strength and durability by locking the *tesserae* together.

guilloche (French) An interwoven pattern that looks like rope, used as a border in mosaics.

hieratic scale Increasing a figure's size to make a holy or important person larger than others in an image.

historiated initial letter A small scene painted in a large initial letter, marking the beginning of a section in a manuscript.

hue Another name for color.

icon A small panel painting of Christ, the Mother of God (Mary), a sacred or biblical event, or one or more saints revered by Byzantine and Orthodox Christians. Artists create icons with embroidery, ivory, marble, metal, mosaics, parchment, and wood.

iconographer A person who creates icons.

iconography The study of symbolic subject matter, including the interpretation of attributes, compositions, costumes, gestures, settings, signs, and symbols.

idealization When artists attempt to create perfect forms and figures, based on a culture's values.

illumination A painting on paper or parchment that illustrates the text of a manuscript. Also, the technique of decorating manuscripts.

impasto A thick application of pigment to create texture on a painted surface.

incipit (Latin) The opening words of a text, usually marked with a visual identifier.

incipit page The opening page of a manuscript, decorated with a large, ornamental initial and elaborate script.

incising Cutting a design or inscription into a hard surface with a sharp instrument.

indirect method In mosaics, *tesserae* (small glass pieces) designed on a portable surface and later transferred to the supporting surface.

initial or initial capital The first letter of a text, enlarged and decorated.

ink A liquid made of gall and gum, used for drawing, ruling, and writing on paper and parchment.

inlay To set pieces of material into a surface, creating a design or pattern.

intaglio A design cut into a surface that can be engraved.

interstice For mosaics, the space between *tesserae* (small glass pieces) filled with grout.

intonaco (Italian) A thin coat of plaster applied over the *sinopia* (drawing) before fresco painting begins. This step seals the drawing between two coats of plaster.

kiln An oven for firing clay in the ceramic-making process.

knop A decorative knob on a candlestick or chalice.

lappet A flowing ribbon extending from a figure's lip or back of the head.

lost-wax casting Also called *cire perdue* in French. A traditional method for reproducing a sculpture in metal, especially bronze. For a solid sculpture, the sculptor models the figure in wax surrounded by a clay cast. During firing the wax melts away and then the sculptor pours metal into the remaining mold. After the metal hardens, the sculptor breaks the cast to release the sculpture.

luster, lusterware A shiny surface on ceramics, created by adding metallic glazes and firing them at low temperatures. Also, the shiny ceramic ware itself.

manuscript A book or document written by hand, usually with calligraphy.

marble One of the hardest stones to carve and among the most prized and expensive for sculpting. Made of crystallized limestone, often with streaks, it polishes to a high shine.

marginalia Planned or spontaneous words, comments, diagrams, doodles, notes, illustrations, and visual jokes in the margins of a manuscript.

marquetry Inlaid thin pieces of ivory, wood, or mother-of-pearl.

matte A smooth surface without shine.

medallion A round decoration or ornament.

medium The material for creating a work of art.

Memento mori (Latin) A warning that means, "Remember you must die." In an image, a skull or extinguished candle represents this concept.

metalwork Creating art from metal, especially iron, gold, or silver. A chemical element, metal can be hammered, stretched, and welded.

middle ground The area in the middle of a composition.

mille-fleurs (French) A textile term that means "a thousand flowers." A repeated pattern of flowers in a tapestry design.

millifiori (Italian) An enameling term for "a thousand flowers." Enamel patterns created by fusing rods of colored glass together and slicing off thin sections.

miniature Any small work of art, including icons, manuscripts, and portraits. Miniature icons and portraits can be worn as jewelry.

minuscule A lowercase letter of an alphabet.

modeling In painting, applying shades of color to create depth, suggesting a three-dimensional shape. In sculpture, creating three-dimensional forms by working with a soft material. An additive process, modeling builds the material bit by bit.

mold A hollow container used for casting sculpture. A sculptor places the medium within the mold and lets it harden into the container's shape. Usually the artist destroys the mold to reach the solidified sculpture.

monogram A combination of letters to represent a name or idea.

monumental A large-scale sculpture.

mordant In icon painting, a fixative that attaches gold leaf to a panel. In textiles, mordant infuses thread or fabric with color.

mosaic A decorative design created by placing colored pieces of glass, stone, or tile (*tessarae*) into a surface.

mural A large painting for a wall, applied directly. Or painted on a canvas or wood panel and then attached to the surface.

narrative A painting or other work of art that tells a story.

naturalism, naturalistic An art style that imitates the appearance of nature and the visible world.

niello A decoration created by incising metal, filling the design with sulphur alloy, and heating it up to create a dark pattern.

nonrepresentational Art that doesn't seek to represent figures, objects, or scenes in the real world.

oil painting Painting with pigments mixed with drying oils, such as linseed, poppyseed, and walnut.

Opus Anglicanum (Latin) A textile term that means "English work." Elaborate embroidery or needlework created for liturgical vestments in Gothic England.

ossuary A stone chest storing human bones, used in ancient Jewish, Roman, and early Christian cultures.

overpainting The final application of paint when an artist creates multiple layers. Also, painting on top of damage or a mistake.

paint A liquid or soft-colored medium applied with a brush or other utensil to create an image on a surface.

painting Creating two-dimensional images by applying paint to a surface.

panel A flat piece of wood for painting. Artists attach panels together to create larger works. When hinged together, the work becomes a diptych for two panels; a triptych for three panels; and a polyptych for more than three panels.

parchment An animal skin, such as sheep or goat, used for a painting or writing surface, especially for illuminated manuscripts. Parchment also includes vellum, made from calfskin and superior in quality.

patina A film or crust that covers a bronze sculpture due to weathering. The copper in the bronze oxidizes to create a green color and protects the sculpture from more erosion.

pedestal A sculpture's foundation or support.

perspective The appearance of a three-dimensional object on a two-dimensional surface, a painting technique not commonly used until the Renaissance.

picture plane The extreme foreground of a picture, the point of visual contact between an image and its viewer.

picture stone A medieval memorial stone decorated with figures, from Northern Europe.

pietà (Italian) Translates as "pity." A grieving Virgin Mary, seated, with the dead body of Christ in her lap.

pietra dura (Italian) A jewelry or sculpting term for "hand stone." Colorful semi-precious stones cut into shapes to form designs such as flowers and fruit.

pigment A powder combined with a liquid or substance to create colored paints.

plaster A mixture of lime or gypsum, sand, and water. It hardens into a smooth paste for coating walls and ceilings.

plinth A block of material between the sculpture and its pedestal. Or a base upon which an artist mounts a sculpture.

polychromy Painting colors on architecture or sculpture.

polyptych An altarpiece or icon constructed from three or more panels, hinged together.

porcelain A white ceramic fired at a high temperature and rendered translucent.

portrait A sculpted image of only the head and possibly the neck. Or a drawing or painting of a person or a group, usually facing the viewer.

potsherd A broken piece of pottery.

pottery Objects and vessels created from clay, hardened by firing, and often glazed. An artist shapes the clay by hand or with a potter's wheel.

predella (Italian) A carved or painted base of an altarpiece, which means "kneeling-stool."

processional icon Icon panels of fabric or wood carried during a church or celebratory processional, often with an image on each side.

putto (Italian) A small, winged angel. Often mistakenly called a cherub. Plural: *putti.*

quatrefoil A decorative pattern identified by four lobes.

quire A section of printed leaves or pages, folded and prepared for binding into the cover of an illuminated manuscript.

realism or realistic The depiction of real-life objects, people, shapes, or events. Painting and sculpting objects as they appear to the eye, without change. Also called objective or representational art.

recto The right side of two facing pages in an illuminated manuscript.

register Horizontal spaces or layers that separate a work into divisions.

relic A sacred object or human preserved for posterity, ranging from a particle to the entire piece.

relief Sculpture that protrudes from its surface or background, as opposed to sculpture in the round. Low relief projects slightly, never detaching from its background. High relief projects at least half of its circumference from the background.

reliquary A container that holds a relic, often elaborately decorated.

repoussé (French) A method of hammering a sheet of metal from the back side to create a protruding image on the front side.

rhyton A vessel shaped like a figure or animal, used for pouring liquids on special occasions.

riza (Russian) An icon covered in thin silver or other metal, with cutouts for the important, interpretive parts of the painting, particularly the face and hands.

rosette A round or oval embellishment resembling a rose.

roundel A circular shape with a decoration inside it.

sarcophagus A stone coffin, often with relief carvings that represent the deceased person's life.

school of artists A group of artists working during the same time frame, sharing similar ideas and art styles.

scribe A person who copies texts, especially the content for an illuminated manuscript.

script Handwritten words, letters, or figures.

scriptorium A room in a monastery for copying or writing illuminated manuscripts.

scroll A long narrow sheet with text written on it. Rollers at each end unroll and reroll a horizontal scroll for reading, or assist hanging up a vertical scroll on a wall for study and contemplation.

sculpt or sculpting Creating a sculpture by carving, modeling, welding, or other methods.

sculpture A three-dimensional form that observers usually view "in the round." Viewers observe the form from all perspectives, except when the artist sculpts in relief or designs the form to set against a wall, lie on the floor, or hang from the ceiling.

shade A variation on a color, or a color mixed with black to darken it.

shading Darkening parts of an object so it appears light fell on it.

shard A fragment of glass or earthenware.

shed In tapestry, the opening in the warp (vertical thread) through which the weft (horizontal thread) passes through.

sinopia (Italian) An artist's drawing for a painting, copied to a wall or ceiling with charcoal sticks.

sketch A quick, preliminary drawing used as a guideline for a painting or saved for future use.

slip A clay-and-water mix applied to a ceramic object as a final, decorative coating.

smalti (Italian) Handmade glass *tessarae* (small glass pieces) in brilliant colors.

stained glass Molten glass that derives its color from organic material. When used in windows, artisans cut colored glass and place it within a design held together by cames (lead strips).

stele A vertical stone with reliefs and inscriptions, used as a grave marker or memorial.

stone Rock for creating sculpture, including alabaster, granite, limestone, marble, and sandstone. Stonecutters cut the rock into slabs for carving.

stoneware An opaque, vitreous ceramic ware fired at high temperatures and often glazed.

syncretism The union of different art, religion, or philosophy styles.

tapestry A woven, decorative wall hanging or furniture cover with colorful pictorial themes.

tempera A pigment (colored powder) combined with any water-soluble media such as glue or casein, made from cow-milk curd.

tenebrism Strong, dramatic contrasts of light and dark.

terra-cotta A fired, hardened, reddish clay. Also, any clay for shaping and firing pottery.

tessara (Italian) A small square of glass or stone that sets into a mosaic. Plural: *tessarae*.

three-dimensional In sculpture, a form viewed from all sides.

tondo A circular-shaped painting or relief sculpture.

trefoil A decorative design with three rounded lobes placed adjacent to one another.

triptych Three panels of the same size, hinged together so the outer parts or wings fold over the center area.

two-dimensional A work of art on a flat surface, with the dimensions of height and width only.

typology When stories from the Old Testament symbolically foretold events of the New Testament. Artists sometimes placed correlating typology messages side by side. Also, the study of these comparisons.

underdrawing A preparatory drawing that establishes the lines and images of the final work.

underpainting A preparatory painting that establishes the main contours and color values of the final work.

uncial A writing style characterized by rounded capital letters, popular in Greek and Latin manuscripts from the fourth through eighth centuries.

vanishing point A point in a composition's horizon line at which orthogonal (right angle) lines meet.

vanitas (Latin) Translates as "emptiness." A still-life painting in which the objects symbolize life's transience. Popular in the Netherlands during the seventeenth century.

varnish A final coat of heated resin and linseed or walnut oil painted on a wood panel. Varnish deepens colors and protects it from dust, scratches, and temperature fluctuations.

veduta (Italian) Translates as "vista" or "view." Prints, drawings, or paintings of city or harbor scenes.

vellum A prepared calfskin used for writing and painting, considered a high quality, superior surface to parchment.

verism (Latin) Capturing the exterior likeness of a person or object with meticulous detail. Translates as "true."

vermicule Scroll or wormlike patterns engraved as a background for enamel ware or masonry work.

verso The left side of two facing pages in a manuscript.

warp The vertical threads in a weaving.

wash A film of diluted pigment broadly applied to a painting surface.

watercolor A transparent technique of painting with pigments mixed in water-soluble gum.

weave or weaving Interlacing threads, yarn, or other fibrous material to create a cloth or fabric.

weft The horizontal threads in a weaving.

wing A side panel of a triptych or polyptych that can fold over the central panel.

woodcut A print created by carving a design into a wooden block and applying ink to the recessed lines for printing.

zoomorphic A decorative and symbolic element in the shape of an animal.

NOTES

PART ONE
The Art of Faith

5 *The fourth-century historian Eusebius recorded* Paul A. Maier, ed., *Eusebius: The Church History* (Grand Rapids, MI: Kregel Publications, 1999), 47–50.

7 *Things which have taken place are expressed* Mary H. Allies, trans., Saint John Damascene, *On Holy Images* (London: Thomas Baker, 1898), 16.

9 *One of the earliest forms of Christian art* This story first appeared in Judith Couchman, *The Mystery of the Cross* (Downers Grove, IL: InterVarsity Press, 2009), 72–73.

10 *the affectionate respect due to the state* Robert Milburn, *Early Christian Art and Architecture* (Berkeley: University of California Press, 1988), 32.

10 *In the second century, Tertullian of Carthage advised* Eduard Syndicus, *Early Christian Art* (New York: Hawthorn Press, 1962), 9.

21 *until there is again a Holy Roman Emperor* Manfred Leithe-Jasper, *The Kunsthistorisches Museum Vienna: The Imperial and Ecclesiastical Treasury* (London and New York: Scala Publishers, 2005), n.p.

22 *What writing presents to readers* Robin Margaret Jensen, *Understanding Early Christian Art* (London and New York: Routledge, 2000), 2–3.

PART TWO
The Holy Trinity

25 *He believed pictures degraded the divine* Alexander Roberts and James Donaldson, eds., *Clement of Alexandria: Ante Nicene Christian Library Translations of the Writings of the Fathers Down to AD 325, Part Four* (Whitefish, MT: Kessinger Publishing, 2004), 52–65.

25 *He cannot be seen* David W. Bercot, ed., *A Dictionary of Early Christian Beliefs* (Peabody, MA: Hendrickson Publishers, 1998), 311.

36 *nurtured their . . . minds* Jensen, *Understanding Early Christian Art*, 54.

53 *But the works of our Saviour* C. F. Crusé, trans., Eusebius of Caesarea, *The Ecclesiastical History of Eusebius Pamphilus* (Methodist Episcopal Church, 1839), 129.

53 *even to our own day* Ibid., 129.

53 *Celsus considered Christ* Thomas F. Mathews, *The Clash of Gods: A Reinterpretation of Early Christian Art* (Princeton and Oxford: Princeton University Press, 1993), 67.

53 *Christ took no money* Ibid., 68.

61 *In the Cross is salvation* Aloysius Croft and Harold Bolton, trans., Thomas à Kempis, *The Imitation of Christ* (Mineola, NY: Dover Publications, 2003), 41.

70 *God here assumed the likeness* William Macdonald, George Ross Merry, Sir James Donaldson, William Wilson, eds., *Liturgies and Other Documents of the Ante-Nicene Period* (Edinburgh, Scotland: T. and T. Clark, 1872), 157.

PART THREE
The Unseen World

80 *The apostolic teaching is that the soul* G. W. Butterworth, trans., *Origen on First Principles: Being Koetschau's Text of the De Principiis, Preface* (Gloucester, MA: Peter Smith Publisher, Inc., 1973), n.p.

80 *death is the golden key* Sir Egerton Brydges, ed., *Poetical Works of John Milton* (London: John Macrone, 1835), 633.

PART FOUR
Faithful Followers

101 *No other sentiment draws men to Jerusalem* Jonathan Sumption, *The Age of Pilgrimage: The Medieval Journey to God* (New York: Hidden Spring Books, 2003), 123.

102 *If anyone does not believe* Philip Schaff, ed., *Nicene and Post-Nicene Fathers*, series 2, vol. 7, *Cyril of Jerusalem, Gregory Nazianzen* (Grand Rapids, MI: Christian Classics Ethereal Library, 2009), n.p.

119 *When the temptress had been driven* Catholic Encyclopedia: Saint Thomas Aquinas website, 2011, http://www.newadvent.org/cathen/14663b.htm.

PART FIVE
Sacred Symbols

128 *From the Cedar of Lebanon* Roberta J. M. Olson, *The Florentine Tondo* (Oxford: Oxford University Press, 2000), n.p.

140 *Man was condemned to death* Bercot, *Dictionary*, n.p.

140 *By means of a tree, we were made debtors* Ibid., 184.

173 *By setting off the ceiling panels* J. G. Hawthorne and C. Stanley Smith, eds., Theophilus, *On Divers Arts* (New York: Dover Publications, 1979), 79.

173 *If a faithful should see the representation* Ibid., 79.

180 *wise may fear the coming of the future judgment of the world's end* "Vision of the Heavenly Jerusalem," Morgan Library and Museum website, 2011, http://www.themorgan.org/collections/collections.asp?id=71.

180 *linking earth and heaven, time and eternity,* Canon Dr. Peter Sills "Descriptive Tour of Ely Cathedral," Ely Cathedral website, 2011, http://www.elycathedral .org/visitors/tour.html

PART SIX

Liturgical Art

201 *The Greeks and barbarians have this in common* Theophile James Meek, "The Sabbath in the Old Testament." *Journal of Biblical Literature* 33 (1914): 201–12.

204 *visible sign of an inner reality* Allan D. Fitzgerald, ed., *Augustine Through the Ages* (Grand Rapids, MI: Eerdmans, 1999), 745.

204 *outward and visible signs* Thomas Cranmer, The Episcopal Church, *The Book of Common Prayer* (Oxford and New York: Oxford University, 1990), 857.

216 *But when something is commanded* G. W. Clark, ed., *Ancient Christian Writers: The Letters of Cyprian of Carthage* (New York: Paulist Press, 1983), 3:98.

216 *one of the most splendid treasures from the Middle Ages* "Chalice of the Abbot Suger of Saint-Denis," National Gallery of Art website, 2011, http:// www.nga.gov/collection/gallery/medieval/medieval-1437-none.html.

228 *You write with the pen of memory* Phil Barber, "A Brief History of Illuminated Manuscripts," Historic Pages website, 2011, http://www.historicpages.com/ texts/mshist.htm.

235 *The Divine religion has one dress* Charles G. Herbermann et al., eds., *The Catholic Encyclopedia: An International Work of Reference on the Constitution, Doctrine, Discipline, and History of the Catholic Church* (New York: The Encyclopedia Press and Robert Appleton Company, 1912), 15:388.

235 *Purify me, O Lord* Isabel F. Hapgood, *Service Book of the Holy Orthodox-Catholic Apostolic Church* (Englewood, NJ: Antiochian Orthodox Christian Archdiocese of New York and All North America, 1975), xxxvi.

INDEX OF ART

This index presents the titles, mediums, and creators for art mentioned in this book. An index of names and terms begins on 285.

INDEX OF NAMES AND TERMS

In addition to art and religious terminology, this index presents the names of art and religious terms, people, places, and objects mentioned in this book. An index for the works of art begins on page 273.

ABOUT THE AUTHOR

Judith Couchman works as an author and has published more than forty books, workbooks, and compilations. These include *The Mystery of the Cross*, *The Shadow of His Hand*, and *Designing a Woman's Life*. She also teaches online art history courses for the University of Colorado at Colorado Springs (UCCS). Her university classes cover art topics from the prehistoric era through the Middle Ages.

Judith speaks to groups in the United States and overseas, usually focusing on the spiritual life, women's topics, nonfiction writing, Christian art, or publishing principles. She holds a B.S. in education (English and journalism), an M.A. in journalism, and an M.A. in art history. She lives in Colorado Springs, Colorado.

Visit Judith online at the addresses below. For speaking queries, consult her website for suggested seminar topics and write to judith@judithcouchman.com.

Website: www.judithcouchman.com.

Notes from Judith (Blog): www.notesfromjudith.blogspot.com.

Facebook: www.facebook.com/judithcouchman.

Twitter: www.twitter.com/judithcouchman.

ABOUT PARACLETE PRESS

WHO WE ARE

Paraclete Press is a publisher of books, recordings, and DVDs on Christian spirituality. Our publishing represents a full expression of Christian belief and practice—from Catholic to Evangelical, from Protestant to Orthodox.

We are the publishing arm of the Community of Jesus, an ecumenical monastic community in the Benedictine tradition. As such, we are uniquely positioned in the marketplace without connection to a large corporation and with informal relationships to many branches and denominations of faith.

WHAT WE ARE DOING

PARACLETE PRESS BOOKS | Paraclete publishes books that show the richness and depth of what it means to be Christian. Although Benedictine spirituality is at the heart of all that we do, we publish books that reflect the Christian experience across many cultures, time periods, and houses of worship. We publish books that nourish the vibrant life of the church and its people.

We have several different series, including the best-selling Paraclete Essentials and Paraclete Giants series of classic texts in contemporary English; Voices from the Monastery—men and women monastics writing about living a spiritual life today; award-winning poetry; best-selling gift books for children on the occasions of baptism and first communion; and the Active Prayer Series that brings creativity and liveliness to any life of prayer.

MOUNT TABOR BOOKS | Paraclete's newest series, Mount Tabor Books, focuses on the arts and literature as well as liturgical worship and spirituality, and was created in conjunction with the Mount Tabor Ecumenical Centre for Art and Spirituality in Barga, Italy.

PARACLETE RECORDINGS | From Gregorian chant to contemporary American choral works, our recordings celebrate the best of sacred choral music composed through the centuries that create a space for heaven and earth to intersect. Paraclete Recordings is the record label representing the internationally acclaimed choir Gloriæ Dei Cantores, praised for their "rapt and fathomless spiritual intensity" by *American Record Guide*; the Gloriæ Dei Cantores Schola, specializing in the study and performance of Gregorian chant; and the other instrumental artists of the Arts Empowering Life Foundation.

Paraclete Press is also privileged to be the exclusive North American distributor of the recordings of the Monastic Choir of St. Peter's Abbey in Solesmes, France, long considered to be a leading authority on Gregorian chant.

PARACLETE VIDEO | Our DVDs offer spiritual help, healing, and biblical guidance for a broad range of life issues including grief and loss, marriage, forgiveness, facing death, bullying, addictions, Alzheimer's, and spiritual formation.

Learn more about us at our website:
www.paracletepress.com or phone us
toll-free at 1.800.451.5006

SCAN
TO
READ
MORE